ART & CRIME

ART & CRIME

STEFAN KOLDEHOFF
and TOBIAS TIMM

TRANSLATED BY PAUL DAVID YOUNG

SEVEN STORIES PRESS

New York • Oakland

Copyright © 2020 by Verlag Kiepenheuer & Witsch, Colgne/Germany
English translation © 2021 by Paul David Young

Originally published in German as *Kunst und Verbrechen* (Galiani Berlin, 2020).

The translation of this work was supported by a grant from the Goethe-Institut.

See page 267 for image credit information.

SEVEN STORIES PRESS

140 Watts Street
New York, NY 10013
www.sevenstories.com

College professors and high school and middle school teachers
may order free examination copies of Seven Stories Press titles.
Visit https://www.sevenstories.com/pg/resources-academics
or email academics@sevenstories.com.

Library of Congress Cataloging-in-Publication Data

Names: Koldehoff, Stefan, author. | Timm, Tobias, 1975- author. | Young,
Paul David, translator. | Koldehoff, Stefan. Kunst und Verbrechen.
Title: Art & crime / by Stefan Koldehoff and Tobias Timm ; translated by
Paul David Young.
Other titles: Kunst und Verbrechen. English
Description: New York, NY : Seven Stories Press, [2021] | Includes
bibliographical references and index.
Identifiers: LCCN 2021030498 | ISBN 9781644211199 (hardcover) | ISBN
9781644211205 (ebook)
Subjects: LCSH: Art--Forgeries. | Art thefts. | Cultural
property--Destruction and pillage.
Classification: LCC N8790 .K6513 2021 | DDC 702.8/74--dc23
LC record available at https://lccn.loc.gov/2021030498

TEXT DESIGN: Beth Kessler

Printed in the USA.

9 8 7 6 5 4 3 2 1

CONTENTS

LIGHT AND SHADOW

AN INTRODUCTION

The international art market—between New York and Beijing, London and Moscow, Berlin and Monaco—has two sides, one full of light and the other dark. Both are the products of a development over the past two decades in galleries, auction houses, and the internet, in which the prices for painting and sculpture have exploded: $250 million for Paul Cézanne's *Card Players* from a private collection in Geneva, $300 million for Paul Gauguin's Tahitian painting *Nafea faa ipoipo*, $157 million in a New York auction for a *Reclining Nude* by Amedeo Modigliani, $141 million for Alberto Giacometti's sculpture *L'homme au doigt*—and, of course, the already legendary $450 million that a Muslim head of state paid in November 2017 at Christie's in Rockefeller Center on Fifth Avenue for the picture of Christ *Salvator Mundi*, although experts still disagree whether the small wood panel was, as was claimed, to any significant extent painted by Leonardo da Vinci. In total, according to the *Art Basel and UBS Global Art Market Report*, more than $50 billion flows through the international art market annually.

And these are only the prices that are publicized—on the daylight side of the market. Here there are respectable auction houses that make

special advisory offers to their customers on a level competitive with that of investment banks—naturally, with discretion and, if it simply has to be, through offshore firms in tax havens, as demonstrated by the plunder of the Malaysian government reserves known as the 1Malaysia Development Berhad scandal or 1MDB.

At auctions, these thieves used the hundreds of millions of dollars in stolen Malaysian government money to buy art by Vincent van Gogh and Pablo Picasso, among others. The sales rooms of the galleries that conduct business internationally look like luxury boutiques for exclusive fashion houses. And they aspire to sell the same magic: these multimillion-dollar transactions aren't about art; rather, lifestyle and prestige are for sale. Those who can show off, say, a fresh Jeff Koons hanging on the wall at their next party in the Meatpacking District in New York are more than just rich. They belong not only to the minority global class of the well-to-do, whose wealth has grown enormously in the past few years, but also to what counts as the global cultural elite, into which one can buy entry through art.

Those who can afford it employ an "art adviser," who, in exchange for sumptuous payment, takes over the search for suitable artworks and, as a practical matter, can identify simultaneously which artists in the current season are particularly sought after and what prices their works command. That this approach can also go wrong—because agreements are not kept and big-name artists such as Picasso, Kirchner, and Lichtenstein also painted some bad pictures—became spectacularly clear in the case of the art adviser Helge Achenbach. "The entry of investment bankers, stock speculators, and brokers vulgarized the art market completely," he said in an interview.[1] "In the stock market, everything is monitored. If you buy stock with insider information, you can expect the authorities to knock on your door right away and arrest you. The art market is easier to manipulate." Achenbach knows what he's talking about: before he was sentenced to six years' imprisonment in 2015 because of millions of dollars in art swindling, he had worked

as an art adviser for banks and attempted to establish an art-based investment fund.

THE DARK SIDE OF THE MARKET

There is the other side, the dark side of the lucrative commerce in art. A business that can make as much money as the art market does automatically attracts those who want to play without following the rules.

In a villa in the Rhineland, an entire collection of supposedly authentic Russian avant-garde art is offered for sale, complete with a printed catalogue on which the logo of an internet photo-book publisher is prominently displayed. But that didn't stop a West German entrepreneur from making expensive purchases, nor did the fact that the accompanying expert reports raised questions as to the works' authenticity.

Then there's the expert in charge of the catalogue of one of the most sought-after and high-priced artists of classic European modernism, who was paid a commission of €91,000 by a German auction house for his expertise, a sum which an independent audit found could not be justified.

And there's the expert who for years produced scientific verifications of works of art, supposedly worth millions of dollars, that were sent to him rolled up like posters and mailed through regular commercial courier services. Any museum or reputable art dealer would have the pictures framed, packed in highly protective, climatized containers, and transported by special art handlers.

These are some consequences of the rapid development of the art market in the twenty-first century, about which much has been said and written. The story of this development includes the hedge-fund billionaires in Manhattan and on Long Island who make collecting art both a hobby and a profitable investment. And this story is inseparable from ever-growing prices and the way art has become the new status symbol of the super rich, with buyers and sellers in Hong Kong, India, Russia,

and South America. It is a story of increasing demand and dwindling supply, because the market is limited in product.

Until now there's been no systematic investigation into how the social and economic developments of the past few decades have turned works of art into investments and what effect this has had on these cultural goods and our relation to them. In this book, we cover the many reasons for what happened and the consequences of it, providing concrete examples.

- The art market has always been both one of the most globalized and one of the least transparent markets in the world. If a work by Leonardo da Vinci, Vincent van Gogh, Alberto Giacometti, or Jackson Pollock changes hands, usually just the few who are directly involved in the transaction know about it. How the price is determined, by whom and to whom it is paid, which middlemen or letterbox entities in tax havens are involved—these things are, as a rule, not disclosed.

- As always, the art market claims for itself special privileges, which were justified over a hundred years ago by the uniqueness of the objects for sale. Whereas cash transfers of a relatively low value and real-estate transactions must be reported, the purchase of works of art under certain conditions may still be used to move profits from illegal practices, such as extortion or drug dealing, into legal circulation.

- And art dealing is the market economy in its purest form. Especially at the high end of the market, these are unique goods whose value cannot be established objectively. The price of a painting by Rembrandt, Roy Lichtenstein, or Gerhard Richter is not determined by its weight, the materials used, or even the size. Demand and supply converge on a certain price. An artist, a dealer, or a collector must be ready to part with the work. And another collector—or, even better, two collectors—must want to own the work. When only a few people possess a whole lot of

money and are ready to spend it on art—for reasons of passion, expertise, prestige, or investment—an ever-higher spiral of prices is to be expected. And it doesn't look as if anything about this will change any time soon.

NOT A UNIVERSAL INDICTMENT

The subjects of this book include money laundering; tax fraud and deception; the consequences of globalization; the connection between art and the mob; counterfeiting at small and large galleries; the secret hoarding of pictures in protected, tax-free, toll-free storage facilities; the dubious market in authentic and counterfeit Nazi relics; and the business of stolen and counterfeit books, which has become more lucrative in the era of digitalization. And yet, our intent isn't to cast suspicion on an entire industry. The overwhelming majority of art dealers conduct themselves properly, adhere to the guidelines and rules, and are genuinely interested in art.

However, nothing could be clearer than the fact that those on the right side of the art marketplace must be more forcefully dedicated than they have been until now to calling out the thugs in the industry and exposing, curtailing, and preventing their activities. There is a weird collective spirit in the art world, as expressed in some industry publications—an insistence upon outmoded traditions that invite suspicion, from the handshake deal to the anonymity of business partners to the code of silence. All of this harms the entire market, and in the digital space, where the worldwide dissemination of data happens instantaneously, it doesn't have a future. Instead of stubbornly insisting on maintaining what is in truth already long gone, instead of refusing to work collaboratively and constructively, and instead of paying experts time and again to manufacture counterarguments, it would be so much more meaningful for leaders within the art world to proactively shape the future of the art market together.

The connection between art and crime described in the following chapters through some particularly sensational examples is hardly

limited to art dealing alone. Museums throughout the world must come to grips with security issues. They remain poorly prepared, both in terms of technology and in terms of personnel, as the hundred-kilogram gold coin stolen in Berlin and the break-in at the Green Vault in Dresden demonstrate. So-called inside jobs—thefts by underpaid workers brought in from outside firms—have taken place recently in, among other places, Rotterdam, Paris, Amsterdam, Istanbul, Cairo, and possibly also London.

In the summer of 2006, it was reported that 221 objects were missing from the Russian department of the Hermitage in Saint Petersburg, in particular icons and enamel works from the fifteenth to the eighteenth century with an estimated worth of almost five million US dollars. It was suspected that they had been spirited away to the Far East and South America. According to research by the Moscow daily online newspaper *Gazeta*, more than fifty million objects have been stolen from Russian museums since the economic reopening of the country in 1990, among them 3.4 million paintings and thirty-seven thousand icons. The newspaper estimated the total value of works formerly held in Russian museums now being sold on the gray market at more than $1 billion. In many libraries, archives, and graphic collections of museums, the holdings are not inventoried, let alone digitalized. If, as happened in Naples, valuable books are stolen or illustrations and early maps are cut out of folios, the theft is often not even noticed. Until both private and public institutions begin to address the security of their holdings according to new higher standards, the situation isn't going to change.

THE GLOBALIZATION OF COUNTERFEITING

Two spectacular cases demonstrate just how international the web of people counterfeiting art is and how quick and global the pathways that counterfeits can take are. Between 1994 and 2011, the New York gallery Knoedler sold work supposedly by world-renowned and high-priced artists such as Jackson Pollock, Mark Rothko, Willem de Kooning,

Barnett Newman, Clyfford Still, and Franz Kline that turned out to be fake. Some of the participants in the scheme were a Spanish art dealer, collectors from Italy and Belgium, and a painter from China living in New York who faced arrest when he attempted to flee to his homeland.

Finally, there are the various old-master paintings that came on the market in the past few years in France, Britain, and the US that turned out to be forgeries. Because centuries-old pictures feature ancient wood or linen as the painting ground, period-appropriate pigments and binding materials, not to mention the techniques of old masters and the traces of age, they can be much harder to copy than works of classic modernism. Perhaps that's why in 2011 *Portrait of a Man* by the much sought-after Netherlandish painter Frans Hals was sold to a collector for $11.2 million by a British dealer in a private transaction through Sotheby's without much critical inquiry. Experts from the Louvre in Paris and the Royal Art Collections in the Mauritshuis in The Hague had earlier declared the portrait to be solely the work of this master. After testing the material proved that was not the case, the purchaser (a US real-estate entrepreneur and art collector from Seattle) returned the painting. The dealer had acquired it together with a London firm and paid $3.2 million for it—to the Italian-based French dealer Giuliano Ruffini. Since then, several other works sold by Ruffini, all of dubious provenance, have come under suspicion as possible fakes. A painting attributed to Parmigianino, *Holy Hieronymus*, dated 1527, hung in the Metropolitan Museum in New York for a long time, although it contained the pigment phthalocyanine green, which was first sold in 1938. In a 2012 auction, the price of the painting was bid up to $842,000. For three years the National Gallery in London exhibited a "discovered" painting by Orazio Gentileschi for which a British collector had paid $5 million. The Regent Hans-Adam, Prince of Liechtenstein, acquired a painting, *Venus with a Veil*, allegedly from 1531 and by Lucas Cranach, from the Bernheimer gallery for €7 million. It was seized as counterfeit in March 2015 in Aix-en-Provence in France, as is permitted under French law. In September 2019 a painter from Northern Italy who

was associated with Ruffini was held in custody for a short time, but the court of Bologna refused to send him to France. There was also a warrant issued in France for the dealer's arrest. The Italian justice department agreed to transfer him to Paris, but only after he was tried on charges of alleged fraud in Italy. Both claim their innocence. Ruffini told the French counterfeiting expert Vincent Noce, who wrote a book on the case,[2] that although he had sold dozens of paintings over decades, he had nothing to do with their attributions to old masters. He was only a collector, not an expert, he said. All the pictures he sold, he claimed, were certified by experts and curators. The defense attorney for the painter in turn told the court that his client had been pulled into the scandal under false pretenses, through a loan of a painting to a museum.[3] In another case, copies that were sold as originals by the counterfeiter Wolfgang Beltracchi over a period of years could be found in private collections in the US and in exhibitions in France. As we showed in our book *Falsche Bilder, Echtes Geld*, published in 2012, experts from all over Europe had provided the authenticating opinions. And then there's the case of the SNZ Galeries in Wiesbaden, Germany, which left clues leading to Israel, Great Britain, and Russia.

On the policing side, there are those who collect the clues and spring into action when a crime has been committed. Italy, for example, runs a very effective special department, Carabinieri Tutela Patrimonio Culturale (CTPC), which in 2016 alone recovered works valued at €53 million. The General Secretary of Interpol in Lyon collects information about art crimes in all member nations and publishes it in an internet databank that is accessible publicly with a sign-in. In the US, in addition to the criminal justice system, the Holocaust Claims Processing Office of the New York State banking oversight division looks for stolen art. And in Great Britain there's the legendary Art and Antiques Unit, which was enlisted in the 1961 investigation into the theft of Goya's portrait of the Duke of Wellington from the National Gallery, although, after numerous reforms, the unit isn't as hard-hitting today as it used to be. That case attracted so much attention at the time that it made its way into the

first James Bond film, *Dr. No*, as an early example of "art-napping": the
attempt to use stolen art for extortion. Insurers once were adamantly
opposed to paying ransoms for stolen art, but today the rules are not
so clear, and the practice has become popular again. This book also
explores this aspect of art and crime.

In German prosecutorial offices, special departments for art crim-
inality continue to be the exception rather than the rule. Such depart-
ments exist only in the federal government and three out of sixteen
German states. The work of these specially trained prosecutors, who
are dedicated to protect and preserve the cultural commonweal, usu-
ally ends when an indictment is handed down and a judgment is to
be rendered. As shown in the cases of the SNZ Galeries in Wiesbaden
or the counterfeiter Wolfgang Beltracchi in Cologne, the prosecutors
most often avoid trouble and show relatively little interest in diving
more deeply into the cases.

While there are hundreds, if not thousands, of instances of stolen
or counterfeited works of art, there are only a handful of prosecutions.
And even then, in many cases plea bargains between the prosecutor
and the defense result in diminished sentences in exchange for a con-
fession. Criminal structures, international webs, and the whole system
of art and crime are reduced in this way to single cases, as if they were
the exception rather than something more pervasive. There's obviously
no desire to get down to the bone of their underlying social, economic,
and, most importantly, global structures.

ART TAKEN HOSTAGE

Mostly it's left to individual experts, attorneys, gallerists, auctioneers,
and investigators to attempt to flush out the deceivers and counterfeiters
in the face of considerable resistance and great personal risk. The vic-
tims of the crimes described in this book are not just billionaires from
Monaco and Long Island but also normal wage-earning apprentices in
upper Bavaria. For some, the fact that they bought a fake is disturbing
and nothing more. Others find themselves under an existential threat by

the deception. Art, however, is the loser every time. It is taken hostage, hidden in modern robbers' caves, and dirtied by counterfeiting.

That's why there is so much more to tell on the subject of art and crime. Who procured their collections with money derived from highly questionable sources? Which Greek shipping magnates, whose families own the world's most important collections of impressionist and post-impressionist pieces, worked closely with the fascist military regime in their homeland? Which of the works from these collections—by Van Gogh, Picasso, and other modern masters—have for some time been on display in the Kunsthaus in Zürich—with their provenance posted discreetly on the accompanying wall plaque as "Private Collection"? And how did the Thyssen-Bornemisza collection, which has been exhibited since 1992 in a museum in Madrid, come from a family of industrialists who grew rich by dealing arms to the Nazis? Then there is the attorney and fiduciary Herbert Batliner, who died in June 2019 in his homeland of Liechtenstein, who administered the fortunes, including the art collections, of countless entrepreneurs charged with tax evasion. Among his clients were the commodities dealer Marc R., who is alleged to have done business with Iran and Iraq, with the not exactly demo-cratic Saudi Royal House, with the Togolese dictator Eyadéma, and with assorted German Christian Democratic Union politicians, who, through Batliner's office and the "Zaunkönig Foundation," among oth-ers, organized slush fund accounts connected with the Hessian funding scandal. Also, according to the investigations, Batliner established four foundations in the name of the wife of a drug boss from Ecuador, who has meanwhile been arrested and convicted by a judge for drug smug-gling, money laundering, tax evasion, and murder. An entire wing of the Albertina Museum in Vienna is named for Herbert Batliner and given over to his collection, which he donated to the museum. It includes seven works of the Russian avant-garde—most of them purchased from one gallery in Switzerland—which, according to the museum, are counterfeit. Sometimes it all comes full circle.

This book concentrates on crimes that bring into focus just how far apart theory and reality are in the art world. These crimes reveal the dirty practices that are used to fight for the good, the beautiful, the true. We are concerned with the fact that often only the material value of art, and not its aesthetic or enlightening value, is foremost when art is discussed. On the basis of selected cases and exemplary figures, we unearth structural problems that put on full display what's wrong with the way the art market and the business of art are run. Only by insisting on the necessity of such an analysis can we seriously contribute to freeing our view of art.

—SK & TT, April 2021

1

STOLEN, ROBBED, KIDNAPPED

Of Legendary Museum Thefts, "Art-Napping," and the 220-Pound Gold Coin

THE DISAPPEARANCE OF THE *MONA LISA*

Museums were built as temples for art, but they must also store their treasures securely. The stories of the big break-ins, raids, and art heists from these temple vaults are the stuff of legend. Leonardo da Vinci's *Mona Lisa*, for example, first became truly famous after it was stolen from the Louvre in 1911.

The theft that time was an inside job. An Italian housepainter who had worked in the Louvre as a glazier and therefore knew the security precautions allowed himself to be locked inside the Louvre on a Sunday afternoon, along with two collaborators. The three hid in a small chamber in which copyists usually stored their painting materials and brushes. Monday morning, when the Louvre was closed to visitors, the three men in white coats entered the Salon Carré, simply took the *Mona Lisa* off the wall, and disappeared through a side exit. In their white coats, they blended in with the employees who cleaned the museum on Mondays.

For two years the picture remained missing. The police investigated, and private detectives tried to uncover its whereabouts. Pablo Picasso and Guillaume Apollinaire were suspected and were called in for questioning but later released. A French newspaper even offered to pay five thousand francs to a clairvoyant. The *Mona Lisa* had vanished.

For a long time, the person behind the theft remained a mystery. The media believed the story that the thief told: he had stolen the picture for patriotic reasons, to bring it back to Italy where it really belonged. Then, in 1932, the *Saturday Evening Post* reported that Vincenzo Peruggia was, in fact, being directed by someone else. The man who was behind him and who had engaged and paid him and his accomplices, Vincenzo and Michele Lancellotti, was Eduardo de Valfierno, an Argentine by birth. Even today, little is known about their South American employer, who had them address him by the title "Marqués." And it is not clear if his story itself is a fake made up by an American journalist.

TWO, THREE, SIX *MONA LISAS*

Valfierno, so the story goes, was never really interested in the painting whose theft from the Louvre he had commissioned. What the man behind the biggest art coup of the pre–World War I period wanted wasn't the most famous painting in the world, but the headlines that proved to the world that he could steal it. Born in Argentina, the son of well-to-do parents, he lived off money generated by selling art that he had inherited. At some point, he progressed to commissioning and selling fakes, made-to-order copies of paintings that already existed in private collections. Valfierno, according to Karl Decker's account, commissioned the copies from a restorer named Yves Chaudron and sold them to his clients as stolen originals.

The two men supported an entire workshop in Buenos Aires for counterfeit Murillos. The only journalist ever to claim he had interviewed Valfierno was the American Karl Decker of the *Saturday Evening Post*. The Marqués allegedly told the reporter that because of him Argentina had more Murillos than cows: "I've made this country

incredibly richer." Even when his clients realized that they had been deceived, there was little risk for Valfierno: nobody who has hired someone to steal a work of art would go to the police to complain that the stolen art was fake.

And so it went when Valfierno had the most famous painting in the world stolen. Even before the theft, he had already offered the *Mona Lisa* to several collectors, most of them living in the US, and had Chaudron's counterfeits shipped to the US as amateur copies. By the time the headlines appeared about the theft of the *Mona Lisa*, he had allegedly already sold his various clients in total six *Mona Lisas*, which Yves Chaudron had probably begun to paint in the winter of 1910—i.e., before the theft. They were sold, however, as originals, at the hefty price of $300,000 each, about $8 million each in today's valuations. The real *Mona Lisa* had never left Paris. It stayed with Vincenzo Peruggia, about three miles from the Louvre.

Valfierno enjoyed his riches, traveling to, among other places, North Africa and the Near East. When Karl Decker supposedly met him for their interview in Casablanca, Decker described the Argentine as a big man with a white mane of hair and an elegant white moustache. "Stealing the *Mona Lisa*," he said, "was so simple, like cooking an egg. Everything was a question of psychology. Our success depended on one thing: the fact that a worker in a white coat was as unsuspicious as an unlaid egg." But the man who had worn that white coat for Valfierno heard nothing further from his employer. He thought first it was an oversight, then a betrayal. And he began at last to craft his own plans.

Peruggia drove with the painting to Florence, offered it through a gallerist to the director of the Uffizi, and was arrested at the point of transfer on December 12, 1913. In his homeland, he was given a surprisingly light sentence of a year and two weeks in prison, after a psychiatrist had testified that he was "intellectually defective." An appellate judge reduced the sentence to seven months, which he had already served while awaiting trial. On July 29, 1914, Peruggia was again a free man. And he was celebrated as a hero.

According to Decker, who is the only source, Eduardo de Valfierno died in 1931 without ever asking for the *Mona Lisa*, whose theft he had commissioned. The Marqués had adroitly covered his tracks. Peruggia didn't even know his real name. Only after the death of the Argentine was Karl Decker allowed to publish his interview. Meanwhile, there remain serious doubts about the veracity of Valfierno's story, for which there is no other source besides Decker. It is uncertain whether Valfierno existed at all.

SAWED-OFF SHOTGUNS IN THE MUNCH MUSEUM

Nonetheless, even today the theft of the *Mona Lisa* is considered the greatest art robbery of all time. That the lowly worker Peruggia and his accomplices managed to pull it off made it the criminal version of the Italian David against the French Goliath. But it has very little in common with art criminality today. The three gentle thieves had spied out exactly where they could hide and which paths they had to take to steal the *Mona Lisa*. They didn't carry any weapons with them, and no one was injured. Double panes of bulletproof glass enclose the climate-controlled viewing area that now protects the picture, which museum visitors can approach only up to a certain safety zone.

Today, art thieves are mostly professional criminals who brutally and recklessly pursue their targets and, according to estimates, cause annual damages in the billions of dollars. The violence with which they go about their business has steadily increased in the past decade and a half. When, for instance, in 2004, a group of unknown culprits stole two paintings by Edvard Munch from the Munch Museum in Oslo, they came during regular opening hours. The masked men threatened museum visitors with sawed-off shotguns and risked wounding or even killing them.

Many criminals aren't able in the end to unload their valuable goods. Today, through interconnected electronic police databases, to which auction houses, art dealers, and museums all have access, every

purchaser of art is able to determine in a very short time whether the work on offer is a clean work or a stolen one that cannot be resold.

Today, theft from a museum is rarely about having the work for its own sake. Rather, stolen works of art serve as the basis for extortion from insurers and collectors. Other thieves are interested only in the material from which the objects are made, whether it be the bronze of sculptures or the gold in coins, which can easily be melted down and resold. For as the prices of art have increased rapidly in the past few years, so has the price of precious metals.

"ART-NAPPING"—EXTORTION WITH ART

The brutal attack in February 2008 on the private museum of the Bührle Collection Foundation in Zürich, which has since closed, was at the time the biggest art theft ever in Europe. While the museum was open to the public, valuable works by Cézanne, Van Gogh, Monet, and Degas, with an estimated worth of $180 million, were stolen. Four years later Cézanne's *Boy in a Red Vest* was seized in Belgrade. Shortly thereafter the state prosecutor's office in Zürich let it be known that one further painting, Degas's portrait of the count Lepic with his two daughters, had been returned to the collection some months earlier. Whether a reward or extortion money was paid for the return was left unsaid.

The clues in another case also led to the Balkans. On a night in October 2012, seven paintings by Lucian Freud, Gauguin, Meijer de Haan, Matisse, Monet, and Picasso that belonged to the entrepreneurial Cordia family were stolen from the Kunsthal Rotterdam. The case didn't have such a happy ending. The mother of the suspect, Radu D., allegedly burned all the works out of fear her son could be extradited. Except for a few ashes in the oven, there's no proof of her story. Supposedly, there were also attempts in this case to sell the loot back to the owners, though in February, a consortium of insurers had already paid €18.1 million for the loss.

The business of art-napping is lucrative. The secretive millionaire who commissions theft so that he can look at art in his hidden basement

doesn't exist, in the opinion of most art investigators. In any case, no such person has been arrested for decades. Not in the two attacks that took place in the final hours of 2009 in southern France, in which thirty valuable artworks by Degas, Picasso, Rousseau, and other classic modernists were stolen, never to be seen again. Not in the theft of two Picasso paintings owned by the Sprengel Museum in Hanover, which disappeared from an exhibition in Pfäffikon, Switzerland. Not after Vjeran T., in 2010, stole works by Picasso, Braque, and Matisse from the Musée d'Art Moderne de Paris. Not after the disappearance of the Degas pastel, which, in spite of security alarms, unknown persons unscrewed from the wall in the Musée Cantini in the center of Marseille on New Year's Day 2009. Here too, the French police assumed it to be an inside job in which museum employees were involved. Similarly, there's been not a trace of the over $100 million worth of treasured paintings by Rembrandt, Vermeer, Degas, and Manet that fake police stole from the Isabella Stewart Gardner Museum in Boston in March 1990, despite a $5 million reward for information offered and the statute of limitations having run out years ago. In the official art market, such world-famous works cannot be sold. And in the digital age, the police at airports, customs officials, and art dealers are all kept well informed through databases of stolen goods.

A GOYA FOR THE TELEVISION

One of the earliest cases of art-napping caused such a sensation that it made its way into the first James Bond film. On August 21, 1961, a truck driver named Kempton Bunton from Newcastle upon Tyne stole a painting by the Spanish artist Francisco de Goya—a portrait of the Duke of Wellington (who would later defeat Napoleon at Waterloo) painted in the summer of 1812—from the National Gallery in London. Bunton, who was fifty-seven at the time, took a ladder and climbed through an open window in the men's bathroom. But he didn't want to extort money. He wanted to strike a blow for social justice. After he turned himself in, he said that he had stolen the artwork in order to establish a fund to pay for the television fees on behalf of needy people.

"I never intended to keep anything for myself. My only goal was to pay the television license fees for poor and old people, who seem to be neglected in our affluent society." He himself watched only private programming, but he was required, as all Britons are, to pay a monthly licensing fee for the publicly funded BBC, which the poor in England generally cannot afford.

The painting remained missing for almost four years. During this time, the first James Bond arrived in movie theaters. The screenwriters explained the theft in the film by saying that the bad guy had commissioned it. On the screen, millions of filmgoers saw the painting that Scotland Yard had been searching for intensively for months. Sixty-four by fifty-two centimeters in size, it hung in the stairway in the underground bunker of the villain Dr. No.

The case was solved only later. On May 5, 1965, a tall, thin man with wavy blond hair brought a carefully wrapped package labeled "Glass, Handle with care" to the luggage storage counter in the New Street train station in Birmingham. He introduced himself as Mr. Bloxham, paid seven shillings to the person at the counter (Ronald Lawson), and received luggage ticket number F 24458. Saying, "Be careful with that," he handed over the package. The package, wrapped in cardboard and wood-wool, remained for sixteen days, jumbled among the luggage on a rack. On May 21, the editors of the newspaper *Daily Mirror* received a letter, which among other things had the luggage ticket with the number F 24458 of the Birmingham train station. Detective Inspector John Morrison and Detective Sergeant Jack Ion rushed there in a patrol car. They rang the attendant out of bed. And at two a.m. on May 22, they held in their hands the unframed, intact portrait of the Duke of Wellington by Goya. Five days later, after exhaustive study, the painting was hanging once more next to other paintings by Spanish artists in Room XVIII of the National Gallery on Trafalgar Square.

Kempton Bunton gave himself up to the police and was sentenced to three months' imprisonment—for the theft of the destroyed frame. It could not be proven that he ever wanted to keep the painting.

Today, art is stolen by well-organized criminal groups that are staffed by well-educated, but poor, former soldiers from the Eastern Bloc or the Balkans. "Since they've been in the business," said Charles Hill, the former head of the art department of Scotland Yard, "it's gotten a lot more brutal. That museums today are attacked during public hours, that visitors are threatened with firearms or a guard is held with a knife at his throat—that didn't used to happen." However easy the theft might be because of bad security precautions, the criminals usually have more trouble transferring or selling the works of art than they do stealing them.

To be sure, a gray market for expensive, colorful pictures has existed for many years, especially after the fall of the Berlin Wall in 1989. They are not traded by proper galleries or auction houses, but rather in backrooms, under the counter, or over the internet. Money is laundered in Luxembourg by means of stolen artworks, which are also used to pay for heroin from Turkey and to finance expensive real estate. Even in the classified advertising of respectable publications such as the *Süddeutsche Zeitung, Frankfurter Allgemeine Zeitung, Welt*, or *Handelsblatt*, works of dubious origin are offered for sale, works that cannot be disposed of in the legal art market. As a rule, this marketing approach is much too public for someone trying to sell stolen pictures. That's why the valuable loot frequently changes hands as payment in illegal businesses—or is eventually offered back to their original owners for extortion money or simply in exchange for immunity from prosecution. "It's not the norm," said a leading figure in one of the largest insurance concerns in the Rhineland on the condition of confidentiality. "But you would be surprised how often these deals are made. We would rather pay a small percentage as a finder's fee than the full market value for which the work is insured by us."

SHADE AND DARKNESS IN THE RED-LIGHT DISTRICT

"Of course, we were under a lot of pressure from Scotland Yard," recalled Charles Hill, who was a police officer at the time. On the evening of July 28, 1994, unknown persons stole two valuable paintings by J. M. W.

Turner and one by Caspar David Friedrich from the exhibition *Goethe and Art* at the Schirn Kunsthalle Frankfurt. Officially, the Frankfurt police were conducting the investigation into this art theft, one of the most spectacular in Germany, but because the Turner paintings were from the Tate Gallery in London, Hill's department was immediately activated as well. "I asked the chief superintendent of the Belgravia police station to loan us Jurek Rokoszynski," Hill recalled ten years later. "He spoke German, and the Tate Gallery was in the Belgravia police precinct. The chief superintendent agreed, and my bosses at Scotland Yard too. So Rocky took over and stayed with it, as he and Micky Lawrence left the police and became independent."

The theft—which happened right in downtown Frankfurt, between the landmark medieval Römer, or Town Hall of Frankfurt, and the cathedral—made headlines worldwide. The last watchman went to turn out the lights in the Schirn Kunsthalle on a warm summer night. All the visitors had left by the time the exhibition halls closed at ten p.m., and the fourteen guards and cashiers had gone home. A lone twenty-eight-year-old watchman took his final turn through the museum. As he locked up the exhibition rooms and went to activate the alarm system, two masked men, who had evidently remained hidden somewhere in the exhibition areas, overpowered him. They pulled a cloth hood over his head and held it in place with tape. Then they handcuffed him, took his keys, and put him in a storage room.

Seconds later, they unscrewed three paintings from the wall on the upper floor of the exhibition. They climbed into the freight elevator with the three paintings, which were insured altogether for about DM 62 million, and left through a back exit on the cathedral side. A driver was waiting there. A married couple walking by saw them load the pictures into a small truck. Since this activity seemed strange to them, they wanted to alert the police, but they were prevented by a long line at the only public telephone in the area.

The three burglars were quickly caught. They had left a fingerprint on a door at the scene of the crime, which led the police to the red-light

district behind the Frankfurt train station. The pictures remained missing for a long time: two seventy-eight–by–seventy-eight–centimeter oil paintings by Turner: *Shade and Darkness—The Evening of the Deluge* and *Light and Color—The Morning after the Deluge*. In a furious swirl of color, the two pictures, which are among Turner's last works, mark the transition from objective painting to nonobjective painting and the representation of pure light. Similarly, the painting *Nebelschwaden* (Clouds of Fog) by Caspar David Friedrich, which had been loaned for the Frankfurt exhibition from the Hamburger Kunsthalle, disappeared without a trace.

A POLAROID FOR £1 MILLION

After the theft, several supposed middlemen spoke up and claimed that they had access to the pictures—for example, one "Mr. Rothstein," who was later revealed to be a criminal from Nigeria. Or two men from Essen who wanted to sell two blatant forgeries in Antwerp to the Dutch private detective Ben Zuidema, who was acting undercover. Again and again, the two museums had their hopes raised. And again and again, they were disappointed.

The big surprise arrived only years later. In December 2002, eight years after the burglary, the Tate announced that the two Turners had been returned, the one picture only a day earlier, the other already in July 2000. Later, in a book about the case,[4] Sandy Nairne, at the time the programming director at the Tate, recalled the futility of the investigation immediately after the crime and waiting in hotel lobbies in Bad Homburg near Frankfurt and in restaurants in Rüdesheim am Rhein. And he remembered the twenty-second of February 1999, when it appeared for the first time that they would be able to contact the men who still possessed the pictures years after the crime. The former police officers Rokoszynski and Lawrence learned from a prisoner, who is known to this day only as "D," that the Frankfurt attorney and notary Edgar Liebrucks could possibly initiate such contact. "An informant of ours succeeded in getting access to the crime ring that had stolen

the pictures originally. When there was talk about returning the pictures, Liebrucks's name kept coming up because he had represented the culprits in the past. The informant negotiated a meeting between Liebrucks and Jurek Rokoszynski. One result of this meeting was that he agreed to work with them." Protected by the highest British court, various authorities, and the Frankfurt state attorney, the Tate opened a special account at the Deutsche Bank in Frankfurt. Of the total sum of £24 million that the insurer of the Schirn had had to send to the Tate, £10 million was parked in the account.

It allegedly cost £1 million as a security deposit just to persuade the men behind the art theft to produce a Polaroid proving their access to one of the Turner paintings. After numerous frustrating cancellations, delays, and ever-changing conditions, £4 million more flowed to the thieves, until finally, on July 19, 2000, *Shade and Darkness* was turned over in Frankfurt. All the participants, including Sandy Nairne, insist to this day that the money wasn't to pay off an extortion demand but as "compensation for information leading to the recovery of valuable pictures."

To avoid endangering the negotiations for the second Turner, the participants agreed to keep quiet about the return of the first painting. Only two of the twelve members on the museum's board were told. Edgar Liebrucks did not want to comment on whether the people handling the return of the painting were the people who stole it in 1994: "I have nothing at all to say about that." It took almost another two and a half years until *Light and Shade* was turned over to Sandy Nairne and his colleague Roy Perry at the Frankfurt office of the attorney. Several earlier dates for the handover had failed, Nairne said, recalling the battle of nerves.

Edgar Liebrucks once stated elsewhere that he had been picked up at his office in autumn 2002 and driven to a hut in the forest: "There, the two Turners and the Caspar David Friedrich were shown to me." After exhaustive examination, the picture was also turned over to representatives of the Tate Gallery on December 14, 2002. And once again

£5 million in cash was paid. A few years ago, Liebrucks explained, "I put the money in a plastic bag and in the Frankfurt Zeil gave it to those from whom the painting came," referring to a street in the downtown retail district.

In his book about the case, Sandy Nairne described the robbery of the Schirn as a story from the abysses of the museum world. To rescue valuable cultural goods, should one work with criminals who probably belong to the Serbian Mafia and possibly have blood on their hands? Do the means justify the ends in this instance? Nairne concludes that this question can be answered only on a case-by-case basis. He was glad that the highest authorities in his country had expressly approved the approach he took.

That the operation would, in the end, be a net plus for the Tate was something that he could not foresee at the time. A year after the theft, in April 1995, the responsible insurance company, Hiscox, transferred the insured amount of £24 million. Three years later, the Tate acquired, with the agreement of the finance and cultural ministries, ownership of both paintings at a cost of £8 million—should they ever surface again. The transaction was risky, since at the time nobody seriously thought that a return was in the cards. When, however, it came to pass, the museum could rejoice not only about the valuable paintings but also because it was now £16 million richer.

CLOUDS OF FOG IN HAMBURG

Regarding the return of *Nebelschwaden* in Hamburg, there are conflicting stories. According to the museum, Liebrucks got in touch with the Hamburger Kunsthalle to begin the process of returning *Nebelschwaden* by Caspar David Friedrich. Polaroid photos of the painting together with current newspapers proved that the offer was serious this time. The persons in possession of the painting demanded €1.5 million for its return, the attorney said, in addition to a transaction fee of €250,000. In an arrangement with the Frankfurt state attorney, the Kunsthalle's chief executive officer, Tim Kistenmacher, gave the appearance of

being interested in the offer, per his own statements. According to the Hamburger Kunsthalle, the intermediary had been told that the museum would not yield to extortion and that the painting could not be sold in the art market. Nonetheless, there was said to be a desire to maintain contact. Allegedly, the attorney reduced his demands repeatedly, ultimately asking only for €250,000 to "reimburse his costs." As Liebrucks later related, when he had already taken possession of the painting in order to conclude the transaction, Kistenmacher demanded the immediate handover of the painting and threatened Liebrucks with civil litigation and criminal prosecution.

Liebrucks provides a completely different version of the events. He himself had negotiated with the fence for the pictures and got him to reduce the demand to €500,000. Next, Mr. Kistenmacher led him to understand that for half of that sum, he had lined up a donor. "Soon after that, I notified the state criminal prosecutor and the Kunsthalle that I was in possession of the painting. Kistenmacher told me that it would take a week to free up the money. When I called him seven days later, he said that the donor was on vacation and could not be reached. Nonetheless, we agreed to meet to exchange the money and the painting on a Monday. But, over the weekend, I got a fax from Kistenmacher, saying that his donor had abandoned him, and he didn't know what to do. Right away, I called the state prosecutor and the Axa insurance company and said that I wanted to give up the painting. But they refused to accept it. Shortly later, a fax came in from a Hamburg legal office that threatened me with criminal sanctions if I did not return the painting immediately. Simultaneously, the Frankfurt state attorney was asked to search my home, but the request was turned down. Next, I called Hamburg and drove to the Schirn with a colleague. In front of the building, I called the director of the Schirn on my cell phone and handed over the Caspar David Friedrich painting."

The Hamburg Kunsthalle hailed the return of its stolen picture in a press conference on August 28, 2003. Nothing was said that day about the role the museum had played in the return of the painting. The

Kunsthalle had already disbursed the insurance payment for the theft so that it did not have to forfeit the money to the city treasury.

THE BREAK-IN AT THE BODE MUSEUM
AND THE GIGANTIC GOLD COIN

On Mondays, the Bode Museum in Berlin is closed, but that didn't stop three visitors. They weren't looking for the main visitors' entrance. On March 27, 2017, at exactly three o'clock in the morning, they climbed the steps to the entrance of the nearby Hackescher Markt train station, all three dressed in black, with hoods pulled over their faces to conceal them from the surveillance cameras, but as if already weighed down by guilt. One of the figures kept putting his hand in front of his face. On the video, the hand looks very white, probably clad in gloves. During the week, there aren't any trains so early in the morning. The station platform was empty, and the men strode determinedly toward its end. One of them, carrying a black backpack, had an unusual gait. A limp? Some physical tick? Or was something concealed in the leg of his trousers?

The men jumped from the train platform onto the tracks and walked along them across the Spree River to the Museum Island. There, where the tracks lead between the monumental buildings of the Pergamon Museum and the Bode Museum, was a strange extension. It was the remains of a bridge that once had risen above the train tracks and connected the Bode Museum with the Pergamon Museum. The bridge itself hadn't existed for a long time. It appears in historical photographs. But the three utilized the remains as a bridgehead: with the help of a ladder, they were able to reach a window in the Bode Museum. If they had shouted a loud hello, the police at Angela Merkel's nearby private home would have been able to return the friendly greeting.

The three men weren't visiting for the first time. They knew exactly where they wanted to go. Ten days earlier, two had conducted surveillance on this way into the museum, and six days earlier, three people returned to survey, according to camera footage from the nearby train

2017, the culprits had already climbed up to the window and tried to remove a heavy piece of security glass that had been installed in 2005. They destroyed one of the bolts securing the glass, which was dislodged but held on by the remaining bolts. This part of the museum exterior had not been under video surveillance for some time.

The object of their endeavors can probably be traced to a tip they got, possibly from a man who had been working at the Bode Museum for a few weeks as a watchman in the employ of a subcontractor. Somehow, they learned about this fabulous treasure: a coin, almost as big as a car tire, weighing 220 pounds, made of the purest gold in the world. Purity: 999.99/1000.

A COIN MADE OF SOFT GOLD

"Big Maple Leaf" is the name of the coin. The Royal Canadian Mint hadn't exactly minted the coin, which would have been technically impossible, but rather, milled it. Only six of them were made, and two of the giant gold coins were sold on the open market. One copy is still in the possession of the Royal Canadian Mint, which is very proud to have been able to produce so large a coin of such purity. The gold is so fine and soft that it is unsuitable for making jewelry. Gold of this purity is principally used for the production of highly sensitive technology, such as for space travel.

The Berlin Big Maple Leaf was exhibited on the third floor, in a vitrine of bulletproof glass, on loan from a real-estate mogul in Düsseldorf. The man had bought the coin at auction in Vienna; there was only one bid. It was brought to the Bode Museum in Berlin for a special exhibition of the museum's coin collection, after it had first been displayed in the Kunsthistorisches Museum in Vienna. At the end of March 2017, the value of the raw material in it was itself about €4 million. Theoretically, one could also use the coin as payment in Canada, heaving it onto the counter at the cashier: the nominal value was one million Canadian dollars, a fraction of its actual worth.

The director of the coin collection said later that the museum had wanted to use the giant coin to attract the part of the public who weren't regular visitors to the museum. His wish was fulfilled in unexpected ways.

WITH AN AX AND A ROLLER BOARD

On that early morning in March, the three men opened the window in the facade above the bridgehead. The window led to a changing room for male employees, in which the presumed tipster had a locker. The alarm remained silent because it was the only window that was not connected to the external security system. The thieves cut through the remaining bolts that held the security glass on the window that they had earlier dislodged.

At the precise time of the break-in, the night watchman made his rounds through the museum. Every two to three hours, he was supposed to walk through the museum, during which time the interior alarm system—the motion detectors and the sensors on the doors—were deactivated. For anyone watching the museum from the outside, the moment of deactivation would be made visible by the so-called guard light: dim lights that illuminate the museum from inside. It is possible that the burglars waited for these lights to go on before entering. Or they listened in on the radio, as the guard announced at 3:20 a.m. that he was about to make his rounds.

The guard, sixty-one years old, toured the lower levels. He testified later that he suspected nothing and heard nothing concerning the visitors on the third floor who raced through the corridors—past historical art treasures, a marble Bacchus, paintings of Friedrich the Great in the guise of a Greek hero—until they reached the room that held the gigantic coin. They could simply open the doors of the room in the direction of the coin because they were outfitted with a so-called panic function in case of fire. They would have needed a key for the way back, or they could have blocked the doors with plastic wedges.

In the middle of Room 243 stood the object that they sought. With a Tomahawk-brand ax they hacked away at the vitrine—with so much

force that they broke not only the ten-millimeter-thick security glass but also the fiberglass-reinforced handle of the ax. (In the Green Vault in Dresden two years later, thieves also utilized an ax.)

When the loaned coin was installed in the museum in 2010, it took four workers to carry it on a stretcher. The vitrine was protected by security glass but without an alarm. The weight of the coin itself was supposed to prevent theft. The culprits were strong enough: they heaved the coin onto a dolly, a simple board with wheels, and pushed it through the hallways back to the window through which they had climbed into the museum. They left traces of their heavy load everywhere, crashing into walls and doorways.

When the guard went to reactivate the alarm at four a.m. sharp following his rounds, the system reported an error. Some doors on the third floor appeared not to be properly closed. The guard, who had just been assigned to the Bode Museum and previously had served at other places in the museum collective Stiftung Preußischer Kulturbesitz, called into the central security office, and when he went on another round through the museum, he discovered the plastic wedges blocking the doors. At 4:33 a.m., two additional guards arrived to help, and together they searched the building. One of them at last saw the smashed vitrine. It wasn't until 5:28 a.m. that an emergency call notified the police, who arrived at the crime scene minutes later.

The police suspected that the culprits might still be inside the museum; additional units were called in to search the entire building. Only when one of the policemen who entered first read the text on the smashed vitrine, which emphasized the weight of the coin, did the magnitude of the theft become clear. The police discovered the broken window in the changing room. Of course, the thieves had long since escaped. From the window, the coin was dropped into a wheelbarrow on the train tracks—the police found traces of gold—and transported in the direction of the Hackescher Markt station. Later, a train conductor reported that he had noticed the wheelbarrow on the track bed a few days before the break-in.

As investigators reconstructed the crime, the thieves steered clear of the station platform on their return trip. They threw the coin off the track just before they got to the station, dropping it into the Monbijou Park, which lay below. Traces of gold were also found there. The burglars used a rope to descend, probably the same rope employed earlier to raise the wheelbarrow and the other heavy equipment up onto the tracks. At 3:52 a.m., the surveillance camera at a nearby construction site shows a car driving away on the pedestrian walkway along the Spree River; the driver kept his headlights off. Because of the distance, further details cannot be seen. There were no eyewitnesses and no other video cameras. Even the bloodhounds that were brought in couldn't find a scent.

A CRIMINAL ACT BY A PHILISTINE?

It was one of the most attention-getting museum thefts in all of criminal history, a case reported in television news across the entire world and in newspapers including the *New York Times*. So where is the coin? And who stole it?

One could call the criminals a bunch of philistines because, to the great good fortune of the art world, they left the important cultural holdings of the Bode collection, such as the statue of Luke the Evangelist that Tilman Riemenschneider carved in wood, or the baroque satyr with a panther that Pietro Bernini chiseled in marble, and the dancer by Antonio Canova. Instead, they wanted the gigantic coin, something straight out of Scrooge McDuck's cartoon dreams. A toy for very rich show-offs.

The coin may not have been the most valuable object in the museum, but the thieves' choice wasn't exactly stupid either. Gold can be turned into money much more easily than a one-of-a-kind historical art relic, whose origin is known to experts and can be entered into search lists and databanks. Unlike a famous painting, a gold coin has only to be sawed through and melted down into easily transferrable bars.

Art was not the object of the crime in this case. The museum just happened to be the place where an especially large lump of gold was

housed. If one wanted to call it an art crime, then perhaps it's possible to do so because of the simplicity of the theft. The crime itself seems like a work of minimalist art.

Not only had the burglars made a lot of money very quickly, they also became instantly famous. They were sung about in rap videos and celebrated on the streets of Berlin. Rumors flew through the internet about who could have been involved in the break-in. And the state criminal investigators began the chase.

SUSPICIOUS MUSEUM FLYER AND TIPS FROM CONFIDANTS

Fairly soon, a policeman reported that a few weeks before the break-in, he noticed something peculiar. After the theft of gasoline from a filling station involving a car with a stolen license plate, he searched the car of the suspect. The young man had left behind a flyer from the Bode Museum with some handwritten notes.

He was not unknown to the police. The investigators discovered that a few weeks before the break-in at the Bode Museum he had begun to work there as a temporary guard, employed by a firm subcontracted to provide security. His locker was located in the changing room where the culprits climbed in through the window and later escaped with the coin. The man was put under surveillance; his telephone was tapped. The officers listened in as the suspect spoke with his friends and relatives about buying a coffee shop or a kiosk.

Confidential informants provided other clues to the police. Allegedly, according to the tips, young members of a large family were involved, a family that was familiar to the police. They came from the Mallahmi, which is today part of Turkey. Their ancestors had fled to Lebanon, and then to Berlin during the Lebanese civil war. Today most members of the family are innocent German citizens. One runs a smoking lounge and is active as the manager and bodyguard of well-known Berlin rappers. Other relatives are frequently mentioned in connection with criminality.[5] One member of the family, a man just under thirty years old, along with a couple of accomplices, had entered a bank in the

Berlin neighborhood known as Mariendorf and stolen the contents of approximately three hundred strongboxes. The take: jewelry, gold, and cash worth €9 million. To cover their tracks, they set the crime scene on fire. A member of the family was injured and left blood at the scene. He was arrested in the airport in Rome and, after a lengthy legal procedure, sentenced to eight years' imprisonment. The millions in loot remained missing.

The suspects who were named by the police informants in the case of the stolen gold coin are relatives of the imprisoned bank robbers. And the young man who worked as a guard at the Bode Museum had gone to school with one of them; at least, they seemed to be acquainted. The investigators were able to piece together a possible sequence of events that also convinced the examining judge.

THE RAID IN NEUKÖLLN AND A LONG TRIAL

Three and a half months after the break-in at the Bode Museum, the raid took place. Three hundred police, almost all officers of the LKA 4, a task force for organized crime, and a special attack commando, simultaneously searched several residences and presumed hiding places across Berlin starting at six a.m. on July 12, 2017. Other search warrants were issued during the day, including for a jewelry store where a portion of the coin might have been sold. In all, thirty properties were inspected, and the police took four men into custody, all of them between eighteen and twenty years old. They seized four rifles, a low six-figure euro deposit slip, and five cars. But they didn't find the coin. Only tiny traces of it were later retrieved from a car and on the clothing of one of the men arrested. The suspected culprits are thought to be part of a criminal clan, the prosecuting attorney announced subsequently regarding her investigation.

A year and a half later, in January 2018, the prosecution of the four accused began in the monumental building that houses the old criminal court in Moabit, the biggest criminal court in Europe. A media deluge accompanied the trial, with journalists from around the world. In the

hallway outside the large Courtroom 700, the accused held magazines or file folders with eyeholes in them in front of their faces. One used the magazine *Wissen & Staunen* (Knowledge and Amazement) as his protective shield. Standing before the juvenile chamber of the Berlin State Court, the accused looked healthy and were respectably clothed. Some of them had sat in jail for months after the raid, but now all of them were free. One of them was a student at a technical university, two were in high school or training programs, one of them worked as a driver for a courier service. They avoided any appearance of arrogance or menace, looking with wide-open eyes into the audience and at the judge in the grand courtroom with its old-fashioned wood interior.

The defense attorneys argued that in spite of the immense investigative work of the detectives there was no real poof of the involvement of their clients. The investigation was one-sided; the watchman at the museum had been eliminated as a suspect too early. Because he was near the coin on the night of the crime, he would have heard the vitrine being smashed. The attorneys did not want to speak to the press during the trial. They had no comment when asked about the proceedings.

In the indictment, the prosecutor relied upon the traces of DNA that had been found on the rope that hung from the train tracks after the crime. Moreover, some of the accused had searched the internet for current gold prices. During the raid, the police had found in an apartment belonging to one of the accused a piece of paper, which the investigators from that point on referred to as the "Gold Note." On it were written various numbers of grams and sums that corresponded to gold prices, according to the prosecution. Although photography is strictly forbidden in the museum, the presumed insider had taken selfies of himself in the museum: his head is visible, along with the path the thieves had to take with the gold coin. His DNA was found, according to the state's attorney, in a so-called mixed sample on the window through which the criminals had entered. Had the young man been trying only to get some fresh air into the changing room after he had finished work? Or had he informed the criminals about the entrance and prepared the way?

An expert opinion had been commissioned from a professor from Mittweida, Germany, for a so-called bio-forensic picture identification, which compared the sizes of the suspects with the movements of the men seen in the surveillance footage using software that is otherwise employed in the film industry to produce special effects.

The nine defense attorneys, among them one of the most famous criminal attorneys in Berlin, performed well at the trial for their clients: witnesses and experts were shredded in cross-examination and tiny details of their statements pulverized, such that at the end of questioning, as for example with the movement analysis of the professor, only vague probabilities remained. There were constant postponements. On February 20, 2020, the verdict was finally announced: The oldest defendant was acquitted, the tipster sentenced to three years and four months, and the two family members convicted of burglary to juvenile sentences of four years and six months each. In addition, the tipster was fined €100,000, and the other two convicted burglars were fined €3.3 million, the gold value of the coin. According to the judge, there may have been other people involved in the crime. The defense lawyers of two of the convicts appealed the verdict, which was still pending when this book went to press.

Besides the DNA traces at the scene of the crime, the purity of the gold turned into a problem for one of the defendants, since gold of the purity 999.99/1000 is extremely rare. Commercially available gold coins and jewelry haven't been that pure in quite some time. Gold dust was found on gloves and a jacket at the home of one of the presumed perpetrators. His DNA clung to the rope that was left behind at the crime scene. Traces of gold were also found on the back seat of a Mercedes-Benz in the perpetrators' social circle. The hope of finding the coin in one piece has all but vanished.

A chemist, who testified as an expert at trial, was able to positively identify the gold traces that were found as the same material that was used by the Canadian Mint to produce the Big Maple Leaf coin, principally because of the very small silver content in the substance. The

expert relied on microscope photography to prove that the particles found by the police showed noticeable deformations: evidence of grinding, as would arise in the process of cutting something apart. In the courtroom, he fascinated the judges, the accused, and the spectators by explaining that refining gold had been introduced under King Croesus in the sixth century BCE. And since the Berlin theft, there's now a much heavier gold coin: the Perth Mint made the Australian Kangaroo One Tonne Gold Coin, weighing 2,200 pounds. One of the accused massaged his neck during the disclosure of this information.

THE CULTURAL AND POLITICAL SCANDAL

The break-in at the Bode Museum wasn't some foreordained, unavoidable event. The governing body in control of the institution, the Staatliche Museen zu Berlin, had made it too easy for the thieves, whoever they were, the investigations by the police and the prosecuting attorney concluded.

It was determined shortly before the trial[6] that since 2013 or 2014 the responsible persons in the museum knew about a broken alarm sensor on the window that the thieves used for their entry and exit. It wasn't repaired in the following years, and not even when the damage to the exterior security window was discovered after the first attempted break-in. At the trial, the head of security for the Staatliche Museen zu Berlin testified that he had assumed that the damage to the window was caused by a stone thrown from a passing train. The person responsible for security at the museum on the night of the crime said that there was another problem: for years it had been scarcely possible to find suitable personnel. The inadequate security procedures are the scandal behind the theft, especially if one considers the cultural and historical damage that could have occurred in a more ambitious robbery. Even the Big Maple Leaf had a cultural-historical value, which was destroyed when the perpetrators and their henchmen presumably cut it into pieces. The remaining five gigantic Canadian coins became more valuable through this act of destruction. Now they are rarer. And rarity as well as a good

story are often two of the most important factors that determine value, according to the art market's idiosyncratic rules.

THE MELTDOWN MOBS VERSUS ART

The theft of the gigantic gold coin is part of a trend in art criminality that is interested only in the raw materials out of which the art is made. In December 2005, Henry Moore's two-ton bronze sculpture *Reclining Figure* was stolen from the Moore Foundation in Much Hadham, England. The perpetrators brought a flatbed truck to disassemble the sculpture and transport it to a warehouse where it was sawed apart. Later, the pieces of the sculpture are presumed to have been shipped via Rotterdam to China by a junk dealer in Essex. Bronze is increasingly sought after by the electronics manufacturers there. The value of the work of art was estimated to be £3 million; the thieves were paid about £1,500 by the junk dealer. Ian Leith, of the British Public Monuments and Sculptures Association, told the *Guardian* in 2009 that the theft of public sculptures had increased an astonishing 500 percent in just three years.[7] The problem of meltdown mobs plagues not only Great Britain but also Germany, where more and more art is stolen to be melted down. René Allonge, the head of the art division of the state office of criminal investigation for Berlin, says five to ten artworks are removed from public spaces in Berlin each year. For example: *The Swimmer* by the German Democratic Republic artist Gertrud Classen, which a thief took from the Treptow area and sold to a junk dealer for €184.80. Or *Large Reclining Figure* by Siegfried Kropp, which disappeared from a park in Obersee.[8] The Ohlsdorf Cemetery in Hamburg is favored by thieves of nonferrous metals: here, it was determined that thieves absconded with a nearly six-foot-tall statue of *Venus in the Shell* and a fountain by the artist Auguste Moreau. At the same cemetery that year, a 250-kilogram bronze lion disappeared from the family grave of Carl Hagenbeck, the founder of the Tierpark Hagenbeck zoo in Hamburg. The police believe that the thieves used a light truck, and that the purpose was to sell the raw metal.[9] The November 2019 theft of valuable

jewelry with precious stones from the Green Vault in Dresden fits this pattern. Here as well, the thieves were probably interested only in the material value of the stones. The cultural value was presumably of no importance. A few weeks earlier, there had been an attempt to steal the gold treasures from the state museum in Trier, Germany, which failed because the vitrines did not yield. The Berlin numismatic collection was, incidentally, the victim of thieves a long time ago. But they did not melt down their loot, and precisely because of that they were convicted in the end. This burglary, as is so often the case, was an inside job. In 1718, in the Berlin palace where the coin collection resided at the time, the castellan Valentin Runck and the court smith Daniel Stief stole 176 gold coins, in addition to jewelry and other precious items. The overseer of the royal collection, the librarian Mathurin Veyssière La Croze, knew they were guilty when he searched them and recognized specific coins in their possession.[10]

THE SECOND TIME AS FARCE:
THE THEFT OF MAURIZIO CATTELAN'S GOLD TOILET

As Karl Marx once put it (in reference to a proposition by Hegel): important world historical events always happen twice, the first time as tragedy, the second time as farce. Two and a half years after the break-in at the Bode Museum in Berlin, thieves in England took a different work of art made of pure gold, which, like the gigantic coin, weighed one hundred kilograms—actually, three kilograms more.

People had waited in long lines, day after day, to use this work of art. A new form of the sublime was to be experienced—on the toilet that the artist Maurizio Cattelan had installed in the Guggenheim Museum in New York in 2016. The once-in-a-lifetime chance literally to shit on pure gold. About one hundred thousand visitors took the opportunity before the end of the exhibition in 2017. More than one hundred kilograms of eighteen-karat gold were needed to produce the fully functional copy of a typical American flush toilet complete with the operational handle. Cattelan's sculpture, titled *America* (which naturally evoked many

associations), could be considered one of the most important markers of avant-garde art, just like Marcel Duchamp's 1917 exhibition of a urinal. The original urinal has disappeared without a trace, though there are several copies that were made later.

The gold toilet went missing in September 2019, shortly before the opening of an exhibition at Blenheim Palace near Oxford. The burglars approached in the early morning hours on a Saturday and ripped out the toilet bowl—apparently without any training in plumbing, since they caused water damage in the palace. The estate has belonged to the family of Winston Churchill for three centuries. The toilet art had been installed right next to the room in which the prime minister had been brought into the world. Of the artwork, only a gold pipe with the flush handle remained. The perpetrators probably came with two vehicles, the police believe. A sixty-six-year-old man was arrested as a suspect but set free on bail. Sometime later, four further suspects were identified. Unlike in the case of the theft of the gigantic coin, nothing here suggested that employees of the museum were involved.

"Some of my work has been damaged, or thrown out by mistake, but I have never had to endure the loss of an artwork like this," said Cattelan, who was born in Padua, Italy, in 1960.[11] Many of his friends suspected him of the deed. At first he thought it was a prank: "I always liked detective films. Now I'm in one myself. Are the people who stole this work of art the true artists? Considering the speed with which they carried out the burglary, they are certainly great performers."

The toilet, which belongs to the Marian Goodman Gallery in New York, is worth $6 million, much more than the $4 million in gold that went into making it. Crafting it in a Florentine foundry had been a highly complex and expensive endeavor. In addition, there's the artistic value that the object has acquired. When President Trump asked for the loan of a painting by Vincent van Gogh from the Guggenheim Museum for his private quarters in the White House, the head curator found that the painting could not be spared. The counteroffer, to install

Cattelan's gold toilet for the president, did not generate interest from the White House.

If the thieves were smart, they would have done well to act as iconoclasts and melt down the toilet right away. According to the state prosecutor's office in Berlin, that's what the perpetrators did with the one-hundred-kilogram gold coin. Some of the old-master paintings at Blenheim Palace probably have a greater market value than *America*. But then again, it's hard to anonymously and expeditiously transform unique works of art into cash, as one can do quite readily with a lump of melted gold.

Maurizio Cattelan fervently hopes that his *America* has been spared the furnace. He said the thieves would do better to use it as a toilet. The last person to take that opportunity had apparently been Cattelan, after the installation. As for the time of the theft, he said, he has an alibi.

THE DISAPPEARANCE
OF THE ORIGINAL

The Second Decline of the Avant-Garde

The police discovered untold treasures in a furniture storage facility in Wiesbaden in 2013. Hundreds of futurist paintings by Russian modernists from the first decades of the twentieth century. What was unbelievable about the discovery was the sheer size of it. More masterworks from this important era, revolutionary for the history of art, than in most museums inside or outside Russia: paintings in the style of Malevich, Jawlensky, Rodchenko, Lissitzky, Goncharova, Popova, and Kandinsky. Such an enormous trove of art would have to be worth hundreds of millions of euros, if not a billion, on the art market. But the collection was stored by its owner like used furniture, without security or climate control, frame jammed against frame.

The search and seizure at the furniture warehouse on June 12, 2013, was part of an international offensive against the trade in counterfeit works of art. Over the course of two days, more than one hundred officers from the Bundeskriminalamt, or BKA (the German federal

criminal police office), searched twenty-eight apartments, galleries, storerooms, and businesses, not just in Wiesbaden, but also in Mainz, Stuttgart, Munich, Hamburg, Cologne, and other German cities. Other raids took place in Switzerland. Accounts were frozen. The police in Israel held eight suspects in custody for a short while. The target of the operation was a global network of alleged counterfeiters and fences, supported by art experts who provided the necessary authentications.

The BKA had been hot on the trail of the alleged counterfeiting ring for months. The investigation was touched off by information from the Israeli National Fraud Investigations Unit of the Israeli Police. They believed that they had discovered counterfeiters from Russia who did business by way of Israel as a connection to Germany, among other countries. In Wiesbaden, two of the lead suspects were taken into custody for questioning about commercial fraud: a sixty-seven-year-old Israeli named Itzhak Z., and a younger man who was born in Mainz, who will be referred to here as "Mohammed W." Itzhak Z. would remain in custody for two years, Mohammed W. for three, while the investigation continued.

Itzhak Z. and Mohammed W. had already been convicted by an Italian court in February 2013—a few months before their arrest in Germany—for a transaction involving a counterfeit Kandinsky painting. The penalty of one year probation and fines was commensurate with the law, but apparently did not stop their activities.

In February 2015, a trial began that would become one of the longest in the Wiesbaden court. Finally, after three years, a total of 150 days of proceedings in the courtroom, both men were convicted and sentenced. By then many of the transactions involving the fake pictures were beyond the statute of limitations. Although the number of offenses had exploded with the seizure of the 1,500 fakes, the charges were reduced. The prosecutor had only sought an indictment in the nineteen cases where proof of fraud seemed most achievable.

The judgment, which runs to more than one hundred pages,[12] reads like a primer on how counterfeiting infects the market for the art of Russian modernism. The judges describe the beginnings of how modernism flowed into Russian art, the success of painters such as Malevich under Lenin, and the founding in the Soviet Union in 1921 of a museum for suprematist and constructivist artists. And they report on the downfall of the avant-garde after Stalin took power in 1922, how the dictator effectively banned abstract art and singled out socialist realism as the one true art of the state. After Stalin's ban of the avant-garde, such work was removed from collections in Soviet museums. Many works were destroyed or disappeared forever. Others were taken into private collections, warehoused in attics and secret storerooms—and this became, decades later, the stuff of countless legends related to their rediscovery. This art was rediscovered first and foremost by George Costakis, the son of a Greek commercial family who was born in Moscow in 1913. He worked in Russia in various embassies and consulates and privately collected pictures by Wassily Kandinsky and Lyubov Popova. At some point, he became known as a good customer for pictures from this forgotten era in art at the start of the Soviet Union. Whoever still had something came to him, and Costakis succeeded in putting together a big collection of several thousand artworks. When he moved to Greece in 1977, as part of a deal with the Soviet state, he gave the majority of his collection to the state-owned Tretyakov Gallery in Moscow. In exchange, he got to export and take with him about 1,200 works of art. A few years after Costakis's death in 1990, the Greek government bought this important art collection. Today, it is housed in the Museum for Modern Art in Thessaloniki.

Costakis was the pioneer in the rediscovery of constructivism, though in the West the collectors and museum founders Peter and Irene Ludwig also proved to be ready buyers. There are many stories told about how these two, originally in the business of chocolate

manufacturing, became collectors and obtained works from the then still communist Soviet Union in the 1970s and 1980s. There are rumors of economic support and food shipments the Ludwigs arranged in exchange for art. And there are witnesses from that time who speak of high-ranking collaborators in the Russian embassy in Bonn who are alleged to have smuggled artworks out of the Soviet Union in diplomatic pouches. Galleries in the Federal Republic of Germany then served as the official sellers. Today these Russian works can be seen in the twenty-six museums from Cologne to Budapest that have been underwritten by the Ludwig foundation. A scholarly work on the provenance of these artworks has been in the making for many years now. An exhibition at the Museum Ludwig, Cologne, in 2020 and the accompanying catalogue made clear, however, that the Ludwigs were also sold some fakes.[13] As were many other collectors and museums in Berlin, London, and elsewhere. With the opening up of the Soviet Union in the mid-1980s during the Perestroika period, more and more works reached the West and sold at ever-higher prices. This, in turn—and here most art historians agree—was a wake-up call to counterfeiters in the countries formerly belonging to the USSR and internationally. What Stalin condemned had turned into lucrative merchandise. And the decades of political upheaval in the Soviet Union made it easy to invent the provenance.

The judgment of the Wiesbaden court explained how counterfeiters worked: trained painters or restorers source the canvas and paints that existed during the lifetime of the artist. From these, works are made in the style of the desired artist by appropriating parts of known originals and assembling them into a new composition, a pastiche. Or the counterfeiters simply copy known works, sometimes in a new medium: a sketch turns into a painting, or a drawing becomes a watercolor. Then the pictures are artificially aged, dried in the oven, rubbed with dust from the attic, or worked on with tea. If the counterfeiter does the job right, the counterfeits look as if they've survived for decades. The "craquelure"—the fine veins of cracking visible in paint, which usually appear only many years later—can be simulated during the painting

process through the addition of certain chemicals or induced by rolling and smashing the canvas and heating it in the oven.

Next, an appropriate history must be invented for the provenance of the painting—a seemingly legitimate list of previous owners, exhibitions, and catalogue entries. Or a very good explanation for the gaps in the provenance: why this work, so long hidden, has now resurfaced. For the works of Russian modernism, it was easy to explain the disappearance and the sudden resurfacing—without any documentation, exhibition history, or named owners—because of the chaos at the time of the Russian Revolution, the condemnation by Stalin, and the decline of old institutions amid the dissolution of the Soviet Union.

AN ANTIQUES HUNTER OPENS HIS GALLERY

Itzhak Z. testified during the trial in Wiesbaden and afterward how he had gathered his enormous collection, which he thought placed him in the same tradition as the great collector George Costakis. Before the court, he called himself the "savior" of the Russian avant-garde.[14] He said that he had not commissioned forgeries, but rather, had assembled the collection over the course of three decades, partly through risky adventures. He testified further that, since the mid-1980s, he had been active as an antiques hunter in the Eastern Bloc, but was robbed and defrauded. He said that he cultivated contacts to artists' estates and through them had uncovered secret repositories in the former republics of the Soviet Union. He claimed that some of the works were smuggled out of the country and covered up with a black overpainting so that at customs they were no longer recognizable. Later, the canvases were cleaned with a solvent, revealing the painting beneath. He testified that he had owned more than the 1,500 works that were seized, but many had been sold over the last thirty years. Several pictures were to be found in the Museum Ludwig in Cologne, which had acquired them through a French gallery. A former director of the museum maintained strong ties to the French gallery in Paris and with its branch in Israel—as a customer. Itzhak Z. said he met Mohammed W. in the late

1990s at the flea market. At first, Mohammed W. bought watches for Z., then he took over the negotiations for pictures. It started with just one painting, by the Russian artist Ivan Puni, but Mohammed W. called for professionalizing the operation. Thus, Itzhak Z., along with two business partners, founded the company SNZ Galeries in Wiesbaden in 2002, with Mohammed W. as chief executive officer. Later one of the partners left the business and Itzhak Z. took over his share. He also established an offshore company in Panama in 2005, Art Society Inc., through which many of his transactions with the pictures later flowed. The entity pops up in the Panama Papers, the files regarding the law firm Mossack Fonseca, which became famous for the establishment of letterbox companies in 2016.

In the rooms of the Wiesbaden Gallery, although they were suitably decorated, there was neither the climate control nor the security that would be expected for old works such as these. The gallery received pictures from Z.'s collection through commercial package services like UPS instead of specialized art courier services; they were rolled up and packed, scarcely insured, and designated at customs regularly as having a declared value of a few hundred euros.

The pictures were then sent to the laboratory of Dr. Jägers in Bornheim, near Cologne, where over time hundreds of works from this source were examined. Itzhak Z. had already worked with Erhard Jägers before the founding of SNZ Galeries. Once Z. had even invited the chemist to Israel to examine a few pictures there. Jägers usually took pigment samples and analyzed them to determine if they corresponded to the alleged age of the work. His laboratory rejected numerous pictures from Z. on the basis of pigments in the paint that didn't belong to the period in which the work supposedly was made. But a large portion of the art sent to him withstood his testing process. According to the testimony of the chemist, between 30 and 70 percent of the paintings examined in his laboratory each year came from SNZ Galeries. And still, for example, works supposedly by Kazimir

Malevich that were worth eight figures if genuine were rolled up and shipped by common carriers.

Even in his affirmative opinions, Jägers did not state that the pictures were authentic. Rather, he opined that nothing in the samples he had taken and examined contradicted the possibility that the work was created at the point in time claimed by the seller.

EXPERTS IN DANGER

The authentication of a painting requires, in addition to the examination of the material and technical aspects, an assessment from the art-historical perspective, in which the provenance and style are tested. Many defrauders thus outfit their works with supplementary art-historical expert opinions, which are supposed to prove their genuineness. In Russia, as well as in Germany, France, and England, there are numerous experts, very often art historians, who have specialized in the certification of Russian avant-garde work. Many of the pictures offered by SNZ Galeries had such art-historical certifications, not infrequently from the same experts. And quite a few of the buyers were plainly dazzled by these reports, although the reports usually emphasized that they were simply descriptions from the perspective of the history of art, which avoided any representation that could be used against them legally.

Besides the compliant or fraudulent dealers, the core of the problem of Russian avant-garde art counterfeiting is the so-called experts. Some experts appear to be either so naive or so corrupt that they write authenticating opinions even for rather fanciful forgeries. Others borrow the suspect works for exhibitions in the second- or third-tier museums that they lead, thus ennobling the works and enhancing their credibility and value. Critical experts are pressured by defrauders with the help of lawyers and massive threats, such that they prefer not to opine that any work is fake. "I can't go to Moscow for my vacation," said one expert, who had exposed one hundred forgeries in the summer of 2013.[15] Another reported, also on condition of anonymity, that one day his car was demolished. When art

becomes the object of speculation, then scholarly authentication turns into a business, and a dangerous one at that.

HOW DEALERS FINANCE AN ADVISORY BOARD

Before they were sold or offered for sale, most of the artworks at SNZ Galeries were examined by art historians with whom Z. had already had good experiences. Many of them were connected to an organization that was founded in Paris in April 2007: the International Committee of Russian Modernism, which was recognized in 2008 as a nonprofit organization and in 2009 changed its name to International Chamber of Russian Modernism (InCoRM). According to its bylaws, the organization is a union of art historians and scholarly experts who are united to support the Russian avant-garde. As explained in a written statement by its president, Patricia Railing, the experts of InCoRM are held to the highest ethical standards. The "Code of Good Practice" of the organization states that the members of InCoRM are not permitted to give an opinion if there is a conflict of interest or a commercial connection.

It first became clear during the investigation by BKA and the ensuing trial that the founding of InCoRM could be traced back to the two accused gallery owners, Itzhak Z. and Mohammed W., as well as a French citizen who was interested in art. The opening event of the foundation was funded in essence by SNZ Galeries; a coworker from the Wiesbaden gallery served as general secretary. The accused were clearly pursuing their own financial gain in setting up the foundation, the Wiesbaden court found. SNZ had created its own organization, whose members would certify the goods for sale while giving itself the appearance of being especially virtuous. The continuation of these legal proceedings would reveal in particular just how compromised InCoRM President Patricia Railing was in carrying out this mission.

INVENTED PROVENANCE

SNZ Galeries even tried to penetrate the higher circles of the international art market in the 2000s, but without success. According to a person

associated with the gallery, pictures were offered to the leading interna-
tional auction houses, such as Sotheby's, Christie's, and Bonhams, but
they were rejected because of the lack of provenance. Still, some pictures
landed at smaller auction houses in Germany, France, and Switzerland.
Market experts were already astonished in 2007 by the boom in the
Russian avant-garde: auction houses in Munich or Stuttgart, which had
previously not dealt in this area, were suddenly and almost simultaneously
staging special auctions. Isolated works of the Russian avant-garde were
also offered for sale at other auction houses in Munich, Hamburg, and
Zürich. The sales at the auction house Nagel on April 26, 2007, stood out
in particular. Fifty-six works were offered at once by this Stuttgart firm
in a special catalogue. The provenance in the catalogue suggests that the
works were sold by a member of the Communist Party of the Soviet Union
to an Italian comrade around 1946, while in some cases a German private
collection is listed as the source.

"Complete nonsense" is what the independent art historian
Konstantin Akinsha called that story in the German magazine *Die
Zeit*: "Foreigners were very strictly surveilled at that time in the Soviet
Union. It would have been impossible to get this work, which Stalin had
outlawed, out of the country."[16] For the US magazine *ARTnews*, Akinsha
had researched and written about the alleged previous owners of the art:
he found out that they didn't exist. And for several dozen of the works
offered, he discovered the originals from which they had been copied
in museums around the world.

This didn't appear to have come to the attention of the experts cited
in the Nagel catalogue, who wrote their opinions in a matter of a few
days in Paris and Berlin, or else they found it not worth mentioning in
the catalogue. It is clear regarding the painting *Still Life with Lobster* by
Larionov that an expert is alleged to have examined it on a day when it
had already been in storage at a facility belonging to the auction house
for the previous eight days. No evidence exists of a visit by the expert to
the storage facility. SNZ received about €1.4 million for the auction of
the works submitted, paid in several tranches, mostly in cash.

The investigations found that in a work on paper allegedly by the artist Alexandra Exter, the hat of a woman was painted with an improper pigment: orange 62 was first patented by the company Hoechst in 1960—so Exter, who died in 1949, could not have used it. Even before the material and technical examination, the Exter expert Andrei Nakov had judged the work to be a fake for stylistic reasons. Itzhak Z. and Mohammed W. were, however, not found guilty for this forgery, which Mohammed W. had furbished with false provenance. It could not be proved that they knew it was a fake. Charges of fraud for the other pictures that Nagel sold at auction—for instance, one with false provenance from an Italian baron—were barred by the statute of limitations. Similar sales of Russian art at a Munich auction house, which Konstantin Akinsha thought included many inauthentic paintings, did not play a role in the trial in Wiesbaden.

THE END OF SNZ GALERIES

Originally, the complaint against the defendants Itzhak Z. and Mohammed W. had included the accusation that they had collaborated with a third person in a criminal gang, which increased the statute of limitations from five years to ten years in a fraud case. But the third person was set free. The court did not see a gang at work, and all cases of fraud older than five years were barred from prosecution.

Still, two works on paper were a problem for the accused: a *Sketch of Color Dynamics* (1917–18) by Alexandra Exter, which allegedly had hung in a Paris gallery and in a private collection in Belgium; and Alexander Rodchenko's *Watercolor for a Construction* (1919), which, according to the invented provenance, had been held in a Soviet museum and a private collection. Both works on paper were sold to a private collector who chanced upon them in the window of SNZ Galeries while strolling through the downtown pedestrian shopping district of Wiesbaden: the watercolor for a price of €43,500 and the work by Exter for €29,000.

For the Rodchenko picture, the collector received a statement regarding its imaginary provenance as well as an expert opinion from

Patricia Railing. On January 7, 2008, she had certified the authenticity of the work from an art-historical perspective and confirmed the provenance. She referred in her declaration to positive technical analysis of the pigments and paper. Yet this work was among the few that Erhard Jägers had identified during his investigation as being counterfeit. The chemist had notified the chief executive officer of SNZ Galeries on December 4, 2007, that he had found phthalocyanine blue in a test of the picture. The painter would have been able to use this pigment at the earliest following its introduction in the mid-1930s—a good decade after the date of 1919 attached to this alleged Rodchenko *Construction*. The picture by Exter was executed on paper that, according to expert opinion, was not yet produced at the time the picture was allegedly painted.

Despite numerous sales, the business of SNZ Galeries did not prosper as its founders had hoped. The storefront in the Wiesbaden shopping district was closed at the end of 2009. After the closing, the court found, Mohammed W. still tried to dispose of the artworks from the fabulous warehouse at the behest of Itzhak Z. At this point, they worked with collectors and middlemen whose business practices sometimes sound beyond the pale. Cheap-looking catalogues were printed, with supposed provenance and citing certifications of authenticity by members of InCoRM in order to facilitate sales from exhibitions in private homes.

At the end of the three-year trial and after lengthy disputes among the prosecutors, defense attorneys, experts, and witnesses, six of the nineteen works in the original complaint remained, and Itzhak Z. and Mohammed W. were found guilty. Judge Ingeborg Bäumer-Kurandt detailed the reasoning in her opinion for an hour and a half on March 15, 2018, in the Wiesbaden state court. The judge found that the charges of commercial fraud had been proven against the accused. Various pictures had been identified scientifically as fakes, and doubt created about their provenance. The accused had been aware of these facts and had nonetheless sold the works as originals. Therefore, the court sentenced Itzhak Z. to two years and eight months' imprisonment; his codefendant

received a sentence of three years' confinement. (At the time of this writing, however, the judgment had not yet been enforced.) Two paintings from Itzhak Z.'s collection were seized as instruments of crime, in addition to six-figure euro payments by both of the condemned. In a deal that reduced his sentence, Mohammed W. had apparently admitted—and it was proven by tapped telephone calls as well—that he had falsified the provenances. It remained unclear from the trial who had counterfeited the works themselves. The court did not pursue evidence that in this case, as in other cases of counterfeit art, the path led to Israel and Russia.

Although he sat at the defense table, Itzhak Z. appeared not to hear the judge's opinion—or he simply ignored it. For, right in the courtroom, his British press representative distributed a prepared statement: "I am pleased that the accusations against me and my pictures have been proven groundless." The second response followed that evening by email: "More than 1,800 works seized by the German authorities in 2013" had been "accepted" by the court "as authentic." Moreover, it stated that the court had "denied the existence of an international counterfeiting ring."

In response to an inquiry, a spokeswoman for the Wiesbaden court wrote that the court had in no sense found 1,800 works to be genuine. The subject of the criminal process had been limited to nineteen works. Nothing could be said regarding the authenticity of other works. An expert reported that many of the pictures were once more offered for sale in London in the fall of 2019. At the time of this writing, Itzhak Z.'s attorney had not responded to questions concerning the whereabouts of the remainder of the works.

THE DISAPPEARANCE OF THE ORIGINAL

The Wiesbaden judges reprimanded some of the appraisers and experts who appeared in court as witnesses. Their professional opinions seemed driven by their personal interests. According to his own testimony, one expert had declared every work sent to him to be genuine, contrary to

knowledge he had obtained in his scientific examinations. The judgment stated that for some of the art-historical experts there was considerable doubt as to their seriousness and their professional methods. The estimation of the accused and their defense attorney that Patricia Railing was an especially respectable art-historical expert was not shared by the judges.

"The original is disappearing," the expert Andrei Nakov said after the two were arrested.[17] He had done research for lists of the works of Kazimir Malevich and Alexandra Exter, and he was himself a disputed figure among some experts. Daily he gets emails with photos of alleged newly discovered works by these artists; the number of counterfeits appears to be unending. He deletes all the emails with photos of industrially produced suprematist compositions after the first glance. He tries to prevent the counterfeits from contaminating his joy in the real pictures.

The myth of Modigliani—how classic modernism is systematically counterfeited

Maria and *Céline* were the deciding factors—although nobody could have actually seen them yet. Nonetheless, somebody seemed to know forty-four days before the official opening of the exhibition that their portraits would be seen starting in March 2017 in the Palazzo Ducale in Genoa—and that with all probability they were counterfeit. This unknown person sent the art collector and Modigliani connoisseur Carlo Pepi an image of *Céline*, an alleged Modigliani painting, one of his famous reclining nudes, which now command prices in the hundred-million-dollar range at auction. This one looked strange to Pepi: the face was expressionless, the hair looked as if it was glued on, the left arm behind the head was anatomically incorrect as was the angled left leg. "Counterfeit," the seventy-two-year-old replied through his website regarding the painting *Reclining Nude (Céline Howard)*. When the exhibition opened and the catalogue was published, Pepi, a former businessman who ran a private museum in

Crespina, near Pisa, also cast doubt on other paintings in the show: for example, another portrait of a woman, titled *Maria*, which, like *Céline*, had been exhibited previously.[18] Soon thereafter, the French Modigliani expert Marc Restellini confirmed the suspicion and identified further counterfeits. The police seized twenty-one paintings after the exhibition closed, three days before its scheduled closing date. Six months later, the restorer hired by the prosecutors to analyze the twenty-one paintings scientifically, Isabella Quattrocchi, proved that the signature of the painter was not authentic and that the pigments used were not those of Modigliani: "It's clumsy counterfeiting," she said. The Italian police investigated at least six suspects—among them, Rudy Chiappini, the curator for the exhibition; Nicolò Sponzilli, the manager of Mondo Mostre Skira, a company belonging to a well-known art book publisher that stages exhibitions; Massimo Vitta Zelman, the president of Mondo Mostre Skira; and Joseph Guttmann, a Hungarian art dealer residing in New York. The traveling exhibition had already been to other locations before it came to Genoa. The state's attorney had not yet decided in fall 2019 if the proof was sufficient for an indictment for fraud and trafficking in counterfeit goods.[19] If there's any classic modernist whose auction prices have rocketed to astronomical heights, it's the Italian Amedeo Modigliani (1884–1920). Today, there seems to be no upper limit on what his works can command at auction and in discreet "private sales." For $170.4 million in November 2015, the Chinese collector Liu Yiqian sold at auction Modigliani's nude *Nu couché* (1917–18). Another, *Reclining Nude (Left Side)*, went for $157.2 million at Sotheby's in May 2018. The Irish horse breeder John Magnier had paid $26.9 million for it fifteen years earlier. Since then, the prices for Modigliani's paintings have climbed steadily. In November 2010, $68.9 million for the seated nude *La Belle Romaine*, and $19.1 million for a portrait of Modigliani's lover Jeanne Hébuterne. In June of the same year, one of only twenty-six surviving sandstone sculptures brought in €43.2 million. Another of those sculptures changed hands in May 2019 for $34.3 million. In 2014, the Swiss art

dealer Yves Bouvier sold the nude *Nu couché au coussin bleu* (1916) for $118 million to the Russian collector Dmitry Rybolovlev.

The life of this Italian artist, like that of Vincent van Gogh, provides dealers an ideal myth with which to sell works on the art market. The debauched life of the Parisian bohemian artist in Montmartre, scandals about his nude pictures, inconstant relationships, alcohol and drugs, tragic illness with tuberculosis, an early death at the age of thirty-five, and, because of that, a shortage of available works of quality. Whoever buys an expensive piece of art is also paying to be a part of art history. The more dramatic the stories that can be told about the artist, the higher the prices that can be achieved with skillful marketing. Increasing prices, too, are always accompanied by the danger that the number of counterfeits will also increase.

Being responsible for an exhibition of the works of Amedeo Modigliani has been a very risky proposition for many years. It's not just a question of the hordes of visitors that can be expected. Modigliani's strangely unreal portraits, which appear to reveal something about their subjects, draw crowds a hundred years after the painter's early death. If the exhibit includes any of the large-format nudes, which unleashed a scandal and nearly forced the show exhibiting them to close when they were shown in 1917 at the Galerie Berthe Weill in Paris, then there's no holding back the public, and visitor records wait to be broken. Modigliani's portraits have long had high recognition value. To be sure, they are psychologically powerful, but not polarizing, because their creator intended that viewers would recognize themselves in the work. Modigliani's pictures are straightforward, but complex and subtle enough not to be dismissed—they appeal to the majority without being dull or pandering.

Modigliani has been in danger from an art-historical perspective for a number of years. No other painter of classic modernism has been forged as often as Modigliani, and still there is no one authoritative catalogue raisonné of his authentic works. At least five lists of his works compete with each other. A sixth is underway, though the publication

date has been postponed several times. In addition, an online project plans to publish a list of all known authentic works, and naturally each author claims to have compiled the definitive list. In the past few years, exhibitions have been shuttered, books and catalogues criticized as amateurish, paintings withdrawn from auction at the last minute, and substantial bribes offered. There have even been death threats related to allegations that this or that painting or drawing was, at best, a "contemporaneous copy," not to use the nasty word "forgery." Modigliani makes the art world tremble, and the art market as well, and not infrequently the two have entered into unwholesome alliances in the past. The only comparable phenomenon from the twentieth century is with sculpture. Similar forgery scandals affected Auguste Rodin and Edgar Degas; most especially, the Swiss sculptor Alberto Giacometti fell victim to counterfeiting. The Dutchman Robert Driessen admitted in 2015 before the district court in Stuttgart that he had forged one thousand Giacometti sculptures. His accomplices—one of whom called himself "Imperial Count von Waldstein" and asserted that he was a friend of the artist's brother Diego—claimed that the sculptures were secretly withheld from the public by Giacometti's heirs. They falsified certificates and even produced their own book with the title *Diego's Revenge*. The total damages of the fraud awarded by the court came to €4.75 million.

It is important to study the continued mythification of Modigliani. He's hardly the only artist of the late nineteenth and early twentieth century for whom the legend eclipses the historical reality and the working process such that, biographically and artistically, truth and falsehood having long since merged. That the personal mythology of the artist was the marketing tool for classic modernism[20] is described quite well by the art historian Robert Jensen: "To market modernism artists, their dealers, critics, and historians required above all to establish its historical legitimacy. The historiographic enterprise was as much a part of merchandising Impressionism as the increasingly refined practices of art dealers to promote not only individual paintings but whole careers, and to do so not only through conventional publicity but through

carefully constructed exhibitions and a mode of personal persuasions that variously appealed to the speculative and/or connoisseurship skills of the potential client, the *amateur*."[21]

To lift him from the flood of other offerings, it is necessary to market the artist either as an established historical figure or as a singular phenomenon of his time. The biographical and sociological representation of the artist increased in importance with the rise of the bourgeois art market, and in some cases got the upper hand. The legend of his life became as important as an artist's oeuvre in many instances, provided that the legend was rich enough to separate him from the crowd of other art producers.

DEATH AS THE BEGINNING

There is a handful of artists about whom everybody can tell a story. Renoir is one of them: the artist who, in the last years of his work, used gauze to fasten the paintbrush to his crippled, arthritic hand. Or Monet, whose sight was failing so badly that he could barely finish the giant water-lily pictures for the Musée de l'Orangerie in Paris. Vincent van Gogh's supposedly slicing off his ear is among the artist anecdotes that over the course of time have penetrated the collective mythological consciousness. And the tragic early death of Modigliani, whose pregnant lover, Jeanne Hébuterne, killed herself one day later.

It is no accident that the rise of this perennially popular legend coincides with the birth of the international art market. When the enlightened bourgeoisie can afford to decorate the walls of their own homes with paintings, the gallerists have to come up with arguments to convince the customers of the worth of whichever artists they happen to represent. That may be done by reference to the quality of the work offered for sale. Another tactic was made possible by the wildly proliferating number of art magazines at the end of the nineteenth century. They told stories to potential customers that allowed them to participate in the lives of artists. The more tragic, romantic, and mythological the stories of the artists were, the more significance their work seemed to gain.

In art history, myths and legends usually begin with a piece of paper and a genuine recollection—nothing much has changed about that in the last hundred years. While even then a good picture did not mirror reality, nor could it, at the beginning of the last century reliable documentation was already occasionally necessary to lend the creator an aura of reality. Some artists might have long ago disappeared into the imaginary worlds that they painted were it not for some extant proof of their existence today.

There is a clear connection between these myths that glorify an artist, usually shortly after death, and mounting success in the art market, often coinciding with an influx of forgeries to satisfy the ever-increasing demand. To understand this connection, it is instructive to consider the parallels between Modigliani and the other great mythologized art personality of classic modernism, Vincent van Gogh.[22] Both artists died young and under tragic circumstances: Modigliani at thirty-five years old, of a tubercular inflammation of the brain; Van Gogh at thirty-seven years old, from self-inflicted gunshot wounds. Both painters led debauched lives filled with drug consumption and visits to brothels. Both received only one piece of published criticism during their lifetimes. The Italian enjoyed only one single exhibition of his paintings in 1917 in the Paris gallery Berthe Weill, at which he sold two drawings for a mere thirty francs each. Although more than the oft-cited single painting sold by Van Gogh, the number of paintings sold by Modigliani during his lifetime can still be counted on two hands. Both men are reputed to have eschewed success and material concerns. For both, artistic recognition and material success began shortly after death. The alleged failure of the two painters to achieve recognition during their lifetimes can be explained in retrospect because they were aesthetic loners. Of course, both Van Gogh and Modigliani had studied to be artists. Relatively quickly, both found their own style of painting, which, later on, had in both cases a high recognition value. Neither left behind acolytes who had continued in their style. That is why both artists' oeuvres are considered singular today. And, finally, the glorification of the

personalities and temperaments of both artists began soon after their deaths—and, thus, included personal reminiscences that were authentic and not at all intended to further this goal.

Émile Bernard, for instance, described the interment of his friend Vincent van Gogh in July 1890 in Auvers, near Paris. Bernard renders the scene so precisely and so movingly that sixty-six years later the Hollywood director Vincente Minnelli incorporated it almost unchanged into his script for the Van Gogh beatification *Lust for Life*, which engraved the Van Gogh myth in the postwar consciousness: "At three o'clock the body was lifted up. His friends carried him to the hearse. Various people cried—Theodorus van Gogh, who had worshipped his brother and who had always supported him in his battle for art and independence, never stopped sobbing. The sun was terribly hot outside. We climbed up the hill of Auvers and talked about him, about the strong forward push that he had given to art, about the magnificent projects that always occupied him, about the goodness that he gave to all of us. His last paintings were nailed to the walls of the room in which he lay at rest, forming a sort of holy glow around him and, because of the brilliance of the genius that radiated from them, made his death all the more painful for us artists. Atop the coffin lay a simple white cloth and countless flowers—sunflowers which he so loved, yellow dahlias, yellow flowers everywhere. That was his favorite color, the symbol of light, of which he dreamed in his heart and in his pictures. His easel, his folding chair, and his brush were placed on the floor in front of the casket."[23] A similarly moving letter about the death of Modigliani serves as the founding document of his mythology. The Polish poet Léopold Zborowski, who was also Modigliani's dealer, wrote the letter to the artist's brother Emmanuel on the day of the burial, January 31, 1920. The reason for the letter was profane: he had to convince Modigliani's relatives living in Italy that they needed to take care of his daughter Jeanne in the future. In fact, he unconsciously laid the cornerstone of a mythological Modigliani mausoleum, whose foundations remain sturdy today despite nine decades of art-historical research:

Today, Amédée, my dearest friend, rests in the Père Lachaise cemetery, covered in flowers as you and we both wanted. All the artistic youth of today came to give our dear friend and one of the most talented artists of our epoch a moving and triumphant funeral procession.

One month ago, Amédée urgently wanted to leave for Italy with his wife and child. He was only waiting for his wife to give birth—he wanted to leave the child that he expected with a nurse who is also now tending his daughter Giovanna [Jeanne Modigliani].

At this time, his health, always fragile, became disconcerting. My advice to enter a sanatorium in Switzerland was not heeded. I told him, "Your health is bad. Take care of yourself," and he acted as if I was the enemy and said, "Don't lecture me." He was a child of the stars, and reality didn't exist for him. Nonetheless, it didn't seem as if catastrophe lay around the corner. He had a good appetite. He went for walks and was in a good mood. He never complained about a hidden illness.

Ten days before his death, he had to lie down in bed and suddenly felt sharp pains in his kidneys. The doctor who came diagnosed a kidney infection (earlier he refused to see a doctor at all). He suffered because of his kidneys but said it would pass soon. The doctor came every day. I myself became sick on the sixth day of his illness, and my wife visited him in the morning. When she returned, I learned that Modigliani was spitting blood. We got the doctor who explained that he had to be taken to the hospital right away to stop the bleeding. He was brought to the hospital two days later, unconscious. We did everything we could. His friends and I called in several doctors. But tuberculous meningitis had taken hold and had been eating away at him for a while, without a doctor discovering it. Modigliani was lost.

Two days later, Saturday at 8:50 p.m., your brother died—without suffering and without consciousness.

His last big wish was to leave for Italy. He spoke of you and his parents often and at length. His unfortunate wife did not survive him. On the day after his death, at four in the morning, at the home of her parents, she jumped from the window on the fifth floor and was dead immediately.

What tragedy, my dear Modigliani. I can hardly believe that I was just together with them, that we talked and laughed, and I said that I would visit them in Italy.

His wonderful daughter, who is now fourteen months old, is staying not far from Paris with the nurse in whose keeping Modigliani and his wife left her. Three weeks before he died, as if he sensed his impending death, Modigliani got up at seven in the morning. That was very unusual for him. He wanted to see his daughter. When he returned, he was very happy. In the meantime, I am the one taking care of her. But you are the only one who can replace her parents. My wife and I would gladly take her as our daughter—but Amédée always expressed the wish that she would grow up with his family in Italy.

Do not be concerned about the little one. I will see her in a few days with my wife. She is in any case in very good health and is starting to walk. . . .

A small committee has been founded as an homage to Modigliani, to collect pictures by various artists and sell them for the benefit of his daughter. That should result in between F 25,000 and F 30,000, which you can accept on behalf of the little one. Because it is a tribute by the painters to her father.

Very truly yours,
Léopold Zborowski
3 rue Joseph Bara
Paris VI

From this material, those myths are made that are needed by the international art market in order to sell the artist's work. There weren't

yet any photo magazines in which intimate at-home stories about the star artist nesting in his atelier might appear, nor were there widely publicized auctions about whose record prices one might report, nor was there television or the internet through which news of the fresh star in the art heavens could spread to customers across the world with the speed of light. The professional marketing services used by Damien Hirst and Jeff Koons today were in the past undertaken by relatives and friends of the artist—the PR that was necessary even then to lift a single artist out of the crowd and make him marketable. A tragic life, ended early, wasn't the worst sales pitch by any means.

THE EARLY FLOOD OF FORGERIES

It almost looked as if Modigliani's work would be forgotten. His wife, who might have publicized his work, killed herself out of despair one day after his death. His daughter Jeanne was soon living in Italy with relatives who had no connection whatsoever with the leading art markets in Paris, Berlin, and New York. That left the Paris artists and painter friends and the two dealers who principally represented Modigliani's work. Already in 1914, the art dealer and collector Paul Guillaume, who in the beginning of his career dealt primarily in African tribal art in his small Paris gallery, had entered into an agreement with Modigliani. His gallery quickly became one of the most important places for contemporary art,[24] because the dealer wasn't just interested in making money by selling art. Guillaume also wanted to support the artists he represented (inter alia, André Derain, Henri Matisse, and Chaïm Soutine) financially and morally. On a 1915 portrait of his dealer, Modigliani painted the words "Novo Pilota"—the new helmsman.[25] It was Guillaume who introduced Modigliani to Constantin Brâncuşi, the Bulgarian sculptor living in Paris, and encouraged him to make sculpture. Modigliani quickly gave up the attempt, however, because of his bad lungs and the dust set loose by sculpting stone. Later, Guillaume terminated his agreement with Modigliani, and Léopold Zborowski took on the task of finding buyers for his pictures.

Modigliani's social circle in Paris was also the same group that became quite active in the miraculous increase in the number of his works. This happened right after his death to bolster his fame and provide financial security for his daughter. That his pictures were copied by his friends for quite a number of years can be explained only by the wretched economic conditions in Paris in the 1910s. It was only after World War II that others devoted themselves with concentrated criminal intent to the lucrative market for work by this deceased painter.

A FRIENDLY FAVOR

Some art historians believe that the first person to bring dubious Modigliani work into circulation was Léopold Zborowski, the very man who had heartily supported Modigliani during his lifetime. His friend and dealer is supposed to have paid other friends and colleagues of Modigliani to complete his unfinished paintings. Later, he is alleged to have asked them to paint work in the style of Modigliani and sign his name. The French painter Fernand Léger, who already had gallery representation at this time with Daniel-Henry Kahnweiler, recalled, in a conversation with the art historian and critic Dora Vallier, that the completion and forgery of works by popular painters was a common practice in Paris artist circles during Modigliani's life and was understandably a good way to earn money:[26] "One day a friend said to me, 'Do you want to earn some money?'—'Of course,' I said. 'But how?' He became secretive: 'I can't tell you.'—'Come on, tell me.' He hesitated. 'Okay, listen, I touch up old pictures, Corot... If you want, I can introduce you.' Two days later he escorted me to a dirty shop, dirty is hardly the word for it. I don't understand how art lovers can buy pictures in such filth. One could say, the more dust there is, the dirtier it is, the more satisfied they are. A little old man received us. He was the owner. He showed me a couple of gloomy landscapes with tiny figures and asked me if I could touch up the figures to make them more pronounced. 'It's a picture by Corot that has suffered a lot, but be careful,' he told me, as he entrusted it to me. The next day I returned the picture: the figures were nicely in place. He seemed satisfied

with me and paid me right away. A few days later, my friend said to me that the dealer wanted to speak to us. 'I saw right away that you had talent,' he told me. 'This time I will entrust you with an assignment that is delicate but also better paid. Do you see this picture?' It was a similar sort of picture. 'You need to add a figure here on the right.' This time, something in me rebelled. I took the picture and bolted without saying a word. It kept going around in my head. Early the next day, I went back to the dealer. He didn't expect me. He came out of the back room quite surprised, and all at once I understood everything. An awful smell of burned oil filled the shop. There was no longer any doubt. Here, pictures were forged, and he was in the middle of roasting a painting on the gas stove, to give the paints a patina. 'You might have told me they were forgeries!' 'What? Huh?' He seemed flabbergasted. 'You're not cooking mutton!' I was enraged. He didn't have any excuses left. He explained that his colleague fabricated the 'Corot landscapes' but wasn't talented enough to paint the figures. He offered me eight francs a day to makes 'Corots' for him. And so I made twenty-five, maybe thirty fake Corots . . . Perhaps they're still around today. I haven't seen them since in any case.

"To the contrary, in America I did once again see the fake Modiglianis that my colleagues made. I had to judge earlier whether these forgeries were well made, and I must say, they were very well made. My colleagues 'borrowed' a picture from Modigliani to 'study it,' as they said, and when they had it back in their atelier, they made a copy. When they were done with the copy, they put the copy next to the original and called me in. I could look as carefully as I wanted, but I couldn't tell which was forged and which was genuine. So I told them: 'Listen, you need to put something in, a sign, so that one can tell the difference.' And they made a mark with pencil on the frame of the forgery. I encountered this pencil mark again in America. . . . That's how life was!"[27]

A NEW BEGINNING AFTER THE WAR

Back then, of course, forgeries were made only of work by artists for whom a market existed. Just as Léger's friend recollected borrowing

works from Modigliani's atelier in order to copy them and sell them for a fee, such practices were hardly failures, despite what many biographies after his death contend.

Léopold Zborowski acquired from Modigliani's estate all the sketches, drawings, sculptures, and paintings of his that were to be found.[28] This gave him a monopoly on an artist whose fame skyrocketed. In the winter of 1922–23, the American pharmaceutical millionaire Albert C. Barnes came to Paris on a buying trip for his private museum in Merion Station, near Philadelphia. In addition to fifty-two works by Chaïm Soutine, he acquired sixteen Modigliani paintings. Even today they constitute the largest single public collection of Modigliani paintings on display anywhere in the world. Not least because of this spectacular purchase, which quickly became known, the prices for Modigliani's works rose dramatically, and Léopold Zborowski became a wealthy man. The art dealer had not long, however, to enjoy his riches. He lost almost his entire fortune in the world economic crash of 1929. When Zborowski died in Paris in 1932, also young, at just forty-three years old, he was buried in a pauper's grave.

The Second World War disrupted all further sales. In Germany and occupied France, Modigliani was officially considered to be contrary to the Nazi ideals of art. A commission seized and removed from the Berlin National Gallery one of his loveliest portraits, a painting of his wife, Jeanne Hébuterne. The German government auctioned it, along with 124 other paintings and sculptures, at the Galerie Fischer in Lucerne on June 30, 1939—eight weeks before the beginning of the Second World War.[29] All the works offered had been seized from German museums. A self-portrait by Van Gogh, dedicated to Gauguin, got the highest price at CHF 175,000. Lorenz Lehr, a cellist from Bern, bought the Modigliani portrait for CHF 6,600.[30] For the international public in attendance, the two artists were thereby enshrined as the most valuable painters of classic modernism.

When the international art business picked up again after the war, Modigliani held on to his place at the top of the artists most in demand.

One of his nudes had already been gaveled out for F 1 million at an auction in Paris in 1952. A 1957 book republicizing the mythology of the artist, which was so helpful for sales, appeared within a few years in French, Italian, and German. In this little book, the French poet and critic André Salmon recorded his memories of Modigliani and added letters and poems. His text had already appeared in 1939 in the Paris magazine *Les oeuvres libres*. Now he brought in the great tradition of the School of Paris and with all due pathos elevated Modigliani once again to be its uncrowned king.

The high prices being paid for Modigliani after the war naturally awoke the appetites of forgers—especially since it seemed that the stylized portraits of faces with long necks and noses, small mouths, and mostly empty eye sockets, as well as the characteristic signature, could be easily imitated. The Hungarian painter Elmyr de Hory was one of the most famous Modigliani forgers in the immediate postwar period. His life story, set forth in a book by the American journalist Clifford Irving[31] and later filmed by Orson Welles under the title *F for Fake*,[32] can be enjoyed with a certain amount of caution. As his life is recounted in that book, de Hory, the scion of an Austro-Hungarian diplomat and a banker's daughter, studied classical painting in Budapest, Munich, and Paris, with Fernand Léger, among others. Because of his associations with a spy, he was incarcerated, put in a concentration camp by the Nazis, and later deported to a Berlin prison hospital, from which he was able to escape and flee to France. When he allegedly sold his first copy, of a Picasso painting, the forty-year-old discovered that he could live much better by forgery than he could by selling his own work. Elmyr de Hory—alias Louis Cassou, Joseph Dory, Joseph Dory-Boutin, Elmyr Herzog, Elmyr Hoffman, and E. Raynal—settled in the US one year later and in Miami began a business forging works of classic modernism, often Modigliani pictures, which were much sought after by American collectors after the war. Elmyr de Hory worked with respected dealers such as Jacques Chamberlin and, of course, Fernand Legros, who knew according to his own statements that they were dealing in inauthentic work.

Everybody in the art world had heard some of the countless legends about Modigliani, the "peintre maudit," and those stories made it easy for de Hory and the Modigliani forgers that came after him. They furnished excellent arguments as to why once again somewhere in the world a new work was discovered that had never been seen before or shown at any exhibition. Modigliani's irregular life, his liking for hashish and alcohol, and his frequent change of abode were the reasons he didn't keep an inventory of his produced work. After he died, there was no record of the works that had left the studio. And his companion, Jeanne Hébuterne, who could have distinguished the genuine from the fake through observation, took this knowledge with her into the grave one day after Modigliani's death. But everyone knew some story about Modigliani being broke and using drawings to pay for a meal, a bottle of wine, a prostitute, or common debts. Or about his generosity toward people he liked. Who would dispute that hundreds of unknown works could be in circulation, just waiting to be presented to the surprised public? One wanted to believe that anything was possible for Modigliani, this genius who was misunderstood while alive. Moreover, Modigliani's daughter had grown up, returned to France at the age of nineteen, and held to the lingering superstition, common among artists' widows and children, that the artist's family could best decide which works were authentic and which were not.[33] As with assorted models of Modigliani, she gave expert opinions about her father's work, at the time of whose death she was exactly fourteen months old, and she was often wrong. "Jeanne was impossible," confirmed the Geneva art dealer and adviser Marc Blondeau, "because she signed certificates of authenticity on a very subjective basis, without serious research. She even authorized people to reproduce her father's sculptures in bronze despite the fact that he only worked in stone." Serious art-historical research regarded Modigliani's work for some time as crowd-pleasing art that wasn't worth much consideration. What authority is needed other than one's own belief as to the authenticity of the work on the wall of one's living room?

The lack of a reliable list of his works caused severe damage to Modigliani's reputation. In 1929 the art historian Arthur Pfannstiel attempted the first catalogue raisonné of Modigliani's paintings[34] and in 1958 there followed a second volume for the drawings.[35] Both are considered to be unreliable: Pfannstiel didn't have the financial resources or logistical capabilities to see the approximately 350 original works of art in person or to provide images for many of them in the catalogues. Moreover, not only was he involved in a 1929 scandal in Berlin in which thirty fake Van Goghs[36] were offered for sale, but after the war he was among those experts who certified the forgeries by Elmyr de Hory as genuine and was paid to do so by Galerie Legros.

Amedeo Modigliani: Peintre by Ambrogio Ceroni appeared in 1958 and remains the foundational work to this day.[37] In that book and in the new edition of 1970, the Italian author, who was chiefly a banker, listed in total 337 oil paintings. But Ceroni was prepared to identify as authentic only those works that he had seen in person. Whatever existed outside Europe at the time his book appeared was not within his reach since Ceroni never traveled, for example, to the US. Thus, Ceroni does not list the *Girl with Blue Eyes*, which belongs to the Marion Koogler McNay Art Museum in San Antonio, Texas, is doubtless authentic, and has been shown in many exhibitions. Transaction records belonging to Modigliani's first gallerist, Paul Guillaume, were not yet available; these records have since been used to reconstruct the provenance of many works. Ceroni often listed only the current location where he had seen the work, without tracing the provenance back to the painter's studio. Nonetheless, respected auction houses and gallerists rely on his book to this day. The London art dealer James Roundell confirmed just a few years ago: "If a painting isn't in Ceroni's index or doesn't have a proven, old provenance, I wouldn't touch it with a ten-foot pole."[38]

The German critic Joseph Lanthemann counted 1,024 authentic works in 1970, among them 420 paintings,[39] and was very much in demand as an expert until a quite advanced age, continuing to provide

his expert opinions of authenticity into the 1980s, though they are considered controversial today. In his book, he cited neither provenance nor current ownership nor any indication of where the works had already been exhibited or at least reproduced. Therefore, his publication was considered unreliable immediately after it appeared. The Milan art historian Osvaldo Patani finally published his list of works in 1991,[40] including 349 paintings; then in the following year Patani published a second list of the drawings;[41] and in 1994 he published an index, claiming academic rigor and including the information missing from Lanthemann's catalogue, which, to the surprise of many, demonstrated that legitimate Modiglianis could still be discovered.[42]

DISCOVERIES ARE POSSIBLE

In 1993 an entire collection surfaced of hundreds of works, mostly on paper, that hardly anyone had known about. They had belonged originally to a Paris doctor named Paul Alexandre who had started assembling the collection in 1907. Some of these works were already in circulation during the collector's lifetime. Today they decorate the walls of wealthy art lovers and the drawing collections of famous museums, and they bestowed on Alexandre a comfortable retirement and gave his family a rich inheritance. Perhaps because his goddaughter, Hélène Perronet Katzen, liked it so much, Paul Alexandre gave the child a charcoal drawing before the war. The forty-three–by–twenty-seven–centimeter unsigned, portrait-format work shows an Egyptian-style female nude with a cat sitting in the foreground. Hélène parted with the work on paper at a Sotheby's auction in New York where it sold for around $250,000. The once unknown Paris painter in Montmartre, whose pictures Paul Alexandre liked so much that he even had his own portrait painted by the artist, was henceforth Amedeo Modigliani, art-market star.

Between 1907 and 1914, Paul Alexandre collected five hundred Modigliani drawings and a considerable number of paintings, and considered Amedeo a friend. Then Alexandre was called to

military duty, and it appears he never saw Modigliani again. The art-inclined dermatologist spoke in his memoir about the years before the war, "I have almost all his paintings and drawings from this period."[43] This assertion is not inaccurate. Though Alexandre helped the painter find a studio on the Rue Delta and begged him not to destroy paintings and drawings or give them away for hashish or a glass of absinthe because Alexandre was willing to purchase them for his collection, some major works from his early period were handled by his dealer, Paul Guillaume, and made their way into other collections. Paul Alexandre had planned to publish his collection in a demythologizing book on Modigliani. Osvaldo Patani took on this assignment as the final part of his lists of works and had also planned a fourth volume. Patani, however, distanced himself from the project in 1999, giving two reasons for the decision. Speaking to the London publication *Art Newspaper*, he said, "I am disappointed, demoralized and also annoyed. I am an honest man and nowadays I have to reckon with too many vested interests and too many fakes in circulation."[44] In particular, Patani continued, lawyers for the Wildenstein Institute in Paris had threatened him in writing with legal action if he disputed any attribution in the forthcoming Wildenstein Modigliani catalogue.

BATTLE OF THE GIANTS

At the turn of the millennium twenty years ago, two book projects were competing to be considered the definitive list of Modigliani works. And the authors are engaged in a public dispute over who is the rightful guardian of the Modigliani legacy. Legally, the authority is quite clear under French law. Christian Parisot, a lecturer at the Institut d'Arts Visuels d'Orléans for twenty years, got to know Jeanne Modigliani during research for his PhD dissertation. They got along well, and the artist's daughter granted him "droit moral" pursuant to her will at the time of her death in 1984. In France, according to droit moral, only the heir of an artist or the persons they appoint have the

right to have guardianship of an oeuvre—and to decide its authenticity. Because, as a rule, the holders of such rights are paid by collectors for their expert opinions, the droit moral can be a lucrative source of income.

Parisot took over control of Jeanne Modigliani's private effects from her father—particularly postcards and letters—and published several dozen books and catalogues. He oversaw scores of exhibitions throughout the world. He founded the Archives Légales Amedeo Modigliani to do his work. It has moved around several times but since October 2007 has been situated in a palazzo in Rome. Parisot started publishing his own indexes of Modigliani works.

According to his statements, Parisot acquired the archives of Ambrogio Ceroni, Joseph Lanthemann, Osvaldo Patani, and Arthur Pfannstiel. In spring 2001, he founded a "Modigliani committee," to which he belongs along with, among others, Jean Kisling, who is the son of Modigliani's painter friend Moïse Kisling and the author of Kisling's catalogue raisonné. His own father is suspected with good reason of forging Modigliani works under commission from and with a fee paid by Léopold Zborowski in Paris in the 1910s. Jean Kisling admitted later that, if Parisot requested it,[45] he sometimes signed certificates of authenticity for Modigliani works even when he hadn't had the chance to see them. At the beginning of 2007, Kisling became a ward of the state because of the deterioration of his mental health.

A new Modigliani catalogue raisonné is supposed to be in the works under Parisot's aegis. Among experts, the project is regarded with great skepticism. Daniel Malingue, doyen of the Paris art trade, announced shortly after the nomination of Parisot's Modigliani committee: "This committee is a total joke. Parisot went fishing and found people that all the world can see don't know enough about Modigliani to say what is correct. No one will take their catalogue seriously." Marc Blondeau in Geneva shared the opinion: "It's nonsense for me—it's a nonevent."[46]

It wasn't the first time that Parisot, the industrious guardian of the estate, garnered attention by publicly presenting in print and in exhibitions new Modigliani works whose authenticity was disputed by experts that he had excommunicated.

In Spain in 2002, the police closed an exhibition organized by Parisot and seized seventy-seven drawings shown in it. The works supposedly came from Modigliani's lover Jeanne Hébuterne. Earlier, in fall 2000, Parisot persuaded Luc Prunet, an attorney and the grandson of Hébuterne's deceased brother André, to lend work for an exhibition at the prestigious Fondazione Giorgio Cini in Venice. Under the title *Modigliani and His Own*, the exhibition included, along with Modigliani, some other artists from his circle; Jeanne Hébuterne herself was one of the artists in the exhibit.[47] There was evidently a disagreement between Parisot and Prunet at the end of the exhibition, which caused Hébuterne's heir to refuse his permission for the exhibition to travel to other Spanish cities. When the tour went ahead anyway, Prunet suspected that forgeries were being exhibited, since the originals, which he owned, were no longer available. The police seized seventy-seven of the works in the exhibition, and Christian Parisot became entangled in a web of massive contradictions, according to the American magazine *ARTnews*.[48] First he claimed that the newly exhibited drawings came from two albums that he had found at the Paris dealer Paradies. When the dealer denied selling the questionable drawings, Parisot made a new declaration and claimed this time that the dealer was named Guy Pellet, who confirmed the new story. Meanwhile, by the end of 2004, independent experts had determined through material analysis and stylistic criticism that the seventy-seven works were undoubtedly forgeries. Under new questioning by the police, Parisot changed his story again, according to *ARTnews*, and claimed that he had bought one of the two albums not from Pellet but from another secondhand dealer whose name he could no longer remember. An exhibition that Parisot organized in Venice in 2006 included works whose authenticity was suspect. In fall 2007, Parisot surprised the art world by

announcing at a press conference in Belgrade that a previously unknown Modigliani painting had been found there.[49] The portrait of a young man with light wavy hair, supposedly from 1918, was alleged to belong to a Serbian no longer living in his homeland. Supposedly, it had taken seventeen years to confirm the authenticity of the picture. As confirmation, it was asserted, the hairstyle of the young man suggested that he belonged to musical or literary circles, and that the paint is so thinly applied could be explained by the fact that Modigliani always had very little money. It was not explained at the press conference how, when, or where the Serbian owner had acquired the painting shortly after the opening of the Eastern Bloc.

Even a highly respected, state-financed institution, the Kunst- und Ausstellungshalle der Bundesrepublik Deutschland in Bonn, got on the wrong horse with a Modigliani retrospective in 2009. The museum director at the time, Christoph Vitali, had long expressed the desire to end his tenure there with a spectacular Modigliani retrospective. He relied on, among other people, Christian Parisot, despite Parisot's reputation. Vitali entered into a cooperative agreement with Parisot as curator of the exhibition in order to obtain the loan of works. The administration of the museum expressed little interest in clarifying when this agreement began or whether Parisot was paid a fee, let alone what the budget was for the exhibition. Just how closely they collaborated may be seen in the fact that both the wall of photographs at the beginning of the exhibition and the printed catalogue displayed the logo of Parisot's Archives Légales Amedeo Modigliani.

At least nineteen works in the Bonn show were suspected to be forgeries: inter alia, the drawings *Woman with a Hat, Hanka Zborowska,* and *Victoire,* five early works that are at the very least questionable, and the paintings *Young Brunette, Maria, Red Caryatid, Young Woman with White Collar, Reclining Nude (Céline Howard),* and *Young Woman with Brown Hair (Elvira).*

Had those responsible for the exhibition done their research, they would have found that this wasn't the first time flags were raised about

some of these works, and that to place their trust completely in Parisot was misguided.

According to the catalogue, Modigliani at age sixteen is supposed to have painted the early work in the Bonn exhibition, *Medea*, as a portrait of a young girlfriend on Sardinia. The portrait in profile was used as advertising for the sale of land at Azienda Modigliani, near Cagliari, and asserted, citing Christian Parisot, that Modigliani's father had been active as a businessman in Sardinia. In the respected literature on Modigliani, there's no proof of his having been there. In 1900, Modigliani swung between life and death because of a tubercular infection. That his mother would let him travel to Sardinia at that time is just as unlikely as his father doing business there.

The half-length portrait called *Young Brunette*, allegedly dating from 1918, landed on the tens of thousands of printed posters, stickers, and folders that advertised the exhibition, which reproduced images of three doubtful works. It looked strikingly like Modigliani's *Seated Woman in Blue Dress* of 1917 in the Moderna Museet in Stockholm. The copyist didn't understand the woman's hairstyle in the original, nor did he recognize that her dress wasn't black—perhaps because of a printing error. Nonetheless the picture was shown in Palermo in 2019 and attributed to Modigliani in the exhibition, from which the Carabinieri seized two other portraits in March of that year. The show had been organized by the Istituto Amedeo Modigliani in Spoleto, with which Parisot also works.

Particularly audacious in the Bonn show was the exhibition of a putative 1918 painting, *Young Woman with Brown Hair (Elvira)*. The catalogue asserted that it had been obtained through a gallery in Frankfurt, and, just a week after the opening of the exhibition in the Bonn Kunst- und Ausstellungshalle, the astonishingly fresh, unframed picture was offered for sale through advertisements in the *Süddeutsche Zeitung* and the *Frankfurter Allgemeine Zeitung*: "At the moment on view in the Bonn museum. Discreet and professional transaction in Switzerland." In response to inquiries about the classified advertisement, an art dealer in

Brugg (near Zürich) sent an offering folder with photocopies principally of expert opinions from the Archives Légales Amedeo Modigliani of Christian Parisot. Not only had Parisot certified the genuineness of the painting, but so had Modigliani's daughter Jeanne and her husband, the philosopher Valdemar Nechtschein, who was identified as a "Modigliani expert." Parisot confirmed the authenticity even though the signature and the way of writing the date were markedly different from each other in two documents. The cover letter cited the Bonn exhibition itself as proof of the authenticity of the painting, as well as the accompanying catalogue and a photocopied article about the show from the *Frankfurter Allgemeine Zeitung*, which had a big reproduction of the painting. The Bonn exhibition served quite openly as a sales pitch for a work for which neither provenance nor prior exhibition history could be provided. The work, which Parisot had already listed in his index as authentic, was supposed to fetch €4.2 million. It is easy to suspect that *Elvira* had only been put in the show in order to sell it later at a profit.

The muddied colors of the half-length portrait *Maria* that was exhibited in Bonn were atypical for Modigliani. And the strangely flat portrait of Céline Howard, which, along with *Maria*, would lead to the closing of the Modigliani exhibition in Genoa in 2017, was already shown in Bonn as well. If one were to compare this picture with the authentic *Reclining Nude on a Red Couch* from the Stuttgart gallery, which was also exhibited in Bonn, several artistic mistakes appear. The face seems as flat as a mask. The shoulder blades and breasts are anatomically incorrect. The body doesn't lie on the pillow but seems to hover over it. And the left thigh is positioned such that it seems to be attached at the stomach rather than the hip.

According to material and technical investigation by Marc Restellini, then of the University College London, another *Reclining Nude* that Parisot declared in the fourth volume of his index of works (*Témoignages*) to be genuine[50] contains titanium white, a paint material that Modigliani could not have used, because it was first sold after his death. Parisot claimed that the values measured were ambiguous, or that

the material could have been added later in a layer of varnish. "We tested multiple layers and found traces everywhere," Restellini countered. "It's not the varnish."[51] Parisot also contends that the *Reclining Nude (Céline Howard)*, which was shown in both Genoa and Bonn, is authentic, although, in a rare moment of unity, experts from both Sotheby's and Christie's had previously rejected it as dubious. The picture was the subject of litigation in the US between the dealers Joseph Guttmann and Paul Daniel Quatrochi, who both claimed the right to sell it.[52] Guttmann also supplied at least eleven of the paintings that the police seized in Genoa, according to the police.

Meanwhile, the French police has in its custody at minimum three paintings that Parisot attributed to Modigliani and whose authenticity has been doubted, to say the least. One of them, *Promenade in Livorno*, a purported youthful work with only a forged signature as proof, was seized in advance of an auction at the Paris auctioneer Drouot. Guy Pellet, the secondhand dealer who was embroiled in the forged Hébuterne drawings, claimed that this painting had belonged to him too, according to *ARTnews*. Pellet said that Parisot promised to confirm the Modigliani attribution if Pellet in turn backed up Parisot's story about the discovery of the Hébuterne drawings.[53] Two other paintings—*Young Man with a Moustache* and *Girl with Bangs*—were seized from exhibitions in France.

The allegations against him were the result of a "witch hunt," Christian Parisot had already told *ARTnews* in 2004.[54] He said he would disprove all the accusations in a thorough trial, including the allegations that the Hébuterne drawings shown in Spain were forgeries. The trial was delayed several times, because the investigating judge was replaced, then a second one died, and then a third had to work his way into the Modigliani case. Chief responsibility for the current dilemma was already clear, Parisot said: "The police are only doing the bidding of their bosses, Marc Restellini and the Institute Wildenstein."[55]

Parisot was referring to the direct competition for the right to decide the authenticity of Modigliani works and consequently the lucrative

exhibitions that would lead to sales.

DUELING CATALOGUES

In 1997, in collaboration with the Institute Wildenstein in Paris, Marc Restellini—former artistic director of the state-owned Musée du Luxembourg (2000–2003) and later the director of the privately financed exhibition space Pinacothèque de Paris—started to put together what was supposed to be the definitive canon of authentic Modigliani paintings and drawings. These efforts were not without controversy. The Institute Wildenstein was supported financially at the time by the gallery dynasty of the same name—one of the most influential art-dealing families in the world. Since the 1930s, the firm has published indexes of work that are put together by in-house expert teams, the so-called committees, at the Institute on the Rue de la Boétie in the elegant eighth arrondissement. At times, the website of the Institute listed forty-seven projects regarding individual artists from Boucher and Courbet to Gauguin, Ingres, Manet, and Monet, and on to Pissarro, Renoir, Van Dongen, and Zurbarán.[56] Critics have for years feared that the interests of the Galerie Wildenstein influence the research activities at the Institute. They say that only after Wildenstein has acquired newly surfaced works for a diminished price—because they remain unauthenticated—are the works recognized as genuine. They claim that Wildenstein has almost unlimited power with respect to the artists whose catalogues raisonnés are prepared at the Institute. No one has proven these oft-repeated accusations, however.

The patriarch of the firm, Daniel Wildenstein, who is now deceased, told the journalist Stephen Wallis that he did not own any work by Modigliani, nor had he bought or sold any work by Modigliani that Marc Restellini had brought into the list of works. He said to Wallis that the Wildenstein Institute in Paris prepares its lists of works completely independently from the activities of the gallery in New York. He explained that his family supports Restellini and his project because he

had known Ambrogio Ceroni well and saw now how many fake works were publicized and sold as genuine after Modigliani's death: "If I had bought all the Modiglianis that were 'discovered' since Ceroni, we would be ruined."[57] Following several scandals about inheritance and taxes in the gallery-owning family, together with the controversy around approximately thirty valuable and presumably stolen paintings in the rooms of the Institute, Wildenstein has since 2016 conducted its work through a joint foundation with the software billionaire, art collector, and museum founder Hasso Plattner. The purpose of the Wildenstein Plattner Institute is no longer the authentication or appraisal of artworks, but rather the scholarly preparation of work indexes.

Marc Restellini parted ways with Wildenstein in 2015 and founded his own Institut Restellini, with offices in Paris, in the toll-free zone in Geneva, and in Dubai. He is also still at work on his own catalogue raisonné of Modigliani. According to his statements, he has access to a portion of the few remaining documents for Modigliani's early sales—such as the archive of Zborowski's business partner Jonas Netter, and papers from the estate of Roger Dutilleul, an important early collector of Modigliani. Restellini has had his own troubles, stemming from his endorsement of an incorrect opinion. The Swiss collector Edgar Bavarel, who owned two drawings by Modigliani, brought a legal proceeding against Wildenstein in 2000 because Restellini refused to include them in his index. The judges declared one of the works, *Young Girl*, to be authentic and directed the experts to include it in their index. A short while later, Restellini announced that he would give up the project of putting together a catalogue of drawings.

Restellini's catalogue raisonné of the paintings had run into problems several times, with its initial publication date of 2002 first moved to 2005–2006, and then with no definite date given. Shortly after Restellini had started his work, the industrialist Moshe Shaltiel-Gracian from Chicago had the London house Phillips auction his *Young Woman with Brown Hair*. The estimate was put at between £1.3 million and £1.7 million. Restellini stated that for his opinion, at the request of Phillips,

he sent a fax to London, on the letterhead of the Wildenstein Institute, the morning of the auction:

"I hereby confirm that lot 56 of the sale, *Jeune Femme brune*, cannot by my opinion have come from the hand of Amedeo Modigliani. This painting will therefore not be included in the forthcoming catalogue raisonné of his works that I am preparing with the Wildenstein Institute. Could you please convey this information [to the audience] at the moment of the sale?"[58] Phillips therefore withdrew the painting from sale, though, in the Leicester Gallery in London, the Pierre Matisse Gallery in New York, and the Cincinnati Art Museum, it had reputable previous owners and was also featured in Ceroni's index of works. Shaltiel-Gracian brought a complaint against Wildenstein in a New York court, which, however, could determine only that it was not able to decide the authenticity of the painting. When the owner then brought a complaint before a Paris court, Wildenstein was quick to explain that Marc Restellini was a freelancer and was responsible for his own opinions.[59] Other prominent dealers, such as Ernst Beyeler in Basel and David Nahmad in London, were already involved in disputes with Restellini because he would not approve the authenticity of works in their possession. Meanwhile, the website modiglianiproject.org, started by the US art historian Kenneth Wayne, called its first meeting in the fall of 2019 and scheduled the first online publication of works for the fall of the following year.

NEW STRATEGIES FOR FORGERY

Christian Parisot says that he knows of at least 130 authentic Modigliani paintings that are not included in Ceroni's catalogue for various reasons,[60] and the total number of works must be estimated therefore to be about 460 pictures. Marc Restellini responds that Modigliani completed only five or six paintings a month and that he assumes that the number of extant paintings would be between 350 and 360. Restellini thinks that for every authentic painting there are three forgeries, and for every genuine drawing there are nine fakes.[61]

It is not merely a matter of fakes that have been in circulation for a long while. New Modigliani copies continue to be painted and offered for sale as originals. A particularly spectacular case came to light in the United States in 2004. The scheme was always the same, recalls the then federal prosecutor David N. Kelley. And it worked extraordinarily well. The New York art dealer Ely Sakhai paid cash for genuine works by real masters of classic modernism, buying preferably from Sotheby's or Christie's—for example, in 1990 he bought Marc Chagall's floral still life *La Nappe Mauve* for $112,000. Three years later at The Art Collection, his gallery on Lower Broadway, Sakhai sold a masterfully painted copy of the picture for $540,000 to a Japanese colleague from Tokyo. He sent the real painting to an auction at Christie's in London in 1998, where it brought in $340,000 more. Eight-year profit: $854,000. The trick of selling a copy and the original with a gap of a few years worked at least twelve times. But starting in spring 2000, Ely Sakhai was undone by mistakes that put the FBI on his trail.

The dealer had bought an early floral still life by Paul Gauguin at a Sotheby's auction in London in December 1985. He sold a copy of this *Vase with Lilacs* through a Tokyo gallerist to a Japanese private dealer. When, after a suitable lapse of time, in spring 2000, Sakhai wanted to cash in the original, it turned out that the Japanese collector was planning to sell his alleged Gauguin at the same time. That's how it came to be that the same alleged Gauguin painting appeared in a catalogue for a Christie's auction in New York on May 8 and popped up in a competing auction at Sotheby's three days later. After thorough investigation, Christie's discreetly withdrew its version from sale. It was not acknowledged that the work that had been offered was a forgery. Sakhai was arrested in New York. Judge Michael H. Dollinger read out the indictment against Sakhai, charging him with a dozen counts of fraud. The damages were calculated by the federal prosecutor to be "in excess of $20 million." After the arrest of its owner, the gallery's website continued to offer works by Monet, Renoir, and Modigliani that could not be found in the indexes of works for these painters.

Today every exhibition of Modigliani carries with it the risk of ennobling questionable works, since there is no reliable catalogue raisonné. The London art dealer James Rondell calls the situation a "nightmare." Roberta Cremoncini, the director of a private London museum, the Estorick Collection of Modern Italian Art, calls the Modigliani problem a "giant minefield." And Philip Hook, who for a long time had to decide at Sotheby's what Modigliani works would be offered to its clients, sees the decision as an ethical abyss.[62] Marc Blondeau confirmed that hardly anyone is comfortable giving an opinion on a Modigliani while there's still no definitive list of works that all participants in the art market recognize: "I remember getting one of his paintings from an excellent French collection for Sotheby's Paris, but worrying because the provenance went back to Zborowski. I accepted it for sale but maintained the right to later withdraw it. Then I asked three major dealers for their opinions. None of them would give me a decision. They all asked, 'What do the others think?' I pulled it out of the sale at the last minute."[63] Blondeau didn't fare as well with other works: when the scandal about the forger Wolfgang Beltracchi broke in 2010, it seemed that Blondeau, like some of his colleagues, had unknowingly sold several fakes of the German surrealist Max Ernst, sometimes for millions.

Hitler's telephone and Thorak's horse—the trade in genuine and counterfeit Nazi paraphernalia

Every few years a painter by the name of Hitler enjoys a surge in demand in the German art market. That's when auction houses, primarily in southern Germany, offer oil paintings, drawings, and watercolors, ostensibly originals by the dictator and overwhelmingly from the time that he made hand-painted postcards to try to keep his head above water: views of historical buildings in and around Vienna; plazas, churches, buildings, and landscapes. It's solid artistic handiwork that portrays its themes half naturalistically, with a true perspective and muted colors that wouldn't disturb the harmony of a bourgeois living

room. They are souvenir pictures, like the ones produced industrially on postcards today.

But there's a catch: almost everything on the market today bearing the signature of the greatest mass murderer of all time is presumably fake. That's why for years law enforcement agencies have systematically seized these supposed artworks in advance of the auctions. Not because of the alleged artist: Hitler's works may be freely sold in Germany as long as they don't contain symbols such as the swastika or the double-S Armanen runes of the Schutzstaffel, both of which violate the German constitution's prohibition of certain organizations. For the police, there's a different problem: the works of art usually carry a forged signature, even if they are accompanied by extremely impressive expert opinions, and thus constitute the criminal offenses of falsification of documents and fraud.

In Nuremberg—officially designated the "City of Nazi Party Rallies" in 1933—the Weidler auction house, which has offered works by Adolf Hitler several times in the past fifteen years, learned from experience. When an oil painting of a mountain in southern Bavaria that was ascribed to Hitler with the title *Der hohe Göll* was auctioned, the city administration tried to block the sale in court. Because the landscape did not contain any symbols forbidden by the constitution, the efforts failed. The Nuremberg city legal director, Hartmut Frommer, told press agencies at the time: "Basically we find it repugnant that Nuremberg should become known as a place where Hitler memorabilia are auctioned." The spokesperson for the Jewish community had a decidedly more relaxed response, commenting succinctly that the sale was not "an attack" and he didn't care "what they did with the junk." The pictures, like Hitler himself, belonged to the "garbage heap of history." There was hardly any reaction in September 2009 when the same place offered for sale four works on paper supposedly with Hitler's signature—among them a *Bullet-Riddled Mill* and a view of the *White Church in the Wachau Valley.*

That changed, however, in 2019 when Weidler announced a "Special Auction: Adolf Hitler," which included the sale of thirty-one works on paper from 1909 to 1936. Shortly before the strange event, the police seized these works along with others ascribed to Hitler. An expert had expressed doubt about their authenticity, suspecting fraud. Just three weeks earlier, the state criminal police in Berlin had confiscated four works on paper that Hitler allegedly created. A spokesperson for the auction house in Nuremburg, which cooperated with the authorities, was quoted in the German magazine *Der Spiegel* saying that she was not concerned that the auction would attract extreme white-nationalist buyers: "The interested parties are international art collectors without any evil background." It was pointed out that museums made money with Nazi art. In fact, the buyers of such memorabilia come principally from the Arab world, but also increasingly from China, South America—and time and again from Germany itself, where there is a very active scene among collectors of military and Hitler memorabilia. To obtain supposedly valuable pieces, they are sometimes not above resorting to illegal means.

The trade in Nazi relics—Hitler's alleged drawings and watercolors, the pompous statues that Nazis favored to decorate their public buildings—rarely takes place in the official art market, through registered auction houses, galleries, and retail establishments. With the promise of anonymity, an antiquities dealer in northern Germany said of his contacts with clients: "Most of it is sold on the telephone or through the internet. I know who's interested in what. And I know what's coming on the market. For most pieces the sale happens quickly. There's a big demand, and naturally the number of important pieces available for sale gets smaller and smaller." The market isn't limited to supposed works by Hitler but extends to all kinds of relics from the Nazi period. Much of it comes from estate sales: "They say, 'I found something that the children shouldn't see.' Many collectors fly under the radar

because no one is supposed to own this kind of thing now. They have a bad conscience if they say that they are interested in this stuff. People contaminated by ideology who aren't even really collectors—who are idiots, in fact—have brought a whole area of collecting into disrepute. They would just as soon paint a swastika on a German army steel helmet themselves."

"SCHOLARLY INTEREST"

The market for what is deceptively referred to as "militaria" or "military antiques" is enormous. That can be seen in the "collectors' exchanges" that take place regularly in Alsace, Belgium, the Netherlands, and the Czech Republic, as well as in Germany. At these events, dozens of dealers offer for sale medals, badges, books, knives, firearms, armament equipment, documents, photographs, uniforms, and other military surplus, especially from the so-called Third Reich. When you go to one of these events in Germany, you see vehicles from all over the country, but also from the Benelux countries and France. In one of the rooms inside, a thickset man shouts in Russian into a red telephone. At a booth downstairs, two men discuss the scriptures that they say drove the American "reeducation" campaign after 1945 in occupied Germany: "It's there right at the beginning: 'Our triumphal march began on Mount Sinai.'—Oh, that was a Jew who wrote that? They were smart people." Both laugh knowingly. An international book dealer offers titles such as *Airfields of the Luftwaffe 1934–1945*; monographs on German tanks, awardees of the knights' cross, and leaders of SS brigades; and *Gorgets and Breastplates in the Third Reich*. In a display case further in, there's a federal cross of service; in another display case, oval stickers with the letter *D* for Deutschland on a background of the Nazi colors red, black, and white are for sale.

These trade fairs are usually billed as events for experts that supposedly contribute to education and research. A scholarly purpose is difficult to discern, however; there are no lectures planned. It is still difficult to file complaints legally about these commercial events under

current law: the dealers use tape to cover up the symbols that are forbidden by the constitution because of their association with prohibited organizations.

RIDICULOUS FORGERIES

For the collectors of these questionable relics, there is obviously no price too high nor story too absurd that it couldn't serve as proof of the authenticity of the object offered for sale. The American auction house Alexander Historical Auctions in Chesapeake City, Maryland, auctioned a red telephone with an engraving of the imperial eagle, a swastika, and lettering that spelled **ADOLPH HITLER**. It was claimed that a Russian officer had given the device to Brigadier Sir Ralph Rayner in 1945 when he visited the so-called Führer Bunker in Berlin, and his son was now selling it at auction with an estimated price between $200,000 to $300,000. Indeed, the base of the telephone had been manufactured by the German firm Siemens & Halske. But the red handset was made in England. It is also highly improbable that Hitler would have had a badly lacquered black telephone instead of one made of red synthetic material. "That's obviously fake," opined Frank Gnegel, director of the collection at the Museum of Communication in Frankfurt. Nonetheless, an unidentified buyer paid $243,000 for it.[64] Then there are the triangular lapel pins with SS runes and the word "Lebensborn" in the Fraktur typeface favored by the Nazis. With a price of $1,295, they were advertised as "very rare" on the website of the US firm Ruptured Duck, which specializes in Nazi memorabilia. An expert in Switzerland who has publicized fake military memorabilia and works under the pseudonym "Jo Rivett" points out that a secretive SS club would not have distributed membership badges to be worn in public.[65] He has since published a book on the forgery of Nazi Party badges.

A German antiques dealer, who hardly deals in militaria anymore, claims that the forgery of such military insignia began immediately after the war. "Good copies came from Israel and nowadays they also come from Poland—where they are sold to tourists who visit Hitler's

'Führerhauptquartier Wolfsschanze' in East Prussia—and from Idar-Oberstein." Moreover, he said that the firms that actually supplied the Nazi regime with medals and badges continued to manufacture them after the war: "Many wanted to buy back what the Allies had taken from them or what they had themselves been careful to destroy or throw away. A lot of them were swindled with fakes."

This theory was confirmed in 2017 with the announcement of the discovery of eighty supposedly important Nazi relics. The German tabloid *Bild* immediately trumpeted the discovery of "Hitler's Silver Treasures." A raid on an antiques dealer not far from Buenos Aires turned up a Nazi dagger with a swastika, metal busts of Hitler, imperial eagles, and a device for measuring skulls and magnifying glasses that Hitler himself is supposed to have used. Various theories circulated about their provenance: Nazis fleeing to South America were supposed to have transported these pieces, among the most absurd of which was a piggybank in the shape of a cat with a swastika on a ribbon around its neck. The concentration camp doctor Josef Mengele or the Holocaust organizer Adolf Eichmann could have played a role, it was said. The Argentine minister of security and the chief of the federal police announced that the pieces would be transferred to the state Holocaust Museum. The director of that institution proclaimed at the press conference that a selection of the objects would be displayed there.

But even Argentine's Holocaust Museum had been deceived, blinded by the name Hitler. In the spring of 2018, a group of experts that included employees of the Bundeskriminalamt and the Central Institute for Art History in Munich (Zentralinstitut für Kunstgeschichte, or ZI) had determined in a visit to Buenos Aires that the knickknacks were not authentic. Sometimes the swastika was added later on; sometimes historical events were invented—for example, references to an agricultural fair in Berlin in 1937 that seems not to have taken place. There had been no 1942 "Erster Prize," with its confused mingling of German and English, as claimed on a small statuette. The little box with

the magnifying glasses that allegedly belonged to Hitler, according to
Stephan Klingen of ZI, has the wrong imperial eagle on the top: "Our
expert opinion was unambiguous."

The matter was seen quite differently in Argentina. There, the
authorities and the Holocaust Museum continued to claim that the
trove of Nazi treasures was authentic—and, to the consternation of the
German experts, expressly referred to the expert opinions of the BKA
and ZI. Headlines with the word "Nazi" in them practically guarantee
a huge visitor turnout.

A NAZI MUSEUM UNDER THE BALTIC SEA

Although the extent of the trade in Nazi memorabilia, much of it
forged, has long been known, investigators from the art division of the
Berlin state criminal office were still shocked when in May 2015 they
stumbled upon a gigantic private museum of Nazi relics in the very
northernmost part of Germany. "Behind the inconspicuous and some-
what conventional-looking facade of his property, Klaus-Dieter F.[66]
had, over the course of many years, put together an impressive collec-
tion of curiosities from the Nazi period," as the detective superinten-
dent René Allonge summarized the investigation in the professional
magazine *Der Kriminalist*.[67] "The house harbored not only one-of-a-
kind items from the possessions of the former commander-in-chief
of the German air force, Hermann Göring, but also unique pieces
from the estate of Fleet Admiral Karl Dönitz. The secrets of the home
revealed themselves to the task force in the cellar of the house in the
form of numerous passageways that stretched across several floors and
were barred in part by massive, floodgate-style doors weighing tons.
Hundreds of mannequins dressed in uniforms from the Nazi period
breathed life into the labyrinth. To the shocked onlookers, it was as if
time had stood still around 1940. Over the course of years, undetected
by the outside world, F. had constructed exact copies of interiors in
the Nazi style with astonishing precision and an exacting eye for
detail, inspired by historical building plans and hewing as close to the

original as possible."[68] This private Nazi museum stretched for hundreds of square meters, allegedly even partly underneath the waters of the Baltic Sea. The property could be reached only by a one-way, dead-end street. On a wall there hung an enamel sign with the imperial eagle and the colonial designation "German Territory." More imperial eagles and enormous swastika flags adorned the walls of the cellar; in vitrines lay collector's pieces, such as medals and decorations, letters and correspondence, artworks, part of the estate of Admiral Wilhelm Canaris, a baptismal cup that had belonged to Göring and had been auctioned by the state of Bavaria in 1966, furniture, entire antique cars and boats. A piano, which had belonged to one of the architects of the Holocaust, Reinhard Heydrich, and had supposedly been smuggled out of Prague, stood in one room; in the garden stood Arno Breker's monumental sculpture *Swordsman (The Army)* from 1939.

It took their breath away when in one of the enormous underground rooms the investigators found, in addition to several torpedoes and parts of the legendary V-1 rocket, a complete army Panzer tank and an eighty-eight-millimeter air defense cannon. Of course, the owner reassured them that they had been "demilitarized" (i.e., rendered unusable). The police did not want to rely on that representation and suspected a violation of the law regarding the possession of military weapons. When, two months later, the forty-five-ton tank was hauled out of its underground housing and into daylight with the help of a special battalion from the German army in Husum in a nine-hour operation, the neighbors could not understand the reason. They told the many journalists present that it was well known that F. had owned the Panzer: years earlier he had used it to clear snow from the streets in wintertime.

The investigators didn't find what they were actually looking for in the far-flung cabinet of curiosities. To be sure, the basement in Kiel housed a replica of the German chancellery in Berlin, but the police had been hoping to locate, among other things, two original bronze horses weighing tons that had stood in the garden of Hitler's government

headquarters. Even before the Wall fell, it was known that these monstrous, exaggerated sculptures by Hitler's favorite sculptor, Josef Thorak, and four other sculptures by Arno Breker and Fritz Klimsch still existed, at least until 1989. The art historian Magdalena Bushart had written about it in spring 1989—just before the beginning of the end of the German Democratic Republic, or DDR—in the German newspaper *Frankfurter Allgemeine Zeitung* and reconstructed the path these gigantic stallions had taken since end of the war.

For fear that they would be damaged, the government had warehoused them in Wriezen in Brandenburg. There, Hitler had given his second-favorite sculptor, Arno Breker, the manor house and Junker's estate "Jäckelsbruch" and expanded it in 1940 with a railroad connection and canal port for the grand new studio for the Workshop of Stone Sculptor Arno Breker LLC, as part of Albert Speer's architectural plans for expression of Nazism. In 1944, Thorak's horses found a new barn here. After the end of the war, the Red Army transferred the horses, along with the sculptures by Breker and Klimsch, to the sports field for one of their barracks in Eberswalde, twenty kilometers away.

A group of criminals in East and West Germany knew what collectors in the West were willing to pay for Nazi relics like the Thorak horses. They understood the subtext of Bushart's reporting to be a hint that they had to act fast if they wanted to cash in on the Nazi sculptures. When an informant told the Berlin criminal police in the fall 2013 that someone had offered to sell her the sculptures, the investigation began. Ownership rights to the artworks, property of the former German Democratic Republic, had been transferred to the Federal Republic of Germany under the unification treaty. Whoever dealt with them, acquired them, or hid them could be prosecuted for theft or receiving stolen goods.

At the end of the investigations, there were not only raids in several places in Germany—among them, Heikendorf, near Kiel—and criminal

penalties, but also the story of an ingenious art-smuggling scheme between the two Germanys just before the Wall fell.

EBERSWALDE—WILMERSDORF—BAD DÜRKHEIM

Curious visitors to the barracks in Eberswalde (about fifty kilometers northeast of Berlin), who had gotten wind of Thorak's horses from the news article in the *Frankfurter Allgemeine Zeitung*, were told before the German Democratic Republic ended that the sculptures were turned into scrap metal in order to help the victims of earthquakes in Armenia. In fact, as the police reconstructed it twenty-five years later, the article in the *Frankfurter Allgemeine Zeitung* brought the horses in the Eberswalde barracks to the attention of the businessman Rainer W. in Bad Dürkheim, who ran a business that specialized in engine technology and was one of the largest employers in the Palatinate region of southwest Germany. He turned to Helmut Sch., a businessman in Aachen, who officially exported and imported vintage cars, but in fact also regularly found collector's pieces from the Nazi period and military vehicles. One of his best customers was Rainer W., born 1941, who collected relics from that period with similar enthusiasm and similar financial investment to that of Klaus-Dieter F. René Allonge and his coworkers reconstructed the sequence as follows: "Sch. took advantage of his contacts to the East Berlin firm 'Interport,' a team of specialists led by the Stasi [state security] chief Helmut Gietel, to smuggle goods from the West that were under embargo by the German Democratic Republic, disguised as the trade in vintage cars."[69] With the help of middlemen, especially Peter Sch., a vintage car dealer living in Belgium, and six-figure payoffs, they were able to bribe the responsible Russian officers and allegedly also a general major in the national defense council of the German Democratic Republic who had the best contacts with the Russians. And they agreed on the cover story of aid to the Armenian earthquake victims. One of the Russian generals involved lives today in Belarus. Two brothers in the junk business picked up the sculptures by Thorak, Breker, and Klimsch in

1989 in Eberswalde—the Russians lent a crane to help with loading them up—and transported the artworks on two trucks, first to a barn in Vehlefanz, north of Berlin.

Because the bronzes, weighing tons, couldn't be transported to the West as complete objects, W. and Sch. decided to cut them up into pieces. They were declared as nonferrous metal scrap and loaded onto trucks along with other junk, without looking suspicious. The important parts, like the heads, hooves, hands, and feet, were first kept by a lover of Helmut Sch. under wool blankets in her bedroom in a nondescript apartment building in East Berlin. The pieces were brought to the West by drivers of the state Interhotel Group who regularly picked up guests at Tegel Airport in the West and, in exchange for a bribe of DM 1,000, would transport the pieces to the West in the trunks of their cars. After being stored at a dealership for camper trailers in Wilmersdorf in West Berlin, an attorney friend of Helmut Sch. smuggled them into West Germany proper in a camper trailer over the special highway corridor across East Germany that linked West Berlin to West Germany. The individual pieces were brought together in a shed near Mainz that belonged to Rainer W., welded back together, and coated with a new patina. Helmut Sch. estimated to the German magazine *Der Spiegel* that the smuggling operation and the restoration of the six sculptures had cost W. between DM 500,000 and DM 700,000.

At some point, their new owner wanted to unload the horses. He offered to sell them more or less discreetly in collectors' circles with photographs and documentation. That is how an informant of the Berlin state criminal police and the private Dutch art hunter Arthur Brand both learned that the Thorak bronzes were apparently still in West Germany. Meanwhile, Brand had also been offered works by Arno Breker that similarly had once been located in Eberswalde. Appointments to see the works—in southern Germany and near Frankfurt—didn't materialize. The search grew difficult as sketchy middlemen intervened in order to take a cut of the profits, although they themselves obviously didn't know where the horses were to be found. Then it became known that since

the 1990s two of the Breker bronzes (*The Prophet* and *The Vocation*) had stood in the garden of the private Breker museum belonging to the publisher Joe F. Bodenstein in Nörvenich, in the west-central German area known as the Nordeifel. Moreover, Bodenstein was involved in a lawsuit with Rainer W. It could be gleaned from court documents in that proceeding that W. had loaned the colossal Breker sculptures to Bodenstein in 1993. That was the first time that the businessman's name had turned up in connection with the sculptures from Eberswalde. And what was more: Bodenstein argued in his court pleadings that his opponent could not demand the return of the works and could maintain no title in them because he had illegally transported the bronzes out of the then German Democratic Republic at the time of the reunification of the two Germanys. The two sculptures were first returned to W. in 2012 in the context of a legal settlement.

At the same time, the investigators kept hearing the name of Klaus-Dieter F. Aerial photography revealed large sculptures in the garden of his estate in Heikendorf. Besides, as the investigator René Allonge said, "The businessman was known in the scene to be a collector of Nazi relics and a discreet subscriber to neo-Nazi publications."

Indeed, W. had given F. the Thorak horses in 1996 as security for a loan in the amount of DM 300,000. F. kept them hidden from prying eyes in his well-guarded garden. When the loan was repaid, the sculptures, which weighed tons, were picked up by a trucking service—at night, so no one could see anything.

"LEGALLY ACQUIRED"

The Berlin art investigators finally found the Thorak horses in May 2015 in a shed in Bad Dürkheim—only after they had explained the possible consequences of his actions to an initially uncooperative Rainer W. Hidden under tarpaulins, they also found both missing bronze sculptures by Arno Breker, as well as some stone reliefs that the sculptor had begun as part of the transformation of Berlin into "Germania." The two

Klimsch sculptures (*Galathea* and *Olympia*), which also came from Eberswalde, stood in the garden of W.'s spacious estate.

W.'s lawyer responded to questions regarding his client's supposedly driving the Panzer around town and possible political inclinations by issuing a general press release: his client had legally acquired the sculptures twenty-five years ago from the Russian army and the "earlier fabricators." Furthermore, artworks that he owned had been exhibited in Nörvenich for twenty years. The museum, however, made clear that at the request of the artist's widow, Charlotte Breker, only the two bronzes (*The Prophet* and *The Calling*) were to be placed there: "Mr. W. withdrew the loan in the end, according to hearsay, to pursue commercial interests." In fact, despite his entanglement in the tyrannical Nazi regime, Breker's works have a high market value. A few years ago, the bronze cast of a decathlete from a mold made in 1935–36 for the Olympic Games was sold at the auction house Schloss Ahlden for €125,000; this casting had been acquired by a private collector directly from the artist in 1989.

Meanwhile, the statute of limitations on crimes in connection with the Nazi sculptures from Eberswalde has run out. Ownership is still being worked out. "Surprisingly and contrary to what was assumed at first, Schalck-Golodkowski's state institution to accumulate hard currency was not involved in this case," as the detective chief superintendent René Allonge summarized his findings in the matter. "In the end, it was employees of the consortium he ran, the East German authorities, and corrupt Russian officers who were lining their own pockets and enabled the smuggling of the Eberswalde sculptures from East to West in the first place. For the Berlin investigators, it gave them insights into a nasty subculture in which extremist sentiments and passionate collecting go together." Allegedly the so-called Flag of Blood of the Nazi Party—the flag with a swastika that the National Socialists carried with them at the attempted "Hitler coup" against the democratic German federal government in November 1923, which was used to "consecrate" all Nazi Party flags and standards of the SA and SS units from 1926 on—may be found today in the possession of a collector in northern Germany.

If one examines the databanks to see, for example, where Nazi art by Thorak is auctioned today, the name of a certain auction house pops up again and again, a house that once was highly respected, which used to be located in Munich and today is found in Grasbrunn, dealing in so-called militaria and knight's armor, swords, arts and crafts, and antiques: the house of Hermann Historica. A bust of Rudolf Hess was sold there in May 2012 for €7,500; two years earlier, the house sold a monumental, carved marble head of Fritz Todt, the builder of Germany's interstate system under the Nazis and imperial minister for armament and munitions, for €6,300.

Along with the "Berlin Auction House for History" and "Military Antiques Limited Partnership Helmut Weitze" in Hamburg, Hermann Historica is one of the most important auction houses in Germany for the trade in Nazi relics, according to research by the Dutch journalist Bart FM Droog. The house has an interesting history. It was founded by a safecracker who had been adopted by a titled aristocrat. The aristocrat's wife and son carried on the business, and in the 1960s the "Count Klenau General Partnership" seems to have begun Nazi auctions. In 1978, the weekly newspaper *Die Zeit* called the business the "best-known wholesale market in Nazi souvenirs in West Germany."[70] Even then, all that glittered wasn't authentic Nazi-brown. The run in Nazi relics, which caused a doubling of transactions,[71] also caused an increase in the number of forgeries. For example, in April 1971, Count Klenau offered fifty-six pieces allegedly from Hitler's Munich housekeeper Anni Winter for sale in a high-visibility special auction. The catalogue featured, among other things, a Christmas card and a draft of a speech by Hitler, his German Automobile Club membership card, his briefcase, and his collar buttons. Bart FM Droog discovered that the apparently thievish housekeeper, who had fled from the approaching American military with two big suitcases in April 1945, had been arrested and permitted to keep only ten items. Where the remaining forty-six pieces

of memorabilia on sale might have come from is just as questionable as their certificates of authenticity. In 1982, Wolfgang Hermann and Ernst-Ludwig Wagner took over what had been renamed "Count Klenau & Son General Partnership" and rechristened it "Hermann Historica." Today, if one visits the firm's website to view the items on offer, one has to first enter a password. Hermann Historica claims to deal in historical objects "only under the strictest standards" with museums, archives, and "serious collectors." It asserts that providing museums and collections the opportunity to acquire historical documentation is "indispensable and important work" that offers a "better understanding of history" and thereby helps assure "that something similar cannot happen again." Supposedly, a "taboo" on this area would "only lead to an opaque market." The offerings include medieval helmets and swords, Japanese samurai armor, and assorted arts and crafts.

Similar arguments are put forward by other auction houses that enjoy a profitable business in Nazism. For example, the Landshut Armory, in its catalogue *Antique Weapons and Armor, Military Memorabilia and Medals*, offers as "historical objects 1933–45" such items as signed photographs of Hitler, National Socialist Democrat Workers' Party of Germany (NSDAP, or Nazi) badges, release papers from the Sachsenburg concentration camp, and a "desk-size bust" of "Imperial Chancellor Adolf Hitler" on a marble base. Approximately half of the 117 lots offered in September 2019 were alleged to come from the Nazi period. The firm defended its offering in the text of the catalogue: "As long as those in possession of the catalogue and sellers and participants in the auction do not indicate otherwise, they affirm that the catalogue and the objects from the period 1933–45 that are included and pictured in it are acquired only for purposes of civic enlightenment, the defense against efforts contrary to the constitution, for academic study or reporting on contemporary events" (Penal Code, paras. 86, 86a).

Similar terms are found in the rules of most of the relevant dealers and auction houses. Whether anybody in his free time "reports"

on happenings in current events or "conducts military or historical research" cannot be seriously investigated. Everything seems to pass muster with the responsible government agencies as long as the swastika is taped over before the sale. Nobody knows what happens afterwards with the object. Nor can anyone explain what historical understanding is facilitated by Hitler's brown shirt and his cap "with a pronounced forward visor for protection from bright lights," which the auction house Thies in Nürtingen, Germany, offered for sale in 2019—the shirt for €600,000, and the cap, whose whereabouts, like those of the shirt, had been traced continuously back to 1945, for €400,000. Both objects were supposed to have belonged to the extensive collection of First Lieutenant Philip Ben Lieber, a Jewish US officer from Louisiana, who, together with two other soldiers, was said to be the first to enter Hitler's home in Munich at Prinzregentenplatz 16. One of the objects allegedly taken then was a porcelain shaving cup with gold feet and a portrait of Hitler on the front.

COUNTERFEITED COUNTERFEITS

In Nuremberg, Germany, where supposed Hitler works are regularly offered for sale, and where such items were seized in 2019, the connoisseur of Nazi relics isn't made to do without. A tablecloth that had not been seized and that allegedly came from a guest house at Hitler's Bavarian mountain retreat, the Gästehaus Platterhof in Obersalzberg, went for €630 at the auction table. A resplendent Meissen vase with a depiction of a swastika flag and a Nazi-era ship, the *Gorch Fock* (named after an author favored by the Nazis), which was supposedly seized by Russian soldiers from Hitler's private rooms in the Berlin imperial chancellery, took in €5,500. A wicker chair—from the country house Wachenfeld, which was converted into the Berghof in the "Führer Restricted Zone" above Berchtesgaden, Hitler's second seat of government—which the dictator is supposed to have given to his veterinarian Karl Reismann for his many years of service, was withdrawn from auction out of caution, with respect to the relevant guidelines.

The swastikas on the armrests could be considered part of historical documentation only with extreme difficulty. The pieces offered for sale in Nuremberg may be used only "for purposes of civic enlightenment, the defense against efforts contrary to the constitution, for academic study or reporting on contemporary events" (Penal Code, paras. 86, 86a), as the auction house explained in the catalogue pursuant to the code. That should also apply to a supposed 1929 watercolor nude, signed "A. Hitler," of his niece and alleged lover, Geli Raubal, which carried a price estimate of €3,500.

Some things suggest that Konrad Kujau, the legendary forger who sold the phony "Hitler Diaries" to the German magazine *Der Stern*, is responsible for this last item. He owns a variation of it himself, confirmed Marc-Oliver Boger, who founded the "Kujau Kabinett" in Bietigheim-Bissingen and has documented the work of this forger. Kujau started in the 1960s, painting battle scenes for "old comrades." As his customers kept asking him for "things from Hitler," Kujau finally altered his handwriting to resemble Hitler's at the appropriate age and manufactured the desired items. Already back then, he was getting DM 2,500 for a quickly penned letter. The respected historian Eberhard Jäckel was even taken in by some of the forgeries.

In the 1970s, Kujau created his first Hitler drawings and watercolors. "In those years, he was the man who could get anything," Boger recalled. "And he had originals too. When the demand exceeded the supply, he produced what was needed to make up the difference." Not only from the Nazi period. To sell a snuffbox he claimed had been owned by Friedrich the Great of Germany, he forged the king's signature. Boger says that he knows that the publisher of *Der Stern*, Gruner + Jahr, acquired not only the forged diaries but also assorted autographs, an alleged first draft of the constitution of the Russian government, and a copy of the founding document of the Socialist Unity Party of Germany, which governed East Germany. His brother was allegedly a general in East Germany and had collected the documents, Kujau told buyers in Hamburg.

On the back of the variant picture of Geli Raubal, Kujau wrote in his Hitler handwriting, "Geli sat for me as a model for 20 hours. Picture remains in my Munich home," said Marc-Oliver Boger. "That was typical for Kujau." He often made mistakes, like using an inconsistent variant of the letter s in a supposed Hitler letter. In fact, on a Hitler diary that he had forged, he attached the letters FH instead of AH. Even today Kujau's works present problems, said Boger: "Meanwhile, he's being forged himself. In the exhibition, we have a whole display case full of it." A man who lives on Lake Constance regularly offers fake Kujaus on eBay. Other forgers have sought out old people who can still command the Sütterlin handwriting style. For a small fee, they fill out blank identity cards with the information of prominent Nazis. With the aid of these documents, great quantities of uniform fragments, knives, medals, and other pieces may be sold with the story that they came from this owner. "They are then brought to the appropriate auctions," said Boger, "and need not be sold there necessarily. It suffices if they are pictured in the catalogue with the false history. That way they are sanitized for the collectors' market and can then be sold afterwards, oftentimes at still higher prices."

HITLER AND SNOW WHITE

The cult around Hitler as a putative artist has meanwhile produced some strange fruits. In 2008, for example, when the Norwegian museum director William Hakvaag claimed to have discovered in the Lofoten Islands of southwest Norway a packet of four cartoon drawings inside the frame on the back side of a Hitler painting. Because the Führer was quite fond of Disney cartoons, according to the story of their discovery, he drew Pinocchio and three of the seven dwarves, painting them with watercolor. Of course, three of the four pages bear his initials. He was absolutely sure that the works came from Hitler, Hakvaag assured the news agency Reuters: "No one would put forgeries on the back of a picture where they might never be discovered." The museum director bought the picture at auction in Germany for the equivalent of $300. He claimed that the signature matched the handwriting of the initials on

the drawings: "Hitler owned a copy of *Snow White*. He thought it was one of the best films ever made." And, finally, it was an adaptation of a fairy tale that's about as German as can be.

In fact, Hitler had a strong affinity for Disney cartoons. His biographer Ian Kershaw recalled that propaganda minister Joseph Goebbels gave Hitler thirty US movies as a Christmas present in 1937, among them eighteen Mickey Mouse films. They could not be shown in Germany at the time. One year later, Walt Disney's brother Roy presented a copy of *Snow White* personally to the propaganda ministry.[72] The cartoon film *Pinocchio* premiered, however, on February 7, 1940. So, a year and a half before that, as he masterminded the world war, Hitler was supposed to have been entertaining himself by drawing the figures of Pinocchio and Doc, Sleepy, and Dopey. That's not very likely. In Belgium in the 1980s, twenty-one drawings surfaced, which supposedly a newly released Adolph Hitler, who had been stationed in Flanders during the First World War, had forgotten and left behind in the attic loft of a farm. The drawings were sold for £115, or about €170, at auction in September 2006 by the modest auction house Jefferys in the provincial city of Lostwithiel in Cornwall. Collectors from Great Britain, Germany, Japan, Russia, New Zealand, South Africa, and Eastern Europe expressed an interest.

Two years later, the British artists and brother duo Jake and Dinos Chapman claimed to have acquired Hitler works on various occasions and to have painted over them with stars, rainbows, and hearts. The grouping was presented as their own work in the exhibition *If Hitler Had Been a Hippy, How Happy Would We Be*—price: €872,000. Allegedly, their gallerist made sure that no Nazi sympathizers would buy the reworked Hitler pieces. Having asked the artists in vain for documentation of the origin of the purported works by Hitler, Bart FM Droog doesn't believe their story: "The Chapman Hitlers came from the controversial American militaria dealer Charles E. Snyder, who has a reputation for selling fakes. The refusal to answer causes us to have some misgivings about the 'Hitlers' that the Chapman brothers are said to have used."[73]

Great Britain, where TV comedies featuring caricatures of simpleton Nazi soldiers still draw big audiences, is a center for the trade in purported Hitler relics. In May 1960, the revered auction house Sotheby's included two watercolors by Hitler in an auction called *Important Impressionist and Modern Drawings, Paintings, and Sculptures*. In the catalogue, Hitler's pictures of the parliament and the St. Charles Church in Vienna were reproduced and presented in the same way as works by Picasso, Renoir, and Toulouse-Lautrec. The seller was a Viennese industrialist by the name of Monica Fischer, who could even prove the authenticity of the works on paper. Correspondence demonstrating that a Hungarian furniture manufacturer had acquired them in 1912 was sold with the watercolors. Walter Lohmann, the Vienna correspondent for the *Völkischer Beobachter*, the Nazi newspaper, who was tasked by the Nazi Party with buying for its archives all the Hitler drawings that were still in private ownership, identified both drawings as "early Hitlers." His attempt to purchase them was unsuccessful for reasons that are unknown. Hitler's photographer, Heinrich Hoffmann, confirmed their authenticity as well. Among others, the London gallerist Jacques O'Hana protested against the sale: "Hitler was an artist only of mass murder. A company that takes in a million pounds in profit every year doesn't need this kind of publicity."[74] His objection fell on deaf ears. A London antiques dealer bought the two pictures for a total of £600, DM 7,100 at the time. He was working as a proxy for Sir Henry Frederick Thynne, the Sixth Marquess of Bath, who commented later: "I bought the pictures because Hitler painted them. I know that they have practically no value. But then why do people buy pictures by Churchill?"[75] The profits from the sale, as indicated by the auctioneer Peter Wilson at the start of the bidding, would go to the British fund to aid global refugees. Surprisingly, since that auction by the eminent Sotheby's, the supply of such items in the UK has hardly dried up. The business has meanwhile relocated from the capital city to the provinces—for

example, to Wall-under-Heywood in 2010. The mother of the artist in graphite: £6,000. A red chalk drawing of the muscular back of a young man: also £6,000. A watercolor showing two laborers in a smithy cost, however, twice as much. A swastika rises in the background from the fireplace of the smithy, and one of the men has a small moustache on his upper lip. The paper is signed at the bottom left: "Adolf Hitler 1929."

These works on paper, offered for sale by the British auction house Mullock's, were, of course, also supposed Adolf Hitler originals. Alone in this single auction in the English Midlands, a total of twenty-one such works on paper were gaveled off. Total estimated price: £165,000. Most of them were supposed to have come from Hitler's early years in Vienna—his last, failed attempt to get into the academy of art there. Once again there was a catalogue, and once more the absurdity of the souvenirs cannot be exaggerated. Under number 382 for £40,000, an engraving by the Jewish painter Emma Löwenstamm was sold that showed Hitler—supposedly with Lenin, who still sported a full head of hair—playing chess in Vienna in 1909. One lot later there followed the wooden chess set itself that they supposedly used—naturally, the original, with all the pieces intact—ennobled, like the engraving, with an estimated sales price of £40,000: after all, that which is expensive must be genuine. By contrast, a red marbled tile from the floor of Hitler's workroom in the imperial chancellery, which a Russian soldier is said to have picked up during the storming of Berlin and carried home in his hand luggage, could be had for a more modest £10,000. Naturally, a certificate of authenticity would be included.

In total, Mullock's has sold—according to research by the Dutchmen Jaap van den Born and Bart FM Droog, who have time and again uncovered fake works—eighty-four alleged watercolors, oil paintings, pastels, and sketches by the dictator in thirteen auctions between 2009 and 2019 alone. According to their research, the works sold are all fake, without exception. And both of them cite dubious experts such as Peter Jahn and the furniture restorer Hans O. A. Horváth, who repeatedly provide expert opinions verifying the authenticity of these purported

originals. Expert opinions by Horváth, who once tried to have Hitler's niece Geli Raubal exhumed to prove a murder theory, are also cited by the Nuremberg auction house Weidler.

STATE-ORDERED SCARCITY

The center of the trade in Nazi relics, apart from Great Britain and the US, is still Germany. The dead dictator makes money flow in the German art market even today. Hitler had tried to prevent precisely this during his lifetime. At some point or other, the "greatest general of all time" recognized that he wasn't a notable genius as a young artist. As his political significance expanded, he ordered his staff to confiscate all available drawings.

On the one hand, he wanted to prevent his pictures from becoming objects for financial speculation in light of what was already an expanding cult of fanaticism. On the other hand, as he styled himself a serious art collector, he was afraid of the derision of art experts to whom the very modest merits of his works would be obvious. The principal Nazi archive acquired around fifty paintings and drawings in the years before 1940—for about RM 2,000 per work, according to the historian and journalist Sven Felix Kellerhoff: "That was more than the average annual income in the Third Reich, the equivalent today of about €40,000."[76] Nonetheless, some owners refused—because they insanely inflated the value of the work, as shown in this letter from a Therese Resl from Vienna, dated July 1938: "I beseech you for information regarding the whereabouts of both drawings, and would like to add that I am not willing to give the pictures to the buyers for the sum of RM 4,000. The Führer is worshipped by a people, 75,000,000 humans. His very own drawings deserve, one would think, a corresponding price. Instead of money in exchange, I would rather have a single-family house and a suitable piece of land near Vienna."[77] After appropriate pressure from the authorities, the woman, in the end, decided to sell. Only about three dozen of the works "secured" in this way survived the Second World War. Reinhold Hanisch, Hitler's former friend and one of the most

prolific forgers of Hitler relics, hoped to profit from this state-ordered shortage. The two had come to know each other in 1910 in a men's lodging house in Vienna, where Hanisch took over the marketing of Hitler's postcards. He knew Hitler's themes and style well. Born in Bohemia, Hanisch started trading in Hitler drawings, which he presumably had forged himself, in the 1930s and was eventually jailed several times. The supposed authenticity of the Hitler pictures had been confirmed by, among others, the painter Karl Leidenroth, who had also met him at the men's home. Hanisch, whose published memoirs are untrustworthy at various points, died in jail in 1937 under circumstances that are unclear.

Despite Hitler's order to recall his own works, just in the last ten years drawings and watercolors that are supposedly Hitler originals have surfaced time and again, leading Sven Felix Kellerhoff to state that 98 percent of the works offered are fakes, often quite dilettantish efforts.[78] The expert opinions for the alleged Hitler works have come for decades mostly from the same experts who always refer to the same literature. For example, the 1984 list of works published by the American multimillionaire and Hitler collector Billy F. Price, which no one takes seriously. Price himself had begun early on to collect supposed works by Hitler and had paid several experts to participate in the publication in order to increase the value of his own inventory. He and his two coauthors Peter Jahn and August Priesack falsely authenticate fakes by the Hitler forger Konrad Kujau as well as by Hitler's contemporary Reinhold Hanisch. They exaggerate enormously the number of supposed works without any proof. And, in turn, they rely upon other dubious sources. Only a dozen of the 725 works ascribed to Hitler in the book are taken to be authentic by respectable experts today. The former Nazi archive staff member, Priesack, who privately wrote hundreds of expert opinions after the war for supposed works by Hitler, is also known to have been deceived dozens of times by Konrad Kujau, the forger of the so-called Hitler Diaries.

The Dutch author Jaap van den Born trapped one of the many other Hitler experts a few years ago by printing a so-so view of Vienna off

the internet. He signed it himself with a felt-tipped pen "A. Hitler" and mailed a scan of it to the US. For forty dollars, he received soon there-after an affirmation by the "forensic handwriting expert" Frank P. Garo: the work had been "carefully examined and compared with known authentic specimens. Conclusion: The signature was made by the hand of the German dictator, in his opinion." In 2019, the auction house in Nuremberg also cited Garo for a series of works whose images were featured in the catalogue for the planned auction, with price estimates between €130 and €45,000.

A QUESTION OF BELIEF

In the text for the Nuremberg catalogue, it is stated that pictures are being offered with the monogram "A. H." or the signature "A. Hitler (probably Adolf Hitler 1889–1945), painter and soldier." Regarding the questionable reputation of the experts put forward, the auction house did not respond to inquiries.

"Some of the works on paper have certificates of authenticity. The studies are sketched on paper with watermarks, and some of them have Hitler's address in his handwriting," asserted Mullock's spokesperson, Richard Westwood-Brookes. And he answered the question about where the works that his firm has offered for sale come from. The draw-ings come from various sources: "We could have opinions from all the leading experts in the world. At the end of the day, the question will always be, whether one believes it or not. We can only put these things before the public to be examined and provide as much information as possible." One decisive detail, however, was not shared by the firm with the customers. All the authenticated works of the future dictator are signed only with "A. Hitler." The unskilled academic studies offered by Mullock's all bore—in a variety of handwriting styles—both the given name and the surname of the alleged artist.

In part, the falsified works of this mass murderer, from which a lot of money is made even today in the art market, are actually by con-temporaries of Hitler who signed his name to their own work after his

political ascendance. And to some extent, the works for sale now were systematically forged after the war and furnished with expert opinions in order to sell them through a careless auction house or on the gray market. Anybody who buys such a painting, watercolor, or drawing— some sold at quite high prices—can find out with a little research that it's counterfeit: because real Hitler originals are not artworks at all but more or less dilettantish decorative handicraft. The money paid has been wasted, no doubt. They can at least comfort themselves with the thought that they are carrying on a tradition: even the central Nazi Party archive, which had been tasked by Hitler to collect his works, fell for forgeries and paid a lot of real money for them.

Mornings Picasso, afternoons Dalí— mass deception with copied graphic reproduction

It is sometimes forgotten that the art market is not limited to the auction houses in London and New York, where millions of dollars, and sometimes even a billion dollars, change hands in only a week. Most of the market in fact consists of places where paintings, drawings, and photographs worth a few thousand or ten thousand dollars are sold. And then there are places like the auction house near the outdoor market in Munich, where for decades, right across from the fruit stands and the cheese counters, more or less antique goods have been auctioned off at affordable prices, sometimes less than one hundred euros. Among those items, however, were pictures that turned into a disaster for the owners of the firm. In summer 2019, the three businessmen sat at the criminal defense table in the Munich state court. There were more than a hundred victims. And there was an indirect connection to a man from the North Rhine-Westphalia region who was alleged to have reproduced in his basement, in massive quantities, various works by famous artists: most of all, Pablo Picasso, but also Egon Schiele, Gustav Klimt, Henri Matisse, Marc Chagall, and Salvador Dalí.

Here, at this auction house, sales weren't held on just a few days of the year, as in the traditional Munich houses, such as Neumeister,

Ketterer, or Karl & Faber. Rather, sales were held each day of the work-week and several times a day: morning, midday, and afternoon. In front of the entrance to the large store, an entire zoo of bronze animals awaited the customers. Two large lions stood watch at the door while an elephant raised his trunk in greeting. They were kept company by a horse, a bull, a crane; and in the window, life-size pigs cavorted—a domesticated pig, a wild boar, and a newborn suckling. Loudspeakers on the street carried the sound of the goings-on in the auction room outside to seduce visitors into coming in: "That's an unbelievable price for a Persian rug. €1,500! Who's offering more? No one? And for €1,000? Really, this price is insane. €900? No one? The rug will be withheld. Well, all right, it doesn't matter. What am I offered? And now, this wonderful fishbowl. What do I hear?" Inside, between lamps that had a sort of stylized flute as their stands, were vitrines with jewelry and silverware, as well as several rows of plastic chairs, on which mostly older people took a seat. Some were clearly tourists, and others locals with their plastic bags of vegetables huddled next to them.

At an event in the summer of 2007, the auctioneer provided some apparently helpful information for all the pieces to be sold, which were brought on by eager coworkers, removed from their boxes, and held high: "Now we have two charming framed bookmarks by Hundertwasser up for sale. Hundertwasser was of course a very intellectual guy," he explained, wearing a proper business suit, wooden gavel in hand: "Hundertwasser died, by the way, on a cruise near Australia." An older woman bid for the framed bookmarks; she raised her hand at fifty euros.

WITH THE AURA OF AN AUCTION

Bookmarks by Friedensreich Hundertwasser, mass-produced decorative objects, and garden furniture would never be sold in the large German auction houses that specialize in art. Since the new millennium, galleries like the auction house across from the Munich food market can be found in almost every large German city, usually in the central

pedestrian shopping district. Their targets are tourists who have come to the city to admire the sights and eat well.

In this particular auction house in Munich, a spectacle is mounted several times every day that is supposed to evoke the auctions at Christie's and Sotheby's—complete with the wooden gavel, signaling that the item has been knocked down, and other insignia of the legitimate trade in artworks. But here, in proximity to the vegetable stands and the butcher stalls, the barriers of social distinction are kept to a minimum, which is made expressly clear by the loudspeaker on the street. It is a matter of participating in a ritual that most people in the room know only through films: the auction house as a sightseeing venue, where for half an hour everyone can jump into the wide world of art, education, and business and play the grand bourgeois. Even here next to the fruit stands, the buyers want to bid for the aura of the original, the patina of antiquity—and participate in the mysteries of the art business.

The customers of such an establishment have as a rule no experience with the conventions of the art market—and so it's not difficult to suggest respectability. Anybody offering works by such big names as Pablo Picasso, Marc Chagall, Salvador Dalí, and Joan Miró with the transparency of wide-open doors reaching all the way to the street could not be out to deceive. No, then he'd be doing business in a dark little back room—not here, in plain sight of the public right in the middle of the city. Anybody who wants to try his hand at collecting art here is not only welcomed directly but also given to understand that important artworks can be taken home to impress friends and acquaintances for very little money. Even those who know little or nothing at all about art have heard of these names. But they don't know that during Dalí's lifetime thousands of blank sheets of paper with the signature of the commercially aware surrealist were seized on the border of Andorra and that one should be suspicious of printed works with his signature.

"Auctions for everyone" had been the motto of the three who ran this business. So they didn't use a lot of specialized terminology, as other auctioneers are wont to do at the rostrum. None of them had studied art

history. All three had fallen into the auction business randomly and had worked for an auction house at the same location since the 1990s. When their former boss had to give up the business because of financial troubles, the trio took over the showrooms in 2000 and founded their own business with a new name. Everything went well for a few years. After dozens of clients and regular customers spoke to the police and inquired about forgery, the three businessmen closed the auction house suddenly in January 2014. The men were alleged to have sold cheap copies in 180 instances, for a total of over €120,000, according to the prosecuting attorney in the complaint against them for commercial fraud.

ORIGINAL FROM THE DISSOLUTION OF THE GALLERY, WITH CERTIFICATE OF AUTHENTICITY

The three were forced to defend themselves in July 2019 before the district court in Munich. Reading the twenty-five-page criminal complaint aloud lasted an hour all by itself. The men sat in a dispiriting courtroom: scratched orange chairs, doors in a torpid green; in front of the windows, beige curtains made out of a material that evoked prison bars. The basis of the charges was the more than one hundred graphic works that the firm auctioned or sold directly. Supposedly, they were selling limited editions of lithographs from drawings, as the buyers that were summoned testified before the court: "original" artworks by Pablo Picasso, Salvador Dalí, and others. They even had certificates of authenticity that named both artist and the purported producer of the edition and identified the supposedly limited edition.

In the courtroom, there was much to be learned about how differently people understand art. And moreover, how they define luxury. For some customers, it appeared, the three-figure sum that they had paid represented a lot of money—for example, for the suntanned woman from Gauting with blond hair and a colorful T-shirt. She thought two pictures by Dalí were pretty; she really liked them a lot—and besides, there was the certificate, which inspired trust. So she bought the two

graphic works as presents for her husband: one for Christmas and one for his birthday.

Another one of the victims, a retired man from Freiburg in light-colored slacks and a blue jacket, had been a tourist in Munich and "spontaneously" chanced upon the auction house with his wife: he was no expert in art, he said. As with the other witnesses at the trial, he spoke German with a pronounced provincial accent. He said that for him an artwork must be original and pleasingly presented. In Munich, a Picasso lithograph came up for sale in a very nice frame. There weren't a lot of people in the auction room, he had thought at the time; he'd snap it up. "I relied upon the fact that it was an original, otherwise I wouldn't have bought it." With the limited edition, he thought that he had made a good investment. Now, he testified, he was furious.

The insurance salesman, soon to be retired—a gray-haired, grumpy man in a blazer and white tennis shoes—appeared somewhat pompous and clearly did not want to be perceived as small minded. When he purchased a picture, he said, he did so because he liked it; whether it was original or not didn't matter. That's why he wanted to have the police return the Picasso print that they had seized. Or at least he would like to get the frame back.

And the receptionist from Grafing, who spoke in a very pure regional Bavarian dialect, said she had paid almost €1,400 for two prints by Klimt and Picasso. The pictures came from a gallery that was going out of business because of financial troubles, she had been told at the time. Many of the buyers were given to understand that the pictures were actually worth much more money than the auction price.

One of the most energetic witnesses for the prosecution was a woman who had been born in Poland but lived currently in Lower Saxony. She was a young mother who worked as an apprentice. While visiting Munich, she went into the auction house, which she believed to be famous. It was conveyed to her during the auction that a lithograph with its own edition number was something quite special. She raised her hand. The sale was made with reservation, she was

told by the auctioneer; they had to speak with the former owners by telephone first—the picture came from a defunct law office—before they could sell the picture at such a low price. After the executives of the auction house made a brief telephone call following the sale, the woman was allowed to buy the picture. She said that she was convinced that she had made a good investment: after all, Picasso was famous, and the auction was a singular opportunity. The edition, with fewer than one thousand copies, had made her into an owner of something exclusive.

When she was contacted by the police and was told about forgery, she said that she was extremely sad and disappointed: "If you're selling a counterfeit, you should say so openly," she raged at the trial. She compared the Picasso prints with handbags by Gucci: you could buy a fake Gucci bag for a few euros from special dealers, in Turkey for example. Everyone knows, she said, that they're fake. But, she testified, if you go into a respectable business and pay a lot of money, you want to get an original for it.

The investigators looked into hundreds of such cases. About 180 of those incidents were brought to trial. The trial encompassed only those cases in which the employees of the gallery had provided "influential information" at the sale—in other words, had wooed buyers with talk of a supposed one-time-only opportunity to buy, because of the dissolution of a gallery or the closing of a law office. And they made these representations despite the fact that the majority of the pictures that graced the auctions for years came from a single source in the North Rhine-Westphalia region.

EXPENSIVE FRAMES, CHEAP COPIES

In a separate proceeding, according to the criminal complaint in the Munich trial, the investigators suspected a man from North Rhine-Westphalia named Günther K., who, at least since 2003, had made the prints, sometimes in quantities of a hundred or more, at very little expense. The Munich complaint states that the copies cost Günther K.

less than one euro per sheet. They were simple reproductions, partly even offset prints, produced without permission from the artists or their heirs.

Günther K. is alleged to have numbered the sheets of paper, as is the practice for genuine artist editions, with a graphite number on the front side, such as "611/888" or "197/500." Sometimes there was an official-looking certificate that was partially adhered to the side of the framed copy, something like a diploma or a stock certificate with an ornate border. A stamp certified Günther K. as an "expert in European art of the nineteenth and twentieth centuries."

The frames were worth more than the cheap copies, according to the complaint. Günther K. made them himself in the basement where he resided, the complaint against him alleged, or he had them made by other firms for less than twenty euros apiece. They were so well wrought that many of the witnesses at trial wanted to have the frames back in case they weren't reimbursed for the cheap copied prints themselves.

CRATES FULL OF COPIES

The Munich auction house was apparently not Günther K.'s only customer. According to the complaint, he produced huge quantities of copies. The police seized still-unframed copies that were stored on industrial wooden shipping pallets. In the end, there was so much paper—actually tons—in the exhibit room of the Berlin district criminal prosecutor's office that concerns were raised about structural stability. And it wasn't just limited to artists from classic modernism. The art historian Hubertus Butin is an expert on editions—graphic reproduction, artist's books, and objects produced in limited quantities—by Gerhard Richter, and also the author of a list of Richter's works. He told the newspaper *Frankfurter Allgemeine Zeitung* and others that in September 2010 a copy of the large-format print *Mao*, which Richter had created in an edition of approximately five hundred in 1968, was sold in an auction house in southern Germany for €2,200. In fact, Butin said, neither the

print nor the signature was genuine—despite the accompanying opinion of an art expert.

The expert worked, as Butin later reported, for an auction house near the Berlin mass transit station Friedrichstraße. There, a buyer had acquired a copy of *Mao* for the surprisingly low price of €3,700—about a third of the average price—in order to sell it quickly on eBay. Butin's report led to an investigation of the business by the district attorney's office in Berlin, and the investigators seized, apart from additional copies of *Mao*, alleged printed works by Joseph Beuys, Jörg Immendorff, and A. R. Penck. Hubertus Butin discovered that the Richter prints weren't screenless collotypes at all, but offset reproductions of a poster for an exhibition from 1992. One could almost see the grid points of the print with the naked eye—that is, if all the *Mao* copies identified had not been mounted in the same silver frame covered with milk glass so that the traces of the printing process could not be identified.

"We at the auction house cannot judge objects as would art experts," explained the business director of the auction house to the lawyer of the credulous customer, who later offered the print on eBay, according to the newspaper *Frankfurter Allgemeine Zeitung*. To the contrary, the label on the back affirmed that the experts employed by the firm had confirmed the authenticity of the print and the signature on it, according to Butin: "During a visit in Berlin, he was there to be met and represented himself to be an art expert for modern printed works." After the publicity, according to the court expert, the expert opinions were switched out for new certificates of authenticity that were signed with the name "Günther J. K." In the art world, K. is, in fact, unknown as an "expert in European art of the nineteenth and twentieth centuries."

His invisibility as an art expert did nothing to prevent K., who was listed in trade publications as a designer, from issuing certificates for other artists, such as Picasso, which were later sold not only in Munich and other German cities but also in an auction house in Maastricht in the Netherlands.

According to the criminal complaint against the Munich auction-eers, K. caused the reproductions to be perceived as artist's editions or original works on paper in order to sell them at a significantly higher price. And the prosecuting attorney provided a definition here: an original printed work is either one in which the artist operates the printing mechanism and prints the work or one in which the printing operation and process occur under his supervision. An original print can also be produced from printing plates after the death of the artist. But for K.'s reproductions, neither of these definitions applies, nor does the claim that the prints, which he presumably made himself and sold to central city galleries and auction houses throughout Germany, had been "signed on the printing plate" (i.e., that the signature of the respec-tive artist was reproduced with permission). In this way, according to the prosecution against the owners of the Munich auction house, K. intended that buyers would be deceived into thinking that they were getting an original print at auction, whose worth was at least €1,000 or €2,000, or even much more. In fact, the photocopied reproductions were worth, if anything, less than one hundred euros.

As in many criminal proceedings for art torts, a negotiated settle-ment was sought by the prosecutors and the accused. In the case of the forger Wolfgang Beltracchi, who was prosecuted in Cologne, it was plain to see that the judge had very little interest in pursuing the minutiae of the case. Additional grounds for a reduced sentence in "recognition of a confession of guilt" could be based on the sheer number of the individual torts committed—every single copied Picasso would have to be considered in the sentencing. Even finding all the victims of cash-and-handshake transactions would be a delusional effort. Or it could be that the courts are simply overwhelmed by the effort to understand the customs of the national and international art markets, which as always claim for themselves special privileges.

In the summer of 2019, the court suspended the proceedings against the three accused in the Munich district court, pending their

payment of financial penalties in the amounts of €12,000, €14,000, and €8,000.

It remained unclear at the time that the first edition of this book went to print whether a complaint against the presumed supplier Günther K. would be folded into the principal proceeding, according to the spokeswoman for the Berlin criminal court. In response to a telephonic inquiry regarding whether he had anything to say about the accusations made against him in the Munich proceeding, he curtly replied that it was false to say that forgeries came from him and that there were no criminal proceedings against him.

How many of the copies were sold can no longer be determined. The investigators came upon credit card receipts whose owners lived abroad, many in the US. The search for victims and the cheap copies themselves proved to be costly. In 2019, Picasso prints with certificates from Günther K. continued to circulate zombie-like in online auctions.

Meanwhile, a number of these galleries in inner-city pedestrian zones have closed, as did the auction house in Friedrichstraße in Berlin in 2011. The internet page of the business now displays a quotation from the US billionaire John D. Rockefeller: "Nothing can unite business and pleasure with such moderation as a profitable auction."

India ink and Italian red wine—
the trade in forged books

In the end, it was a tiny black mark, a point no bigger than a square millimeter, that threw the Italian library director Marino Massimo de Caro in jail, put a respected New York antiquities dealer in a tight spot to explain himself, and cost the German art historian Horst Bredekamp a not insubstantial portion of his reputation. And it led to the recognition that something was being forged that until lately had not been considered in danger of forgery: old books. The tiny point appeared on the title page of a centuries-old little volume that is considered to be one of the foundational works of modern astronomy

and, like nothing else, marks the turn away from the Church and superstition, astrology and alchemy, toward modern science. That is precisely why this book is so sought after. It was printed with lightning speed, starting in December 1609, and appeared on March 12, 1610, as its author wrote one week after the delivery in a letter to the court of the Medici in Florence: "Because, honestly, I didn't want to postpone the publication, because of the danger that somebody else might think of the same thing and get there ahead of me."[79] In addition, there was the danger that the censors of the mighty Catholic Church would block the publication and accuse its author of heresy, condemn him, and perhaps burn him at the stake. In his book *Sidereus Nuncius* (*Messenger of the Stars* or *News from the Stars*), which appeared in an edition of only 550, Galileo Galilei laid the foundation for questioning the ancient worldview of the Church, in which the earth stands in the middle of the universe as a divine creation. He cast his lot on the side of Nicolaus Copernicus, who had published this theory fifty years earlier and proved it, although only on a theoretical and mathematical level. For the first time, Galileo had observed the heavens, and especially the moon, with a telescope that he had built himself, and later in his book he corrected the axioms that had been believed with such certainty—using not only mathematics but concrete observation. Collectors pay top prices for such early documents in the history of thought, religion, and world history, most especially when they believe that what is being offered to them is particularly rare and singular. But the flash of so much money draws swindlers like honeybees to clover: wherever the scent is found, they will not be far away.

Galileo's publication is thus something quite extraordinary: it was a turning point in history. Hans Lipperhey, a maker of eyeglasses who had been born in Wesel, Germany, but emigrated to Middelburg in the Netherlands, had just invented the telescope in 1608 as "an instrument to see into the distance." Two Dutchmen applied soon after, in fact, for similar patents, but neither received one. Galileo Galilei, at the time a professor of mathematics at the University of Padua, heard

about it, bought correspondingly shaped optical lenses, and built a telescope himself. By altering the shape of the glass, this learned man was able to increase the magnification of the telescope from 4x to 33x. He presented his telescope to the government of Venice in August 1609, because he rightly thought there was a military use, and sold the exclusive rights to produce it in exchange for an increase in his pay. This Italian inventor was, however, far from finished with telescopes and the moon and stars.

A NEW CONCEPT OF THE UNIVERSE

He wasn't interested in the military use. Galileo needed the instrument for his scientific research. Already, a few years earlier, Galileo had observed the heavens with his unaided eye and come to the conclusion that the geocentric view formulated by Ptolemy and Aristotle could not be correct: the sun, the moon, the planets, and the fixed stars do not circle the earth. Rather, the earth itself, like the other heavenly bodies, is located on a path around the sun. In *Sidereus*, to permit the scientific basis of his theory to be tested, Galileo describes his observations in detail and how he built the telescope. Then he proves that the surface of the moon isn't flat but covered in mountains and valleys. And he shows that the moons of Jupiter that he observed changed their position regularly with respect to the planet and, thus, must circle it. Therefore, the prior prevailing concept of the universe was placed in doubt. It was the first time that such a fundamental question was debated not from the point of view of opinion or belief but based on objectively demonstrable scientific observations.

The Vatican, nonetheless, remained unconvinced by these unimpeachable proofs. In the struggle against the Protestant Reformation, it perceived scientific research as questioning the institution of the Church—and it brutally suppressed heresy in many places. And so Galileo, who had spoken out and published writings in favor of the Copernican worldview, was forced to appear before the Inquisition in April 1633. On May 10 of that year he asked for forgiveness, and the

judgment on June 22 was correspondingly mild. Galileo renounced his earlier errors, condemned them—and was sentenced to lifelong imprisonment, instead of being burned at the stake as a heretic. The sentence was never carried out; instead, it was changed to house arrest with a prohibition on publication. In January 1642 the revolutionary scientist died at his Villa il Gioiello in Arcetri, in the mountains south of Florence.

Galileo's small, sixty-page book from 1610 exerts such importance not just because its discoveries are foundational to modern science. The *Sidereus Nuncius* is also a fantastic witness to the history of art. Apart from the text, the small volume also contains printed engravings in which Galileo captured his observations: constellations of stars, the paths of the planets—and representations of the surface of the moon, on which fine crosshatching renders the gradients of light from which it can be seen that the surface of the earth's satellite is uneven.

Only about eighty copies of Galileo's *Sidereus Nuncius* survive today. Most are to be found in publicly owned libraries, which would never part with them. At the time it was created, books were not yet automatically bound between two covers. The printed pages were bound, to be sure, put in the right order and held together with thread. Whoever bought a copy would have to go to the bookbinder and decide what kind of binding to have made for it. Each of the existing copies looks different in packaging, material condition, and size.

THE HOLY GRAIL OF BIBLIOPHILES

When an apparently heretofore unknown copy of *Sidereus Nuncius* suddenly popped up at a rare-book dealer's in the US, the excitement was appropriately enormous. It wasn't just another copy: this one had a quite special aspect to it, so that it was at once the holy grail of bibliophiles the world over, the equivalent of the Blue Mauritius for philatelists or the Mona Lisa in art. And thus, it became a commercial item for which no price might be too high. The apparently newly discovered copy contained not only the five engravings of the

surface of the moon that Galileo Galilei must have sketched during his observations in 1609. In this edition, there were also five original ink drawings—well executed and nicely preserved. That Galileo had recorded his observations by drawing them immediately afterwards wasn't new. Until this point, only a single sheet of paper with his own representations of such things was known to exist, in Florence. That the handwritten signature of the author, in a brownish ink, adorned the title page led to only one conclusion: this must be the first copy, which Galileo printed himself as the master copy. If true, the book could be sold for tens of millions of euros. And it almost was, except for that thing with the little bitty black mark.

Horst Bredekamp, a professor of art history at Humboldt University in Berlin, recalled later that Richard Lan, a co-owner of the rare-book dealer Martayan Lan on West Sixty-Sixth Street in the Upper West Side of Manhattan, first showed him the new discovery in July 2005: "Seeing this book left me no less perplexed than Galileo must have been when he looked through his telescope at the moon for the first time. On the title page, next to the stamp of the Roman Accademia dei Lincei, to which Galileo had belonged since 1612 as a prominent member, and underneath the last line, there was a signature: 'Io Galileo Galilei f'— translated, 'I, Galileo Galilei, made this (feci).' Here he is signing with both first and last name, which makes the doubling of the name in the title appear even more provocative. Moreover, the spaces that were left open on the plate for printing the pictures of the moon were filled in with matte ink drawings. Since no comparable authentic documentation of Galileo had surfaced in well over a hundred years, I was at once electrified and skeptical. At first glance, I couldn't decide if it was an authentic document, a contemporary or later copy, or a forgery."[80]

Lan had been offered the book by an Italian named Marino Massimo de Caro, who visited him along with his friend Filippo Rotundo in New York. With regard to the origin of the volume, in which Galileo's *Discorso* and other writings were bound together, the two Italians indicated that it came from a Freemason organization that was active in Italy, Malta,

and Argentina. Lan and his visitors traveled to Harvard to show the book to Owen Gingerich, the professor emeritus of astronomy and connoisseur of Galileo, in June 2005. After the elderly scholar affirmed, "The drawings had either to be made by Galileo himself or with his supervision," the dealer bought the book for $500,000.[81] That the book came from South America, as Bredekamp had been told, would prove to be true, though not in the way that many of the participants might have wished. Richard Lan wanted to resell his new acquisition quickly. First, the presumably sensational find had to be subjected to scientific analysis, and he had to obtain a legitimate expert opinion. With that in hand, the book could be priced at $10 million at least. Horst Bredekamp was the right man for the job: he had researched Galileo extensively, published widely, and held the view that scientific discovery and pictorial representation are inseparable. Thus, Lan brought the *Sidereus Nuncius* to Berlin in November 2005, where Bredekamp had assembled a team of nine experts, from Italy and other places, in assorted fields. They were assigned to examine the contents of the book and to investigate its material composition from a technical point of view. Two other copies of the book, from Graz and Paris, were at their disposal for purposes of comparison. Other experts from Italy and elsewhere were added to the team. In the end, it was concluded, as Horst Bredekamp formulated it in an essay for the professional journal *Sterne und Weltraum* (Stars and Outer Space): "A thorough examination of the pages of this book has proven that it is a galley proof of this epochal work and it has led to a better understanding of Galileo's achievement and of Galileo himself."[82] In 2007, this Berlin art historian published his findings regarding the presumed sensational discovery in a book titled *Galilei, der Künstler* (Galilei, the Artist).[83] Representatives from fourteen institutions were gathered in spring 2008 in Berlin to reexamine the volume, known by then by the initials SNML. Once again, there was a positive finding. Apart from the Gutenberg Bible, Horst Bredekamp explained afterwards, no book had been so rigorously analyzed as this one. The conclusions of the research were published in fall 2011 in English under the

title *Galileo's O*.[84] And the academic world, as well as that of art, appeared to have become richer through this sensation: direct evidence of one of the most significant steps in the history of humanity, from the Middle Ages toward the Enlightenment and modernity.

DOUBT IN ATLANTA

The historian Nick Wilding, an assistant professor at Georgia State University in Atlanta, had Bredekamp's book sent to him so that he could review it for a professional journal—and he was puzzled. He recalled in a Skype conversation, "It wasn't clear to me why Galileo would paint pictures into the master copy that would be reproduced later in the printing process through engraving. That didn't make sense in the work routine." Wilding next turned his attention not to Bredekamp's book but to the sensational discovery itself. And he found other discrepancies. "There was something not quite right about the stamp indicating that the volume was supposed to have come from the library of Federico Cesi, the founder of the Accademia dei Lincei, to which Galileo belonged as well. It didn't match the original, in which the oval frame isn't closed all the way around. Besides, in the historical catalogue of Cesi's collection, no copy of the *Sidereus Nuncius* is listed. Also, the signature looked strange. I was puzzled." He learned also that Owen Gingerich meanwhile had had to revise his favorable judgment. That expert had learned that other forgeries of writings by Galileo had come onto the market at about the same time as this *Sidereus Nuncius*, among them three copies of the book *Le Operazioni del Compasso Geometrico e Militare*. The watermarks were not correct. Shifts inside a printed letter suggested that photopolymer printing plates had been used, and that they had slipped. This kind of mistake could not be explained in classic printing typefaces. At least one of these dubious volumes had found its way strangely enough into the hands of the rare-book dealer Richard Lan.

Nick Wilding recalls that he had notified Horst Bredekamp early on about his doubts regarding the SNML: "He wasn't particularly friendly in response. But that's natural if someone comes along and casts doubt

on your research." It was "foolish" to doubt Lan's copy of the *Sidereus Nuncius*, the Berlin professor wrote to Atlanta: "I wonder how often you were able to see the book in the shop of Richard Lan? Writing on authenticity without having studied the original carefully is a methodological death-sin."[85] Moreover, the Berlin academic insisted, it was a special test printing in which Galileo had painted. That was why this copy had so many irregularities and mistakes.

But then Wilding discovered that tiny black mark. At the very bottom on the title page, the imprint—next to the place (Venice) and the name of the printer (Tommaso Baglioni) and the year (1610)—contained the permission to print "Superiorum Permissu & Privilegio" in the last line. Strangely, the second *P* (Privilegio) has an extension in the foot, to the left: a small oval point that looks like a dash or half a serif. This extension is missing from the first *P* (Permissu): it doesn't belong to this typeface. Wilding uncovered the banal reason for this peculiar irregularity—and thus the proof that Horst Bredekamp and his team of experts had not examined the book as carefully as they had thought. Their American colleague spoke of "superficial historiography and sloppy research."

Wilding knew that at the time of the four hundredth anniversary of Galileo's birth, a facsimile copy of the *Sidereus Nuncius* had been printed. A copy from Milan was used as the template. In this book, there is a small brown stain, a dirty spot, at the foot of the second *P*. When it was photographed to make the copies, the analog camera used at the time apparently could not distinguish between the color of the printed letter and that of the little spot, so that it had morphed into the unusual dash—and the facsimile was printed with the changed *P*, which otherwise is not found in any print of the original edition. The erroneous *P* appears only in the reprint from 1964—and this copy must have been used to create the alleged new discovery. The Berlin experts claimed to have meticulously compared all available copies from the original edition with the one from New York. But they overlooked the erroneous *P*.

Meanwhile, other mistakes have become known, things the Berlin experts overlooked or didn't delve into. For example, in the original printing, a damaged *L* appeared in the typeface, which didn't print the letter completely. In the forgery, this mistake is missing. The paper restorer Irene Brückle in Stuttgart proved with the help of fiber analysis that the paper used for the printing could have been produced only after 1930. Horst Bredekamp argued that this kind of analysis had not taken place earlier and instead reliance had been placed upon methods that did not involve touching the book, such as X-ray fluorescence and infrared reflectography, because it would have been necessary to remove small samples of the presumably valuable book. "Because it contradicts the ethics of preservation. In the same way that one would not remove material from an expensive wooden sculpture."[86] In the German weekly newspaper *Die Zeit*, Hanno Rauterberg succinctly described the scientific carelessness that seeks to justify itself by pointing to a supposed reverence for the material: "In the end it was art itself, its elevated aura, that blinded the researchers to any skepticism or objections. Bredekamp recounted how he knew, when he first looked upon the spotty ink drawings, that they were the work of Galileo. Only he, that brilliant master, could have painted with this combination of freedom and precision."[87]

"THE BOSS IS A CRIMINAL"

The man behind the sophisticated forgery claimed later that he had intentionally worked small errors into the Galileo copy in order to fool the experts and sometime later go public with them. Like other unmasked forgers, Marino Massimo de Caro, born 1942, can't prove this assertion of course. The suspicion that, for him, it was all about making a lot of money seems much closer to the truth—because the forged *Sidereus Nuncius* wasn't the only book that he misused for criminal ends.

De Caro popped up because Nick Wilding retraced the path of the suspect book from Richard Lan's rare-book dealership backward. Soon

he came upon the man from Verona who had at one time studied law in Siena but left without a degree. He then became communications director at the Italian state pension fund. He liked to go to rare-book fairs and met a librarian from the Vatican at a rare-book dealer's in Argentina. He had done business with him and received Galileo doublets in exchange for early printings known as incunables. At some point, de Caro was known as a specialist who could get almost any book that people sought. Richard Lan became his customer and received from de Caro, among other things, a rare book by Johannes Kepler, dated 1611, from the inventories of the Vatican.

De Caro changed his profession after the sensational Galileo sale to Richard Lan. He had established contact with the energy company Avelar, which belonged to the Russian billionaire Viktor Vekselberg; first he became the PR coordinator, then the vice president of the firm. Meanwhile, after he had become a rich man with a grand estancia outside Buenos Aires, he was thrown out of Avelar. But Senator Marcello Dell'Utri, a confidant of Berlusconi who was later imprisoned for his Mafia ties, found de Caro a position first in the agricultural ministry and later in the cultural ministry. Here de Caro was entrusted, among other things, with the inventory of the state library collections. Later it was revealed that the supervisor along with two accomplices in the library of the Montecassino Abbey stole a copy of Dante's *Divine Comedy* and a copy of Galileo's *Compasso*, for which they substituted a forgery that they had made. Investigators later determined that de Caro sold the Dante book for €800,000.[88] In June 2011, this book thief and forger was named director of the Biblioteca dei Girolamini in Naples, founded in 1586. Nine months later, when the art historian Tomaso Montanari, who was teaching in Naples, visited the library with a student, he found bizarre conditions: stacks of books on the floor, drink cans on the shelves, a librarian who whispered to him that the director was a criminal. He said that de Caro's friends from Russia visited all the time, and that every evening, books were packed in suitcases and loaded onto trucks. Montanari published an article

about it, and the district attorney began an investigation. He had de Caro's telephone tapped and learned that the library director was stockpiling books in his private house, in a warehouse in Verona, and at the home of his aunt. Approximately 450 titles were set to be sold on May 9, 2012, at a Munich auction house—among them, a later copy of the *Sidereus Nuncius*. The listings of the titles and descriptions covered eighty-four pages. An installment payment of €900,000 had allegedly already been made to a middleman.[89] The auction was halted. The director of the auction house was arrested in August 2013 pursuant to an international warrant and extradited to Italy where he was sentenced, after a year of being held in custody, to five years in prison for illegally exporting cultural goods. According to statements by his attorneys, he was sentenced without the presentation of evidence, without taking statements from witnesses, and without transporting the books that had been impounded by the Munich district attorney's office.[90] They appealed, and the director was allowed to return to Germany. Plainly, he was the sacrificial lamb who was supposed to divert attention away from the sorry conditions in the administration and supervision of Italian libraries. The director denied even knowing de Caro. The books, he said, were delivered in a bundle—originating supposedly from a Swiss collection and from a reputable colleague. The police in Italy seized around two thousand books. Soon, de Caro was wearing handcuffs. After denying the allegations and lying for a while, he made a confession in the beginning of August 2012. De Caro, who had meanwhile turned thirty-nine, said he had stolen books not only from Montecassino but also from libraries in Florence, Padua, and Rome. De Caro was sentenced to seven years' imprisonment for embezzlement, of which he actually spent only five months; the remainder was converted into house arrest. Additional proceedings based on embezzlement and looting are supposed to follow. De Caro claims that the books that he sold in Naples didn't come from the publicly owned library but from the private collection of a priest at the abbey. And, he asserted, the proceeds from his thefts were to go

is also no proof.

IN THE OVEN AT 250 DEGREES CELSIUS

While he was in custody pending trial, de Caro confessed to the forgery of the New York copy of the *Sidereus Nuncius*. He told the American journalist Nicholas Schmidle in fall 2013 that the idea arose in 2003. An artisan in Buenos Aires had the paper. A printer produced the photopolymer printing plates. The template was supposedly a digital copy of an original edition that de Caro acquired from an Argentine widow and later sold to a French dealer. He did not say whether the 1964 facsimile with the telltale extra tiny black spot that betrays its origin had anything to do with the template for the forgery.

Because he was of the opinion that every forgery should have something special, he considered the thirty advance copies that Galileo had received from his printer, which had blank areas instead of illustrations, and decided to forge a copy with hand-painted images. Finding the right ink was difficult. A painter and "well-known restorer" in Buenos Aires had drawn the pictures: "I promised him that I would never reveal to anyone what he had done."[91] The pictures of the moon were made by tracing the bottom of a wineglass, and the illustrations were completed with a mixture of India ink and red wine, allegedly a 1990 Masseto. Twenty minutes in the oven at 250 degrees Celsius with a small plate of hydrochloric acid transformed the black ink into a rusty color. A bookbinder in Milan had made the binding from genuine seventeenth-century parchment. De Caro claimed that he intentionally made the mistakes in the stamp for the Cesi library: "If I hadn't done that, it would have been impossible to tell whether this book was a forgery."[92] It had been considered unthinkable that valuable books could be forged, until the Galileo incident. Criminals took an interest in manuscripts and documents. In February 2018, the State Library of Bavaria in Munich announced that its copy of the famous Waldseemüllerkarte, dated 1507, was a forgery from approximately 1960. In 1990, for DM 2

million, Bavaria had purchased the map, which shows the earth on a plane, unfolded, as it were, in sections. Waldseemüller's map was the first to use the word "America," and this was one of only six surviving copies.[93] But counterfeiting books had not caught on with criminals. In the end, it's not a question of a creative imitation in the style of an artist. A forgery that is intended to deceive must correspond in all details to the originals found in libraries. Every single letter must be identical with the prototype from the typography down to all irregularities. The paper and the color of the ink have to be the same. The distances between letters and lines have to fit exactly. The impression of the printing plate on the paper may be neither too great nor too little. The binding, the glue, the threads of the binding: everything must pass age tests. To provide for all these considerations and produce a forgery manually such that it doesn't betray itself under an electron microscope—the business doesn't quite make sense. Marino Massimo de Caro claimed that altogether the production of the fake *Sidereus Nuncius* cost him $150,000. He said he had sold the book for the same price.

The digitalization of all areas of life has also had a lot of influence on this arena. In fact, even if de Caro himself denies it, clearly more than one copy was made under his direction from digitally created photopolymer printing plates, apart from the now famous book forgery. There are the four alleged volumes by Galileo that the forger donated to the private Universidad Abierta Interamericana, for which he was given an honorary professorship. And then there was the book for which Nick Wilding didn't need a confession from the forger to identify as counterfeit. In his research, he had meanwhile come across a catalogue for the auction house Sotheby's in which another forgery of a later edition of the *Sidereus Nuncius* was offered for sale in November 2005 for $250,000 to $350,000.[94] This fake had exactly the same elongated *P* as the New York copy, and given his earlier research, this could hardly be an accident: the same printing plates had been used here. In the end, de Caro confessed to the Italian criminal investigators that he forged up to five copies of the *Sidereus Nuncius* alone.

By the time he discovered the auction catalogue, it was plain to Nick Wilding that a very sophisticated trap had been laid for Horst Bredekamp. On June 11, 2012, Wilding published his findings in an online forum for rare-book dealers, collectors, and librarians: the sensational, recently discovered book by the great Galileo, with drawings made by the scientist himself, was, in fact, a fake. Horst Bredekamp seemed not to want to acknowledge this fact for some time. In an email to Wilding, he wrote that he was "quite wounded" by Wilding's accusations.[95] Later, he pronounced the fake, despite all the mistakes that he and his colleagues had overlooked or not followed up on, a "masterpiece." An advocate formerly on Bredekamp's side, the Princeton book expert Paul Needham, concluded self-critically in the second volume of writings on the *Sidereus Nuncius*: "Is it a clever forgery? I am not convinced, although I am one of those who were tricked by its printing as well as the paper. I would rather say that it shines a bad light on me than that it shines a good light on its maker."[96]

CULTURAL HISTORY DESTROYED

The international smuggling and illegal excavation of antiquities

The Polaroids were a problem for Giacomo Medici. It all began in October 1994 in Pullach, a municipality outside Munich. Actually, the German and Italian police were only looking for clues in connection with eight Hellenic terracotta vases that had been stolen nine months earlier from the castle museum in the small city of Melfi in Southern Italy. What the investigators found led to the discovery of the biggest antiquities smuggling scandal in modern times, a scandal that shook the very foundations of the museum world. In the villa in Pullach, the investigators came upon documents that quickly put them on the trail of the art dealer Giacomo Medici and his Swiss company, Éditions Services. Eleven months after the discovery in Pullach, three Swiss and three Italian police officers, a Swiss judge, and an officially commissioned photographer stood before room 23 in hallway 17 on the fifth floor of the warehouse in Geneva's freeport, search warrant in hand. When the port director opened the door, the investigators found mountains of

photographs, armoires filled with antique art objects, and a safe, a meter and a half tall, which housed the most valuable pieces. The number of prints, negatives, and Polaroids alone in the investigators' report numbered some four thousand.

The investigators had to look only at a few of the pictures before it became instantly clear to them what they had stumbled upon. The pictures showed ancient vases, statues, floor mosaics, and frescoes to which clumps of earth adhered. They were obviously dug up and photographed by so-called *tombaroli*, robbers who plunder archaeological sites. Room 23 in the distinguished Genevan depot, according to the accusations of the police, was nothing other than a salesroom in which Giacomo Medici sold his customers art objects from Italy, Greece, and other countries. The objects came from illegal excavations and did not have the export permissions legally required by the respective antiquities authorities. The photographs in the Geneva warehouse had served as a kind of catalogue for this dealer in stolen goods, who has since been convicted. Documents accompanying the photos showed who his clients were, and evidence of the illegal sales came in the form of bills of lading, expert opinions, invoices, and checks. The investigators uncovered the names of collectors who had long been suspected of buying stolen goods. But until this discovery, the investigators had lacked proof of their suspicions. And some of the documents were electrifying: tying the scheme to one of the most respected art museums in the world, the J. Paul Getty Museum in Malibu. It was the first time that an important public art institution was implicated in the systematic, illegal plunder of cultural assets.

The Getty Museum, which has since moved into a gigantic art castle designed by starchitect Richard Meier that sits atop a hill in Los Angeles, is considered the richest art institution in the world. The oil billionaire Jean Paul Getty created a foundation upon his death in 1976 with an endowment of $700 million. In order to maintain its nonprofit tax-exempt status, the foundation is required to spend several million every year to support the museum. For decades, the Getty has been

able to buy what other institutions can no longer afford: paintings by
Pontormo and Van Gogh, valuable photographs and books—and also
artworks of classical antiquity.

A MUSEUM IN COURT

The direction of the department of classical antiquity had since April
1986 rested on the shoulders of the curator Marion True. When she
arrived at the Getty at the age of thirty-six, the museum was in the pro-
cess of significantly expanding its collection of antiquities in order to
keep pace with the competition, such as the Metropolitan Museum of
Art in New York. As she sat in court in Rome, accused of receiving stolen
goods, smuggling national cultural assets, and indirect support of the
theft of archaeological finds, it was established that she was comfortable
with many methods of acquisition. According to the complaint against
her, she absolutely knew that many of the new purchases that she made
were from illegal excavations and thus did not have the requisite export
licenses—a requirement under both US and Italian criminal law. Both
she and the administration of the museum had long denied that they
were aware of the illegal source of the artifacts. But then hundreds of
documents that were leaked to the *Los Angeles Times* unveiled a different
set of facts. The documents, which a disgruntled employee had leaked to
hurt his boss, were partly handwritten and could have come only from
the museum itself; they proved unequivocally that the management of
the museum must have known very early on that a substantial part of
the antiquities collection was acquired from illegal sources.

Giacomo Medici told the administration of the museum in 1985,
for example, that three objects that the Getty wanted to acquire had
been removed illegally from excavation sites near Naples. Nonetheless,
the museum proceeded undeterred to pursue the ultimately success-
ful purchase for $10.2 million. In another letter, the art dealer Robert
Emanuel Hecht Jr. told the curator Marion True that the police were
searching for an ancient urn. Despite that, the Getty later acquired that
very object. Hecht at first withdrew an ancient pelike vase, which Hecht

had also tried to sell to the museum in the mid-1980s, writing to True: "Yesterday my friend broke off the negotiations because the Carabinieri were looking for the pelike with the arms of Achilles. Therefore, he won't get it. Perhaps others will buy it. Sorry. All my best, Bob." In July 1986, the Getty acquired the vase nonetheless for $42,000.

In 1993, the museum bought a gold burial wreath, although True herself had at first characterized the acquisition as "too dangerous." Later, she even received an Interpol telex that described the wreath as being "of illegal origin." In internal memos also leaked to the *Los Angeles Times*, the director of the museum at that time, John Walsh, and the chairman of the board of the Getty Trust, which controls the museum, Harold Williams, mused about the traffic in stolen cultural goods (purely hypothetically and prophylactically, they later asserted): "Are we prepared to purchase stolen property out of overriding principles?" Harold Williams freely admitted in the context of the True prosecution: "For decades, it was common practice for respectable museums and collectors to acquire artifacts without documentation of their origin—in particular, when the possible countries of origin did nothing to secure their excavation sites or to improve their laws." Many of the details that came to light in the Getty proceeding are anything but appetizing. But True gave up her position at the Getty only when it came out that she had bought a vacation home on the Greek island of Paros with a $400,000 loan from the London art dealer Christo Michailidis, who, together with his business partner Robin Symes, had sold the Getty artworks valued at more than $30 million during Marion True's tenure there.

THE SECRET ANTIQUITIES NETWORK

Italian prosecutors were able to prove quickly that a systematic network for trading in stolen property had operated at all levels, from the *tombaroli* to certain antiquities dealers and on to prominent institutions and museums. A piece of ruled paper with handwriting that had turned up in the search was decisive for the investigators in this regard. A copy

was shown to the writer Peter Watson, who, together with the journalist Cecilia Todeschini, published a book about the case, *The Medici Conspiracy*. Watson describes the spectacular find in his book: "The whole thing showed nothing less than the organizational diagram of the secret antiquities smuggling networks throughout Italy, Switzerland, and other countries, naming every single person in the entire hierarchy, from the very top to the very bottom and everyone in between. Moreover, it was annotated with the relationships of these people to each other, who supplied whom, who was in competition with whom, which middlemen supplied from which Italian regions, and what relationship they had to international dealers, museums, and collectors. It was breathtaking. The blue ballpoint pen writing was easy to read. In the upper right in capital letters, 'Robert (Bob) Hecht' with two horizontal arrows to 'Paris and USA—museums and collectors.'" In the end, Hecht stood accused along with Marion True before the court in Rome. Medici was sentenced in Rome in 2004 to ten years' confinement and a monetary penalty of €10 million. True resigned from her position in September 2005. When, in 2007, she was ready to testify about the structures inside the Getty Museum, the civil case against her was dropped by the Italians. Many criminal charges against her had meanwhile aged past the statute of limitations. Her business partner Robin Symes, who is said to have thirty-three art and antiquities depots in his control, was convicted in 2005. Then, in 2014, in one of his warehouses in Geneva, investigators discovered forty-five crates of artifacts that had been stolen from excavations in Sicily, Apulia, and Calabria in the 1970s. They were returned to Italy.[97]

Following the successful investigations, Italy demanded the return of forty-two ancient artifacts from the Getty Museum alone. Meanwhile, attorneys working at the behest of the museum have carried out research, and they found that many more exhibition pieces in the museum's collections are involved. At least eighty-two objects on display can be traced back to art dealers whom authorities accuse of illegal practices but from whom the Getty regularly made purchases

anyway. Of the 104 ancient art objects that the museum itself labels as "masterpieces," fifty-four have questionable provenance. The list of individual cases of questionable practices at the museum has grown long and thus reveals systemic misconduct. As a young curator gave up his post in 1986, he summarized the developments at the Getty that had been going on for years. In a letter he said that the museum was guilty of deliberate blindness regarding the circumstances in the antiquities department. Almost prophetically, the art historian wrote that "curatorial greed" would lead to an external investigation and that a foreign government would demand the return of stolen cultural assets. Twenty years later, that's exactly what happened. But the Getty wasn't the only institution implicated.

The Italian authorities conducting the investigations quickly turned their attention to the Museum of Fine Arts in Boston, the Toledo Museum of Art, the Princeton University Art Museum, the Minneapolis Institute of Arts, and the Metropolitan Museum of Art in New York. The board of trustees of the Metropolitan acquired a vase in 1972 that has since become world famous. It was painted in approximately 515 BCE by Euphronios and came from an Etruscan grave. The site robber received $880, but the Metropolitan paid $1 million to Robert Hecht. When the archaeologist and antiquities curator Oscar White Muscarella publicly voiced his opposition to the acquisition of the piece by the museum, he received notice of his termination from Met director Thomas Hoving because of "social incompetence with colleagues." Muscarella, who successfully litigated against this dismissal, as well as two other attempts to fire him, is considered worldwide to be one of the most knowledgeable experts on the cultures of the Near East—and the conscience of his field. Again and again, he has pointed out that the illegal purchase of ancient artworks—by private collectors and museums—contributes to the destruction of excavation sites, the loss of contexts of the artifacts, and thereby the erasure of ancient cultures themselves. His employer, the Metropolitan Museum of Art, had warned him repeatedly about alleged disloyalty and defamation. Hoving's successor, Philippe de

Montebello, attempted in vain to fire this inconvenient employee. In the spring of 2006, however, de Montebello met his own downfall. In order to avoid an embarrassing proceeding parallel with the True prosecution, he finally announced, after extended resistance, that he was ready to yield to the pressure of the Italian cultural minister at the time, Rocco Buttiglione, to return the Euphronios vase to Italy, along with fifteen pieces from the silver hoard of Morgantina. Buttiglione had threatened beforehand that otherwise Italy would no longer approve the loan of art to the museum.

THE SPOILS OF WAR IN MUSEUMS

War can lead to an increase in supply and, correspondingly, an increase in demand, as, for example, with the 2003 conflict in Iraq. And the art market is a seller's market: only what is offered can be acquired. Whether the source is legal or illegal is a matter of indifference to some collectors. In Baghdad, both the national library, which was later burned, and the national museum were systematically plundered. The US military showed no interest in the security of either, despite early warnings from experts. Ancient excavation sites, which had already been severely damaged by heavy military vehicles, had no protection at all after the end of the war. Under the Hussein regime, the administration of antiquities departments and the protection of archaeological monuments and excavation sites had collapsed. Many archaeological sites, such as the ancient city of Nimrud, where teams of international researchers had worked up until the war, were left to the mercy of organized groups of thieves. Later, the landscape was as cratered as the moon.[98]

The civil war in Syria and the absence of protection for archaeological sites there have similarly led to an increase in illegal transactions. According to the US government, terrorist organizations were involved. In 2015, Undersecretary of State Andrew Keller presented a paper at the Metropolitan Museum of Art in New York, according to which the Islamic State had established its own "ministry for natural resources, with sub-departments for excavations, research of new and old discovery sites,

as well as the marketing and sale of antiquities."[99] Seven hundred objects destined for sale, some of them plundered from the museum in Mosul, were found in the possession of the assassinated Islamic State leader Abu Sayyaf. The documents and receipts seized prove that, while the Islamic State did not itself do the excavation work, it gave out licenses for others to do so. Twenty percent of the profit from sales had to be diverted to the Islamic State as "taxes."[100] In October 2019, at the Kerem Shalom border crossing to the Gaza Strip, Israeli authorities seized ancient Greek coins in a truck that was supposedly transporting textiles. They were prohibited from commerce because of their age (about 2,300 years) and the absence of documentation of a legal provenance.[101] According to information from the US Treasury, Hezbollah is supposed to fund itself by way of a prominent art dealer in Lebanon.

WORLDWIDE BUSINESS

The European Union prohibited the import and export of cultural goods from Iraq and Syria and the commerce in such goods. But this did nothing to stop the illegal import. It is always easy to manufacture the necessary documentation of provenance. In his treatise on the illegal trade in cultural goods, the journalist Günther Wessel cites the archaeologist Neil Brodie of the Scottish Center for Crime and Justice Research at Glasgow University: "If you go to a dealer and say that you need a provenance to go with the object that you want to buy, you'll get it. You get a piece of paper on which the names of one or two previous owners are listed, perhaps there's a signature. You can accept that, or not. You have to decide for yourself. If, for example, you want to buy an Iraqi object in London, and there you are presented with a provenance that says that the artifact has been in a family collection in Jordan since the 1950s, you have two choices. You could examine the document yourself and say, That doesn't seem very likely. It is much more likely that the object comes from an illegal excavation last week. Or you say to yourself: Yes, it's my provenance. Jordanian family since the 1950s. Great. And when

you resell it later, then you have your documentation of provenance."

Markus Hilgert, the former director of the Near East Museum in Berlin and the current general secretary of the Cultural Foundation of the German States, explains: "The most expensive items are precisely those that are not sold publicly. And many finds are warehoused in freeports, perhaps for years, until the traces of their origin have disappeared."[102] In 2002, the German Federal Criminal Investigation Office was aware of about two thousand instances of the illegal trade in cultural goods that had been discovered. In 2011, that number had climbed to 2,400. UNESCO estimates the value of transactions in antiquities for that same year at $6 billion to $8 billion annually.[103] That number is disputed, however; the International Association of Dealers in Ancient Art stated five years earlier that the value of this commerce was €440 million, of which €180 million was transacted at the two great auction houses, Christie's and Sotheby's.[104]

The claim that the illegal trade affects the German market and that terrorist organizations had financed themselves from the proceeds was placed in question in 2019—at least by the industry association Interessengemeinschaft Deutscher Kunsthandel, founded in January 2019, a collective of six membership organizations that do lobbying work together. In the summer of 2019, an initial progress report was published for the ILLICID study, financed with €1.2 million and produced by the German federal ministry for education and research, the cultural foundation Stiftung Preußischer Kulturbesitz, the Fraunhofer Institute for Secure Information Technology, and the Leibniz Institute for Social Sciences in Mannheim. The investigation is supposed to "develop and test efficient methods and tools to investigate, document, and analyze information regarding the illegal trade in cultural goods in Germany," according to the project description. "Against the background of the latest political developments in Iraq and Syria, the study concentrates especially on the dynamic market in ancient cultural goods from the eastern Mediterranean."[105]

ART & CRIME

In a press release, the industry association celebrated the preliminary findings as essentially an "acquittal for the art business": "After three years of research and €1.2 million in costs, the results of the ILLICID study have come in. It was begun to investigate the illegal trade in cultural goods in Germany. It has found nothing. The final report contains no indications of theft from archaeological sites, terror financing, or money laundering."[106]

Apart from the fact that, contrary to representations in the media, the preliminary findings are plainly not a final report, the self-declared "acquittal" disregards what the report actually says. It can hardly be used, as it was, as a supposed argument against the German law for cultural protection, which has been vehemently opposed by the art trade. (Compare Chapter 6.) Critical archaeologists point to other interpretations, starting with the goals that were set for the study: "The study does not address Germany's role as the principal place for the illegal art market. In order to do that, a comparative analysis would be necessary."[107] The academic blog *Archaeologik* additionally points out that the high number of forgeries convincingly suggests that in Western Europe there is a lucrative market for antiquities: "As much as possible, the finds offered for sale were identified and classified by referring to academic and professional indexes. Only 24 percent were (very) likely to be authentic, genuine pieces; for 12 percent forgery was highly suspected—for Near East cultural goods even 24 percent. . . . 2,387 objects (39.9 percent of the inventory observed) potentially came from Syria or Iraq."[108]

These high numbers in no way indicate, according to independent archaeologists, that the trade in excavated objects is almost exclusively legal:

Compared with the guidelines in the German laws for the protection of culture, only 2.1 percent of the finds offered (128 pieces) had a verifiable provenance tracing back to a date before the deadline

in the law (April 26, 2007, or inside the EU December 12, 1992). Forty-three percent of the objects were proven to be illegal under the conditions set forth in the law, because the provenance was prior to the deadline (approx. 32 percent), or did not exist, or had been falsified (approx. 11 percent)! Table 2 provides the following numbers with respect to the German laws for cultural protection:

verifiable provenance before the deadlines	2.1% (128 pieces)
unverifiable but detailed provenance before the deadlines	6.9% (1,039 pieces)
unverifiable provenance without detail before the deadlines	38.1% (2,337 pieces)
unverifiable provenance without detail after the deadlines	31.9% (1,958 pieces)
contradictory or falsified provenance; no provenance	0.9% (671 pieces)

Compared with the EU statutory standards, only 0.4 percent of the declarations of provenance for objects from Iraq and only 9.6 percent of those from Syria fulfill the legal requirements.[109]

ONLY 2.1 PERCENT ARE INNOCENT

The statistical basis for the ILLICID study was questionable, the blog *Archaeologik* explains; it did not permit comprehensive collusions: "On the one hand, the 6,133 objects are the sum total of the antiquities that can be unquestionably grouped for purposes of examination, of which, as elaborated upon above, only 2.1 percent are recognizable as conforming completely with the laws (although the deadlines in the law, which become later and later, present their own problem). Thus, 97.9 percent of them are suspicious cases, because antiquities come from archaeological excavation sites for which the finds must be reported almost everywhere and export licenses are required—or they are placed in museums or scientific institutes, and therefore don't reach the market.

It is furthermore to be noted that the 6,133 objects in the study represent only objects that could be included without question. The numbers in the report must be understood thusly: numerous coins and small finds from the Hellenistic or Roman periods are offered for sale that cannot be traced because of the lack of a declaration of provenance or because the region of origin is difficult to prove, as a result of the cultural similarities across the Mediterranean, e.g., they could come from North Africa, and therefore such objects were not considered. . . . Testing the provenance provided was of course only partially possible. Reference was made to old auction catalogues, storage and loan lists, publications and databases from collections, but also lists of losses from museums and depots, the databanks of Interpol as well as LostArt. It must be noted that objects stolen from excavation sites can scarcely be identified by this process because they come fresh out of the ground and thus cannot be included in such listings."[110]

With regard to the ILLICID study, the German newspaper *Frankfurter Allgemeine Zeitung* also came to a different conclusion from that of the art trade associations, pointing out that the study was essentially based on questionnaires sent to all German art dealers. It remained "questionable whether the evaluation of the immediately accessible business and the reports of those questioned was sufficient to track the trade in goods stolen from excavation sites and their more or less visible commercial pathways—or whether it's necessary to use investigative forces. No respectable dealer—nor any sophisticated criminal—would openly try to sell something that he himself considers illegal. The real gray market lies beyond the auction catalogue."[111] Even here, the procedures of the study and its ability to reach conclusions were placed in doubt: "From the perspective of the countries of origin, the small number of seized objects does not ameliorate the urgency of the problem. In addition, the international protection of art is less well established than, for example, the search for drugs and commands less investigative power. That means that the dark numbers might be disproportionately high in relation to the cases on record."[112] In fact, many stolen cultural

goods with unclear provenance appeared on the European art market during and after the war in Iraq—especially in France, Great Britain, and Germany. The Iraqi cultural minister Mufid el Dschasairi spoke in November 2003 of 14,000 plundered exhibition pieces. Three years later, just about four thousand of them were voluntarily returned, discovered, or impounded.[113] And today, after another decade and a half has passed, there is a list of missing items online.[114]

An acquittal would be something else again. The effective prohibition on trade in antiquities without the required documents is still problematic: in the case of pieces, for example, that have been in the possession of a collector or a family for a number of years—since a time when it was not yet a requirement to present official export papers of the country of origin when purchasing an antiquity legally. Still, the object can't be contraband or something stolen from an excavation site. And today it's hard to sell such pieces without running into difficulties. Legislators have not yet found a solution for this general suspicion, which can have both criminal and severe financial consequences.

THE GOLDEN HAT WITHOUT A PROVENANCE

When the Berlin Museum for Prehistory and Early History acquired one of only four known "golden hats" for DM 1.5 million through a Frankfurt art dealer, the source was given only as a "private collection" in Switzerland that was built up in the 1950s and 1960s. Further inquiries were blocked. Material examination demonstrated meanwhile that the artifact is indeed about three thousand years old and comes from the Late Bronze Age. Everything else about the object is shrouded in mystery, including where it was found, who found it, and who the intermediaries were. Wolfgang Schönleber, who was for many years the antiquities expert for the district criminal office for the state of Baden-Württemberg in Stuttgart, Germany, said at the time that there were no concrete demands for the object's return from Italy or Greece, which were thought to have been the possible countries of origin. To be sure, the art department of the Carabinieri searched the antiquities museum

in Berlin for the origin of twenty-four ancient vases from Apulia. Proof of their illegal acquisition was not found. "But that doesn't mean," explained Schönleber, "that there's not a problem. The pivot point and hub for the sale of stolen antiquities at the moment is Frankfurt."

At the time, the acquisition of stolen artworks from antiquity was not a punishable offense in Germany. At last, in November 2007, after thirty-seven years of delay, Germany yielded to international pressure and ratified the 1970 Convention for the Protection of Cultural Property of UNESCO. This declaration was even then already outdated and in Germany in particular was not translated into a national law. Of course, EU proscriptions since 1992 prohibit the illegal import of cultural goods from the partner countries Italy and Greece and since 2003 from Iraq. The impossibility of proving that a single piece came, in fact, from one of the proscribed countries and was not found twenty kilometers over the border in a neighboring country precludes most prosecutions.

"Anyone with an ounce of common sense knows that it's all but impossible to obtain antiquities from ancient excavation sites legally," affirmed Michael Müller-Karpe, a curator at the Römisch-Germanisches Zentralmuseum in Mainz, Germany. "I'm not aware of any country in the Near East that permits any kind of export. The one exception is Israel, but there are strict conditions that are enforced." Müller-Karpe has therefore spoken in favor of a complete ban on the trade in antiquities. The working group of German art dealers accordingly called Müller-Karpe a "fundamentalist archaeologist" in a press release, accused him of waging a "defamation campaign," and grouped him along the spectrum close to Islamic extremists.

But Müller-Karpe found support from his colleague in New York Oscar White Muscarella: "It's true, many collectors and museum directors argue that excavated objects are more secure with them than in their country of origin. The objects that these directors 'securely protect' were ripped from the earth, the place and cultural context in which they originated forever destroyed. I've worked in the Near East a long time and have seen excavation sites destroyed: holes made by exploding

dynamite, retractable belt stanchions, bulldozers. All the objects are gotten out of the ground as quickly as possible, brought to various dealers, and smuggled out of the country and sold to museums. What is secure about that? The museums' claims are not simply lies, but despicable attempts to justify their crimes. It is precisely the university museums at Harvard, Princeton, Missouri, and Indiana that are the leading thieves and destroyers of world history."

THE DESTRUCTION OF HISTORY

Cultural destruction refers not only to the material harm but also the cultural damage that site robbers cause. It is of tremendous importance to researchers to know where exactly and in what context historical finds are made: Were the objects found inside, outside, or at all near buildings? What was in the area? Are there indications of usage that can be recognized? Are the objects interred in graves or are they everyday objects? The thieves usually concentrate on metal objects and leave the ceramics, the material and form of which can provide incriminating information about the date of the find.

These problems don't occur only in countries in Central and South America, Arabia, Africa, or Asia, where there were well-known early civilizations and cultures. Eckard Laufer, the antiquities expert for the Hessian police and contact person for the preservation of monuments there, points to a little-noticed aspect of the problem: "In Germany itself, there are objects stolen from excavation sites and sold to museums despite murky provenance. One only has to think of the 'Sky Disc of Nebra' or the discovery of treasure at Bullenheimer Mountain. Many German museums to which such finds were offered could recognize what was what. But they closed both eyes and argued that such finds were better off with them in the museum than that they should disappear into some dark channel. Those responsible know exactly what they are doing. They are creating a market for illegal goods and thus ensuring that site robberies continue to be seen as lucrative, and so they continue to occur. I would wish that more curators would dare to take

the step of going to the police. But changing the mindset in Germany is a slow process."

Indeed, two known site robbers dug up the four-thousand-year-old "Sky Disc of Nebra" from the Mittelberg, a mountain in Ziegelroda Forest in the German state of Saxony-Anhalt on July 4, 1999. One day later they sold the bronze plate with the oldest known representation of the sky and stars along with other found objects for DM 31,000 to an antiques dealer in Cologne. Allegedly, the Sky Disc was offered for sale for DM 1 million in Berlin and Munich. As it became clear that the find belonged to the state of Saxony-Anhalt, it furtively changed ownership several times. In consultation with the museum educator Hildegard B., a teacher named Reinhold S. bought it in the summer, allegedly in good faith, as B. later testified in court. The two attempted to sell it for DM 700,000 to the state archaeologist of Saxony-Anhalt. The district court of Naumburg sentenced the woman, who was then forty-four years old, to twelve months' confinement for sale of stolen goods, and gave the man a six-month sentence. The appeals proceeding two years later affirmed the sentences, which had been suspended in favor of probation. The artifact turned up in Switzerland, where the two current owners had stored it. The two site robbers were sentenced a week earlier to four months' and nine months' probation, respectively.[115] Since 2002, the Sky Disc may be seen in the Museum for Prehistory of the State of Saxony-Anhalt in Halle, Germany.

In the high plateau of Bullenheimer Mountain near Neustadt an der Aisch in upper Bavaria, there was plainly a settlement in the Late Bronze Age that was an important trading post. The area was first investigated in the mid-1970s by the state office for the preservation of monuments, which recognized its importance. Nonetheless, for decades illegal excavators with metal detectors were permitted to search for treasure unscientifically, without any kind of documentation, and without regard for the context of the finds. Among the first were US soldiers stationed in Würzberg, who used minesweepers to excavate. In the 1990s the plateau

was a cratered landscape.[116] It is possible that the golden hat of Berlin also came from here.

WHEN THE STATE TRADES IN STOLEN GOODS

Sometimes German authorities are involved quite directly in the trade in ancient cultural assets. In the fall of 2018, the two auction lists of the Munich treasury office quickly disappeared, quietly and secretly and without any comment. Anyone entering the corresponding URLs received only an error message. On a third site, where the authorities had given notice of a larger auction including antiquities on September 12, there remained a brief note: "The liquidation of the ancient objects and art objects has been stopped, and they will not be auctioned." If a request for clarification was made in Munich, the response was simply "organizational reasons." In September, the treasury offered for sale, instead of the antiquities, a collection of traditional German clothing, such as twenty-three pairs of the men's knee pants known as *Lederhosen* and *Kniebundhosen* along with four similarly styled vests and five *Dirndl*, traditional women's dresses in southern Germany and Austria—cultural goods of a different order.

Apart from organizational reasons for the clandestine cancellation, there were other causes. Around seven hundred objects from the most varied epochs and continents were supposed to go under the hammer once again, many of them made of gold: a pre-Columbian vessel from the north Peruvian culture Lambayeque for €5,000; a Scythian bracelet for €600; and a semicircular golden sacrificial knife (or *tumi*) from the same region and period for €15,000. The State of Bavaria estimated the value of the ancient objects to be in total €110,000. At least two embassies, those of Egypt and Peru, which had not been informed of the sale in advance, protested to the government of Bavaria against the planned sale on the grounds that the cultural goods might be stolen objects for which the countries had claims.

Already in the summer of that same year, absurdly low minimum bids were listed in two auctions that were to take place in an

unassuming building in the vicinity of the Hohenzollernplatz in Munich. The items listed for sale and pictured on the website, which was later removed, included: a pre-Columbian Peruvian bronze mask (500 CE–1000 CE) for €60; a painted ancient Egyptian mummy mask for €120; a group of prehistoric hand tools made of bone for €15; and countless pre-Columbian terracotta figures, vessels, and silver needles from the Andes and Mexico, sickles from the Bronze Age, ancient Egyptian figurines, and Byzantine bowls.

In the international art market, high prices are paid for such ancient objects because the supply has run thin. Many countries now prohibit their export; the trade is permitted only on very rare occasions when official governmental export approvals are provided. The countries of origin regularly assert rights of ownership to whatever pops up on the market without the necessary papers: obviously, in these cases, the suspicion is that the goods have been excavated illegally.

The Bavarian treasury allowed 280 individual pieces to be auctioned in the first two low-priced sales in the summer of 2018 during two afternoons in the Schwabing neighborhood of Munich. By far the most expensive object was a massive Sasanian silver plate from the fourth century CE with a minimum asking price of €9,000; the cheapest items were two ancient oriental clay weights exchanged for the price of a pack of cigarettes, five euros. The responsible office for taxation will no longer reveal what was sold and at what prices on those two days—because of tax secrecy, the press spokesperson Florian Schorner said in response to questions: "I hope you understand." "Tax secrecy" is also the answer to the question of just how the state of Bavaria came to possess these ancient cultural goods in the first place.

The source may be reconstructed, however; in fact, these ancient cultural wares came from auctions raided by Department SG 622 of the district criminal office almost exactly twenty years ago. In 1997 and 1998, about three thousand pieces were seized from a Turkish dealer named Aydin D., who had lived in Munich since 1979, and from other dealers and collectors—discovered in such hiding spots as a rebuilt attic room

or behind a double wall. The total value was given at the time as DM 30 million. D. might have drawn attention ten years earlier: he had sold the American art dealer Peggy G. a centuries-old mosaic depicting the archangel Gabriel for $1.2 million in a duty-free warehouse in Geneva. The sacred artwork had been stolen from a church in Cyprus. It was offered a little later for $20 million to the Getty Museum in Malibu, which discovered the dubious origin and informed the Cypriot church. After being held in custody for one year during the investigation, D. was sentenced to a two-year suspended sentence because he had not paid taxes on his share of $350,000. Later he disputed his participation. There were no searches conducted with respect to him at that time.

The impounded antiquities had been stored since 2001 in a climatized room in the building for criminological technology of the district criminal office while a search was conducted for the rightful owners. Plainly, this did not proceed too swiftly. In spring 2002, the German foreign office warned the Bavarian ministry of justice in unusually blunt terms that there was increasing "international pressure on Germany from Peru and various Cypriot officials for the return of these artworks that had been illegally taken from their countries of origin and had been seized from Mr. D." The government in Cyprus sent Germany an unsigned diplomatic message known as a "verbal note" demanding the return of the stolen goods.

THE AUTHORITIES PERCEIVED NO VIOLATION OF THE LAW

The return occurred only in the summer of 2013—and included only a small portion of the goods that had been seized. Cyprus received approximately 170 returned items, among them a Byzantine fresco from the sixth century depicting St. Thomas (estimated value of €5 million to €8 million) that had evidently been stolen from a church in the northern part of the country following the Turkish occupation in 1974. Beate Merk, the minister of justice for Bavaria at the time, was quoted as saying that she was glad that after all these years a majority of the treasures had been returned to their homelands. The politician,

a member of the Christian Socialist Union Party, did not let on at the time that there were still thousands of cultural goods in the custody of the Bavarian state.

Another seven years later, Bavaria finally wanted to conclude the case and the search for owners and to collect what it could for the tax debts from the Munich auctions. Of course, the general regulations for the protection of cultural goods must be followed, explained Florian Schorner of the Bavarian state tax authority, but: "Rightful third parties (especially other countries) that are affected by the current auction are not known. The objects are in particular not listed in any relevant indexes."

Georgea Solomontos, cultural attaché for the Cypriot embassy in Berlin, confirmed that his country did not have any more claims regarding the two prior auctions: "After examination by the department of antiquities, we were informed that no antiquities from Cyprus were offered for sale in these two auctions in Munich."

What can be done with illegally excavated and exported objects, which naturally don't show up in any listings because neither their discovery nor their export nor their sale is known to their country of origin? The Peruvian ambassador in Berlin, Elmer Schialer, replies: "Unfortunately, neither the Bavarian state government nor the Bavarian treasury contacted our embassy to determine the legitimacy of these cultural goods."

The press spokesperson Florian Schorner doesn't see a problem: "The law for the protection of cultural goods does not preclude liquidation if the preconditions set forth are met, especially the duty of care in Section 41 GSG." Were stolen art to be included in an auction by the treasury, the acquirers would not be permitted to export the pieces bought in Munich, once enactment of the German law for protection of cultural goods was in effect.

Peru's representative Elmer Schialer went to work on the issue: "Through the appropriate channels, our embassy sent a message to the German foreign office to communicate our request to immediately cancel the auction of these Peruvian, or presumptively Peruvian,

objects, so that their authenticity and the rightful ownership could be determined." A gold mask had already been returned to Peru following the proceedings.

And the Egyptian authorities hired a lawyer to demand information from the German authorities. "We were not informed," explained the embassy spokesperson. "The Egyptian embassy suspects that the works sold in Munich were stolen and belonged to Egypt. We did not give permission. It surprises us quite a bit that an authority would do such a thing." After diplomatic intervention, the third auction was finally canceled. No further auctions have since been announced.

4

WHEN DICTATORS COLLECT

The art market,
the international kleptocracy, and ethics

Somebody must have given Vilma Hernandez B. some money. A lot
of money, in fact. A whole lot of money. Over and over again. B.,
born in 1939, earned a tiny salary as a secretary for the Philippine
diplomatic mission to the United Nations in New York. She could not
possibly have afforded the luxury real estate and expensive works of art
she purchased. For example, the $350,000 she paid for an apartment
on the twenty-ninth floor of the Olympic Tower on Fifth Avenue in
Manhattan in 1976. Or the $880,000 that she paid a year later for three
more apartments in the same luxury building on the forty-third floor.
The seller was listed as a firm registered in Hong Kong by the name
of Thetaventure, whose New York branch was the same as Vilma B.'s
apartment in shabby subsidized housing on West Seventieth Street.
Although her home address was on West Seventieth Street, she was
often seen going in and out of the elegant Fahnestock Mansion at 15
East Sixty-Sixth Street, between Fifth and Madison Avenues, and also

another building at a different address on East Seventieth Street in the elite Upper East Side of Manhattan. And she regularly paid the property taxes, starting in 1981, for The Lindemere, a 3.5-hectare estate with fourteen bedrooms and seventeen bathrooms in Center Moriches on Long Island. The single largest bill in Vilma B.'s name is dated July 20, 1978. It was on that day at the New York branch of the Italian jeweler Bulgari in the Hotel Pierre that the secretary acquired earrings, bracelets, and necklaces with emeralds, rubies, and diamonds valued at $1.4 million—a lot of money for a woman whose salary was just $3,000 a month.

A second look at the receipt from this luxury jeweler solves the mystery of this small-time employee and her mountains of money. For it tells the story of the family of a dictator who stole at least $10 billion from his country's coffers and invested that money in, among other things, works of art, hundreds of which he stashed away in secret hiding places just before his downfall. Today successor governments continue to search in vain for many of them.

The Bulgari receipt wasn't found in New York but rather in Manila on February 25, 1986, in the Malacañang Palace, the abandoned residence of President Ferdinand Marcos, the long-standing dictator of the Philippines. It was on that night that, with the help of the American army, the strongman fled from the palace into exile in Hawaii, where he died three years later. In the two decades before fleeing, he systematically looted his country. Ten months before Marcos's ouster by the Philippine people, an editor of the German newsmagazine *Der Spiegel*, Tiziano Terzani, wrote about the reason for the economic decline of the country. Marcos had established an economy based on unbridled favoritism, which hurt the populace but profited a select group—principally members of the Marcos family: "Under martial law, Marcos ruled by decree and by decree Marcos gave what he wanted to whom he wanted. . . . The national debt was $2 billion in 1972. Today it is officially $25.6 billion, unofficially $35 billion. The economic situation of the Philippine people has meanwhile grown worse. A third of those able to work are unemployed; almost a million people lost their jobs

in 1983 alone; salaries do not increase; prices rise. A kilo of rice costs five times as much as in 1972; a kilo of sugar costs six times as much. Hundreds of thousands of Filipinos die of measles, diarrhea, and tuberculosis. In infant mortality, the Philippines ranks just behind India and Bangladesh. One-third of deaths in all age groups can be traced back to hunger. By the government's own reckoning, 85 percent of Filipinos live below the UN poverty level."

Two and a half percent of the proceeds from the sale of sugar was funneled directly into a fund at the disposal of the president who, over the course of ten years, is supposed to have transferred a billion dollars from this enterprise overseas. In total, members of the Marcos-Romuáldez clan had interests in over one thousand Philippine businesses—and hundreds more internationally, which could do nothing without first paying commissions to the presidential family. At the same time, the corrupt police and the corrupt military enforced a regime of terror that Marcos both tolerated and encouraged. Anyone who dared to criticize or ask questions could expect to be murdered or tortured with barbed wire around his neck. At one time, there were fifty thousand political prisoners in the Philippines, held at fifty-nine locations across the country.

THE INCRIMINATING INVOICE

The incriminating $1.4 million Bulgari invoice revealed the true purchaser—under the name Vilma B.: "Mrs. Imelda Marcos." The glittering wife of the dictator had bought the jewels on one of her legendary shopping sprees. The former beauty queen, née Imelda Romuáldez in 1929, was also the owner of the luxury Manhattan apartments. She used the townhouse at 15 East Sixty-Sixth Street, simultaneously the seat of the Philippine consulate, for sumptuous parties to mingle with Hollywood actors like George Hamilton. After she moved to the Olympic Tower, employees at the embassy and the consulate liked to call the townhouse the "warehouse," because it was where Imelda Marcos stored the things she bought on her shopping sprees. The wife

of the president spent more than $7 million on a single ninety-day trip to Rome, Copenhagen, and New York. In one day in Manhattan, she spent $560,000 at Fred Leighton for antique jewelry, $451,000 for jewels at Cartier, $43,730 at Asprey for a serving dish of sterling silver, $10,000 for an antique dessert service, $34,880 on limousines, $10,340 at Pratesi for bedlinens, and $23,000 for books. Vilma B. was her straw woman, who settled the payments with the Marcos's accounts afterward and was regularly picked up from her rental apartment on West Seventieth Street by a limousine with diplomatic plates.

Besides being one of the people that the Philippine dictator's wife trusted most, Vilma B. also helped the little woman with the big sunglasses with her art purchases, successfully sequestering uncounted riches months before the ouster of the dictator couple by the Philippine people—including hundreds of artworks for which the Philippine authorities have been searching unsuccessfully for the past three decades: paintings by Van Gogh, Monet, Degas, Cézanne, Picasso, and Mondrian—and, allegedly, also by Rembrandt, Goya, and Michelangelo, although leading experts have cast doubt on the authenticity of the old-master works in the Marcos's possession.

Imelda Marcos took the money that she and her husband extorted from her nation's people and spent it wantonly, with both hands, as if she couldn't do it fast enough. After she fled—apart from jewels valued at $20 million, fifteen mink coats, sixty-five parasols, seventy-one pairs of sunglasses, 508 evening gowns, and 888 handbags, there were also 1,060 pairs of shoes, size 8.5.[117] Imelda didn't understand very much about art. And that's why, like a lot of collectors who have more money than knowledge, she was taken to the cleaners by dealers, middlemen, and gallerists.

In 1976, the Philippine First Lady used the occasion of a meeting of the International Monetary Fund in Manila to portray herself on the world stage as the founder of her own museum. A building, originally planned as a military museum, was commandeered soon enough. All that was missing were the artworks. Friends in the US arranged for the

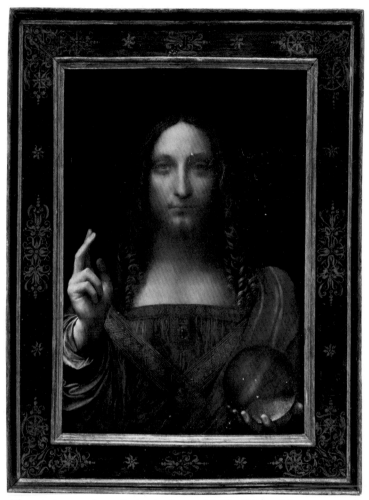

*The most expensive painting in the world: The "King of the Free Ports,"
Yves Bouvier, very quickly earned many millions of dollars from the
sale of* Salvator Mundi *to the oligarch Dmitry Rybolovlev. Though
experts dispute the attribution of the painting to Leonardo da Vinci,
it was nonetheless sold later at auction for about $450 million.*

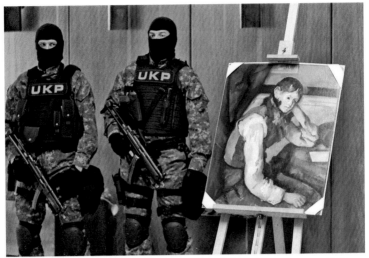

Brutalization: Unidentified persons stormed the private museum Stiftung Sammlung E. G. Bührle in Zürich. The paintings resurfaced in Serbia later on.

Phony avant-garde: The German federal criminal authority, the Bundeskriminalamt, seized more than 1,500 purported masterpieces of Russian modernism in a warehouse belonging to the SNZ Galeries of Wiesbaden.

Greed: Many paintings from the collection of Imelda Marcos, the wife of the former dictator of the Philippines, disappeared after her husband was forced from power. Since her return to the nation, she has displayed herself quite openly with other works from the collection.

Each hole marks an illegal excavation: The mangled ruins of a five-thousand-year-old Sumerian city in southern Iraq.

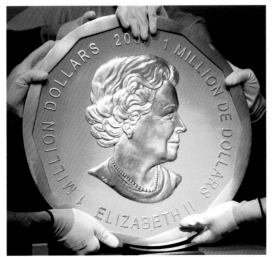

Taking an ax to the museum: The Big Maple Leaf, a gold coin weighing 220 pounds, was stolen in 2017 from the Bode Museum in Berlin.

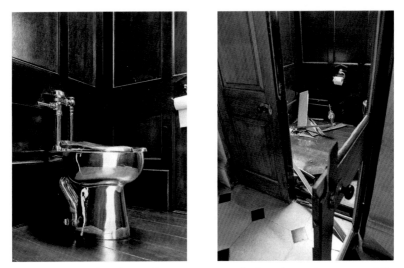

Flushed: In 2019, burglars stole Maurizio Cattelan's sculpture America, *a fully functional toilet made of solid gold, from Blenheim Palace in England.*

In numerous urban galleries and auction houses, reproductions of Picasso drawings are sold as supposed originals, with certificates of authentication.

Wrong number: A handset made in Britain sits on top of what was claimed to be Hitler's red telephone.

Nazi remainder table: Most purported drawings and watercolors by Hitler that are for sale are just as phony as their signatures and authentication certificates.

The telltale little dot: An entire team of respected experts was fooled by a forged book allegedly by Galileo Galilei. PHOTO © BARBARA HERRENKIND

loan of art from the Brooklyn Museum and the Los Angeles County Museum of Art, and also from private collections, like that of her long-time friend Armand Hammer. The oil billionaire had his own art gallery in New York and had a financial interest in the Knoedler Galleries. According to information provided by employees, the museum's collection was treated as a self-service emporium for the Marcos family and their friends: they could borrow works without the obligation to return them, ever.

Beginning in the 1980s, Imelda Marcos made her mark in the New York art world as a particularly aggressive buyer. The First Lady left no doubt that she wanted to put together an important collection in the briefest time. Money didn't matter. For instance, when Sotheby's wanted to auction the collection of the deceased shopping-center billionaire and philanthropist Leslie R. Samuels with an estimated sales price of $5 million, the auction, for which the catalogue had already been printed, was canceled on short notice. An unnamed collector had bought the entire collection en bloc, the firm stated: English paintings from the seventeenth and eighteenth centuries, furniture, and ceramics. The buyer was also interested in buying Samuels's three-story apartment in a building at 660 Park Avenue, which was priced at $9 million. Imelda Marcos outed herself as the buyer a little later: she had paid just $6 million for the entire Samuels collection. She did not get the collector's apartment, however; the building association denied her application. They feared there would be protests by political opponents of the Marcos regime.

Marcos bought a number of paintings of modern masters at the New York Hammer Galleries, owned in part by her friend Armand Hammer. In the month of December 1982 alone, Imelda Marcos acquired from the gallery: a *Still Life with Idol* by Paul Gauguin for $1.5 million; the landscape painting *Kew Gardens, Near the Greenhouse* by Camille Pissarro for $420,000; *Rain* by Claude Monet for $365,000; two pictures by Maurice Utrillo and Pierre-Auguste Renoir, altogether for $475,000; the painting *Moon Madness* by Andrew Wyeth for $300,000; seven paintings by the American painter Anna Mary Robertson Moses,

a representative of outsider art who called herself Grandma Moses, costing $214,000. (Later, Imelda Marcos allegedly purchased another eleven works by Grandma Moses for an additional $393,000.) Payment was made in the form of checks made out to cash, drawn anonymously; and the paintings were delivered either to the Tantocos, the department-store-owning couple in the Philippines who were the Marcoses' friends, or to Imelda Marcos's residences in Manhattan.

FAKE OLD-MASTER PAINTINGS

When Gliceria R. Tantoco introduced herself as an adviser and friend of Imelda Marcos and the wife of the man whom Ferdinand Marcos had named as his ambassador to the Vatican, the Knoedler Galleries, at 33 West Fifty-Seventh Street in New York City, found itself on the cusp of some major business. According to an investigation by the *New York Times*, Gliceria Tantoco is reported to have said in May 1983 that she wanted "a big collection of paintings by one man." Or maybe a woman. The Hammer Galleries still had fifty-two paintings by Paule Gobillard from a failed exhibition—Gobillard was a very late impressionist painter who was related to Berthe Morisot and acquainted with Pierre-Auguste Renoir, but had otherwise left hardly a trace in the history of art. The pictures—unremarkable still lifes, landscapes, and portraits—were sold by the gallery en bloc to Manila for a mighty $273,000. "That was a good opportunity to get rid of those pictures, which no one wanted anymore," a dealer involved in the transaction was later quoted as saying. Over the next several years, Imelda Marcos acquired from Hammer a total of seventy-seven artworks at a cost of $4.61 million. "Special prices, authorized by Dr. Armand Hammer, for President and Mrs. Marcos," as it says on one invoice dated July 20, 1983, above the price of $2.2 million—issued to Galerie Bleu, a poster shop in the Tantoco department store in Manila.

Twelve works were flown to the Philippines in Hammer's private jet—including a *Madonna with Child* by the early Renaissance master Fra Filippo Lippi. Imelda Marcos wrote a check to the Hammer

Galleries for the sum of $700,000 for that piece. The picture had been offered for sale for the prior eight years without any luck—for example, to the respected Frick Collection in New York for $1 million in 1974. The Frick's director at the time, Everett Fahy, declined the purchase because the panel was too severely damaged.

Still, this picture was genuine. Many other old-master paintings that were bought for the Marcos collection were, in the opinion of experts, probably fake. That $3.5 million, for example, that Imelda Marcos wired in four tranches from July to December 27, 1983, to Adriana Bellini, the wife of the Italian art dealer Mario Bellini, might have been better spent elsewhere. For her money, the wife of the dictator got a wooden panel on which supposedly there was a painting by Michelangelo. If it were authentic, it would be worth a great deal more than $3.5 million. There is only one convincingly attributed work on panel by Michelangelo, the *Doni Tondo* (1504–1506) in the Uffizi Gallery in Florence. Everett Fahy of the Frick Collection considers the Marcos picture to be a misattribution.

Fahy was also familiar with many of the other seventy-five paintings that Mario Bellini sold to Imelda Marcos starting in 1977, all of which were shown in an exhibition in the Metropolitan Museum of Manila. The First Lady wrote the foreword to the catalogue herself and was designated the exhibition curator as well. And in that costly volume, the art dealer Mario Bellini sang the praises of the pictures that he had sold to Manila for a lot of money.

At least sixty of these works were not by Tintoretto, Canaletto, and the other artists of similar quality to whom the works were attributed, in the opinion of the independent old-master expert Everett Fahy, who was quoted at the time in the *New York Times*. Rather, according to Fahy, they were works "by unknown provincial artists of the period or copies from the nineteenth century of works from the eighteenth century." Nine further pictures had dubious attributions; the remaining six were painted by insignificant artists. The attributions in the catalogue were deemed "scandalous" by Fahy. An altarpiece ascribed in the catalogue to the Sienese artist Lippo Memmi, for example, was by an anonymous

Ligurian painter: "That is a piece of religious furniture that one could take home on a bad day from the auction house Parke-Bernet for $5,000." By contrast, a genuine Lippo Memmi would cost "millions." In total, the entire collection exhibited was worth $500,000, some pictures just about $1,000. In a quote in *ARTnews* about the exhibit, Fahy even spoke of "absolute trash."

There was also considerable doubt about the supposed second masterpiece of the Marcos collection, the picture of the reclining *Marchioness de Santa Cruz*, which had been purchased as a masterpiece by Francisco de Goya. True enough, the picture belonged to the collection of the Los Angeles County Museum of Art until 1977–78. The museum had then sold it discreetly to the London gallery Marlborough Fine Art because of doubt regarding the quality and whether it was the work of multiple persons. A much better version of the same subject hangs in the Prado in Madrid.

Imelda Marcos is said to have told Jun Gonzalez, her restorer, that she had in her possession a 3.6-by-3.6-meter painting by Hans Holbein—one of the most sought-after artists, whose work all but never appears on the market. "How could she have bought a Holbein?" Gonzalez asked himself. "Surely, the whole world would know when a Holbein had been purchased on the international art market? Where had it come from? Who had sold it to her—or had she been duped—yet again?"[118]

It was surprising that the "really good pieces were not to be seen in the museum," countered the respected New York restorer Marco Grassi. When the Marcoses asked Bellini in 1980 for "important European pictures," he sold them authentic paintings like *The Crowning of the Virgin* by El Greco (for $900,000), *David and Goliath* by Francisco de Zurbarán (for $750,000), and *The Apotheosis of Aeneas* by François Boucher (for $550,000), which he had received from clients in Spain. Mario Bellini disputed ever having sold a Michelangelo to Manila: "That would have been wonderful." Jack Tanzer of the Knoedler Galleries, who was admitted to the Marcos townhouse on East Sixty-Sixth Street,

reported that, in fact, Imelda Marcos had shown him the painting there and spoke of "her Michelangelo." In any case, according to notes from Imelda Marcos's private secretary in Manila, Fe Roa Gimenez, who was listed as the official owner of a $40 million bank account at Bankers Trust in New York, $3.5 million was sent in payment to Adriana Bellini for a "Michelangelo" painting.

The artworks in the Manila museum weren't safe from the greedy hands of this kleptocratic couple. According to the German newsmagazine *Der Spiegel*, the museum's director, Arturo Luz, described how it happened that "the First Lady commanded him to come to the museum in the middle of the night and waited for him there. After a short tour, she pointed to one or two pictures that she liked and had them sent to her home. 'No receipts, no documentation,' said the director. 'She told me only that I should keep my mouth shut.' The pictures were never returned to the museum." The Marcoses' daughter Maria Imelda ("Imee") was named cultural commissioner for the Philippines: "For that position, she had her headquarters and office in the Metropolitan Museum. She also took whatever she wanted from the museum for her various apartments and guesthouses. No receipts. 'For us, the pictures have been lost,' Luz laments. The hopes of recovering some of the artworks after the dictatorial clan fled, possibly in the official offices of the cultural commissioner, were not realized. The office was empty—except for a shelf full of porno videos."[119]

DOING BUSINESS WITH ARMS DEALERS

After Ferdinand Marcos was chased from office and fled the country, the new government under Corazon Aquino began right away to search for the riches that the couple had hoarded inside and outside the Philippines. The Presidential Commission on Good Government found countless receipts and proofs of purchase in the documents left behind. True enough, the couple had carried 2,300 pieces of paper regarding their economic entanglements with them on the plane sent by the US government, which the dictator thought was taking him to his home

region of Ilocos Norte. The American customs authorities, however, seized the documents. These papers later helped an investigative committee of the US House of Representatives and the new government in Manila to reconstruct the Marcoses' embezzlement of billions.

Much of what Imelda Marcos had accumulated over decades and the fortune that she had pilfered from her nation could not be brought with her into exile. As enumerated in customs documents, her escape luggage encompassed, among other things, three hundred cardboard boxes and crates—twenty-two of which were stuffed with Philippine currency valued at $1.4 million, jewelry, gold, and foreign currency valued at more than $6 million—which were seized as being in violation of the restrictions on importing cash. But for a fortune that the chairperson of the investigating committee "conservatively estimated at between $5 billion and $10 billion," according to *Der Spiegel*, it was clear that somewhere there had to be a great deal more. In the end, the documents that were found demonstrated ownership in real property and buildings in Manhattan ($350 million), Texas ($2.5 million), a bank account in Switzerland ($800 million) and five other accounts ($88 million), and a deposit of gold, probably also in Switzerland ($280 million). In 1986, the Swiss government closed all the accounts as a precaution.

Many jewels and valuable furnishings turned up in the Malacañang Palace and in assorted other residences, offices, and depositories in the Philippines. The new government had Christie's New York auction off recovered silver, porcelain, furniture, and works of art in 1988. In 1991, this was followed by the sale of old-master paintings—among them some authentic works that had not been seen in public after Imelda Marcos bought them. The New York dealer Stanley Moss paid $2.1 million for El Greco's *Crowning of the Virgin*. An allegorical painting with Mary and the baby Jesus that Imelda Marcos had bought from Knoedler in 1976 brought in $1.04 million. With a bid of $1.65 million, the Italian government took home an early Raphael for the Uffizi. Titian's *Portrait of Giulio Romano* went to the Zürich old-master expert David Koetser with a bid of $1.1 million. The alleged Filippo Lippi, for

which Imelda Marcos had paid $700,000, was attributed now to Zanobi
Machiavelli—with an estimate price of $40,000 to $60,000. Each of the
seventy-four paintings on offer found a buyer—many of them well over
the price estimate.

Twenty-five of the most valuable works that came up for sale from
the former Marcos collection had been seized in France at the behest
of the US government while they were in the possession of the Saudi
arms dealer Adnan Khashoggi—among them, the Raphael, the Titian,
and the El Greco, as well as works by Zurbarán, Rubens, Picasso, and
Degas. First the paintings were held on his yacht *Nabila* in Cannes,
then hidden in a penthouse in the city. Underlying paperwork quickly
drew the attention of the authorities in the Philippines and in the US, as
Khashoggi entangled himself in a web of contradictions.

It is demonstrably true that in May 1986, after the Marcoses fled, the
artworks from the Malacañang Palace and the New York townhouse on
East Sixty-Sixth Street were shipped to the arms dealer. After the raid
on the apartment in Cannes, Khashoggi first told the French police
that he had already bought the whole lot of thirty-eight pictures in
1985 from Imelda Marcos, his neighbor in the Olympic Tower in New
York: "Mrs. Marcos told me that she wanted to sell some paintings." The
check in payment was allegedly made out in Monte Carlo. When these
representations didn't hold up, Khashoggi explained that the pictures
had served as collateral for a $5.6 million loan that he had given to the
dictator's wife. Still later he alleged that he had sold twenty pictures
for $5 million to a Panamanian firm—which led the authorities to
suspect that Khashoggi himself was behind it all, in order to make the
works disappear. In fact, the price was probably $6.5 million, of which
$700,000 was delivered immediately in cash; the remainder was paid
with an anonymous cashier's check made out to Ferdinand Marcos in
Hawaii. In later legal proceedings, it came to light that Khashoggi's New
York driver, Ernest S., was ordered on May 19, 1986, to rent a truck and
"to wait on a call from someone named Irene," the name of the youngest
Marcos daughter. When she called, S. allegedly drove to a shopping mall

in Douglaston, Queens, turned the vehicle over to two men, and waited in the parking lot. After he took the truck back, he supposedly drove to Khashoggi's private Boeing 747 at Butler Aviation Terminal in Newark Airport in New Jersey. On the way there, he left the truck parked on a side street in New York while he ate Chinese food. He couldn't say whether something happened with the valuable cargo in Chinatown. He was later asked to sign a receipt for the inventory, the driver recalled: "Looked like names and titles. I didn't load the truck, so I signed with 'Mickey Mouse.'"

In a 1988 interview, Khashoggi denied that the paintings were worth more: most of them were copies.[120] Khashoggi had also taken over four expensive properties on Manhattan's Upper East Side from the Marcoses: the Crown Building (730 Fifth Avenue and Fifty-Seventh Street), Herald Center (1 Herald Square at Broadway and Thirty-Fourth Street), the seventy-story office building 40 Wall Street and the twenty-five-story skyscraper 200 Madison Avenue between Thirty-Fifth and Thirty-Sixth Streets.[121] As was later revealed, the contracts here were also backdated to at least a half year before the Marcoses fled.

He was arrested pursuant to an international warrant while meeting with another arms dealer in the Hotel Schweizerhof in Bern, Switzerland, on April 18, 1989. Khashoggi fought in vain against an extradition order that would send him to the US. He ordered expensive meals from the hotel nearby and had a fax machine installed in his single cell as part of the furnishings. The complaint charged him and Imelda Marcos with unlawful trade, conspiracy, obstruction of justice, and fraud. The proceeding at the US district court on Foley Square in Manhattan ended surprisingly with an acquittal. After the trial, both shockingly declared that they would forfeit all rights in the valuable artworks and real estate. Khashoggi's lawyer, James P. Linn, confirmed that a deal had been made with the prosecutor: "My client was tired of appearing before our country's courts." After deducting the costs of the proceeding, the money from the sale was transferred to the Philippine government. To this day, it is still unclear whether Khashoggi had taken

possession of other pictures belonging to the Marcoses. The case also involved a $2 million home in Beverly Hills that officially belonged to Imelda Marcos's close friend, the actor George Hamilton.

Over time, Imelda Marcos had distributed the art collection to her homes all over the world. When, in the mid-1980s, it appeared that Marcos's rule in the Philippines might be ending, there was a frenzy of activity in New York. Eyewitnesses reported seeing very large delivery trucks parked in front of properties belonging to the dictator and his wife, and shipping containers of the kind used to transport artworks on the sidewalk. The most valuable works had apparently hung in the building on East Sixty-Sixth Street. But when allies of the new government searched the rooms on a cold day in February immediately after the couple had fled, they found no pictures at all. Instead, brass plates betrayed the names of the great figures in art history with which Imelda Marcos had once surrounded herself: Van Gogh and Degas, Picasso and Monet. Which works belonged to these names could be reconstructed from the documents left behind. For Degas, it was a large-format pastel *Le petit déjeuner à la sortie de bain*. For Van Gogh, it was an early watercolor showing a woman spinning wool. A *Head of a Woman* by Picasso, probably dated 1954, had hung there, as well as a view by Monet of the small village of Vétheuil and its church situated west of Paris along the Seine. A still life by Henri Fantin-Latour lay, wrapped in a blanket, underneath the bed in a bedroom. Other documentation was found in a warehouse in Hackensack, New Jersey, across the Hudson River from Manhattan.

RETURNING WITH STOLEN TREASURES

In total, the Presidential Commission on Good Government reconstructed a list of 151 works, of which no trace could be found: paintings, drawings, and pastels by Francis Bacon and Jan Brueghel the Younger, Paul Cézanne and Marc Chagall, Oskar Kokoschka and René Magritte, Piet Mondrian and Édouard Manet, Paul Signac and Alfred Sisley, Jan van Eyck and Rembrandt van Rijn.

Imelda Marcos surrounded herself shamelessly with fifteen of the paintings that were sought when she returned to the Philippines from her American exile in 1991. She was elected as a representative in the Philippine legislature in 2010. She allowed herself to be photographed and filmed many times in one of her former residences, on Don Mariano Marcos Street at the corner of P. Guevarra Street in Manila's exclusive San Juan City district. Among the paintings hanging on the walls were: the alleged Michelangelo, *Madonna with Child*, the supposed Goya painting of the Marchioness de Santa Cruz; impressionist works such as Pierre Bonnard's painting *La baignade au Grand Temps*, Camille Pissarro's *Kew Gardens, Near the Greenhouse, Still Life with Idol* by Paul Gauguin, *Dawn* by the Spanish surrealist Joan Miró, *Vase with Chrysanthemums* by Bernard Buffet, and *Reclining Woman VI* by Pablo Picasso. It is still unexplained how Imelda Marcos succeeded in holding on to these works during her fifteen years in exile, hiding them, and getting them back when she returned to Manila. Marcos loyalists in the ministry of justice and the police probably tipped her off to the raids, and the works of art were likely removed and stored with friends and relatives.

The homes of Imelda Marcos's three children were not searched. A friend of Irene Marcos and her husband Greggy Araneta later remembered a visit to her house in Woodside, California. He saw a dozen paintings in the garage, carelessly strewn about and stacked, and he recognized a Renoir. Apparently, the discovery was not reported.

Back in Manila, the First Lady, who had been driven into exile and had returned and was still beloved by parts of the populace, could still claim that she bought these artworks with her own money and so they belonged to her legitimately. A Philippine court saw the matter differently and ruled that they had been paid for with embezzled money. On September 29, 2014, the court ordered that the works should be removed from the Marcos residence for the benefit of the state. When the investigators attempted to gain entrance to one of Imelda Marcos's homes, the sheriffs were kept waiting outside for an hour. When they

were allowed inside, they came upon a crying presidential widow and empty walls on which picture hooks still hung. Her legislative office and her parents' home were also searched. Fifteen works were impounded and deposited in a safe in the Bangko Sentral ng Pilipinas.

The government commission was also successful in recovering Picasso's *Head of a Woman* (1954), of which there had been only the brass plaque with its name remaining at the mansion on East Sixty-Sixth Street. Louis Singer, a lawyer in Upland, California, delivered the painting in December 1997 to Christie's at the request of a client. The undisclosed seller did not want to blow his cover as he was about to lose the Picasso following demands from the government in Manila. A New York court permitted the auction, which took place on May 13, 1999. From the proceeds in the amount of $992,500, the Manila government and a Philippine human rights organization received an unspecified share.

In the end, Vilma B. also played a central role in the search for the Marcos pictures. And she continues to play a role today, since the former secretary who served the dictator's wife is possibly the only person who knows where the more than one hundred works of art that were spirited away from various properties in Manhattan, and are still missing, might be hidden. And once again it's a question of money, a whole lot of money.[122]

Many witnesses reported that on the same night that the Marcoses fled Manila, February 26, 1986, a large truck was loaded with artworks in front of the townhouse on East Sixty-Sixth Street, directed and supervised by Vilma B. After that historic night, most of the paintings, furniture, and Ming vases transported from the townhouse have disappeared. Vilma B.'s crucial involvement in this operation was first uncovered a quarter century later when one of the missing artworks resurfaced.

After the September 11, 2001, attacks, the Major Economics Crimes Bureau (MECB) of the Manhattan district attorney's office began monitoring unusual flows of money with greater attention than before. When, in September 2010, the sum of $28.1 million was transferred into

a money market account belonging to Vilma B., there was an investigation. On April 13, 2011, at 7:45 a.m., the investigators Donato L. Siciliano and Edward Starishevsky, on behalf of the Manhattan District Attorney's office, stood in front of B.'s home at 188 East Sixty-Fourth Street, apartment 703.[123] When the doorman called the seventy-three-year-old B. down to the lobby, she spoke with the officials—and told a strange story about where the money came from. She said that she had worked for Imelda Marcos for over thirty years, talked with her regularly, and had often received presents of jewels and works of art from the former First Lady of the Philippines. Some of them she kept, others she sold, she said. And then she said this: she had parted with a landscape painting whose title and artist she did not want to name. She said it was about two meters by two meters in size.

Vilma B. also did not want to disclose why she had sold this painting at exactly this moment. But she did say that she had given a portion of the proceeds from the sale to the Marcos family. She declined to say more. She told the investigators that Imelda Marcos had given her the picture twenty or thirty years earlier and she had kept it since in her apartment on Long Island—without security. She added that a Brazilian or Panamanian firm named "Dalek" had picked up the painting just before it was sold.

HOW DOES ONE SELL A $35 MILLION MONET?

The investigators only gradually reconstructed how these events had actually played out. The painting that Vilma B. had sold was one of the famous water-lily pictures by Claude Monet—one of the sought-after versions of 1899 with the view of the small Japanese bridge that crossed the pond in the painter's garden at Giverny. The work did not appear on the list of lost or stolen items assembled by the Philippine government. Plainly, Imelda Marcos had stashed it away early on without leaving any clues behind. Thus, Vilma B. could tell the investigators honestly that she had not sold an artwork that was sought by the government.

After a first attempt to sell it failed in 2009, B. employed two inter-mediaries that she knew from the real-estate world, Diane D. and Barbara S., who were active at the time from their shared office on Madison Avenue. According to their own statements, the two ladies, then sixty-three and sixty years old, got in contact with Acquavella Galleries, a firm on Manhattan's Upper East Side that specialized in classic modernism and contemporary art. On April 9, 2010, in Vilma B.'s apartment, a director of the gallery gave her expert opinion on the extremely well-preserved Monet, which was wrapped in a blanket. Her nephew filmed the visit with his video camera. The price named for the painting was $35 million. It was transported the next day to the gallery's space on East Seventy-Ninth Street for further examination and negotiations.

That was when the staff at Acquavella began to have doubts. Not about the authenticity of the painting—of that, there was no question. But rather whether Vilma B. was the rightful owner of the artwork. All that she presented by way of proof was a certification dated 1981, allegedly signed by Imelda Marcos and witnessed by a notary. The gallery requested more current documentation. Staff members even offered to fly to Manila to obtain confirmation from Imelda Marcos that she had given the Monet to B. When she refused, the deal fell through. It came out later in court that the notary listed had never witnessed the signature of Imelda Marcos. Emails from B.'s nephews, Pongsak N. and Chaiyot Jensen N., played a role in the proceedings. They spoke of a necessity to offer the picture "on the black market" and "at a lower price": "I don't want to go to prison if I try to get the authenticity confirmed." Moreover, there were discussions of setting up a letterbox company in Bangkok "to cleanse the picture." There was obviously some awareness that the valuable Monet painting had been bought with "ill-gotten money" and probably still belonged to Imelda Marcos.

Nonetheless, the efforts to sell the painting continued. Diane D. and Barbara S. made contact with the London gallery Hazlitt, Gooden & Fox and offered the painting through an intermediary for just $32 million.

Once again there was a request for more current documentation of ownership rights, but in the end a "letter of explanation" was accepted, in which the former secretary again confirmed that she was the owner. In their email correspondence, the nephews wrote, "[The gallery] is prepared to find creative ways to get the documentation that they need. They will only ask for a signature appended to the explanation." Five days later the sale was completed.

The new owner of the Monet painting through which the art sales by Imelda Marcos and Vilma B. came to light was the British hedge-fund manager Alan H., whose company had its headquarters in the tax havens of Jersey and the Cayman Islands and whose worth is estimated to be over $2 billion. Allegedly, firms registered in Panama and the British Virgin Islands were involved in the transactions. According to press reports, the gallery earned a fee of $7.5 million from the sale, valued at $43 million.

The new owner had to ante up a bit more in the end. In 1995, 9,539 Philippine people brought a class-action lawsuit against the Marcoses for human rights violations. A court in Hawaii awarded them the record-breaking sum of $1.9 billion, which first had to be found somewhere. The representatives of the lawsuit by the Marcoses' victims made a claim in a New York court to all assets belonging to the family of the dictator that could be seized. Included in this reckoning were, apart from a $35 million bank account at the New York office of Merrill Lynch, the water-lily painting by Monet that now belonged to Alan H. The same claims were also made by each of the successor Philippine governments after 1986, using the argument that the money belonged equally to all the citizens of the Philippines. To extricate himself from this dilemma, H. gave the representatives of the Marcoses' victims $10 million in fall 2013.[124] The government maintained its position that Vilma B. never had the right to sell the Monet painting in the first place.

The real-estate brokers D. and S. each got $1.9 million for the seven months that they were involved, and a person allegedly

working with the Philippine government in the negotiations by the name of Gavino A. received $1 million. Vilma B. wired $5.1 million to her two nephews and $2.7 million to other relatives. She admitted that she had sent the Marcos family some of the money from the sale of the Monet, but she didn't state an amount. She bought a co-op apartment in Manhattan for $2.2 million, allegedly for her sisters and herself. She spent $637,000 to pay off a mortgage and $1.3 million on an insurance plan and a retirement pension. Fifteen million dollars remained in her account from the sale of the Monet. Apart from the accusation of conspiracy, Vilma B. was also accused of tax evasion: in her tax filing for the year 2010 she had stated that her income was just $11,000.

In November 2012, B., then seventy-four years old, was arrested and charged with fraud, conspiracy, and tax evasion. She had apparently also tried to sell other selections from the approximately fifty artworks of the former Marcos collection that she still had: the landscape painting *Langland Bay* by the impressionist Alfred Sisley, the Algerian panorama *Le Cyprès de Djenan Sidi Said* by Albert Marquet, and another Monet painting, *The Church and the Seine at Vétheuil* (1881). In addition, the investigators uncovered several accounts, each with tens of millions of dollars. Surprisingly, the district attorney Cyrus Vance justified the allegations in part by saying that "the integrity of the international art market must be protected."

A jury of the State Supreme Court of New York found Vilma B. guilty in January 2013, and she was sentenced to six years and ordered to pay $3.5 million in taxes—although her lawyer had argued that the accused had wanted to give the proceeds to the Philippine government. Judge Renee A. White, to the contrary, spoke of "overwhelming proof." After posting bail in the amount of $175,000, B. remained free at first because of a heart condition. She appealed several times but began to serve her time in December 2017. The Philippine government and the fund for the Marcoses' victims continued to dispute ownership of the artworks found in B.'s possession.[125]

Dozens of other artworks remained missing. After her return to the Philippines, Imelda Marcos ran for the presidency and lost, despite her persistent popularity. She has served as a representative in the Philippine parliament continuously since 1995 and therefore, like many of her relatives, enjoys immunity from various accusations and charges. Up until the class-action complaint by the human rights victims, Imelda Marcos never lost a case. Recently Philippine governments have expressed little interest in continuing to search for her luxury goods that have disappeared or trying to give the proceeds from the sale to the victims of the Marcos regime. For example, the collective of Philippine farmers complained that the then current president Gloria Macapagal Arroyo had financed her campaigns since 2004 with money from the Swiss bank accounts of the Marcoses. Documents published in 2013 name the Marcos family as the beneficiary of at least one offshore company, the Sintra Trust, which still exists in the tax haven of the British Virgin Islands.[126] In 2016, the highest court in the Philippines ordered that Ferdinand Marcos be buried with honor in the heroes' cemetery in Taguig City.

Imelda Marcos herself has provided no information about the missing works of art. The Presidential Commission on Good Government still doesn't know how to locate Van Gogh's watercolor, the supposed Rembrandt, the Cézanne landscape, the pictures by Mondrian, Magritte, Manet, and Modigliani, and the painting by Pierre-Auguste Renoir that was hidden in a California garage, and which wasn't even on the government's official list of lost items.[127] A court in Manila in December 2019 once again ordered the Marcos family to return more than one hundred works of art worth in excess of $24 million.

THE OTHERS

Ferdinand and Imelda Marcos were not the only rulers who robbed their people and invested the booty in works of art. The former Indonesian president-dictator Haji Mohammad Suharto (1921–2008) and the

Congolese dictator Joseph-Désiré Mobutu (1930–1997) are considered kleptocrats that defrauded their peoples of tens of billions that they secreted abroad.

Both apparently had no ambitions to surround themselves with valuable art or to use art dealers to send money out of the country. Mobutu invested the money—allegedly up to $50 billion, which he and his family extracted through compulsory payments from companies and through corruption—principally in real estate: a sixteenth-century castle in Spain, a thirty-two-room palace in Switzerland, and other luxury homes on the French Riviera, in Paris, and in the Ivory Coast. Like the enormous palace near his birthplace in Gbadolite, these homes were outfitted with Louis XIV furniture, Chinese porcelain, and Carrara marble, rather than important works of art. To be sure, Suharto had allowed works of art to be bought and distributed among his dwellings and government and ceremonial buildings, primarily works by Asian artists, but it would be an exaggeration to speak of him as a collector. Similarly, after the authoritarian ruler of Tunisia, President Zine el-Abidine Ben Ali, was toppled, the Tunisian government auctioned off his possessions, but it was mostly a matter of real estate and fancy cars, such as an Aston Martin and a Lamborghini.

To the contrary, Farah Diba, whose husband, the Shah of Iran, crowned her empress in October 1967, had art advisers and dealers, primarily in New York, London, and Paris, who purchased art from the nineteenth and twentieth centuries on her behalf, using state funds. Her acquisitions included important work by twentieth-century masters Jackson Pollock, Andy Warhol, Roy Lichtenstein, Willem de Kooning, and Pablo Picasso, and by nineteenth-century masters Edgar Degas, Paul Gauguin, Camille Pissarro, and Claude Monet. These paintings and sculptures could be seen publicly starting in 1977 in the contemporary art museum in Tehran, where most of them remained after the so-called Islamic Revolution.

A year after the fall of the dictator Jean-Claude Duvalier (1951–2014), representatives of the Haitian government discovered, in 1987,

fifty-six valuable paintings by Haitian artists in a storage area belonging to Security Storage Co. in Washington, DC. The pictures, allegedly from the collection of a close Duvalier adviser, were part of a touring exhibition that traveled to various US cities between 1978 and 1982 and were later stored in the capital.

Swiss authorities in Geneva seized eleven luxury automobiles that were about to be brought to the airport for export by the son of the dictator of Equatorial Guinea, Teodoro Obiang Nguema Mbasogo, whose people live in abject poverty despite enormous oil revenues.[128] French investigators found art worth millions of dollars in a four-thousand-square-meter villa with 101 rooms in the deluxe sixteenth arrondissement in Paris: pictures by Edgar Degas, Paul Gauguin, and Pierre-Auguste Renoir, five sculptures by Auguste Rodin, and other works that the African kleptocrat had bought at the auction of the estate of Yves Saint-Laurent.[129]

In the summer 2016 it became apparent that even supposedly democratic governments misuse works of art as a convenient way to dispose of private money. The government of Malaysia had established a fund in the Cayman Islands called 1Malaysia Development Berhad (1MDB) for international information, and the Malaysian prime minister Najib Razak quickly assumed the position of chairman of the board of directors. By 2015 the fund was in debt to the tune of tens of billions of dollars and threatened to bankrupt the nation. After a blog reported huge transfers of money to a Swiss bank account, a financial watchdog in Singapore went to work. Indeed, regulators found $681 million in a private account in Switzerland belonging to the head of state, who claimed that it was a gift from the Saudi royal family.[130] Razak's friend and art collector, Low Taek Jho, is said to have invested massive sums from the state fund not only in real property, airplanes, music rights of the company EMI, and the Hollywood film *Wolf of Wall Street*, starring Leonard DiCaprio, but also in expensive works of art. (See, generally, Chapter 6.)

The Malaysian authorities investigated Najib Razak for several years. Shortly before publication of the complaint against Razak, the

chief public prosecutor was dismissed from office. In the court in Kuala
Lumpur in which the trial on suspicion of corruption and money laundering began in April 2019, he repeatedly emphasized his innocence with respect to all seven charges, and more recently again in December 2019. In July 2020, he was found guilty in the first of a total of five proceedings, which allege altogether forty-two criminal charges in the indictments against him. In the opinion of the investigators, banks in Switzerland and Luxembourg were also involved. Investigations have been underway in Switzerland for several years concerning corruption and money laundering.[131] The *Wall Street Journal* reported that the US investment bank Goldman Sachs made an offer to the US Department of Justice to pay a financial penalty of $2 billion for its involvement in Najib Razak's offenses.

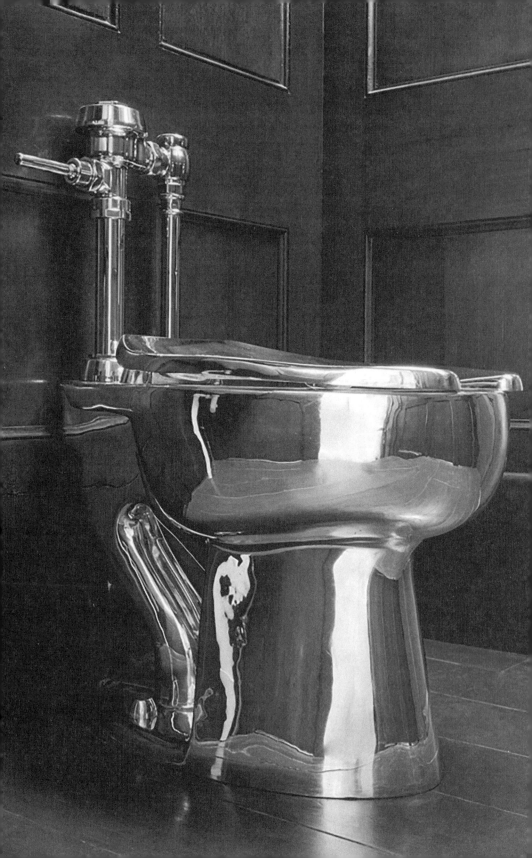

5

THE FAKES PRESIDENT

Donald Trump and Art

The verdict against the sitting president of the United States of America was a fine of $2 million. Moreover, he was ordered to dissolve his family foundation and transfer its assets to an organization that was actually directed toward the social good. It must have been especially painful for Donald Trump that it was a piece of art that led to this exceedingly embarrassing penalty. No US president has so aggressively advertised his anti-intellectualism or proved as antagonistic toward culture as Donald Trump.

This US president never had an emotional attachment to visual art but rather a strategic relationship, one that was not always legal. That differentiates him from most of his predecessors. When artworks and artists were pleasing decorative elements and useful to him, he happily surrounded himself with them. And when it served his purposes, he violated agreements and rules time and again. There are countless examples. Thus, for instance, there are several photos from the 1980s

that depict Trump and Ivana, his wife at the time, with Andy Warhol. The world-famous artist eventually developed a real antipathy toward Trump, as Warhol's meetings with him also concerned commissioned work and payment therefor, and the relationship soured. On other occasions, Trump claimed that he owned a masterpiece by one of the most important artists of French impressionism. In fact, the picture was demonstrably a copy, a forgery, or even a print. The US president nonetheless claimed several times that he had the original hanging on his wall. He had other works destroyed, although he had earlier promised them to one of the most important museums in the world for its collection. And the question of how Trump paid for the rare purchases of art that he made led to the legal proceeding referred to above, financial penalties, and the dissolution of the foundation through which Trump had for decades played at being a philanthropist. In fact, as the court found, he used the Trump Foundation for private acquisitions too. False attributions, broken promises, and illegal payments tell the larger story of Donald Trump and art.

Donald Trump appears to have no personal connection to visual art. For him, it's pure decoration. Other presidents consciously made political statements through their choice of pictures and sculptures for the Oval Office, but Trump had it decorated with new gold curtains.[132] His roomy, three-story apartment at the top of Trump Tower in New York is dominated by inoffensive art that is of no value (except, at best, as decoration), art which a person in Trump's circle would not consider a mistake, because it's standard issue for the white upper class, just like the fake ancient columns, marble floors, fireplace clocks, heavy gathered drapery, and voluminous upholstered furniture. At least since Ronald Reagan, Republicans have had a distant relationship to contemporary art, which doesn't tell heroic, patriotic stories, communicates mostly through indirect means, and, according to conservatives, tilts toward the progressive left. They still love the landscape paintings of the Hudson River School with their topographical, identity-building themes of discovery and settlement; the kitschy, banal scenes of Norman

Rockwell; and cowboy sculptures like the *Bronco Buster* by Frederic Remington, which likewise stood in Trump's office.

From other realms of culture there are reports of Trump's preference for straightforward action films, like those starring Jean-Claude Van Damme (*Bloodsport*),[133] or easily understood musicals like *Evita*, which Trump has said he's seen over and over. After the show about the wife of the former dictator of Argentina concluded its Broadway run, Trump still pined for it in his 2004 book *Think Like a Billionaire*:

"My favorite Broadway show is *Evita* by Andrew Lloyd Webber, starring Patti LuPone. I saw it six times, mostly with Ivana. *Evita* is not on Broadway right now, but I'm hopeful that they'll bring it back."[134] During Trump's 2016 presidential run, his campaign rallies featured music from *The Phantom of the Opera*, another play by Andrew Lloyd Webber, who was also Trump's former tenant.[135]

In the 1980s on the TV talk show *Crossfire*, the businessman was asked about his favorite book. His first answer was, "I think Tom Wolfe is excellent." When host Pat Buchanan asked about Wolfe's current bestseller *The Bonfire of the Vanities*, which he mistakenly called *Vanity of the Bonfires*, Trump answered that he hadn't read the book. Then the conversation segued into the following dialogue with Buchanan and his co-host Tom Braden asking what book his guest was currently reading, as reported by the news website *Political Flare*:

"I'm reading my own book again because I think it's so fantastic."—and Buchanan pressed him to name "the best book you've read beside *Art of the Deal*."

"I really like Tom Wolfe last book [sic]," Trump replied. "And I think he's a great author. He's done a beautiful job—"

"Which book?" Buchanan asked.

Trump: "His current book."

Buchanan: "*Bonfire of the Vanities*."

Trump: "Yes, and the man has done a very, very good job. And I really can't hear with this earphone, by the way."[136]

On several occasions, Trump named the Bible as his favorite book.[137] When Bloomberg Television asked about his favorite passage, Trump was unable to name even one.[138]

"Trump seems utterly confused in even defining the word culture," commented Virginia Shore about the president's preferences. Shore was formerly the chief curator of the State Department's Art in Embassies program, which since 1963 has commissioned US art for foreign embassies and consulates as a means of cross-cultural diplomacy. "I wish the president would spend time in a museum or gallery and learn the true meaning of culture."[139]

The president's distant relationship with art quickly bore consequences. During his first year in office, the sixteen artists, architects, and writers who sat on the President's Committee on the Arts unanimously resigned out of protest against the inappropriate comments by the president after the Nazi demonstration in Charlottesville, at which a woman was killed and nineteen people were severely injured. He maintained that leftist demonstrators were also guilty in these terrible events:

"I think there's blame on both sides. And I have no doubt about it, and you don't have any doubt about it either. . . . But you also had people that were very fine people, on both sides."[140]

A spokeswoman for the White House announced tersely after the resignation of these experts that the president had already planned to wind down the committee.

CHARITY MONEY FOR TRUMP PORTRAITS

Donald Trump obviously likes one type of artwork so much that he has been ready to spend money on it several times in the past, even if the money wasn't his own. These artworks aren't abstract or even political, but objective, very concrete, and, for Trump, transparent and easy to understand: they depict him.

The society painter Ralph Wolfe Cowan suggested painting his portrait in 1989. Trump didn't make a commission but signaled his agreement, after which Cowan presented him with several oil sketches.

Some of Cowan's other subjects had been the Philippine dictator's wife Imelda Marcos, the Sultan of Brunei, and King Hassan II of Jordan. The journalist Nicole Pasulka described Cowan's flattering style of painting: "In his paintings people are twenty pounds thinner and twenty years younger, often surrounded by heavenly light, riding exotic animals, or framed by mountain ranges."[141] The artist himself calls his style "romantic realism."[142] He portrayed Trump in a white tennis outfit beneath a somber sky from which presumably divine light shines down upon the earth. The title of the embarrassing painting was packed with heavy-handed symbolism: *The Visionary*. Mark Bowden, who much earlier wrote about the future president for *Playboy* magazine, analyzed why Trump, like other powerful men, fall for such art:

"The kind of painter he can appreciate, one who truly sees Trump the way he sees himself in the mirror, is West Palm Beach artist Ralph Wolfe Cowan, whose Sun God portrait of Donald hangs in the library at Mar-a-Lago. Cowan's portrait depicts a wide-shouldered, thin-hipped Donald, his youthful face eclipsing the sun itself, his skin glowing like the top floors of Trump Tower at sunset, the color of warm bullion."[143]

Nonetheless, there were soon problems getting paid. Cowan had deliberately left parts of the portrait as unfinished sketches: the left hand and parts of the left leg were only suggested. Trump didn't understand the artistic concept which didn't meet his expectations of an idealized representation. "When are you going to finish my painting?" he asked the painter. Cowan replied that the picture was finished. At some point, Trump asked Cowan how much it would cost to paint in the missing parts, and Cowan gave up his concept and painted in the rest in 2002.[144] A price of between $18,000 and $24,000 had been agreed upon for the picture. In the end, the artist gave Trump a 60 percent discount and opined later: "He always tried to bargain and I don't like that at all."[145]

Trump bought more pictures of himself. For some of them, it was later revealed that the vain businessman had not paid for them out of his own pocket but rather from funds that were actually set aside for

completely different purposes. Even for a sitting president, that would have consequences.

At a benefit auction in 2007 for the Unicorn Children's Foundation at his private club Mar-a-Lago in Florida, the millionaire bought a four-foot-tall depiction of his head painted by the Argentine artist Havi Schanz. Beneath his face, the lines of an architectural drawing shine through. The design was derived from a PR photo of Trump in a dark suit jacket and a blue-and-white tie and with a decisive look on his face. In 2000, when Trump first toyed with running for president, it appeared on the cover of the book *The America We Deserve*, which was written with a ghostwriter. Trump opened the bidding at $10,000 and, to his embarrassment, remained the only bidder. The larger-than-life-size portrait of his head didn't interest anyone else. The picture was gaveled off to the person it represented. Nonetheless, Trump proudly had himself photographed with the artist and the painting on an easel after the auction.

In that same year at a society benefit at Trump's Mar-a-Lago, the so-called speed painter Michael Israel painted the club's owner in five or six minutes. His wife Melania at first bid $10,000 for the unkind portrait of him in a blue tie. She was convinced by the auctioneer to double the price for the benefit of the organization Children's Place at Home Safe. But the check in payment, according to an investigation by the *Washington Post*, didn't come from the Trumps, but rather from the Trump Foundation. According to statements from an assistant to Israel, the picture was to be sent to Trump's golf club in Westchester County in New York.[146] Thus, money that the Trump Foundation had raised ostensibly to benefit the public good was in fact spent solely for the benefit of the foundation's president, Donald Trump, to avoid his having to personally make good on his wife's commitment to buy the painting. And that wasn't the only time this kind of thing happened.

Seven years later, Trump took a liking to the portrait that William Quigley had painted of him based on the same PR photo that Havi Schanz had earlier used as his model. It was this picture that years

later led criminal investigators to the trail of the money that Trump had used for many of his art buys. This time, Trump wanted to make sure that nobody should be left with the impression that only Trump was interested in buying his portrait. And he didn't want the price the portrait would bring to be so shamefully low. Trump therefore did some planning in advance—and after the auction he played at being pleasantly surprised:

"Just found out that at a charity auction of celebrity portraits in E. Hampton, my portrait by artist William Quigley topped list at $60K," the real-estate developer shared on Twitter on July 16, 2013.[147] He carefully concealed that he was the one behind the alleged record price and that once again he had illegally siphoned off funds from his public charity. But that wasn't the biggest problem for Trump that arose out of this auction.

Four days before Trump's tweet, Quigley's picture—a boring, large-format, head-and-shoulders portrait—had been auctioned off in fashionable East Hampton on the South Fork of Long Island. The sale, which Trump apparently wanted to use to embellish his reputation, didn't take place in one of the globally recognized auction houses, such as Sotheby's, Christie's, Phillips, or Bonhams, but rather in the much humbler rooms of the artist's studio-gallery. Not much earlier, Quigley had opened his space on Newtown Lane, not far from the center of the town of twenty-one thousand people. To draw the attention of the well-to-do local citizenry to his new atelier, the artist organized an auction in connection with a reception for an exhibition called *The Pleasurists*. Part of the proceeds were to be given to the Guild Hall of East Hampton, a cultural center founded in 1931 that includes a small museum.[148]

According to the local newspaper, only three pictures were to be offered, including a portrait of the actor Ethan Hawke and that of Donald Trump. Quigley's mother had suggested that Trump might be good material, Quigley said later, and she recommended the TV show *The Apprentice* as a possible way to learn more about the business world. Without a commission, the painter began the portrait in 2006: a bust

portrait of him in a dark suit and a red tie. The style is conventional; the portrait of Trump looks almost like a photograph that's been painted over. To someone who doesn't understand very much about painting, the pseudo-expressionist brushstrokes might look daring. But, in fact, they aren't: the representation of Trump doesn't express in any way the artist's take on his subject. According to his own statements, Quigley finished the picture in 2011 and adjusted it quickly for age. The face didn't look quite as young as the one in the photo on which the painting was based, and orange-colored accents glowed in the subject's formerly dark hair.

Mediocre pictures like this can be still be seen by the dozen on William Quigley's website today: Michael Jackson, Arnold Schwarzenegger, Mick Jagger, Paul Newman, Ray Charles, Bob Dylan, Johnny Cash, Frank Sinatra, and so on. And Abraham Lincoln and Elvis Presley aren't the only ones who didn't know about their portraits.[149] William Quigley told the local weekly Hamptons newspaper *Dan's Papers* that Donald Trump had apparently gotten wind that his portrait was going to be auctioned in fashionable East Hampton. And he had expressed an interest. That's why the starting bid price was increased, the artist said—"so as not to embarrass Trump."[150]

Trump didn't bid himself, as his former attorney Michael Cohen admitted six years later before the House Committee on Oversight and Reform, the congressional committee tasked in 2019 with investigating Trump's business practices, his connections to Russia, and the possible manipulation of the 2016 presidential election. The fifty-two-year-old attorney, who had worked for Trump for many years and, as the legal adviser for his election team, had arranged the payment of hush money to a woman who claimed to have had an affair with Trump, testified before the committee on February 27, 2019. There he provided some interesting details about the art auction in Long Island:

> Mr. Trump directed me to find a straw bidder to purchase a portrait of him that was being auctioned at an Art Hamptons event. The

objective was to ensure that his portrait, which was to be auctioned last, would go for the highest price of any portrait that afternoon. The portrait was purchased by the fake bidder for $60,000. Mr. Trump directed the Trump Foundation, which is supposed to be a charitable organization, to repay the fake bidder, despite keeping the art for himself. Please see Exhibit 3B to my testimony.[151]

William Quigley identified the strawman bidder as Trump's friend, the billionaire Stewart Rahr,[152] founder of the pharmaceutical company Kinray Inc., which was acquired at the end of 2010 for $1.3 billion by Cardinal Health Inc.[153] The artist recalls that Trump paid personally: "Quigley met Trump in person to pick up the check—which came out to $67,000. 'He was nothing but a gentleman,' he recalls."[154]

The check was not, however, drawn on an account belonging to Donald Trump, as Michael Cohen testified before the US Congress. In his testimony, the attorney presented—in his own words—"a copy of an article with Mr. Trump's handwriting on it that reported on the auction of a portrait of himself—he arranged for the bidder ahead of time and then reimbursed the bidder from the account of his nonprofit charitable foundation, with the picture now hanging in one of his country clubs."

What is probably his most famous sale, the portrait of Donald Trump modeled on the PR photo, can no longer be found on Michael Quigley's website. He has stated that he donated a modest 10 percent of the auction price for the picture to the Guild Hall of East Hampton.[155]

Not only had Trump lied in making a pretense of surprise in his tweet after the auction, he himself had orchestrated the high price and financed it. In order to benefit himself and present himself publicly in a favorable light, he had also used funds that, under the charter for his foundation, were intended for charitable purposes. This violation of the rules would have consequences for him only after he had won the election and become president of the United States, when the strange business practices of the Trump Foundation came to light—illegally financing both the vanity of its founder and his presidential campaign.

In November 2017, New York State judge Saliann Scarpulla ordered "Donald J. Trump to pay $2 million in damages for improperly using charitable assets to intervene in the 2016 presidential primaries and further his own political interests."[156] The payment was part of a settlement in a legal proceeding against Donald Trump, his sons Donald Trump Jr. and Eric, as well as his daughter Ivanka, as New York attorney general Letitia James explained: "Chiefly, Mr. Trump admits to personally misusing funds at the Trump Foundation, and agrees to restrictions on future charitable service and ongoing reporting to the Office of the Attorney General in the event he creates a new charity. The settlements also include mandatory training requirements for Donald Trump Jr., Ivanka Trump, and Eric Trump."[157] The proceeding was halted in return for the settlement. The nonprofit, founded in 1987, had to be terminated and liquidated, however, with its remaining assets distributed to other nonprofit organizations.[158]

"ABSOLUTELY GROSS DEGENERATE STUFF"

With respect to contemporary art in particular, Donald Trump's aesthetic horizons don't stretch far, and he's short on patience. Trump's non-relationship with visual art has yet another peculiar quality that leads him to disregard boundaries and go too far, aesthetically as well as legally.

In what he claims as his autobiography, the 1987 *Art of the Deal*, whose true author has since revealed himself to be the journalist Tony Schwartz, Trump quite openly admitted his particular dislike of modern and contemporary art:

> A friend of mine, a highly successful and very well-known painter, calls to say hello and to invite me to an opening. I get a great kick out of this guy because, unlike some artists I've met, he's totally unpretentious.
>
> A few months back he invited me to come to his studio. We were standing around talking, when all of a sudden he said to me,

"Do you want to see me earn twenty-five thousand dollars before lunch?" "Sure," I said, having no idea what he meant. He picked up a large open bucket of paint and splashed some on a piece of canvas stretched on the floor. Then he picked up another bucket, containing a different color, and splashed some of that on the canvas. He did this four times, and it took him perhaps two minutes. When he was done, he turned to me and said, "Well, that's it. I've just earned twenty-five thousand dollars. Let's go to lunch."

He was smiling, but he was absolutely serious. His point was that plenty of collectors wouldn't know the difference between his two-minute art and the paintings he really cares about. They were just interested in buying his name.

I've always felt that a lot of modern art is a con, and that the most successful painters are often better salesmen and promoters than they are artists. I sometimes wonder what would happen if collectors knew what I knew about my friend's work that afternoon. The art world is so ridiculous that the revelation might even make his paintings *more* valuable! Not that my friend is about to risk finding out.[159]

Whether there ever was this painter friend, or if Trump-Schwartz had only invented him as a vehicle for Trump's own populist opinions about the supposed mechanisms of the art world, is not known. Trump's prejudices are the same time and again, on those occasions when he is unable to avoid contact with the topic of art and culture.

In 1999, then New York mayor Rudolph Giuliani, who would later become President Trump's controversial legal adviser, threatened the Brooklyn Museum with financial consequences. As part of the exhibition *Sensation*, the respected museum had included provocative artworks that earlier had been shown at the Royal Academy of Arts in London and in the Hamburger Bahnhof museum in Berlin. Among the works exhibited from the collection of the British advertising magnate Charles Saatchi there was the painting *Myra* by Marcus Harvey, which

was based on the police photograph of a woman who had killed children. This piece had already been defaced twice in London, once with ink and again with eggs.

In particular, an assemblage entitled *The Holy Virgin Mary* by the British painter Chris Ofili, who is of Nigerian ancestry, was shown in the exhibition. Vehement protest erupted because of this representation, in which Mary has black skin and is depicted through a collage of pornographic magazines, but most especially because her exposed breast is made of dried elephant dung and the picture leans against the wall, resting on two balls made of the same material. Leading the charge, Mayor Giuliani declared that the artwork was "sick" and "blasphemous" and demanded cancellation of the show before it opened. He revoked $7 million in city funding for the museum and threatened to take away the museum's building. Giuliani claimed that it wasn't censorship but "rather a correct use of public funds."[160] Only in 2019 did a court finally decide that these actions by the conservative politician were a violation of the museum's right to artistic freedom.[161] The picture was subsequently defaced with white paint in New York. The planned fourth stop for the exhibition at the National Gallery of Australia in Canberra was called off by that museum.[162]

Donald Trump was among the few who supported Giuliani in his undemocratic effort to stifle artistic expression in 1999. Trump was then considering a run for the presidency for the first time, and he hoped that the City of New York would build an expressway that would improve the location for one of his construction projects. The possible candidate provided a statement to the tabloid newspaper *Daily News*: "As president, I would ensure that the National Endowment of the Arts stops funding of this sort." Apart from the mistake in the name of the NEA—instead of "of" it should be "for"—the newspaper noted correctly that the government cultural-funding organization had not, in fact, provided any money at all for the *Sensation* exhibition. Trump stated with respect to Ofili's picture: "It's not art. It's absolutely gross, degenerate stuff."[163] The art magazine *ARTnews* opined on this choice of words: "Note the word

'degenerate.' There was, of course, another politician who used that adjective to describe works of art that offended him." The reference is to Adolph Hitler.[164]

Donald Trump maintained his personal opposition to the National Endowment for the Arts. Shortly after his election, he indicated that he might want to select *Rambo* star Sylvester Stallone as the new chairperson of the NEA, the organization that still provides some very low level of public funding to cultural institutions in the US, which otherwise depend entirely on private donations. Stallone, at least, paints some and owns a respectable art collection—works by Claude Monet, Francis Bacon, and the German painter Anselm Kiefer, for example.[165] When some straw fell off one of Kiefer's works, the actor simply glued it back on himself. Later he sold the large-format piece, for family reasons: "My wife thought it could make the children depressed."[166] Diplomatically, but decisively, the actor turned down the cultural post.

The NEA had its headquarters in the historic Old Post Office Pavilion on Pennsylvania Avenue in Washington, DC, in immediate proximity to the White House. After a consortium led by Donald Trump's investment company DJT Holdings LLC was able to lease the 114-year-old building from the US government beginning in 2013, the arts-funding organization had to find new space, because the building was to become a hotel after a $212 million makeover. The Trump International Hotel Washington, DC, opened with a media splash in September 2016 during the presidential election. The NEA had to relocate to a functional office complex in the southern part of the city. When Trump announced his plans for the hotel before construction began, he told the *Daily Post*, "Friends of mine, they spend these ridiculous amounts of money on paintings. I'd rather do jobs like this, and do something really that the world can cherish and the world can see and that everyone in DC can truly be proud of."[167]

In budget plans, the Trump administration sought time and again to kill financing for the NEA, which had been only a more or less symbolic $30 million annually. Congress blocked this move for the fiscal

year 2018–19 and voted to increase the NEA budget by $3 million.[168] For 2020–21, the elimination of funding for the NEA was once again on Trump's agenda.[169]

GOLD INSTEAD OF GOGH

The reaction of the Guggenheim Museum in New York was appropriately sarcastic when the Trumps, who were moving into the White House, requested the loan of a painting by Vincent van Gogh. There was a long tradition of presidents being lent artworks from public collections. When her husband was elected president, Jacqueline Kennedy at once banished the dreary furniture from the Truman era and hung modern art on the walls of the White House. She asked the director of the nearby National Gallery, John Walker, for the loan of, among other items, four paintings by Paul Cézanne, and he agreed. In 1952, the First Lady had a documentary about the White House made for TV in which she expressly referred to the pictures on the walls. That Jacqueline Kennedy knew something about art was no secret after the film. As First Lady, Hillary Clinton selected a painting by Georgia O'Keeffe, along with other works. Michelle Obama ensured that works especially by women and people of color graced the rooms of the White House. For her own collection of art in the White House, she had acquired, among other pieces, an abstract representation of a glowing colorful circle in yellow, orange, and blue, which was to be hung above the table in the family dining room. The artist who created the painting, Alma Thomas, was the first Black female artist to enter the White House collection. Among his selections, President Obama hung two works on loan from the Whitney Museum of America Art: paintings by Edward Hopper that depict not so much the American Dream but American loneliness.[170]

It isn't known why the White House at the behest of Donald and Melania Trump asked the Guggenheim specifically for Vincent van Gogh's *Landscape with Snow*, a view of Arles in the South of France that shows a lone rambler with his dog. The response by the curator Nancy Spector to the request, however, was no secret. The respected art

historian replied to her professional colleague Donna Hayashi Smith at the White House that unfortunately the request could not be granted. As the artist had agreed, she could offer, nonetheless, a different work of art: the hundred-kilogram, eighteen-karat gold toilet that Maurizio Cattelan had fabricated "should the President and First Lady have any interest in installing it in the White House. It is, of course, extremely valuable and somewhat fragile, but we would provide all the instructions for its installation and care."[171] Spector said that more than a hundred thousand people had already used the object while it was installed in the Guggenheim Museum in 2016–17. Now, she added, Cattelan was ready "to offer it to the White House for a long-term loan."[172] The evocative title of the work: *America*.

Spector's witty, courageous, polysemous answer was at once taken by the public exactly as it had been intended: an affront to the sitting president of the United States and his empty slogan "Make America Great Again." A commentator on Fox, the TV network devoted to Trump, demanded the immediate resignation of the art historian.[173] There was, however, no word from the presidential couple in the White House. The request to the Guggenheim and the gutsy reply to it remain as public symbols of the impaired relationship of the US museum community to this art-phobic president. And not without reason.

BROKEN PROMISES

Conversely, the relationship of Donald Trump to the museum as an institution appears to have been permanently damaged early on. He refused to donate artworks that he had promised to the Metropolitan Museum of Art and instead had them destroyed, along with a venerable building that had played an important role in American art history.

At that site, the intersection of Fifth Avenue and Fifty-Sixth Street in Manhattan at which Trump constructed his prestige project, Trump Tower, between 1980 and 1982, the flagship store of the luxury department store chain Bonwit Teller & Co. had earlier stood. The 1929 building was the work of the same architects who had designed Grand

Central Terminal, Whitney Warren and Charles Wetmore. It was intended originally to house the women's department store Stewart. Bonwit Teller, who took over the building in 1930 and opened it anew, soon began working with world-famous artists. Starting in 1936, the Spanish surrealist artist Salvador Dalí regularly decorated the windows with spectacular installations—as he did, for example, in 1939, working with the theme "night and day."[174] In the 1950s, Jasper Johns and Robert Rauschenberg worked for the company on the side as window dressers, using the pseudonym "Matson Jones." Among other things, Johns displayed his now iconic painting *Flag on Orange Field* behind a mannequin in the windows in 1957. That same year in the same place, Rauschenberg showed his *Red Combine Painting*, along with others. Two years earlier, the large photographic work *Blue Ceiling Matson Jones* could be seen in the background of the Bonwit Teller windows.

In 1959, James Rosenquist was also working for the department store. A half century later, he recalled: "By the late 1950s I'd begun to lead a double life. In the daytime I painted billboards and designed display windows for Bonwit Teller, Tiffany, and Bloomingdale's; at night and on weekends I hung out with artists and painted."[175] In 1961, five large-format paintings, by the then almost completely unknown artist Andy Warhol, stood and were hung in the windows on Fifth Avenue. Warhol was then earning his living mostly with advertising assignments, starting in 1951 with work for the Bonwit Teller display director Gene Moore. At the time, this descendant of Carpatho-Rusyn immigrants was not taken seriously as a painter. Ten years later, Warhol changed his approach, putting his own works in the windows of Bonwit Teller, and his global career took off.[176] Today a museum director would kill for one of these paintings—among them, the now famous *Blast*, with its Superman theme, and *Before and After 1*, which depicts a nose job. "For more than 50 years, Bonwit Teller had an eye for the New York avant-garde art scene," as the scholarly publication *The Art Story* summarized the meaning of this New York art site. "Under Moore's direction

in the midcentury, Bonwit Teller gave many modern artists their starts in the world of art and design. With free creative reign, avant-garde artists experimented in the department store window, turning a glass case into an alternative art space, and introducing the public to new and exciting styles."[177]

This part of the history of art and of New York City appears to have eluded Donald Trump. And that's not all: the developer wasn't even willing to save the artworks inside the building from destruction—breaking a promise to the renowned Metropolitan Museum of Art, which is nearby—because profit and time were dearer to him than culture.

After all, Trump hadn't bought the Bonwit Teller building for $15 million in 1979 when the department store went bankrupt[178] in order to preserve an historical monument. He wanted to create a monument to himself: Trump Tower. The demolition was already decided upon when the contracts were signed. And the art that decorated the building was only of interest to the developer for a short time, when he believed that he could do some business with it and buff up his reputation—Trump's eternal principle when it comes to art.

Close to the top of the eleven-story building there were two limestone relief panels of two nearly naked women brandishing large scarves, as if dancing, in which the Metropolitan Museum of Art had expressed a strong interest for its sculpture collection.[179] The Metropolitan, one of the largest and most important museums in the world, had also wanted to add to its department of applied twentieth-century art the six-by-nine-meter, geometric-patterned bronze latticework that hung over the entrance at Bonwit Teller. By all accounts, Trump had agreed to donate both, if his workers were able to remove them from the walls.[180]

The *New York Times* and the *Washington Post* reconstructed what happened next. Their investigations demonstrated that Trump had not just broken his promise and destroyed valuable art. The journalists discovered that, when his cultural crime caused an uproar, Trump hid behind a pseudonym and lied to the public: "What followed was a display of arrogance, excuse-making and avoidance of tough questions

that is familiar to anyone who has observed Trump's interactions with the media throughout his campaign for the White House."[181]

When journalists asked the Trump Organization about the existence of the two limestone Art Deco friezes, a spokesperson going by the name John Barron replied that three independent experts had found that the works had "no artistic value" and were worth, at most, an estimated $9,000.[182] According to "Barron," the removal would have cost $32,000 and would have meant a week and a half delay of the demolition work. The alleged costs for the delay were later calculated by Trump's side to be $500,000.[183] The next day "Barron" was quoted as saying that the bronze latticework that had hung over the entrance to the Bonwit Teller building was also missing: "We don't know what happened to it." The artist Otto J. Teegan, who had designed the piece in 1930, responded, "It's not a thing you could slip in your coat and walk away with."[184] "It's odd that a person like Trump, who is spending $80 million or $100 million on this building, should squirm that it might cost as much as $32,000 to take down those panels."[185]

The journalists didn't give up searching for these artworks that had been promised to the American public. Three days later, the *New York Times* wrote, "Repeated efforts over the last three days to reach Mr. Trump have been unavailing." On the fourth day, the real-estate developer contacted the journalists and explained that he had ordered the destruction of the Bonwit Teller reliefs himself: "Because their removal could have cost more than $500,000 in taxes, demolition delays and other expenses, and might have endangered passing pedestrians on Fifth Avenue. 'My biggest concern was the safety of people on the street below,' said the 33-year-old developer, who contended that cranes, scaffolding and the most careful handling could not have assured the safe removal of the cracked and weathered two-ton limestone panels from high on the building's facade. 'If one of those stones had slipped,' he said, 'people could have been killed. To me, it would not have been worth that kind of risk.'"[186] In truth, Trump's biographer Harry Hurt III confirmed, Trump himself ensured that the workers were told to remove

the bronze latticework over the entrance with blowtorches, separate the friezes from the walls with jackhammers and break them off with crowbars, and throw them down into the interior of the building where they shattered into a million pieces.[187] Ashton Hawkins, the vice president and secretary of the board of trustees of the Met, was among those outraged and told the *New York Times* in June 1980: "How extraordinary. I know that there was an offer of a gift in the event that the objects could be saved. I would think that would be sufficient to guide them in their actions. We are certainly very disappointed and quite surprised."[188] Hawkins dismissed with a single sentence Trump's argument that the sculptures had no value: "Can you imagine the museum accepting them if they were not of artistic merit?"[189] "The reliefs are as important as the sculptures on the Rockefeller building," elaborated the gallerist Robert Miller, who had assessed the reliefs. "They'll never be made again."[190]

Today, President Trump labels everything that doesn't conform to his political ideas "fake news," but he had to admit that he had adopted a false identity to explain his point of view to the public. The alleged press spokesperson John Barron, who sometimes called himself Barron and occasionally identified himself as the vice president of the Trump Organization,[191] was none other than Trump himself. In a legal proceeding in the US District Court for the Southern District of New York in Manhattan concerning the illegal employment of Polish workers in the building of Trump Tower for four dollars an hour,[192] Trump admitted that he and one of his executives had used the name John Barron in some of their business dealings.[193] Outside the courthouse, he explained confidently: "Lots of people use pen names. Ernest Hemingway used one."[194] Sometimes Trump used the alias "John Miller" for statements, such as those claiming that famous women like Madonna or Kim Basinger supposedly wanted to meet him.[195] In March 2006, Melania and Donald Trump named their son Barron.

Two contemptuous statements Trump made later in 1980 show that the Bonwit Teller affair, which did long-term damage to his reputation in New York's intellectual circles, continued to trouble Trump.

At an event in the Grand Hyatt Hotel in Manhattan, Trump, its owner, expressed his opinion about the table decorations made out of gold mylar and the lion's head medallions over the entrance to the ballroom: "Real art, not like the junk I destroyed at Bonwit Teller."[196]

And in the summer of that year, a *New York Times* story quoted Trump: "'There is nothing I would like to do more than give something to a museum,' he said in a recent interview. Why? 'I've always been interested in art.' A visitor observed that there was no art in Mr. Trump's office. The developer considered this for a moment. Then, with a smile, he pointed to an idealized illustration of Trump Tower hanging on one of the walls. 'If that isn't art,' Mr. Trump said, 'then I don't know what is.'"[197]

"I JUST HATE THE TRUMPS"

The skyscraper that in 1980 arose on the place where the Bonwit Teller Building had earlier stood was planned from the beginning as a monument to its builder. It seemed swiftly to dawn on Donald Trump that collaboration with the person who, at the time, was the most important artist in the New York art scene could glam up the meaning and reputation of the project, which had been damaged by the Bonwit Teller affair. He knew Andy Warhol personally, since the two had met in February 1981 at a birthday party for the notorious lawyer Roy Cohn. In the 1950s, Cohn had been one of the closest advisers of the communist-hunting senator Joseph McCarthy. Later, Cohn counted among his clients not only Cosa Nostra bosses, such as Anthony Salerno, Carmine Galante, and John Gotti, but also Donald Trump.[198] After their first meeting, Marc Balet, the art director of Warhol's magazine *Interview*, set up a visit to Warhol's famous Factory. In his posthumously published diaries, the artist wrote afterwards:

"Had to meet Donald Trump at the office (cab $5.50). Marc Balet had set up this meeting. I keep forgetting that Marc gave up architecture to become an art director, but he still builds models at home. . . . He told Donald Trump that I should do a portrait of the building that would hang over the entrance to the residential part. . . . It was so strange, these

people are so rich. They talked about buying a building yesterday for $500 million or something. . . . He's a butch guy. Nothing was settled, but I'm going to do some paintings anyway, and show them to them."[199]

A few weeks later, during a joint visit to the building site for Trump Tower by Balet and Warhol, Warhol's assistant Christopher Makos photographed the models of the future building. In Warhol's studio, a series of paintings in black, silver, and gold were made; some of them the artist coated in diamond dust.[200] There wasn't a contract. Warhol, who was always conscious of money, nonetheless noted hopefully in his diary on June 1, 1981:

"Marc's arranged it so that the catalogue cover he's designing will be my painting and then the Trumps would wind up with this painting of their building. It's a great idea, isn't it?"[201]

Two months later, the dreams of a new big customer were shattered. On August 5, Donald and Ivana Trump visited the Factory again:

"The Trumps came down. Donald Trump and his wife and two ladies who work for him, I guess. Mrs. Trump is six months pregnant. I showed them the paintings of the Trump Tower that I'd done. I don't know why I did so many, I did eight. In black and grey and silver which I thought would be so chic for the lobby. But it was a mistake to do so many, I think it confused them. Mr. Trump was very upset that it wasn't color-coordinated. They have Angelo Donghia doing the decorating so they're going to come down with swatches of material so I can do the paintings to match the pinks and oranges. I think Trump's sort of cheap, though, I get that feeling. And Marc Balet who set up the whole thing was sort of shocked. But maybe Mrs. Trump will think about a portrait because I let them see the portraits of Lynn Wyatt behind the building paintings, so maybe they'll get the idea."[202]

They did not. Not only did Trump not buy any of the Trump Tower paintings, he didn't commission a portrait from Warhol, who remained a mortal enemy of the developer from that point on. In May 1984, he recorded in his diary:

"And I just hate the Trumps because they never bought my Trump Tower portraits. And I also hate them because the cabs on the upper level of their ugly Hyatt Hotel just back up traffic so badly around Grand Central now and it takes me so long to get home."[203]

Eleven years later, the legendary architectural historian Herbert Muschamp attempted a reconciliation—at least with the work of the artist, who had died in the meantime. Muschamp had written a not altogether flattering piece about Trump International Hotel and Tower on Columbus Circle, still under construction, which of course the real-estate developer didn't like. To smooth things over, the critic had invited Trump and his architect Philip Johnson for a conversation in the Museum of Modern Art, in front of the famous *Marilyn* by Warhol that Johnson had donated to the museum. The meeting didn't turn out as expected. Muschamp's recollection in any case says much about Donald Trump's relationship to modern art:

A Wednesday morning before the museum is open. Winter, very cold. Mr. Johnson and I are waiting in the lobby. He's wearing his famous astrakhan fur hat. Limousine pulls up, very black. Mr. Trump gets out with three associates. Gray and blond. Great color combination. But a terrible expression on his face: pursed mouth, no smile, I'm going to get this guy. We head upstairs and clip through the galleries. When we reach the room where the *Marilyn* is hanging, I point it out. "Philip gave that. Isn't it great?" There's a large sculpture in the middle of the room, a brass floor piece by Donald Judd. Evidently Mr. Trump mistakes it for a coffee table, for he uses it as one, tossing his overcoat and some binders full of pictures on top of it as we walk over to the painting. Mr. Trump barely glances at the *Marilyn*, but this doesn't matter. My goal is to capture them together in the same frame. He's a work of art himself, as well as a piece of work, a living self-portrait with a trademark signature sought by foreign banks, condo dwellers, autograph hounds, advertisers and publishers. Warhol's dream was to live off

putting his signature on soup cans. Mr. Trump has more or less fulfilled it.[204]

Trump, who plainly couldn't connect to Andy Warhol's art, didn't have a problem many years later with brazenly making use of the artist's ideas:

"If you like art and can't make money at it, you eventually realize that everything is business, even your art. That's why I like Warhol's statement about good business being the best art. It's a fact. That's also another reason I see my business as an art and so I work at it passionately."[205]

A FAKE IS A FAKE IS A FAKE

There are also artworks in Trump's three-story apartment in Trump Tower, but first and foremost there is a lot of tasteless, pretentious interior decoration. In his plans and purchases, the interior designer Angelo Donghia ("You should feel at all times that what is around you is attractive . . . and that you are attractive."[206]) had channeled the style of the absolutist "Sun King" Louis XIV of France ("L'état, c'est moi") and most likely didn't grasp how closely he had modeled Trump's future style of government. Gold decoration everywhere, marble from the floor up to the ceiling painted with themes from ancient mythology. Plus mirrors, candelabras, crystal glass, gold serving trays, heavy pseudo-baroque furniture, dark pillows with the family crest. The British journalist Peter York, the author of the book *Dictator Style: Lifestyles of the World's Most Colorful Despots*, comes to the conclusion: "Trump's design aesthetic is fascinatingly out of line with America's past and present. . . . But it also has important parallels—not with Italian Renaissance or French baroque, where its flourishes come from, but with something more recent. The best aesthetic descriptor of Trump's look, I'd argue, is *dictator style*."[207] The design style of today's president fulfills the three principal criteria that define the palaces of despots: monumentality, the unwitting and inept imitation of historical models, and the almost unconditional surrender to the style of absolutist France.

Where there's still some room left for pictures in Trump's private New York apartment, they hang in heavy frames: a painting of Aurora and Apollo in a chariot of war over the fireplace, a family portrait in the next room, and before it a statue of Amor and Psyche.[208] And then there is a painting that doesn't fit in with the others and has raised questions for years. If it's really an original by one of the most famous masters of French impressionism, as Trump has claimed on many occasions, then it would be worth tens of millions.

Originally, Pierre-Auguste Renoir's large-format representation of a young woman and a small girl with a basket of flowers must have hung on board Trump's private Boeing 727. That's where the then *Playboy* reporter Mark Bowden saw the picture when he once accompanied the businessman on a trip.

"His behavior was cringe-worthy. He showed off the gilded interior of his plane—calling me over to inspect a Renoir on its walls, beckoning me to lean in closely to see . . . what? The luminosity of the brush strokes? The masterly use of color? No. The signature. 'Worth $10 million,' he told me."[209]

Trump's biographer Tim O'Brien reported a similar experience, speaking to *Vanity Fair's* podcast *Inside the Hive with Nick Bilton*. He, too, saw the alleged Renoir painting when he boarded for his flight with Trump to Los Angeles and asked whether it was genuine. When Trump confirmed that it was, O'Brien answered: "No, it's not, Donald." Trump insisted that it was authentic.

"Donald, it's not," the journalist repeated stubbornly. "I grew up in Chicago, that Renoir is called *Two Sisters on the Terrace*, and it's hanging on a wall at the Art Institute of Chicago. That's not an original." When Trump contradicted him again, O'Brien gave up pushing the issue.

For Trump, though, it wasn't over. When the two of them boarded the next day to fly back to New York, Trump again pointed to the painting and explained, as if the conversation on the preceding day had never occurred: "You know, that's an original Renoir."[210]

In truth, Renoir's painting *Two Sisters (On the Terrace)* has hung in the Art Institute of Chicago since 1933. In her will, Annie Swan Coburn, the wife of an attorney, had left the 1881 painting to the museum, where it can still be seen today.[211] What is plainly a copy of the picture no longer hangs in the plane but in the Trump family apartment in Trump Tower. When the president-elect had his first interview after the election, with the CBS news program *60 Minutes*, the alleged Renoir could be seen hanging in the background. When Trump's wife Melania showed the apartment to a television team from *Fox News*, her tour included walking in front of the reproduction. In the New York office of the First Lady there is also an elaborately framed Renoir picture: the portrait of a woman wearing an evening gown in a box at the theater. This is also a copy: without any doubt, since the original hangs in the gallery of the Courtauld Institute in London.

Donald Trump appears never to have let himself be constrained by questions about authenticity and fakery. On a state visit to France in 2018, the US president noticed several decorative artworks in the Hôtel de Pontalba, the residence of the American ambassador in Paris: a bust of the writer, inventor, and statesman Benjamin Franklin, a painted portrait of Franklin, and a group of small silver statuettes depicting figures from Greek mythology. He would be taking these works back to Washington on Air Force One, Trump explained, stunning the ambassador, Jamie McCourt, according to witnesses. McCourt had made financial contributions in support of Trump's 2016 election and in return had been named ambassador in 2017. The pieces would be returned at the latest in six years—at the end of his (hoped-for) second term, the president joked. "The President brought these beautiful, historical pieces, which belong to the American people, back to the United States to be prominently displayed in the People's House," the White House spokesperson Judd Deere said of the incident when it became public in fall 2020. Neither he nor his boss knew, however, that both the bust and the painting were copies of older originals. And the kitschy little figurines had been made by the Neapolitan artist Luigi Avolio after 1900 in

large editions—to be pawned off as authentic works from the sixteenth or seventeenth century. The London art dealer Patricia Wengraf called them "20th century fakes of wannabe 17th century sculptures" and said they weren't worth much. Trump nonetheless prominently displayed them on the mantel of the fireplace in the Oval Office.[212]

Sometimes Trump would tell guests at his club Mar-a-Lago the story that the builder of the place had commissioned Walt Disney personally to create the nursery-rhyme-themed tiles in one of the rooms, which would later be used as a bedroom for his daughter Ivanka. But Disney was already working 2,700 miles away in Hollywood when Mar-a-Lago was built between 1924 and 1927.[213] The supposedly original Disney tiles are no more genuine than the fake *Time* magazine cover that hangs in at least five of Trump's resorts.[214]

Trump evidently never developed a taste for the genuine works of art that hang at Mar-a-Lago. Sixteenth-century Flemish tapestries had hung in the living room for decades, curtains protecting them from unnecessary exposure. But, according to his former butler Anthony Senecal, Trump blasted the room with light. The centuries-old tapestries faded in the merciless Florida sun.[215]

ART INVESTMENT AS FRAUD

Helge Achenbach and the Aldi connection

The art consultant Helge Achenbach always liked something extra, something more: bigger was better. He didn't drive any ordinary car, but rather the Bentley that had belonged to Joseph Beuys. And not just that one Bentley but four or five more. Likewise, he didn't fly first class, but took private jets. He rented extra-large spaces for the artist Gerhard Richter so that he could paint especially big pictures. And his fee for negotiating the purchase of a single painting by Pablo Picasso would yield him not just the approximately €180,000 that his contract specified but another €2 million he took secretly. In the end, Helge Achenbach's prison cell was just ten square meters, the same as any other prisoner's.

The story of Helge Achenbach is the story of a hustler from the West German provinces who grew up in petit bourgeois circumstances and who, as the self-declared first art consultant in Germany, powered the rise of this business in Düsseldorf, the West German city that, at the time, was the city of artists. Achenbach is a paradigmatic figure of

the commercialization of art at the end of the twentieth century. To be sure, the sale of art had been pursued as a profitable business, often using dubious methods, for centuries. But in West Germany starting in the 1970s, art became a status symbol for large companies and their managers. Art advisers sold these companies and their chairpersons works of art to confer some sort of social meaning, and the art that was sold included important work along with very insignificant work. It was important, as the art scholar Wolfgang Ullrich has pointed out, that modern art could be described to these corporate officers with the same adjectives that were to be found in job descriptions for managers: the pictures were said to be dynamic, open, creative, innovative, courageous, and resolute.[216] And Helge Achenbach conducted the sale of art by following American models for management consulting, resolutely and dynamically. He celebrated his life in an autobiography published in 1995, which was mainly intended as a marketing vehicle. The book carried the title *From Saul to Paul*,[217] referring to the instantaneous conversion of the apostle. His next autobiography appeared twenty years later, a large-format book, complete with a head shot of Achenbach on the cover, depicting him as a successful yet serious man, with a reckless tilt to his mouth. The title this time was: *Helge Achenbach: The Art Agitator—On Collecting and Hunting.*[218] Only in his third autobiography, which appeared in the fall of 2019 under the title *Self-Destruction*, did he self-critically label himself a "dealer" and a "junkie."

Achenbach liked to tell people that he sold his first pictures while still a schoolboy. A friend encouraged him to cut out photographs from his father's porn magazines on the sly, and then they would sell them together or rent them out: ten pfennig for a look, a German mark for the purchase of a color photo. According to another anecdote, as an eighteen-year-old on a trip to France, he talked down the price of carved ebony figures to a fraction of the street market price—and then resold the statues in Geneva for several times as much. His pride in making a big profit is a constant theme in his stories, even today.

Achenbach studied social science, specializing in pedagogy, did his required internship at a prison, and toyed with the idea of emigrating to Chile, then ruled by the socialist Salvador Allende. But after General Augusto Pinochet came to power in the South American country, Achenbach started work in a gallery in Düsseldorf. He had been drawn to artists during his studies; he liked their freedom, the libertinage, the pretty women, the bars, and the feeling of celebration. But he wanted to earn money too. The job in the gallery soon proved to be too rigid for Achenbach. Having to show up for work every day became a burden, and he wanted to make bigger leaps. And so he designated himself an art adviser, driving like a door-to-door salesman from one big construction project to the next, trying to persuade entrepreneurs to buy art with his "informed semi-expertise,"[219] as he described it. Persuading people was Achenbach's métier.

THE SOCIAL CLIMBER AND CORRUPTION

In 1977, Achenbach founded the first German art advisory firm, together with the architect Horst Kimmerich, who was knowledgeable about art. Achenbach understood that works of art had become objects of prestige, but that knowledge about art was not something that was associated with a fee. That's where he saw his chance. For DM 30,000, he bought an expensive car telephone weighing several kilograms and eagerly built up his networks. Achenbach seemed to have a gift for making friends. And for doing so in moneyed circles that were usually thought to be insular. Kasper König, the former director of the Museum Ludwig in Cologne, describes how Achenbach needed only a couple of hours with business leaders who were completely uninterested in art and previously unknown to him and they were transformed into new collectors. Soon the former social sciences student was wearing hand-tailored three-piece suits and mingling with bankers, managers of insurance companies, and famous artists. He considered Gerhard Richter, Jörg Immendorff, Günther Uecker, and later the photographer Andreas Gursky to be his friends, and he got commissions for them from the

business world. Some artists—almost exclusively men—earned good money through him. Others didn't like what he was doing.

For many, the rise of art advisers sounded the death knell for traditional collecting, the kind driven by passion. Art dealers and gallerists still complain today that the new type of art collectors, which are handled by advisers, are most interested in art as an investment. They prefer the profits to be guaranteed. And Achenbach was completely comfortable talking about how much the value of the work he was selling by his artist friends would grow.

Shortly after founding what was advertised as the first art advising company in Europe, he liked to promote the illusion of a booming business and had friends call him during client meetings in order to create the impression of being in high demand. The tricks worked. He negotiated the commission of two gigantic colorful abstract paintings by Gerhard Richter for the Victoria insurance company, which now belongs to the Ergo Group. Other clients included the corporate giants Allianz, Audi, HypoVereinsbank, and Deutsche Telekom. Along with New York, in the 1980s the German Rhineland became the international epicenter of the booming art market. "It was a bonanza for contemporary art, and Achenbach was the most successful goldminer in Düsseldorf," said a person who has known Achenbach a long time and, like others in his orbit, spoke about Helge only under the condition of anonymity. Gerhard Richter has publicly called Achenbach a "swindler." "He was a go-getter and uninhibited marketer of art," said another person who often had occasion to see him in Düsseldorf. Achenbach had also put together a few art projects with the artist Thomas Struth. "He has a lot of ambition; he is a seducer and enjoys being influential," Struth said later.[220] Achenbach is also a seducer in his private life. Today he summarizes his love life thusly: "I have eight children by four women. I love my children above all and have loved each of my wives intensely. On the other hand, I wasn't always faithful. I paid women for sex. Affairs? Yes, a few."[221]

As he reports in his 2019 book *Self-Destruction*, Achenbach quickly became immersed in corruption. In order to be allowed to decorate the

headquarters of a large firm with art, he had to pay 10 percent of the high six-figure contracted commission to the wife of one of the principal managers of the firm. This story cannot be verified; no names are given. According to Achenbach, for art transactions made in the name of their corporations, executives demanded pictures by famous artists for their private collections as a bonus. He claimed to have paid for the wedding of a curator.

As business grew, Achenbach's empire expanded. He opened offices in Munich, Heidelberg, Bonn, Frankfurt, Hamburg, Berlin, and Leipzig. He founded a network of companies. He administered his businesses through AKB GmbH, which in turn belonged to Achenbach Beteiligungs GmbH. Many of his employees were also employed by AAC Leasing und Verwaltungsgesellschaft mbH. In 2006, Achenbach founded State of the Art AG, of which he owned 82 percent of the stock. After his first forays into gastronomy in the 1970s, in 2002 the art entrepreneur established a "Beachclub," and afterwards three restaurants that were named after the Jörg Immendorff monkey sculptures displayed in each—Monkey's East, Monkey's West, and Monkey's South—and which incurred grotesquely high financial losses. The motivation was obviously not to make money from the restaurants but rather to build a stage on which one could present oneself with actors and artists, bosses of industry and politicians, soccer players and pretty young women. Achenbach was up for just about anything. Together with one of the largest candy companies, he organized so-called Black Dinners at which dishes were plated on licorice. These celebrity events in the Monkey's restaurants made such a lasting impression on at least one billionaire couple that they soon placed enormous sums of money at Achenbach's disposal to buy art for them.

Achenbach sought to hobnob with the big players in business, sports, and politics. He counted as a friend Gerhard Schröder, the Socialist Party of Germany (SPD) politician who later became the federal chancellor. And curators sought him out, because this powerfully built man radiated a nimbus of seemingly inexhaustible sources of

money. He could generate contributions for exhibitions or negotiate with people to have art lent for a show. He collaborated with some of the busiest people in the museum world, such as Martin Roth, Hans Ulrich Obrist, and Klaus Biesenbach.

Biesenbach was involved with what remains to this day one of the biggest spectacles that Achenbach staged. In order to portray Volkswagen as a progressive company, Achenbach organized a well-funded partnership between the carmaker and the Museum of Modern Art (MoMA) in New York. Martin Winterkorn, the VW chairman, justified the partnership in an interview with Biesenbach, the German MoMA curator, for the German weekly Sunday newspaper *Welt am Sonntag* when the partnership began: "For us, it is interesting for contemporary artists to engage with the great social and political questions of our time. Environmental protection, social justice, equal opportunity, to name only a few."[222] His company, he said, was focused on the question of how to really change the world, and that's why they built environmentally friendly cars in efficient factories.

Eight years later, Winterkorn would be indicted because of his role in Volkswagen's fraudulent noncompliance with environmental regulations for auto exhaust, but at the time, the VW sponsorship in New York was hugely celebrated. German journalists were flown business class to New York. Madonna came to dinner, along with Yoko Ono, Lou Reed, Patti Smith, and Salman Rushdie. James Franco acted as DJ. And Winterkorn drove up in an experimental one-liter car with the actress Lucy Liu. The German magazine *Bunte* reported: "A breathtaking performance by the young Korean violin virtuoso Hahn-Bin. *Sex and the City* star Kim Cattrall chatted easily with starchitect Richard Meier and art adviser Helge Achenbach, who had threaded the needle of the connection between culture and industry."[223] Glenn D. Lowry, the director of MoMA, said later: "Helge is an exuberant person full of ideas—some are crazy, others brilliant. . . . I don't know exactly how he does it, but he seems to be able to do great things." Achenbach was happy; he placed this quotation by the

museum director, for whom he had raised millions of dollars from the German auto industry, in big red letters at the beginning of his *Art Agitator* biography.

FORGED INVOICES FOR KOKOSCHKA, PICASSO, AND LICHTENSTEIN

In the end, Achenbach was felled neither by the debt-ridden restaurants, nor by the expensive parties, nor by his regular visits to a female escort, but rather by business with his best client. He must have thought he had a white whale on the end of his harpoon at the end of the 2000s: a single client from whom he could take more than all his earlier customers, someone who could make him even richer. This person was Berthold Albrecht, born in Essen, Germany, in 1954, the son of Theo Albrecht, one of the two founders of the supermarket chain Aldi. The Albrechts have been considered for decades to be among the richest, and also the most discreet, billionaires in Germany. Achenbach had come to know this son of the Aldi Nord family and his wife Babette Albrecht at a private dinner given by mutual friends. The friendship grew slowly. They would meet for a casual dinner at an Italian restaurant or at one of the Monkey's restaurants.

At last, at the end of 2008, Achenbach was assigned to invest about €60 million in an art collection. Babette Albrecht explained later that her husband wanted to invest money in art because the interest rates at banks weren't profitable anymore. And: "A stock is a stock. At least you can look at art." Like the rest of his family, Berthold Albrecht had until then led a very reserved life. He was afraid that in buying art he would be charged inflated prices if galleries learned that an Aldi heir was the customer. The couple didn't want to pay some kind of "Albrecht surcharge," his wife Babette said later, when a court conducted proceedings regarding the former friendship.

Their friend Helge Achenbach was supposed to serve as an agent who could discover really good art while being discreet about his client's identity in order to secure proper market pricing. An advisory honorarium of 5 percent of the sales price was agreed upon in return for this

service—a portion that Achenbach later claimed was much too small to cover the costs of his efforts.

Normally dealers or advisers comfortably take 10 percent or more for their services in art acquisitions, but, of course, most often the amount of money involved is less than it was in the case of the Albrechts. The art purchases by the Aldi heirs achieved an order of magnitude rarely seen in Germany. According to the *Art Market Report* of the Art Basel fair, German activity accounted for only 1 percent of the estimated $67 billion world art market in 2018. Achenbach had won an extremely promising client, considering the domestic market conditions, and despite his lower percentage take on purchases he could have earned €3 million on the €60 million allotted. But that was of course too little for him, much too little.

For the very first purchase he arranged on behalf of Berthold Albrecht, a painting of London's Tower Bridge by Oskar Kokoschka, Achenbach simply falsified the invoice from the Marlborough Gallery in London. Using a photocopier, he doctored the price he negotiated, changing $800,000 to $950,000. He also switched the dollar sign for a euro sign, which, according to the exchange rates at the time, increased the profit by yet another €200,000. Correspondingly, all other charges increased according to the percentages: the size of the commission, the value-added tax. Not only had Achenbach calculated the 5 percent for his advisory honorarium—a sum that would have been about the same as the average annual salary of a German worker—but, by means of the manipulated invoice, he had added more than 50 percent to the original price. He didn't just double his honorarium: he increased it tenfold. Achenbach didn't have any limits, even in fraud. And from there things happily rolled along.

The second art acquisition by the Albrechts, in March 2009, was the painting *Mother and Son* by Ernst Ludwig Kirchner. Achenbach bought it for about €1.3 million from the gallerist Michael Werner, while telling Albrecht that the purchase price was €1.8 million. With his commission

of 5 percent, now calculated on the inflated price, Achenbach earned more than €500,000 in the sale. One month later, he bought two more Kirchner paintings from the same dealer and similarly earned, because of his manipulations, about €1 million. In June 2009, the Albrechts visited the Art Basel fair together with Achenbach and bought Picasso's *La famille du jardinier* (1965), supposedly for €5.5 million net from the Richard Gray Gallery of Chicago. In this transaction, Achenbach piled on €2 million extra.

There were also deals—involving pictures by Neo Rauch and Anselm Kiefer, for example—for which Achenbach didn't inflate the price. But there were other transactions—involving works by Albert Oehlen, Takashi Murakami, and Francis Picabia—in which he continued to deceive his friend from Essen with imaginary numbers. On the sale of a Roy Lichtenstein painting in spring 2010 he covertly earned €1 million. Kasper König, at the time the director of the Museum Ludwig, also got indirectly involved in this deal. König had connected Achenbach to Lichtenstein's estate for the transaction, which Albrecht repaid by donating €100,000 to the museum, and this sum, in turn, helped to finance a Lichtenstein exhibition. According to his own statements, König knew nothing of the inflated prices from which the art adviser in nearby Düsseldorf was profiting.

In the fall of 2010, Berthold Albrecht decided that he had enough art in his house. He would concentrate on buying vintage cars, and once again Achenbach came to his assistance—and once again profited mightily through his firm State of the Art by way of hefty commissions and markups. Instead of brand names like Richter, Picasso, and Kirchner, Albrecht collected Bentleys, Bugattis, and Jaguars. In 2011, Achenbach took in more than €1.5 million in the €12 million purchase of a Mercedes-Benz 540K Special Roadster. Through Achenbach's efforts in 2012, Albrecht bought a Ferrari 121 LM, with the additional truck to transport it, for more than €11 million—of which a good €3 million went to the art adviser's firm.

The Aldi heir wasn't the only victim of Achenbach's fraudulent practices. Always eager to expand, Achenbach had, together with the private bank Berenberg in Hamburg, established an art advisory firm for the bank's clients, Berenberg Art Advice GmbH. Besides Achenbach, a former employee of an important German art insurance company was supposed to assist. As a leading insurance manager, the man had for years had access to confidential private collections and the storerooms of art dealers and thus had amassed an enormously valuable reservoir of knowledge of the whereabouts of masterworks. He became Achenbach's business partner. The bank owned 51 percent of the art advisory company, Achenbach 39 percent, and the former insurance executive 10 percent. A few years later, he shared the defendant's table with Achenbach in the district court in Essen.

The firm went live in 2011, as those involved appeared in various media. Just as Achenbach's art consulting firm had introduced the business culture into the art world, now art would become an instrument of finance. More and more, private investors would become interested in putting money into this "investment class," as a representative of the bank was quoted in a press release: "From our long-term strategic perspective, investments in art contribute positively to diversification of total assets."[224] Interestingly enough, Helge Achenbach was cited explicitly in this press release with a warning about inflated prices: "An artist is always overpriced if a group of dealers and collectors team up, agree and possibly even artificially drive up the auction prices." The bank representative commented further that the goal of Berenberg Art Advice was to "protect" buyers of art. The new firm would provide its clients with the "requisite transparency in the art market" and also "the greatest possible discretion." That they were inviting the fox into the chicken coop had apparently not occurred to the bankers at Berenberg.

In November 2012, an art fund was also established, the Berenberg Art Capital Fund. It was supposed to collect €50 million from investors to buy up two hundred artworks. The works were to be sold after

seven years; the return on investment was estimated at between 7 and 9 percent per year. The minimum investment in the fund was set at €100,000. In April 2013, an employee of the firm reported that they had already brought in €10 million. A few months later, in July 2013, the bank declared that the ambitious project was terminated: there had not been sufficient interest.

Dozens of similar art fund projects had already crashed throughout the world, including some whose model can be described more appropriately as fraud than a legitimate investment vehicle. Art funds fell apart mostly because of too little financial expertise or insufficient knowledge of art.

At the time, the investment specialist at this private bank, Jürgen Raeke, explained that the demise of the Berenberg fund was due to the way the art market was constituted. The banker, as the principal of Berenberg Private Capital GmbH, had been involved in investments in tangible assets—from real estate and parking garages to farmland and forests—but he had worked his way into the art market. Art differentiated itself from these other markets by its deep opacity, the quite unequal distribution of information, and the very limited number of players. An inside deal is not forbidden in the art market; the prices at public auctions can be easily manipulated by representatives of the artist. "It's another world that's already partially suspect," Raeke said after the termination of the art fund.[225] The practices of the art market were said to be as secretive as those of the diamond market—though one could agree relatively easily on the value of a diamond. It wasn't just the opacity of the art market that made the arena so difficult for the fund manager, but also the complicated questions regarding the—fictive—value of art. The symbolic capital of art and of buying art must always be factored into the record prices at the auction houses: placing the winning bid for a certain work of art is meant to demonstrate membership in an elite class or to distinguish oneself within this elite class. Anyone who simply buys a share in an investment fund, and not the Picasso painting itself, cannot profit from this symbolic capital or

receive, obviously, what bankers call the "emotional profit"—the experience that someone has in looking at art.

In 2013, Berenberg Bank closed the art fund along with the firm Berenberg Art Advice, which had been established with Achenbach and the former insurance executive and was supposed to shepherd wealthy clients through art transactions. Achenbach said later that they had gotten hardly any clients; the returns had been much less than planned. But there was another reason for the end to these dreams of huge profits, a reason that was best kept secret.

THE PHARMACEUTICAL ENTREPRENEUR
AND THE ART OF WRITING FALSE INVOICES

One of the few big clients for the Berenberg art advisory was the pharmaceutical entrepreneur Christian Boehringer. The chairman of the board of the traditional firm Boehringer Ingelheim had just begun collecting works with the theme of "the art of writing" and now wished to be advised professionally. He became acquainted with Helge Achenbach at the European Fine Art Fair (TEFAF) in Maastricht in 2012. Achenbach discussed the concept for the collection with him and assisted him in the purchase of a Gerhard Richter painting, *Untitled—Green*. They entered into an agreement in September 2012; Boehringer wanted to invest €1.5 million in art annually. Already that September, Achenbach bought Tracey Emin's *I Can't Believe How Much I Loved You* for the pharmaceutical mogul and dutifully calculated his commission at the agreed-upon 5 percent. Of course, for later purchases—works by Lawrence Weiner, Alighiero Boetti, and Andreas Gursky—Achenbach proceeded as he had with Albrecht, the Aldi heir: he secretly added extra-high profits to the price and forged the galleries' invoices. Since the transactions of Berenberg Art Advice would be monitored by the bank, he had the purchases first run through his own art advisory in order to pass on the forged invoices to the bank. Nonetheless, in the end, one of the inflated transactions with Boehringer saw light of day.

In another case, meanwhile, an early work by Georg Baselitz had been offered for €875,000 to a business couple from the Lower Saxony area of Germany, longtime clients of Berenberg Bank. Achenbach and the former insurance executive had bought it for €200,000 from a well-known photographer in Cologne, an old friend of the artist. As later revealed in the court proceedings concerning the Achenbach case, the couple's purchase was also motivated by tax reasons. The painting was to be given to a son; artworks are exempted under certain conditions from gift taxes. There was a payment, but the deal did not come to fruition. And all other transactions at Berenberg Art Advice suddenly came to an end. Not—or rather, not just—because the fund didn't attract enough clients, as was publicly stated. The bank had received a tip and hit the brakes.

An independent contractor who worked for Achenbach, Thomas Kellein, who had earlier served as the director of various exhibition spaces in Switzerland, Germany, and the US, enlightened Berenberg in June 2013 about the fraudulent practices using undisclosed profit margins. He had himself been paid a bonus in the amount of €200,000 by Achenbach for the sale of an artwork at an inflated price. Now, however, he made the bank aware of the strange goings-on in the sale of the early Baselitz work, repaid his bonus, and got hold of the original invoice from the Marian Goodman Gallery in New York, through which Achenbach had acquired artworks by Lawrence Weiner for Christian Boehringer. The collaborator had turned into a whistleblower.

Under the pretext that it wanted to make a short advertising film with Achenbach and his coworker, the Berenberg bank enticed the two to come to its headquarters in Hamburg. While separated, each of them was confronted with the accusations made by the independent contractor. Achenbach admitted the concealed profit margins in the Boehringer case; the former insurance executive disputed the facts. Both had to forfeit their ownership interest in Berenberg Art Advice that day. A notary who was present for the occasion supervised the termination of the firm that had been founded two years

earlier out of concern for more "transparency" and "protection" in the art market.

FROM FIRST CLASS INTO A PRISON CELL

The bank and Achenbach indemnified Christian Boehringer. The incomplete transaction involving the Baselitz painting and the business couple from Lower Saxony was reversed—quietly and discreetly, as is the custom in private banking, in order to protect the reputations of vastly wealthy clients. Life rolled along nicely for Helge Achenbach. In December 2013, this man, who had taken millions from his friend Berthold Albrecht, who had died the year before, was swimming in a pool at a jet ski resort, when a woman spoke to him, according to his own account. She was active on behalf of the Munich entrepreneurs who were at the time planning the Campo Bahia, the hotel in Brazil that would host the German national soccer team. Achenbach was entirely in his element here, as he related in his most recent autobiography. He immediately met with the industrialists and just a few weeks later was outfitting Campo Bahia with works by Brazilian and German artists like Andreas Gursky and Claus Föttinger. But Achenbach was unable to join the celebration in the stadium when the German team won the world championship, as he had planned to do. Instead, he had to watch it on the television at the penitentiary in Essen, Germany.

Early in the morning on June 10, 2014, Helge Achenbach and his wife landed at the airport in Düsseldorf. They were coming from a three-day celebration in Washington, DC, and had flown overnight in first class to Frankfurt and changed planes to Düsseldorf there. When they left the plane in Düsseldorf, Achenbach was approached by two men who spoke to him, showed him the arrest warrant, and took him into custody. Achenbach reported that, at first, he thought it was a mistake.

But this time, the problem wasn't solved quite so easily and quickly, as so many other problems had been for this native of the Rhineland. The police had investigated the deception of Berthold and Babette Albrecht for weeks. In the dissolution of Berenberg Art Advice, the

bank had found on a computer a list with many other artworks for which dramatically different prices were recorded. The bank informed the Albrecht family, which filed criminal charges following its own investigation. And the case played itself out: Achenbach's telephone was bugged, witnesses were questioned, and finally the arrest warrant was issued.

The photo of him on the cover of the autobiography *Art Agitator*, published a year earlier, resembles a mugshot. Certain sentences in this autobiography read as particularly mendacious. "I always wanted to make the system more transparent," Achenbach wrote in 2013, after he had forged invoices and swindled millions of euros. "From the beginning, it was my desire to protect the collectors and firms that I advise from the extremes of a quickly moving art market." He wrote that he felt a bit like a pilot who steers his clients through the dangerous waters of the market to safety. "We have to protect art from the market so that our society again senses its power."[226]

Achenbach was held in pretrial detention and occupied a cell on the same floor of the Essen prison where Thomas Middelhoff, the former manager of Bertelsmann, would serve his sentence for embezzlement and tax evasion in November 2014. Two of the biggest movers and shakers in Germany, who eschewed commercial air travel to fly by private jet, as Achenbach favored, or commuted to work by helicopter, as Middelhoff did when traffic was bad, were now singing in the prison choir. Middelhoff as a baritone; and Achenbach, by his own account, as a bass.[227]

THE TRIAL

At the same defendant's table in the appropriately large and high-ceilinged room 101 of the Essen district court where Thomas Middelhoff had already been found guilty, Helge Achenbach sat for numerous days of proceedings. The room, outfitted in pale wood, was the light-filled stage for a trial that played like a gripping television series about the dark side of the art market, an epic about money and pretty pictures, friendship and deception, famous

artists and the richest of the rich. But above all else, it was about the rise and fall of the chief defendant, Helge Achenbach.

Each day of the trial was a different episode with new twists and more suspicious facts. At the front of the room, three judges reigned along with two jurors and one court reporter. Helge Achenbach and his codefendant and ex-partner, the former insurance executive, sat with their four lawyers at the defendants' table; across from them, all by herself, the young prosecutor Valeria Sonntag.

At the start of the proceedings, on December 9, 2014, Helge Achenbach entered the courtroom looking pale, almost reserved. The art adviser had lost several kilos in custody, which was why his fitted suit ballooned around his belly. His codefendant continued to dispute every accusation: he had not been part of an illegal business. Achenbach, by contrast, whose defense strategy was unknown until then, announced that a complete explanation would be given on the second day of the trial. His defense attorney, Thomas Elsner, sketched his line of argument in a brief statement to the court: Helge Achenbach had not engaged in fraud because even the prices with inflated profit margins corresponded to the market worth of the artworks or fell under the market value. Furthermore, his expenses were not covered by the commissions. Allegedly, the art adviser had given Albrecht as the buyer a very generous return warranty: the billionaire could return the works within either five or seven years, as the case may be, for the full purchase price. In addition, Achenbach claimed to have promised to pay interest of 4 percent per annum in the event of a return.

Even though Albrecht's legatees disputed the existence of this return guarantee, which the judges also didn't believe existed, it showed something symptomatic about Achenbach's case that was also true in general for the art market, which had been running wild for years. In what other markets could such interest rates be guaranteed for half a decade? Could one guarantee a continuing boom in the art market? With these guarantees, if indeed they existed, Achenbach had driven some wealthy people to have fantastical expectations about the profitability of investing in art.

Art wasn't allowed to be just art anymore: it was the perfect investment vehicle. Because, in his opinion, Achenbach had more than fulfilled the responsibilities of an investment adviser, he had approved the high profit margins, margins that are entirely common in the all-too-discreet and, compared with other investment markets, unregulated art market.

In the second episode of this art crime drama series, which is to say, on the second day of the trial, the art adviser admitted to sometimes charging not just the agreed-upon 3 or 5 percent commission on the purchase of.artworks or vintage cars, but additional, hidden high margins. He admitted to doctoring invoices from galleries and brazenly called them "collages," as if he were himself an artist, as if his fraud wasn't really fraud, but somehow an ingenious creative artwork.

The chief judge Johannes Hidding was the star of the trial. Not because he made grand gestures or the like: the young judge was, in fact, quite reserved and polite. With relentlessness and concentration, he simply posed the right questions, pursuing suspected fraud, shedding light on the peculiarities of the global art market and the market in the German Rhineland in particular. He could not be accused of bias: he always interrogated the witnesses impartially, some of them for hours at a time. Judge Hidding was as proper as his severely parted hair. "How exactly does it work with editions of photographs by Andreas Gursky?" he asked one witness, one of the most powerful gallerists in Germany.

At the beginning of the trial, because of the banality of the questioning, one had the impression that this judge was perhaps not especially well versed in the art market. The opposite quickly proved to be true. Hidding and his fellow judges had studied up on the smallest details of the case: they were constantly chasing after incriminating or exculpatory facts. They tried to contextualize the events in the logic of the art market. And they exposed, whether intentionally or not, the absurdities of the system.

For instance, there was that problem with the editions of the Gursky photographs. Again and again, Hidding interrogated the gallerist and earlier the two defendants about the circumstances under which edition

2 of 6 of an untitled photo series by Gursky was sold. In the photograph, one sees pages from Robert Musil's novel *Man without Qualities*, but the photos are worked and collaged in such a way that important sentences by Musil appear in a new context. The judges noted not only that edition 2 was sold to Boehringer for an inflated price but also that the same number in the series was hanging in the collection of a museum in Sydney, according to the museum. Had Andreas Gursky sold his supposedly strictly limited edition twice?

The gallerist was able to explain that a different edition number was hanging in the Sydney museum and there had simply been a bit of confusion. But the answers to Judge Hidding's questions unveiled the absurd system in which the supply of a photograph, a medium that in reality is infinitely reproducible, is artificially restricted in order to create high prices. The spectators also learned that for Gursky, as for many other photographers, in addition to the strictly limited editions, there were "exhibition copies," which—unlike the completely identical prints made for sale—were simply thrown away after they had served their purpose in an exhibition, and that individual prints could be converted quickly into "exhibition copies." They have no value, have no insurance costs, and can be easily transported. The gallerist admitted that all this was difficult to understand.

Although Albrecht, through Achenbach, had bought over €120 million worth of art and vintage cars between 2009 and 2011, there was no written agreement about commissions, which could be explained by the friendly relationship between the two men. In fact, oral agreements are today still the rule rather than the exception in the art market. Perhaps this scandal was the inevitable product of recent trends: here is a market in which from year to year ever crazier sums of money are spent and that nonetheless operates largely without rules.

"One makes friends quickly in the art scene," the widow of the victim Berthold Albrecht affirmed during her hours of interrogation. The longer the trial lasted, the more the defendants' network appeared to be deeply enmeshed in the elite of the international art market. It emerged,

for example, that at Achenbach's instigation the director of the venerable Albertina Museum in Vienna, Klaus Albrecht Schröder, escorted the Aldi heirs for hours through the Art Basel fair. In the end, he advised them to purchase a painting by Francis Picabia and thereby placed himself, as the leader of a public institution, in the service of private collectors and dealers and their commercial interests. In response to an inquiry, Schröder explained that such a guided tour is part of the educational responsibility of a museum director and he had received nothing in return.[228]

Everybody in the art market is connected to everybody else, the trial's spectators learned, and even the rich seemed to be indebted to others. Achenbach's collaborator, a banker, and many others allegedly owed Achenbach money, as was revealed in the course of the trial. Later, Achenbach's businesses—Achenbach Art Advisory, State of the Art, and the Monkey's restaurants he had founded—were placed in bankruptcy. "More than a hundred creditors" had sent notices to Marc d'Avoine, the bankruptcy administrator for the ten Achenbach enterprises in the district court. He estimated the total of the demands at between €40 million and €50 million. D'Avoine was supposed to auction off 2,300 artworks held in the storerooms of the Achenbach firms in the same year. Even the bankruptcy administrator expressed shock at the business practices of the art market—missing invoices, oral agreements, and demands by shady galleries in Switzerland. He said he had to find terra firma first. Three associate lawyers and a bookkeeper were supposed to assist him in the undertaking.

With each day of the trial, the spectators dove ever deeper into the material and came to think eventually that they knew the principals quite well. And then they would be surprised by new evidence and new connections. Each week, a group of mostly out-of-town journalists waited with bated breath for the new players that would testify as witnesses—the artist Tony Cragg for example, or the former museum director Thomas Kellein who had uncovered Achenbach's concealed profit margins.

"Even the super rich are not fair game. The fortunes of well-to-do people are just as protected by the laws as those who earn a normal salary." Thus, Judge Johannes Hidding justified his judgment against Helge Achenbach and his former collaborator on March 16, 2015. Achenbach was sentenced to a total of six years' imprisonment for eighteen counts of fraud, in part in connection with embezzlement, as well as another count of attempted fraud. His former partner, whose lawyer had pled his innocence and asked for an acquittal, was sentenced to a year's imprisonment and three months' probation. As an aggravating factor, the court found that Achenbach had exploited his friendship with Albrecht, the reclusive billionaire. That Achenbach had partially confessed was an alleviating factor in the sentencing—but he was condemned for other deals with vintage cars whose propriety he constantly defended during the trial. "Achenbach takes risks," was how Judge Hidding characterized the condemned. He pointed, among other things, to the debts that Achenbach's Monkey's restaurants were running up: "A business that Achenbach didn't have a handle on." But where all the ill-gotten gains had ended up remained a mystery, even after the trial was over.

There would follow other judgments against Achenbach in civil trials. In June 2017, the district court in Düsseldorf ordered the convicted fraudster to pay €18 million to the legatees of Berthold Albrecht. The appellate court lowered the payment to €16.2 million but affirmed the judgment. A member of the Viehof family, which had established the Rheingold Collection with Achenbach, a collection which was supposed to be shown in museums and sold off at the earliest twenty years later, accused Achenbach of irregularities in art sales. After Achenbach's arrest, the Rheingold Collection was divided up and liquidated.

The auctions of the approximately 2,300 artworks from Achenbach's storerooms established a record on behalf of the auction house Van Ham for the biggest sale of contemporary art in Germany and brought in altogether about €10 million for the creditors of the insolvent firms—a large sum but, of course, only a fraction of the outstanding debt. In

under their estimated values. They could have made €25 million, he
pompously claimed.

A NEW BEGINNING FOR A NARCISSIST

In June 2018, Helge Achenbach was released early on probation. In prison, not only had he sung in the prison choir, but he had also taken painting classes—a hobby that he sought to turn professional after his release. Achenbach's paintings can be found on Instagram: studies of the sky, sea, or mountains, most executed in various gradations of a single color. One could describe the style as postimpressionism. Many of the pictures are titled, with little ambiguity, *Spirit of Freedom.*

Together with the nonprofit Culture Without Borders, Achenbach wants to create a refugee center for politically persecuted artists at an old farm near Düsseldorf. His friend, the architect David Chipperfield, has already drawn the plans for the annex. Achenbach himself moved into a top-floor apartment in Cologne that the journalist and author Günter Wallraff put at his disposal. Until he repays the millions of euros that he owes, the former millionaire is allowed to keep only a modest monthly income out of the revenues from his activities; the rest is garnished. And still Helge Achenbach, who describes himself as a narcissist, dreams of big business. He spoke to the German magazine *Stern* in September 2019 about a potential big deal in Mallorca that involved transforming a sheikh's estate into a sculpture park. Achenbach seems to be looking for big deals in his old trade.

To be sure, his latest autobiography, published in fall 2019, bore the title *Self-Destruction*, and in it Achenbach expresses his self-criticism and admits his guilt—though for long stretches it does read like a lengthy "it wasn't all that bad." In many anecdotes, Achenbach portrays himself as a bold man with the right instincts at the right time. He gleefully recites the alleged increases in the value of artworks that he handled by Gerhard Richter, Yves Klein, or Andy Warhol. He is seemingly forced to recite the profits and increases in unrealized gains from

his art deals: for the sales of pictures to the Aldi Albrechts there is even a table with estimated increases in value. There are always millions in gains, if not billions. He claims that the art he handled in the course of his eventful career is worth four or five billion euros today. The book reads like a belated defense and the desperate attempt of a disgraced man to find a place again in society.

Unrestrained, boastful, narcissistic—all adjectives that Achenbach has applied to himself—could also be used to describe the art market. "Whoever swims in this shark pool, whether dealer, gallerist or artist, knows that deception isn't the exception but the rule," Achenbach writes in his book. He says that there's a culture in the art market that "favors cynicism and corruption, which makes any honest people idiots." For decades, Helge Achenbach was one of those who engendered this culture. And he is apparently always ready to jump back in with the other sharks in the pool and give chase.

In December 2019, Achenbach announced that he would facilitate the sale of approximately five hundred drawings that Gerhard Richter had allegedly abandoned in the Democratic Republic of Germany before he fled to West Germany in 1961. The collection, whose ownership is unclear and has been disputed, has been making the rounds for more than ten years in the art market. The artist has himself emphasized that he does not consider those pieces, which could be his work, to be a part of his artistic oeuvre.

7

DIRTY MONEY AND CLEAN ART

Van Gogh in the basement, Basquiat in a box—how the art market serves international money laundering

There was definitely something wrong with these prices, even if they were only estimates: a small, typical, signed pastel on cardboard by Joan Miró—just €30,000. A chalk sketch from about 1880 by Edgar Degas for €10,000, a pencil drawing by Amedeo Modigliani for €20,000, a somewhat faded watercolor of Collioure, France, by Henri Matisse for €30,000. All these estimates were just as clearly too low as the €50,000 set as the cost of the Pissarro depicting two seated peasant women in his typically vibrant pastel hues. But, in fact, everything was aboveboard and proper with the fifty-five works by great artists of classic modernism that were sold by the auction house Pandolfini in Florence at the end of October 2019. Even the abstract Kandinsky watercolor of 1913, a somewhat kitschy Chagall gouache of his favorite set pieces (rooster, pair of lovers, and violin), and a pointillist landscape by Signac weren't forgeries or works in bad condition, as is usually the case with similarly low estimates. All the pictures were furnished with expert opinions

by prominent specialists, could be found in the relevant catalogues of works, or had been traded during the past decades by respectable galleries or auction houses.

The secret behind the collection, which had been advertised with the title *Recovered Treasures*, lay with the consignor. These and 123 other works that were offered exclusively online weren't from a private collector but rather the Italian state institute for court sales—and with very good reason. The 178 works hadn't been missing, nor was it a question of "recovered treasures." Quite to the contrary, anybody could have recognized the paintings, gouaches, watercolors, drawings, and sculptures. In December 2019, some of the most important pictures were even to be seen in the evening news on Italian television. Media in other European countries also reported at the time how Carabinieri in gray uniforms and helmets gently carried the works into a room at the tax authority. It was apparent that some of them, such as the early Van Gogh *Still Life with Apple Basket*, were reproductions. Others that were paraded before the assembled press were, in fact, originals. These artworks were supposed to have helped a businessman hide money from the state. The plan leaked out, and that's why the tax authorities were auctioning off art in the fall of 2019 at such low prices.

€14 BILLION IN DEBTS

It was formerly the property of the Italian industrial magnate Calisto Tanzi, who had become a billionaire principally through Parmalat, a food company he founded in 1961. When the company went into bankruptcy in 2003, it had €14 billion in debt, as well as thirty-two thousand investors, large and small, who had been harmed. Tanzi was sentenced to ten years in prison for stock manipulation and corruption, and then in a second proceeding in 2010 to an additional eighteen years for fraud and the formation of a criminal enterprise. Parts of his private fortune were still missing until his son-in-law led tax investigators to the basements of three homes in Parma.

There Tanzi had attempted to hide money and property in the form of artworks. When they were found, the media estimated the total value at $100 million—most likely because of the names: Van Gogh, Gauguin, Cézanne, Manet, Degas, Signac, Monet, and Modigliani. In fact, most of the pictures were neither major nor large-format works, which would have made them automatically more expensive. The Italian tax authorities had set the estimated sales prices with corresponding caution, even for the more expensive pictures. A view of Varengeville by Claude Monet, dated 1882, had the modest opening price of €800,000—and fetched in the end €1.53 million. Similarly, the early Van Gogh *Still Life with Apple Basket* from 1885 had an opening price set at €280,000, and his surprisingly large watercolor of a pollarded willow was set at €200,000. There was a bidding war that pushed prices well over the estimates: to €495,000 for the still life and €800,500 for the watercolor of the tree. In the online portion of the auction, it was plain that the convicted fraudster Calisto Tanzi himself had sometimes been ripped off. Many of the works offered for sale bore the inscription "work is not authentic"—pictures allegedly by Giovanni Boldini and Giovanni Fattori, for example, or forged bronzes in the style of de Chirico and Alberto Giacometti. The supposed Giacometti *Female Figure*, for example, was offered for just €800—for the benefit of the Italian treasury and the victims of Parmalat.[229]

"ART IS ATTRACTIVE FOR MONEY LAUNDERING"

If money laundering is defined as the attempt, through purchases and sales, to give illegally acquired money the appearance of being completely legitimate, then Calisto Tanzi isn't an isolated case. In all big disclosures about hiding fortunes illegally—whether they're called the Panama Papers, Paradise Papers, Bahamas Leaks, Offshore Leaks, or Russian Laundromat—investing dirty money in art plays a substantial role. In his treatise *Money Laundering through Art*, the Brazilian judge, criminologist, and money-laundering expert Fausto Martin De Sanctis explains why transactions in art have come to play an increasingly

important role in money laundering in the past few years: "Art is an attractive sector for the practice of money laundering because of the large monetary transactions involved, the general unfamiliarity and confidentiality surrounding the art world, and the unlawful illegal activity endemic to it (theft, robbery, and forgery)."[230] De Sanctis points out that neither this business sector itself nor the society at large has a sufficient awareness of the problem: "Indeed, repeated tolerance of illegal activity in the art world, which is known to be widespread, undermines the market and its credibility to the extent that authorities have been unable to properly enforce the good practices required by both the law and the will of society."

Concrete examples from the past few years prove these observations to be correct. For instance, a packing crate at Kennedy Airport in 2007 seemed to customs personnel, as it was about to be shipped off as freight, to be too large and too expensive for what it was supposed to contain. "An artwork valued at $100," said the packing papers from London, where it was to be sent; no title or artist was named. The search that was ordered revealed that the box actually held a 1982 painting by the artist Jean-Michel Basquiat: 152 centimeters by 152 centimeters in size, acrylic and collaged paper on linen, which was attached to wooden stretcher bars at each end—minimum value $8 million.

The valuable picture was one of about 1,200 works that the Brazilian banker F. had purchased. According to law enforcement authorities, these purchases were made with money that he had withdrawn from investor funds of Banco Santos and embezzled. When his system collapsed in 2004, F. left behind debts of $1 billion. Before he was sentenced two years later to twenty-one years' imprisonment for bank fraud, tax evasion, and money laundering, this banker was able to smuggle at least $30 million worth of art out of Brazil. F. and his wife had bought many of the works, such as the Basquiat painting, through a firm named Broadening-Info Enterprises, which was registered in Panama. This enterprise later attempted to resell the pictures in the art market. Where that succeeded, illegally acquired money was washed clean through art,

and its origin could no longer be determined. "You can have a transac- tion where the seller is listed as 'private collection' and the buyer is listed as 'private collection.' In any other business, no one would be able to get away with this," elucidated Sharon Cohen Levin, the head of the division for asset forfeiture of the New York US Attorney's Office.[231]

In particular, since the prices in art sales are set at will, how much an owner asks for a Basquiat picture and how much the prospective buyer is ready to pay depends primarily on good old supply and demand, which in the art market plays out with respect to a unique object that cannot be compared with anything else. The result has been the huge auction records of the past few years. Even the few spectacular price records that leak into the public realm from discreet private deals suggest that there are no upper limits: including allegedly $300 million for Paul Gauguin's Tahitian painting *Nafea faa ipoipo* from the Staechelin collection, and $320 million for Paul Cézanne's *Card Players* from the Embiricos col- lection. On the other hand, in none of these cases can it be proved that these prices were actually paid and not just the stuff of rumors.

PICASSO, MATISSE, AND DAMIEN HIRST

The art dealer Matthew G., whose father owns a gallery in London, was accused by the US Department of Justice of having participated in an ongoing fraud for many years. It was a question of money laundering. According to the criminal investigation, two managers at the investment firm Beaufort Securities had defrauded its investors through illegal market manipulations. The unlawful gains were laundered through the art market, among other methods, as described in the comprehensive twenty-nine-page criminal indictment. Named by the British press as a friend of Prime Minister Boris Johnson, G. was unmasked in London at a February 2018 meeting with someone he thought was a new client. In fact, the client was an investigator wearing a wire who claimed that he had profited from illegal stock-market manipulations. According to the indictment, G. offered to sell the investigator the 1965 Picasso painting *Personnages* for $6.7 million. After a certain amount of time,

G. was to resell the painting and afterwards transfer the $6.7 million through a US bank to the man's bank account. The undercover detective indicated quite openly that he wanted to launder money this way.[232] In the opinion of the investigators, G. had thereby become an accomplice. In May 2019, his gallery went bankrupt.[233] The art dealer flew to Spain, where he underwent treatment in a clinic for substance abuse. Legal proceedings have not yet begun.

On May 11, 2009, the former attorney Marc Dreier confessed to fraud and money laundering. Like the notorious Bernie Madoff and his $65 billion fraud, Dreier had, over a period of five years, defrauded professional investors, such as hedge funds, with forged debt instruments to the tune of $400 million.[234] The fortune earned by this scam was laundered by acquiring art, among other things. A list of his assets from the New York district attorney encompasses more than 150 works—among them paintings by Alex Katz (*Red Tulips*, 1967), Roy Lichtenstein (*First Painting with Bottle*, 1975), Agnes Martin (*Loving Love*, 2000), Mark Rothko (*Untitled*, 1957–63), and nine canvases by Andy Warhol. Apparently, no one ever asked Dreier where he got the money that he paid the galleries and auction houses.

SALES THROUGH PANAMA

The story of the Greek family named Goulandris is to be found in the Panama Papers. They are one of many shipping dynasties that invest their fortunes in, among other things, art collections, which are administered through offshore firms they are associated with. In this way, the assets are at least partially removed from governmental scrutiny.

Basil Goulandris and his wife Elise were always willing to lend out their pictures. The two owned paintings that some museum directors would kill for. Their collection included a self-portrait by Cézanne, one of the renowned views of the Rouen cathedral painted by Monet, abstracts by Kandinsky and Klee, a portrait triptych by Francis Bacon, a drip painting by Jackson Pollock, and a half-dozen major works by Vincent van Gogh—such as the famous *Still Life with Coffeepot*, one

version of *The Olive Pickers*, and *Les Alyscamps*, his painting of the ancient Roman necropolis in Arles. Over the course of half a century, the two had gathered over two hundred works valued altogether at $500 million. In constant competition with his fellow countrymen Stavros Niarchos, George Embiricos, and Aristotle Onassis, Basil Goulandris captured headlines in 1957 when he paid what was then a record price of $297,000 for a *Still Life with Apples* by Gauguin. Almost everything that followed was of museum quality: for example, one of the last pictures that Cézanne painted of his garden, shortly before his death in 1906. As photos show, many of the paintings hung in Goulandris's chalet in Gstaad, Switzerland, during the winter months, and then, in the summer, the pictures were moved to his villa in Lausanne or brought to a storage facility.

Those who needed paintings for a retrospective or thematic exhibition could count on the support of this Greek couple who resided in Switzerland. In the summer of 1999, a year before her death, Elise Goulandris decided to exhibit the major works publicly for three months—in a small, radiant, white art museum on the island of Andros in the Cyclades that the couple themselves had had built. They rarely sold work during their lifetime, though a duplicative cathedral painting by Monet was sold in 1990 through the Basel gallery Beyeler to the collection of the Japanese securities company Nomura. Two versions of the same motif appeared to be too great a luxury even for a billionaire.

Basil Goulandris, who had made his money with the tankers of the Orion Shipping & Trading Company and maintained close connections to the Greek military regime before democratization, died in April 1994 at the age of eighty-one. His wife survived him by six years. Before their deaths, both had decided that the core of their collection should be shown someday in Athens. The architect Ieoh Ming Pei was hired for the building. The size was to be ten thousand square meters, and to cost approximately €27 million. The Greek state provided a piece of land for the construction, but it had to stop early when in fall 1996 workers doing the excavation encountered walls of a lyceum in which

Aristotle was supposed to have taught his students. Another location was abandoned after protests by neighbors. In 2009, the Goulandris Foundation, which had been created three decades earlier to shepherd the collection, announced the purchase of a neoclassical building on Eratosthenous Street in the Pangrati neighborhood, though it was only seven thousand square meters large. The Goulandris Museum would supposedly be ready in 2012. Then ensued the threatened bankruptcy of the Greek state, drastic cutbacks, and higher taxes. The Goulandris Museum finally opened in October 2019. But only with part of the original collection: some pictures had been sold in the meantime.

OPAQUE TRANSACTIONS

A niece of this collector couple, Aspasia Zaimis, sued in Switzerland because she believed that the intent of her aunt had been disregarded and she feared that pictures could have been sold in secret. Elise Goulandris, who was childless, was supposed to have ordered that all her personal possessions that were not sufficiently ancient or otherwise suitable for a museum should be kept by her nieces and nephews. Instead, as Zaimis, who stood to inherit a sixth of the estate, claimed in speaking with *Bloomberg* news, numerous works had disappeared. The report cited an agreement, dated 1995, in which Basil Goulandris was supposed to have sold eighty-three works to a Panamanian firm named Wilton Trading SA, for a total of only $31.7 million (i.e., well below market value).

Basil Goulandris's sister-in-law, Maria, who died in 2005, had formally owned Wilton Trading SA, which had been founded in 1981, but didn't name directors until 1995, as her son, Peter John Goulandris, attested before the Swiss court. His uncle had needed money to pay debts. That's why the price was acceptable to him. Besides, he said, his sister, Marie "Doda" Voridis, had agreed that the works that were sold could remain hanging in the chalet belonging to Basil and Elise Goulandris in Gstaad. Some of these works were to be transferred in the middle of 1992 to a foundation called Sirina, registered in Vaduz,

Liechtenstein. From the perspective of the litigant Aspasia Zaimis, various facts contradict this representation. An expert opinion of the Lausanne public prosecutor's office was said to have found that the 1985 contract was drawn up on paper that was not available until 1988. Basil Goulandris, who had Parkinson's disease, was no longer capable of signing in 1988. *Bloomberg* reported that Basil Goulandris was named in 1993 as the owner in the insurance documentation for the loan of the Miró painting *Paysage (La Sauterelle)* to the Museum of Modern Art in New York—and not Wilton Trading SA, which had allegedly purchased it eight years earlier. And in the 1999 exhibition on Andros of works by Bacon, Balthus, Bonnard, Braque, Cézanne, Ernst, Gauguin, Giacometti, Van Gogh, Kandinsky, Klee, Léger, Miró, Monet, Picasso, Pollock, Rodin, and Toulouse-Lautrec, plus an edition of the Degas sculpture *Little Fourteen-Year-Old Dancer*, nothing indicated that they weren't the property of Basil and Elise Goulandris.

Zaimis's coheirs—her sister and four other nieces and nephews—contradicted her claims through a common lawyer. Everything was in order, countered the executor for the will of Elise Goulandris, Kyriakos Koutsomallis, whom the Swiss authorities were investigating on suspicion of misrepresentation of ownership and the transmission of forged documents. Even Peter John Goulandris, one of the coinheritors, stated through his attorney: "There is a piece of land for the museum and advanced plans and preparations for the construction. The paintings at issue here were a part of a private transaction between Basil Goulandris and Wilton Trading SA about ten years before his death."

In fact, works were sold after the death of Basil and Elise Goulandris that were not ancient, to be sure, but were so museum-worthy that every museum director would clear a wall right away to make space to show them. The New York art dealer Alexander Apsis handled the sale of the 1890 Vincent van Gogh double-portrait *Two Children*, painted shortly before his death, to the owner of the investment firm Perpetual Corporation, Joseph Allbritton, in Washington, DC, for example. He owed his fortune to, among other things, business with the regime of

the Chilean dictator Augusto Pinochet. The rumored purchase price stood at $17 million. Apsis also negotiated the sale of Van Gogh's late still life *Vase with Zinnias* from the Goulandris collection to a private collection. Other paintings pop up in the Panama Papers because they were plainly also sold through firms registered overseas specifically for that purpose. Van Gogh's 1888 *Still Life with Basket and Oranges* thus found its way in 2005 through the offices of Alexander Apsis and the gallery Heather James in Palm Desert to the California collection of a direct-marketing tycoon and his wife. The seller was a firm by the name of Jacob Portfolio Incorporated. Similarly, in 2005, several more Goulandris paintings were offered by Sotheby's. The consignors were once again various companies: Tricorno Holdings for Pierre Bonnard's nude *Dans le cabinet de toilette*, Heredia Holdings for Marc Chagall's *Les comédiens*, and Talara Holdings for his *Le violoniste bleu*. According to research by the International Consortium of Investigative Journalists (ICIJ), all these entities were established just before the transactions and were closed soon thereafter. The common owner of all four companies: Marie "Doda" Voridis.[235]

SHOPPING FOR ART LIKE MR. LOW

Eileen M. Decker, the US attorney for the Central District of California in Los Angeles, made headlines in the summer 2016 when she presented an impressive list of artworks. Even more impressive were the prices that a single customer had paid the auction house Christie's three years earlier, inside of just six months. The buyer didn't have long to enjoy the collection, which from the beginning was acquired purely as an investment vehicle. In July of that year, the Swiss police seized parts of it from a duty-free warehouse at Cointrin Airport in Geneva. The art acquisitions contributed significantly to a crisis of state in Malaysia. In Switzerland, the financial market authorities were investigating several banks—one of them, Tessiner Bank BSI, was dissolved by Swiss banking regulators in May 2017.[236] The anonymous purchaser, of whom at first it was known only that he came from Asia, began modestly in May 2013,

with relatively cheap buys at the benefit auction *11th Hour* for Leonardo DiCaprio's environmental nonprofit LDF. There, this unknown person paid $717,000 for Mark Ryden's *Bee Queen*, and $367,500 for the painted text work *Bliss Bucket* by Ed Ruscha. In addition, he won bids for two sculptures by Alexander Calder: a *Standing Mobile* for $5.4 million and the work *Tic Tac Toe* for $3 million. Two days later he drew down mightily on the customer account (number XXX7644) that he had set up only days before at Christie's in the name of a "Tanore Finance Corporation": just at the New York auction for contemporary art, which set a record for total sales at a single auction of $495 million and carved its place in the history of the art market, he paid $48.8 million (a record price then) for the painting *Dustheads* by Jean-Michel Basquiat. Six weeks later, on June 28, there followed direct purchases from Christie's of a *Concetto spaziale, Attese* by Lucio Fontana and the color field painting *Untitled (Yellow and Blue)* by Mark Rothko for a total price of $79.5 million.

THE MONEY WASN'T FROM A FAMILY FORTUNE

And merrily it rolled along: for the multimillion-dollar sales at the New York Impressionist auction in the first week of November 2013, this top customer had reserved a skybox for twelve in Rockefeller Center, prompting a Christie's employee to email a colleague: "It better look like [the Las Vegas casino] Caesars Palace in there. The box is almost more important for the client than the art."[237] From the perch of his private lounge above the auction room, this big mysterious buyer snapped up Van Gogh's pen-and-ink drawing of the Yellow House in the southern French city of Arles for $5.5 million. He concluded his buying trip a week before Christmas when he paid $35 million for Monet's view of Venice, *Saint-Georges Majeur*, at SNS Fine Art, from the art-dealing Nahmad family. The sun-filled picture had previously been exhibited at the Art Institute of Chicago. At Sotheby's in London just a half year later, in June 2014, he followed up with the purchase of Monet's water-lily painting *Nymphéas avec reflets de hautes herbes* for £33.8 million. The art purchases by the presumed Asian buyer added up to $250 million.

He had most of the works delivered quickly to a duty-free warehouse in Geneva. The two Monets and the Van Gogh drawing were seized there in July 2016.[238]

After the matter was investigated, it was soon clear to the US attorney that the Malaysian investor and alleged billionaire Jho Low was the man behind Tanore Finance Corporation. Low had already attracted attention for many years with spectacular acquisitions of art and real estate in Beverly Hills and New York. According to the investigation, the money came not from a private fortune but rather from a multibillion-dollar state fund by the name of 1Malaysia Development Berhad (1MDB). The Malaysian state had in fact created the fund to support development projects. Meanwhile, it proved to be the case that persons in the inner circle of the Malaysian prime minister Najib Razak had diverted more than $1 billion from the state fund through sham purchases of shares. According to the investigation, even shortly after the first transactions of 1MDB, $500 million was transferred to an account that Low controlled. From there, transfers were made to other accounts that in part belonged to Low's relatives.[239] The head of state was similarly implicated: his wife was said to have received, among other things, a necklace of twenty-two-carat diamonds worth almost $30 million. Najib Razak later claimed that the large sums in his bank account were a gift of the Saudi royal family. In fact, however, the transfers could be traced back to Tanore, the company through which Jho Low had distributed embezzled state funds. Najib Razak was voted out of office in May 2018, and two months later he was taken into custody on suspicion of embezzlement and money laundering. At his residences, artworks, luxury goods, and cash worth $300 million were impounded. The investigators found another $700 million in a bank account belonging to Najib Razak, against whom numerous legal proceedings are currently underway. In December 2019, he pled innocent before the court in Kuala Lumpur.

The art buys that Jho Low made with state funds served no other purpose than money laundering, according to the investigations. Low's assignment was to spend the embezzled state money in the largest

competing interests come into play. Many auction houses long ago established specialized departments for these private sales. And those who are not selling might also put up a piece of art bought with illegally obtained money as collateral for a loan and then not seek to redeem the artwork. There might be a financial loss in the transaction. But even if they receive half of the value of a painting or sculpture, they now have clean money to spend.

These practices were supposedly built up through tradition as trade secrets of the business of buying and selling art—business practices that don't exist in any other part of international commerce and can include frequent cash payments, which might be ideally suited to the needs of individuals and organized crime alike, as Monika Roth concludes:

"With its culture of discretion and opacity, the art market cannot be easily regulated. The identification of art objects is hard. The value of objects is difficult to determine because of subjective factors.

"There are massive amounts of money at play. Money laundering influences the value of objects which causes market manipulation. Tax evasion in this arena is the order of the day. The transactions are conducted in secret. The parties can remain anonymous or might even be virtual. Auctions can be easily manipulated."[243] Roth is clear that the art market as such cannot and should not be put in the same category as organized crime. She has found, however, "that such organizations use the art market, and those who conduct art transactions with corrupt dictators who have never earned money legitimately must be open to the accusation that they didn't do their homework and didn't 'take all the necessary steps' to satisfactorily complete the transaction. [So] it can still be said of the art market: 'There is no supervisor, there are no rules: unlike in most financial markets, in the art market, lack of transparency is still the norm . . .' Everybody is making their own rules as they deem fit. Preferably none."[244] The *New York Times* put it this way: "In the United States federal money laundering statutes apply to nearly every major transaction through which illegal profits are disguised to look legal. Typically, dirty money is laundered through the purchase of,

possible amounts. As studies have consistently found in the past few years in Switzerland, the US, Brazil, and Germany, art is especially well suited for money laundering, along with real estate and expensive yachts. The Basel Institute on Governance, a nonprofit research group, issued a warning in 2012 about the large number of illegal and suspicious transactions in the art sector.[240] Two years later, Monika Roth, a Swiss attorney and professor for compliance and the law of financial markets at the Hochschule Lausanne (as the Federal Institute of Technology Lausanne is known), was more concrete as she made plain: "It was found that there was a strong correlation between the illegal trade in drugs and weapons and money laundering and art crime."[241] The independent researcher named a reason for this startling association of dirty businesses and the presumably noble trade in the good, the beautiful, and the true—art: "It is entirely reasonable to conclude that antiquities and art are well suited to money laundering simply because enormous cash payments are not at all unusual and crazy sums are moving around."[242]

THE SECRETS OF THE MARKET

No one in the art world has to justify paying thirty times as much for a Van Gogh drawing or a picture by Monet than what the work sold for five years earlier. The market has changed, and a—naturally anonymous—competitive bidder has driven the price up. Whether the competitor in fact exists cannot be proved. For decades in the auction houses, the so-called chandelier bid was acceptable and customary: in order to drive the final price up as high as possible, the auctioneer simply claimed—after looking up at the chandelier—that someone in the back of the room had just raised a hand to bid.

Sellers and buyers, through strawmen, can be the same person in an art auction. Sometimes all it takes is a quick look at the auction book on the "rostrum," the auction podium, and then the announcement that there is a written offer registered to drive the price artificially higher. Even today, there is no way to validate such claims. Still less subject to verification are transactions that occur in private, when allegedly

say, a penthouse apartment, or mixed in with the earnings of a legitimate business like a restaurant. When gambling winnings or drug proceeds come out the other end, they appear as a real estate asset or business profit. They look clean. . . . Roll up a canvas and it is easy to stash or move between countries; prices can be raised or lowered by millions of dollars in a heartbeat; and the names of buyers and sellers tend to be guarded zealously, leaving law enforcement to guess who was involved, where the money came from and whether the price was suspicious."[245]

There is oversight in most of these areas. Real-estate transactions and deeds require at least a name. Mortgage brokers, securities brokers, casinos, banks, and Western Union are required to report suspicious financial activities to the government network overseeing financial crimes; banks must report all transactions of $10,000 or more.

This network of brokers, casinos, and banks logs more than fifteen million currency transactions each year, which can help trace dirty money, said its spokesperson, Steve Hudak. The art market lacks these safeguards.[246]

THE LACK OF AWARENESS

The quantitative research of Professor Kai-D. Bussmann, a legal expert who heads up the interdisciplinary Economy & Crime Research Center at Martin Luther University in Wittenberg-Halle, Germany, helps to explain the lack of awareness of the dangers of money laundering within the art world. He writes, "A very high risk of money laundering exists likewise in the business sector of expensive luxury and consumer goods. An interesting segment is the trade in art and antiquities, which in 2015 boasted a sales volume of over €2 billion. This market is of course much smaller than the real-estate market, but extraordinarily attractive for money laundering. Expensive art objects have the quality of an easily convertible currency, and cash payments are common and plainly favored."[247] The Economy & Crime Research Center adds that the risks of money laundering are greatest "if the investments of suspicious funds satisfy several of the following criteria":

- Characteristics of a currency, easily convertible and stable
- Inconspicuousness of converting large sums or values (buying and selling)
- Possibility of high acquisition price for the good (such as real estate or art)
- Possibility of significant increase in value
- Large cash transactions are possible (e.g., construction projects managed by real-estate developers, architects, the hotel and restaurant industries, as well as specially established import and export firms)

According to independent researchers, among the commercial sectors that meet these criteria—apart from businesses with fiduciary accounts and escrow accounts held by legal advisers and financial consultants, the hotel and restaurant industries, and real estate—is the trade in expensive art objects and antiquities.

Moreover, Professor Bussmann's research emphasizes, the awareness of the problem is woefully inadequate in the art market. Of the art and antiquities dealers and auction houses and galleries questioned, 27 percent said that they frequently or sometimes accept cash payments of over €15,000. Only about two-thirds (64 percent) of the deals identify the counterparty to the transaction or the beneficiary. The remaining transactions are conducted more or less on a handshake—without the dealer or auctioneer knowing from whom they received these large cash payments.[248]

Similarly, about two-thirds of the art and antiquities dealers, auction houses, and galleries surveyed (65 percent) assume that the risk of money laundering in their field is small or nonexistent.[249] The results of the study show that this self-evaluation has little to do with reality: "For this group of dealers, the volume of money laundering might be substantially greater than we could estimate in the study because of the very low level of awareness about the issue. There are very few controls, which makes it highly improbable that deficiencies in fulfilling the

duties of due diligence might be discovered. Within the subgroup of
businesses selling goods, we found the risks in the sector of fine art
and precious antiquities to be by far the greatest. The awareness of the
problem is completely insufficient in this group. The same can be said
of dealers in boats and yachts. But, as a consistent route for money
laundering and a hub for large cash transactions, expensive art and
antiquities are the best, since all the criteria for goods that are vulnerable
to money laundering are squarely met. Art and antiquities are not only
especially effective for cultural development as well as generating social
capital, but, in contrast to consumer or luxury goods, the risk of money
laundering in art and antiquities arises from their unlimited capacity to
function as currency with a high degree of global mobility, stable value,
and inconspicuousness."[250]

THE BENEFICIARY: ORGANIZED CRIME

Criminals worldwide have profited for some time from the plainly
undeveloped awareness of wrongdoing and absent or unused monitor-
ing mechanisms. When in fall 2016 the Italian police raided the house
of a drug dealer in the Camorra stronghold Castellammare di Stabia
in the Gulf of Naples, they came upon two early works by Vincent van
Gogh that thieves had been hired to steal from the Van Gogh Museum
in Amsterdam in 2002. In the meantime, the paintings had changed
hands several times, for money-laundering purposes and as currency
to pay for drug deals.

In America, the FBI suspects that the Mafia is behind the spectacular
robbery of the Isabella Stewart Gardner Museum in Boston in 1990, in
which paintings by Vermeer, Rembrandt, Manet, Degas, and others were
stolen. Drug dealing and money laundering are also behind the 2004 theft
of Edvard Munch's world-famous painting *The Scream* in Oslo.

The dirty business in pictures operates worldwide. When the
Japanese economy was booming in the mid-1980s, the art market there
boomed as well. In the expensive Ginza district of Tokyo alone, three
hundred new galleries opened. Between 1985 and 1990, the import

of Western art increased twentyfold. $40 million for Van Gogh's *Sunflowers*, $82.5 million for his *Portrait of Dr. Gachet*, $78.2 million for Renoir's *Bal du moulin de la Galette*: in those five years Japanese corporations, banks, and collectors bought art for a total of $3.6 billion, before the art bubble burst.[251] An FBI report found that various galleries were associated with Japanese organized crime (Yakuza). Art market experts suspect that during this same period up to 90 percent of the money in the Japanese art market came from dubious sources. The entrepreneur Yasumichi M., for example, whom the Japanese media have dubbed the "king of dark money," allegedly bought hundreds of impressionist and postimpressionist paintings in New York for about $1 billion—among them, more than twenty Renoirs and also works by Van Gogh, Monet, Degas, Vuillard, and Gauguin, plus the two early Picassos, *Maternité* and *Au Lapin Agile*. Besides that, he also acquired a 6.5 percent share in the auction house Christie's.[252] After 1990, many Japanese buyers had to part with their artworks, and the pictures and sculptures discreetly returned to the galleries and auction houses—at significantly lower prices. In China, the prices for art rose more than 300 percent between 2009 and 2011. It is noteworthy that many young Chinese collectors at art fairs such as Art Basel Hong Kong are interested in Western art.[253]

THE HOLLYWOOD CONNECTION

In the Malaysian state funds case, Jho Low became a big player in America on both the East and West Coasts. He associated with stars like Paris Hilton and Leonardo DiCaprio, who were later, unknowingly and involuntarily, involved in his art dealings, and he acquired $60 million worth of real estate in New York and Los Angeles. In Manhattan he lived in an apartment in the Park Imperial on Fifty-Sixth Street that cost $100,000 per month. His neighbors in the luxury building were the James Bond star Daniel Craig and the rapper Sean "P. Diddy" Combs, among others. In a bar in New York, the actress and singer Lindsay Lohan is said to have treated Low to twenty-three bottles of champagne for his twenty-third birthday.[254]

According to investigations by the *Wall Street Journal*, Low's company Jynwel Capital shared in the investor buyout of EMI Music Publishing in 2011 for $2.2 billion and two years later for the same sum participated in the acquisition of the Canadian company Coastal Energy. After he bought the Basquiat for a record price, the New York art magazine *ARTnews*, in the summer of 2013, put him on its prestigious annual list of the top two hundred art collectors.

But his social and cultural prestige didn't last long. As the investigations into the Malaysian state fund reached the US, Jho Low quickly turned from celebrated buyer to discreet seller in the same year. Starting in February 2015, works in his possession valued at $205 million changed ownership—among them, pictures by Pablo Picasso and Claude Monet, both of which Low sold at prices that were under Sotheby's estimates. In February 2016, at Christie's he had auctioned off the 1908 Claude Monet painting of a view of Venice, *Doge's Palace Seen from San Giorgio Maggiore*, for $16.7 million, less than the low estimate. Low accepted $27.5 million, instead of the estimated $40 million, for Picasso's *Head of a Woman*. Sources have confirmed that in April 2016 a hedge-fund manager identified only as Daniel S. of Connecticut had paid only $35 million for the once record-setting Basquiat *Dustheads*, which portrays two drug addicts—$13.8 million less than Low had paid for it.[255] Voluntary losses are quite the norm in money laundering: the main thing is that the remaining money will from then on be clean and unsuspicious.

MARLON BRANDO'S OSCAR

Selling works that allegedly belonged to him was by no means the end of the story for Jho Low. The scandal created waves and made headlines for, among others, one of the most famous Hollywood stars of the twenty-first century. Low had placed the money that had been entrusted to him not just in artworks, real estate, record companies, and energy concerns. He had also invested in a film project that involved the director Martin Scorsese and the actor Leonardo DiCaprio.

Investors often finance Hollywood productions in the hope of respectable returns from a strong box office performance. So it didn't surprise anyone when in 2013 the production company Red Granite put millions into three films: *Dumb and Dumber To*, *Daddy's Home*, and, fittingly enough, *The Wolf of Wall Street*. Riza Aziz, the son-in-law of the Malaysian prime minister Najib Razak, was a cofounder of the US company. Low allegedly had met DiCaprio earlier in connection with the work each of them did on behalf of environmental groups. As Low told the *South China Morning Post*, he supposedly suggested DiCaprio for the role in Scorsese's Wall Street picture. And he gave him art: the Picasso painting *Still Life with the Skull of a Steer* (1939), worth $3.2 million. He sent a note with his gift to DiCaprio: "Dear Leonardo DiCaprio: Happy Birthday belatedly! This gift is for you."[256] A spokesperson for the actor confirmed later that he had accepted the gift in order to sell it at an auction for the Leonardo DiCaprio Foundation (LDF). And Jho Low would purchase some of his art at LDF auctions: for example, in 2015 in San Tropez, he bought Roy Lichtenstein's 1982 sculpture *Brushstroke* for $600,000, and earlier, at the aforementioned Christie's auction for the benefit of DiCaprio's foundation, he bought paintings by Ed Ruscha and Mark Ryden for, collectively, $1.1 million.

In the spring of 2017, DiCaprio conveyed ownership of the Picasso picture to the US government. He also parted with the 1982 Basquiat collage *Red Man One*, which he had received from Low. In addition, DiCaprio gave back the Oscar for best actor that Marlon Brando had won in 1955 for *On the Waterfront*. The two Red Granite owners, Riza Aziz and Joey McFarland, had given the Oscar to DiCaprio, who at that point had not won the honor himself, for his thirty-eighth birthday in November 2012.[257] Ralph DeLuca, a dealer in memorabilia, had sold the statuette in fall 2012 for $600,000.[258] It had disappeared from Brando's possession during his lifetime.

Jho Low pledged a fortune worth $700 million to the government in connection with a settlement with the US Department of Justice at the end of October 2019. Apart from artworks by Basquiat, the Van Gogh

drawing of the Yellow House in Arles, and the photo *Child with a Toy Hand Grenade in Central Park* by Diane Arbus, there was the Picasso painting that Low had given to Leonardo DiCaprio. Moreover, the Malaysian handed over Claude Monet's painting *Saint-Georges Majeur*, which had previously belonged to Nahmad. Low let it be known that he had not been required to make an admission of guilt.

ONE PERCENT FOR GERMANY

The German art market is considerably smaller than its American counterpart. According to the 2019 *Art Market Report*, an annual publication by the Swiss megabank UBS that is produced in early summer for the Art Basel fair, the turnover internationally in the art market was $67.4 billion in 2018. Three countries are responsible for four-fifths of this sum: the US with a 44 percent share, Great Britain (pre-Brexit) with 21 percent, and China with 19 percent. Germany can claim only 1 percent internationally and within the European market a modest 4 percent. Still, Germany has the most people who possess fortunes in excess of $50 million after the US and China.

When the Nazis robbed, deported, and murdered or exiled thousands of—mostly Jewish—art collectors, they permanently destroyed a big part of the art market in Germany. The near proximity of tax havens, which opened up plainly illegal but lucrative possibilities, is also a cause of the small size of the postwar market in Germany. Those who want to hide money from the government prefer to buy art in galleries and auction houses or from private collectors with their official residence in Zürich or Luxembourg, Monaco or Liechtenstein. The art market is booming there; but in Germany it never really recovered, in part because of the forty-four-year isolation of Berlin. Really valuable artworks of international stature rarely came on the market in Germany after the war; instead, they were exported for sale. Just as German artists—from Ernst Ludwig Kirchner to Martin Kippenberger—are considered favorites today at auctions in New York and London, German collectors are among the chief consignors

in the auction houses there. Germany placed fourth in 2018 in the rankings of the countries where the most sellers come from, behind only the US, Great Britain, and France. Dealers and auction houses in those countries lose out on those foreign sales and tend not to keep up with changes in taste of the global collector base and the interests of a steadily younger clientele.

German art dealers, for example, have complained for years about supposed barriers to competing. They say that legal restrictions—such as the laws protecting cultural goods, the artist's resale right (according to which, since 2006, the artist or the artist's heirs are entitled to up to 4 percent of the proceeds of a sale), or high sales taxes—allegedly scare off the art community from buying paintings, drawings, sculptures, and prints in Germany, or from selling: those who want to sell a Caspar David Friedrich, an Ernst Ludwig Kirchner, or a Gerhard Richter look to the international market.

That many of these regulations were instituted by the German government only to encode the European standards into national law is willfully overlooked. Similarly, they disregard the fact that, for example, the German law protecting cultural goods is more generously drawn in favor of collectors and dealers than in many other EU countries, and that the cost of the bureaucracy has proved to be considerably smaller than the doomsday scenario that professional groups of German dealers had conjured up at the time the law was implemented. The law protecting cultural goods, claimed Bernd Schultz, cofounder of the revenue-rich auction house Grisebach in Berlin, would be "the guillotine for the art market."[259] The chairman of the board of the publisher Axel Springer, Mathias Döpfner, himself a collector, labeled the draft legislation a throwback to the communist East German State: "German Democratic Republic all the way."[260] Contrary to those claims, the revenues of German auction houses didn't crater: they remained stable at the same lower level as before when compared with Great Britain and the US.

The terrorist attacks in Paris in November 2015 and in Brussels in March 2016 and the question of how the responsible terrorist groups had financed themselves led to the European Union's adopting a new directive on money laundering. The scandal surrounding the Panama Papers also propelled this development. The member governments throughout Europe were obliged to enact the directive into national law.

When the German treasury published its "Draft Legislation to Enact the Change of Directive for Four Money Laundering Directives" in late summer 2019, the arguments put forth by art dealers resembled those they had used against the law for the protection of cultural goods. With the new directive, the former scope of the law on money laundering expanded to include additional professional groups, which were also required to establish risk management and fulfill duties of due diligence and identification and, in appropriate cases, report suspicious activity to the criminal authorities. Outside the finance sector, this change from that point on applied to art dealers, who already felt themselves under the gun: "also art dealers and art storage businesses (these last only in duty-free zones) for transactions of €10,000 or more."

In the future, the planned security measures apply not just to cash deals but also to transactions by credit card, through payment systems like PayPal, or through bank accounts. According to the legislature, it is no longer quite so easy in a suspicious case to trace the flow of money because of the increasing digitalization of the payment business: "In particular the pseudonyms or anonymity employed in the trade of cryptocurrencies enables their misuse for criminal and terrorist purposes." The G20 has spoken of the necessity of "regulating 'virtual assets' in order to fight money laundering and the financing of terror."[261] Developments in Europe also led to a new debate in the US on the topic of art and money laundering.[262] At a forum in New York in October 2018, lawyers and money-laundering experts discussed the Bank Secrecy Act, which also meant stricter regulation on the art market in the US. At the end,

they came to the conclusion that "further regulatory restrictions on the art market will eventually be needed."[263] And the numbers were almost unbelievable: partly because of the restrictions in other business sectors, through 2026 collectors and investors worldwide will invest $2.7 trillion in art.[264] In Germany, the backlash by the industry didn't take long. In the art magazine *Monopol*, the Munich attorney Gerd Seeliger summarized the possible structural effects of the new law in a somewhat considered fashion: "Fact: art dealers, gallerists, and auctioneers in the future not only have to identify their client; they have to conduct a risk analysis, document that analysis, and—regardless of the sales price—report suspicious cases. In practice, this will lead to substantial organizational and financial costs. The concern is not just that the buying behavior of the collector could change, but also the structure of the market, because smaller galleries and auction houses will go under."[265] Seeliger mentioned that even at auctions where an offshore company, an anonymous numbered bidder, and proof of sufficient funds in an account formerly sufficed, "soon all participants will be registered at the start since it is not foreseeable which work will sell for more than €10,000."[266] He qualified the fears about whether to expect a huge increase in bureaucratic expense: "Whether the fear is justified remains to be seen. There were fears when the law for the protection of cultural goods was introduced, 100,000 export applications would be filed each year, but in the year after it was enacted there were barely 1,000. Most art collectors won't have a problem revealing their identity as long as the art dealers use the personal information solely for the prevention of money laundering. The request for identification will not redound negatively upon the art dealers because they can always refer to the fact that they are implementing the statutory requirements."[267] In the *Kunstzeitung*, a publication friendly to the art market, the lawyer Peter Raue pulled out the heavy artillery against the proposed law: "The German legislator obviously considers the German art market to be an association of money-laundering specialists who must be gunned down through legislative means." The lawyer, who has regularly represented collectors, museums, and members of the art market, writes about "a

proposal to discriminate against an entire industry" and in his antipathy toward the law comes to the polemical conclusion: "Resale rights, social security contributions for artists, higher sales taxes for art dealers, the law for the protection of cultural goods and now restrictions on money laundering. Can't German legislators get it into their heads that art dealing is not where terrorist financing and money laundering originate, stop with the schizophrenic directives, and perhaps instead pay attention to the Arab clans in Berlin? They don't buy art, but rather real estate, jewelry, cars, and are therefore free from the requirements of these duties."[268] Then the lawyer takes a misleading populist swipe at the German legislature: "It is of little consolation that the €10,000 cutoff is expressly applied to the art market in its fifth EU money-laundering directive and the German legislator doesn't have a choice but to carry that over into law."[269] In fact, the new German money-laundering regulations also applied to real estate. The polemic on behalf of his clients unmasks itself. The coarse argument resembles in many respects that of the German art-dealing associations that complained that their members were regarded with suspicion. At a meeting of the federation of German galleries and art dealers (BVDG) in May 2019, Irmgard Elhachoumi, who leads the unit for the prevention of money laundering at the Office of Economics, Trade, and Innovation of the state senate of the city of Hamburg and who is one of those responsible for overseeing compliance with the new regulations, contradicted the fears of the German art-dealing associations: "It's not half as bad as it seems. It can actually be done. We start with the assumption that art dealers become victims [of money laundering] and are not the offenders." Citing the German business newspaper *Handelsblatt*, she said that the art market wasn't being put in the dock, but she adds: "The dealer has to know to whom he is selling."[270]

SOCIAL DAMAGE

Art dealers cite, moreover, contemporary studies that they say show how little the German art market has to do with financing terrorism, as has been claimed since September 11, 2001. Peter Raue also makes reference

to such a study when arguing against the new regulations: "The ILLICID study, published in July of this year—an independent project financed by the German federal ministry assigned to investigate the illegal trade in cultural goods in Germany—determined that the assertion often made by UNESCO that there was a worldwide illegal trade in works of art of around $6 billion did not withstand scrutiny. This study estimates the scope of the legal art market in ancient cultural goods in Germany at just €800,000 per year! Concerning illegal art dealing, let alone financing terror, there are no findings at all."[271] But that's not really the problem. In financing terror, the art trade plays at most a subordinate role (compare Chapter 3). The new law, which the industry opposes, is principally focused on the commonplace money laundering and tax evasion that are committed daily, not by terrorists, but by upright citizens, cloaked in ostensible legality. The tangible damage caused by this antisocial behavior, the political and social harm that these perpetrators can wreak, is considerably higher than collectors are willing to admit.

International experts argue for the elimination of special rules, like handshake deals and cash transactions, and the end to the strange insistence upon business secrecy, which the art trade justifies based on longstanding tradition and the special cultural significance of art. Just how long this absurd argument has abetted criminal activities is demonstrated by the ongoing debate about the ownership of art stolen by the Nazis and the scandal concerning the forger Wolfgang Beltracchi, who invented the fictitious Jäger collection, whose provenance allegedly could never become known. Once again, the problem was compounded when prominent art dealers used anonymous letterbox companies in offshore tax havens and were drawn into this business of selling what later turned out to be forged artworks. The witnesses presented during the trial in Cologne refused to provide information about who had bought specific artworks.

"Questionable practices were permitted in the name of independence and the art trade's requirement of secrecy," as the Brazilian money-laundering expert Fausto Martin De Sanctis described these customs

that are defended as grounded in common law but, in fact, have no juridical support. "At the same time, legal proceedings, reports in the international press, and various studies suggest that international, organized, illegal crime syndicates could be behind it."[272] Based on that finding, this legal expert concludes that there must be clear and systematic guidelines about money laundering with regard to art "to exclude all criminality. . . . Closer attention to banking or non-banking transactions in order to prevent money laundering is not following to business in galleries or international auction houses which have become centers for cultural diffusion and eminently social institutions."[273] Professor Bussmann asks similarly that a maximum amount for cash transactions be introduced: "It should be understood that a limit of €5,000 would exclude the bulk of consumer goods. . . . In general, even the German market appears to be switching over to simplified noncash payment methods as shown recently in the intense competition for the use of cashless payment methods through smart phones. Although the market can mostly switch to cashless payments, the practice of accepting cash payments for lucrative deals in the five- to six-figure range continues nonetheless, as the trades in real estate, art, and luxury cars show. Lawmakers must eliminate the pathways to money laundering. In most countries, one would have to wait too long for the market itself to set an upper boundary."[274] And the American lawyer Phoebe Kouvelas has developed a checklist of red flags with which all participants in the market can determine whether they are being drawn into a transaction involving an attempt to launder money:

- The price of the artworks lies significantly below or above the market value
- The artwork is an antiquity and/or the country of origin has recently been the site of conflict
- The artwork is presented with little or only very meager documentation
- The buyer insists on paying large sums in cash

- The buyer insists on paying for a single transaction with separate small payments
- The client refuses to provide sufficient information about personal identity or ownership
- Intermediaries act at the behest of unknown buyers or sellers
- Buyers or sellers wish to route a payment through a third party

Not all of these red flags mean unequivocally that money laundering is being attempted, but as Phoebe Kouvelas explains, "they indicate that further measures need to be taken in order to rule out such possibility."[275]

Freeports—the dark rooms of the global art business

Today, for really expensive art, the super rich use a vault that doesn't even try to be inconspicuous. It is as big as a multistory warehouse and shines in the night far and wide. The architects planned the building with delicate care: green spotlights illuminate the facade of the massive building, which looks as if it were covered in cloth and lies in close proximity to the airport in Singapore. Visitors must pass through numerous locked gates and security barriers and at the end be x-rayed by an armed security guard. Then they enter a huge atrium marked by a spectacular sculpture by the designer Ron Arad. A kind of lattice of reflective metal winds its way for several meters upwards through the space. Arad has given it a telling title: *Cage without Borders.*

Through fireproof, multiple-secured doors, one arrives at the storerooms and laboratories where artworks are examined, professionally photographed, and restored. There's also a framing workshop on site. Various air-conditioning systems ensure that the temperature remains at twenty degrees Celsius and 55 percent relative humidity.

Clients of the freeport can rent so-called showrooms to present the art stored there to their business partners or to sell artworks. Business can be taken care of in small, elegantly furnished offices—"discreetly and securely," as the internet page reads. If desired, the works stored at

the freeport can—as a special service—be exhibited in the museums in Singapore "free of tariffs, indirect taxes, or payment of a deposit."

The back door leads directly onto the landing field of the airport: items can be brought from airplanes without any detours, directly into the building. Collectors can travel by limousine from their airplanes into what is under customs law the extraterritorial area of the freeport. On a tour through the building, visitors are shown gigantic X-ray machines, which are used to examine large shipping containers for explosives and other prohibited substances. Forged pictures or falsified provenance are, of course, not detected by these apparatuses.

For years this enormous vault, which earlier went by the name "Singapore Freeport" and is called "Le Freeport" today, was advertised at the biggest art fairs in the world. It was supposed to provide protection not only from theft, natural calamities, and climate fluctuations but also and most especially from the reach of tax authorities. There appears to be nothing that the rich fear more than the taxman. A favorite topic among collectors when they meet in the VIP lounges and the free limousine shuttles at art fairs such as Art Basel Hong Kong or Frieze in London is apparently the excessive demands of tax authorities. It is not accidental that many of the successful art fairs are held in places that offer templates for tax avoidance to the super rich.

Freeports and tariff-free storerooms have played an increasingly important role since the start of the new millennium. They are the duty-free zones and dark rooms of the international art market. Legal business transactions may be conducted there, but also transactions involving money whose origin is unclear. One can hide objects with delicate provenance from the claims of the Nazis' victims or conceal illegally excavated objects from governments.

The freeports developed in the boom years of the art market into the bunkers for beauty. They also house masterpieces with a clean history of ownership, securely packed away of course, seen only by the surveillance cameras of the security guards. For art serves as an investment vehicle and is more favorable from a tax and actuarial perspective. The

speculative value appears to have transcended the value of everyday enjoyment and the symbolic value that one usually gains by exhibiting an artwork. Freeports are thus an integral component of a system that deprives art of its most important purpose: to be seen. Not only do they serve as dark rooms in which anything is possible and everyone remains anonymous. They are also the black holes of the art universe.

THE HISTORY OF FREEPORTS

There have been freeports and warehouses for a long time in many trading centers and port cities of the world. They are extraterritorial under tax laws. Originally, the freeports were conceived as places for short-term storage of goods that were intended for further transport by import and export businesses, without import taxes or customs tariffs becoming immediately due in the given country. These levies were to be extracted when delivery was made to the customer at their final destination, not at a transfer point. But in the global art trade, this system, which was supposed to provide distributors with bureaucratically simple, tax-neutral interim storage, was exploited and perverted. In freeports in Switzerland, Luxembourg, and Singapore, works of art worth billions of dollars are warehoused not just for days or weeks but for years and even decades, for a variety of purposes—for example, to artificially constrict the market for Picasso or Warhol, or to wait out the statute of limitations on legal action. And that's not all: the art can be sold tax free. Often these transactions are conducted by letterbox companies that are registered in tax havens like Panama or the British Virgin Islands, thus concealing the true owners.

Some of the most well-known freeports are located traditionally in Switzerland, at the Zürich Kloten airport, in the Dreispitz quarter of Basel, or in Geneva's La Praille. According to Swiss estimates for 2013, in the Geneva freeport alone 1.2 million works of art were stored, in addition to three million bottles of wine. The freeport is the biggest wine cellar in the world, the director has stated.[276] Large insurance companies

point to the quick increase in coverage amounts that the construction of the new freeports has necessitated.

ANTIQUITIES FROM ILLEGAL EXCAVATIONS AND ART
STOLEN BY NAZIS IN THE GENEVA DUTY-FREE WAREHOUSE

Until 2007, the Swiss freeport warehouses weren't even monitored by customs. The Swiss Federal Audit Office wrote in a 2014 report that the duty-free warehouses had "frequently" proved to be "gray zones with a high risk of smuggling and illegal activities."[277] When the Swiss authorities instituted more exacting monitoring, stolen goods were found. Thus, in January 2016, two Etruscan sarcophagi were seized at the Geneva freeport warehouse and returned to the Italian government. They had been stored in the warehouse for fifteen years, along with vases and other objects. A British antiquities dealer had put them there. The investigations confirmed the suspicion that it was a case of illegal excavation. Another sarcophagus with a dubious provenance was seized at the same location in 2015 and returned to Turkish authorities.

The Geneva duty-free warehouse made headlines in April 2016 when a work by Amedeo Modigliani, conservatively valued at $25 million, was seized there. The painting *Homme assis* (ca. 1918) had once belonged to the Jewish gallerist and collector Oscar Stettiner. He had to leave it behind when he fled from Paris in 1939. The Nazis in occupied Paris auctioned off the painting along with his other property. Decades later, ownership of the painting *Homme assis* was transferred by way of a Christie's auction to an offshore company called International Art Center.

There had long been speculation about who was behind this company. Certainty arrived in 2016 with the publication of the so-called Panama Papers—secret documentation of the establishment of offshore companies by the specialty law firm Mossack Fonseca. David Nahmad, scion of one of the most successful art-dealing families in the international trade, was closely allied with the International Art Center.

The Nahmads have been dealing art for decades in London, New York, and Paris. At the big auctions at Christie's and Sotheby's, they can be seen time and again sitting in the front rows and bidding. Sometimes different members of the family appear to be bidding against each other. The Nahmads own not just dozens but hundreds of works by artists such as Picasso, Braque, and Miró. How many exactly and which ones are not publicly known.

In October 2011, the public was afforded a rare peek at the quality of the collection, when about one hundred selected works by Monet, Magritte, Gris, Kandinsky, and especially Picasso were shown in the Kunsthaus in Zürich. The exhibition was controversial because the difference between the collection and inventory for sale by the Nahmads was, at least from the outside, hardly clear. The museum was being misused to increase the value of goods for commerce, critics asserted. In an article about the exhibition in the newspaper *Neue Zürcher Zeitung*, the Nahmads' holdings at the Geneva customs warehouse were estimated at five thousand works valued at many billions of Swiss francs, including three hundred works by Picasso alone.[278] Only Picasso's family is said to own more of his pictures.

A lawsuit by a grandchild of Oscar Stettiner in a New York court for the return of the painting *Homme assis* had not yet been decided at the time that work on this book ended. David Nahmad's lawyer argued that the Modigliani owned by International Art Center had nothing to do with Oscar Stettiner's painting. In holding that the complaint contained a sufficient factual basis to state a claim, the New York judge opined in April 2018: "New York is not and shall not become a safe harbor for [art pillaged] during Nazi genocide."[279]

THE KING OF FREEPORTS: YVES BOUVIER

The man who first made the system of freeports truly productive for art dealers is one of the most interesting shadow figures in the international art trade. Yves Bouvier, born in Switzerland in 1963, was one of the main lessees of the Geneva duty-free warehouse. He built the freeport in

Singapore described earlier, and later he established yet another facility in Luxembourg, thus earning him the moniker the "Freeport King." This success story took a shocking turn in February 2015 when Bouvier was arrested in Monaco on his way to visit one of his best clients.

Bouvier started his career in the family business, the shipping company Natural Le Coultre, domiciled in Geneva. In 1997, he took over management of the business from his father and in subsequent years developed it into one of the most important logistics operations in the art world. Objects were no longer simply transported: they were securely warehoused, restored, and photographed.

Freeports aren't some kind of smugglers' den, Bouvier averred in a 2013 conversation with J. Emil Sennewald for the German weekly newspaper *Die Zeit*: "Only idiots still try to hide drugs in artworks or to conceal stolen goods. Such a thing would be discovered, because everything that goes in or out is precisely registered and x-rayed. We help unmask art thefts."[280] In the register of Swiss companies, Bouvier's name appeared, apart from the family firm, in connection with a dozen other entities that were also involved in the art business. Intermittently, through one of these companies, he organized art fairs in Moscow and Salzburg, and he owned numerous residences in various countries. Of course, his expansion plans extended further: freeports were to be established in Shanghai and Beijing—and near Paris, there were plans for an entire "art island."

Bouvier planned an art center for twenty-eight thousand square meters of land on the Île Seguin, where earlier the billionaire François Pinault had wanted to display his art collection, before turning his attention to Venice and central Paris. Jean Nouvel was to design the architecture for Bouvier's so-called hub, with plenty of room for studios, apartments for a residency, exhibition spaces, storerooms, and auction halls. The cost of the project, which was named R4, was estimated to be €100 million. "It will become an art Disneyland, in which one can experience everything that is happening in art," Bouvier said in 2013.[281] Three years later, as Bouvier was embroiled in several legal proceedings,

the land for the project was sold to the collector Laurent Dumas, who soon introduced new architects and new plans for the site.

BOUVIER'S OFFSHORE COMPANY AND THE BELTRACCHI FORGERY

When the art forger Wolfgang Beltracchi was arrested and convicted because he and his wife Helene and other accomplices had smuggled dozens of alleged masterworks into the art market over the course of three decades, causing at least tens of millions in damages, a picture appeared in the files that could be readily traced, unlike the usual secret commerce in the dark underworld of the art market.

In March 2004, Werner Spies, who until then had been a renowned art expert, had assessed the Max Ernst forgery *La Forêt* at Beltracchi's country home in the South of France. He found the painting to be genuine and received in return for his expert opinion and assistance in the placement of several pictures a total of €400,000 from the Beltracchis alone, according to his own statements. The money was wired to his Swiss bank account with the name "Imperia"—an outrageous procedure for an art historian, whose reputation rests upon his knowledge as well as his independence.

Then the picture took a journey that, in its multiplicity of waystations, is typical for today's art market. Shortly after the visit by Spies, the Geneva gallerist Marc Blondeau traveled to the Beltracchis' country home and bought the Ernst painting for €1.7 million. The picture then went on a two-year trip, with stops at the freeport in Geneva and at the Paris gallery Cazeau Béraudière. It was ennobled by exhibitions in the Max Ernst Museum in Brühl and at an art fair in Paris. It belonged to anonymous companies such as Salomon Trading LLC in Wyoming and Lontel Trading SA, registered in Panama. Finally, it was sold on September 29, 2006, through the company Diva Fine Arts SA, based in Tortola in the British Virgin Islands, for $7 million to Hanna Graham Associates Inc. in the Bahamas. Through that entity, the forgery came into the collection of a former French publisher in New York. It is not known whether these transactions, in which, astonishingly, the value

of the painting increased more than threefold in just two years, created any tax liabilities and whether the taxes were in fact paid.

What is the connection of this case with the logistics entrepreneur and freeport operator from Geneva? Not only was the painting *La Forêt* transported several times by the entity Natural Le Coultre, but for a time it even belonged to Yves Bouvier. Investigators in the Beltracchi case and experts all over the world had been asking themselves for a long time who was behind the firm Diva Fine Arts SA. The authors of this book made a discovery in the trial records for a New York civil case that was completely separate from the Beltracchi matter: the address for the European office of the company that was printed on the invoice for the forged Max Ernst painting was Avenue de Sécheron no. 6 in Geneva— the domicile of Natural Le Coultre. The New York trial concerned the confiscation of a painting by Willem de Kooning, not forgery. In that proceeding, Yves Bouvier intervened in December 2011 with a sworn statement, which was made available to the authors. In that document, he stated that the de Kooning once belonged to the firm Diva Fine Arts SA, and that he was the only director and owner of the company. After Bouvier liquidated the company in November 2011, he said that all the assets of the company became his property. He operated the business of Diva Fine Arts through the company New City in Hong Kong, which he also controlled. For a time, Diva Fine Arts also owned the Max Ernst painting *Tremblement de terre*, which was auctioned off at Sotheby's in New York for $1,142,500—and was later revealed to be a forgery by Beltracchi.

According to statements by witnesses, Bouvier is said to have been involved in the placement of two other pictures by Max Ernst and Heinrich Campendonk. Both pictures, it turned out later, were also forgeries. In response to inquiries by the German police who were investigating Beltracchi, the Geneva district attorney replied that Bouvier could not be questioned: he was no longer a Swiss resident. The industrious art shipper had meanwhile become a citizen of Singapore. His spokesperson said in 2019 that Yves Bouvier had been the victim of

the forger Beltracchi, whom he did not know and had not dealt with. The spokesperson further stated that Bouvier had bought the forgeries from other dealers and indemnified his customers in these questionable transactions, and that he had himself been indemnified.

Bouvier appeared to be closely tied to the gallerist Béraudière: in July 2008 in the presence of a Geneva notary public, he established the firm Galerie Jacques de la Béraudière SA, in Béraudière's name as well as his own. Béraudière testified in the New York trial that he advised Bouvier on buying art and that Bouvier bought art principally as an investment vehicle. Other documents demonstrated that Bouvier was involved with other so-called letterbox companies such as Arrow Fine Art LLC in the low-tax state of Wyoming. He had built up not only a network for the transportation and tax-free storage of art but also an offshore structure of companies through which art purchases could be covertly financed and transacted. Bouvier was a hardworking, hands-on service provider, and he used his accumulated knowledge about the secret pathways that pictures take in order to engineer some of the biggest deals in the global art market. Until that became a problem for him.

ARREST IN MONACO

When on February 26, 2015, Yves Bouvier went to the principality of Monaco to meet the man who was probably his best client, he was arrested. Bouvier had wanted to discuss the purchase of a painting by Mark Rothko for $140 million. What he didn't know was that this collector, the billionaire Dmitry Yevgenyevich Rybolovlev, had already filed a complaint against him weeks before. The allegation was that Bouvier had defrauded him and sold him dozens of pictures over the years at inflated prices.

Yves Bouvier's client, Rybolovlev had been in the mood to buy—art by Van Gogh, Gauguin, Modigliani, Picasso, and Rothko. The scandal played out between Monaco and Cyprus, Geneva and New York, Hong Kong and Singapore. The total amount of money involved in Bouvier's alleged fraud of the Russian Rybolovlev was said to be about $1 billion.

Since then, the assets of the Freeport King have been frozen in several countries by court order. Through his spokesperson, Bouvier disputed all the allegations as unfounded and defamatory. Bouvier stated that he had always behaved legally and to the letter of the contracts. But later, Rybolovlev and his attorney themselves also became targets of investigations in Monaco.

The first suspicion that he might have been the victim of a massive art fraud came to Dmitry Rybolovlev supposedly on New Year's Eve 2014 on the small Caribbean island of St. Bart's. The billionaire, who was the majority owner of the soccer team AS Monaco and a businessman from Russia residing in Monaco among other places, was conversing at dinner with the American art adviser Sandy Heller. Rybolovlev was telling the story of one of his art buys, a painting by Modigliani that showed a naked woman reclining on a blue pillow: *Nu couché au coussin bleu*, dated 1916. The masterpiece, from the holdings of the US hedge-fund manager and mega-collector Steven Cohen, had cost him $118 million, the Russian related. Sandy Heller appeared to be astonished by the price: since he advised the Cohen collection, he knew that the seller of the painting of the lightly blushing nude had received at the time about $93 million.

Rybolovlev realized that Bouvier, whom he had previously believed to have advised him well for years, had as the intermediary for the picture made a profit of $20 million on the sale of the Modigliani alone, an extraordinary surcharge that Rybolovlev said he knew nothing about. The billionaire said he had assumed that he obtained the works at the purchase price and that he was paying a commission of at most 2 percent to Bouvier for his services as intermediary. Bouvier had gotten to know the Russian through the wife of his dentist, when the oligarch was looking for an expert opinion on a Chagall painting.

Rybolovlev immediately had audited the other art transactions that he had done with Bouvier and found his suspicions confirmed in early January 2015. Bouvier had also earned a fortune on the purchase of the disputed painting *Salvator Mundi*, attributed to Leonardo da Vinci, which had surfaced just a few years earlier.

THE HISTORY OF *SALVATOR MUNDI*:

A PIECE OF ART WRECKAGE FOR $450 MILLION

Jesus had two thumbs on his right hand. That was one too many, and reason enough why this painting on a walnut-wood panel didn't pass muster as the work of one of the greatest artists of the Renaissance. While admittedly in Italy in 1500 there was a general belief in Christ's miraculous multiplication of bread loaves, the Bible didn't say anything about multiple thumbs. Five hundred years later, that's why the restorer Dianne Modestini took a paintbrush and painted over the thumb that she believed the master had chosen to discard and had therefore painted a second one.

The creator of this Christ, with his right hand raised in blessing and in his left hand a glass ball, had to be Leonardo da Vinci, of that Modestini was at some point certain. The picture was, in her opinion, a so-called sleeper, a hitherto unknown work, by the greatest master of all time, which Modestini unveiled in her atelier through painstaking, detailed work. Or in part painted anew, as certain critics remarked later. Her work was in any case so perfect that this painting, only twenty-six inches by nineteen inches in size, cost $450 million—and immediately became an icon. Not necessarily for art historians, but for the business of art in the twenty-first century, in which true masterworks are slowly becoming quite rare. The odyssey of this so-called last Leonardo says much about the longings, drives, and abysses of collectors, dealers, scholars, and museum directors in the supposedly dry-eyed, enlightened present. The fabulous story of how the most expensive artwork of all time was discovered has long overshadowed the picture itself.

It all began in May 2005 at the St. Charles Gallery in New Orleans, when the art dealer Robert Simon and his colleague Alex Parrish, who still studied the catalogues of even the smallest auction houses, bought a painting at an estate auction that they had seen only in a reproduction. As Ben Lewis, author of the book *The Last Leonardo*,[282] found in his research, the two paid $1,175. The picture was a mess. The wood panel was damaged and split, with some amateurish overpainting, perhaps by a former

owner who had wanted to hang the picture up for religious reasons. It had
adorned a small stairway, as demonstrated by a photo. The picture had last
publicly changed hands at Sotheby's in London in 1958—for £45. An art
historian who saw the painting then at the auction made a one-word note:
"wreck." Modestini later told various media that Jesus had a "clown face"
in the painting. She had established a good reputation for herself over
several decades as an art restorer, was a professor at New York University,
and until the mid-1980s she was employed at the Metropolitan Museum
of Art. Robert Simon had given the painting to her and her late husband
Mario Modestini, also an art restorer, to work on. After their efforts, Jesus
looked like an androgynous being with an eye affliction. As if he had hay
fever—or had smoked a fat joint, as some critics quipped.

That didn't prevent the officials of the National Gallery in London
from showing the newly beautified picture in November 2011 next to
other, doubtlessly authentic paintings by the artist in one of the largest
Leonardo exhibitions in the history of art. Three years earlier, the newly
installed director, Nicholas Penny, had assigned his young curator
Luke Syson to organize a sort of conclave of five Leonardo experts at
the museum, where the experts were supposed to vote. Robert Simon
says that all five experts had responded "positively" in emails before
the picture was publicly displayed. The meticulous investigatory work
of Ben Lewis discovered that not all the experts wanted to attribute the
picture to Leonardo. Only two of them—including the Oxford professor
and Leonardo doyen Martin Kemp—saw the single hand of that great
master in *Salvator Mundi*. Two experts abstained, one voted against.
The master contributed something to the painting, on that many experts
today agree, whether it was merely the composition or the blessing hand
itself. Here the two thumbs once again came into play: they are said to
prove that a true master was at work. For only those creators searching
for the expression of genius make mistakes, contemplate them, and
paint over them in their work. These rejected drafts, lingering beneath
the surface, are called "pentimenti." On the other hand, a good copy is
worked to perfection in one pass.

At the National Gallery in 2011, a question mark was no longer placed next to the attribution to Leonardo. The exhibition in one of the most important museums in the world ennobled the painting, which was allegedly not for sale at the time.

Shortly after the exhibition, Simon and Parrish in fact sold the piece with the help of a third party—for $80 million, or forty-five thousand times as much as they had paid for it originally. Not even cocaine trading or weapons smuggling multiplies profits forty-five thousand times so quickly. But the true marketing campaign for the painting would come just a few years later.

According to analysts of the art market, the big whales in art dealing (i.e., those items that cost in the tens or hundreds of millions of dollars) don't produce a quick profit. At least not financially: they serve rather the accumulation of social and symbolic capital. The megaprice paid becomes itself a trophy of immeasurable spending, a sign of the unlimited financial powers of the owner. The symbolic power of this action is increased further by the unlikelihood that there will be a resale at the same price.

Salvator Mundi, despite this apparent norm, returned to its buyer a huge and quick profit. He didn't face much risk, since he already knew the purchaser.

Although Bouvier at first advised Rybolovlev against buying *Salvator Mundi*, the oligarch absolutely wanted to own this picture of Jesus. Then Bouvier, with the help of the auction house Sotheby's, acquired the painting himself for $80 million from Parrish, Simon, and a third party—in order to resell it to Rybolovlev the next day through Mei Invest Limited, a company Bouvier had registered in Hong Kong. Even in the global trade at the top of the market, $50 million for a day's work is a phenomenal sum.

So phenomenal in fact that Rybolovlev's team of attorneys in Monaco, where he has legal residence, in the end filed a complaint of fraud against Bouvier, and not just because of these high profit margins. The police began to investigate, and Bouvier remained in the dark. He

was thus shocked when he was arrested in February 2015 in front of the building in which Rybolovlev lived in a penthouse worth hundreds of millions of euros. The Freeport King was released after posting millions of euros in bail money. The legal war between Bouvier and Rybolovlev would soon spread across various continents.

A TITANIC LEGAL WAR ON THREE CONTINENTS

The dispute between wealthy Yves Bouvier, the billionaire Dmitry Rybolovlev, and their armies of lawyers has unfolded since 2015 in at least six places—France, Switzerland, Monaco, Singapore, Hong Kong, and the US. The judge in the US District Court for the Southern District of New York, Jesse M. Furman, in June 2019 called the case an "international saga." A saga that offered juridical delights for specialized attorneys. The official plaintiffs from Rybolovlev's side are once again two offshore companies located in the British Virgin Islands: Accent Delight International Limited and Xitrans Finance Limited.

The criminal investigation in Monaco widened to encompass Rybolovlev in 2018. According to the allegations, he is supposed to have influenced the Monégasque investigators, right up to the minister of justice, with invitations to soccer games or ski weekends in Gstaad, among other goodies. Hailing from the Russian city of Perm, Rybolovlev has a flashy history: he studied medicine and quickly became extremely rich through investments and favorable connections after the collapse of the Soviet Union. Robert Mueller investigated a real-estate deal with Donald Trump in Florida in 2008, in which the future US president reaped tens of millions of dollars—although in the US at the time real estate was in a crisis. Rybolovlev and his spokesperson dispute that there is any guilt or any wrongdoing whatsoever.

Similarly, Yves Bouvier rejects each and every accusation of fraud. According to his spokesperson, Bouvier has never functioned as an intermediary for Rybolovlev. The former Swiss citizen now living in Singapore says that he has always been an art dealer who bought work at his own risk and sought collectors for the art. He stated that in 2014

he was possibly the most successful art dealer in the world. The 2 percent that Bouvier had added to the invoice for the sales price to the Russian had covered only the costs of transportation and other things. In December 2019, the court of appeals in Monaco declared the criminal investigation of Bouvier to be null and void, because it had been conducted with bias. The effort to appeal the decision was not successful. However, at the time of this writing, other proceedings were underway in Switzerland, where Bouvier was accused of fraud and tax evasion.

The list of works that Bouvier dealt to Rybolovlev over the years is an amazing one. It begins in June 2004 with the Picasso painting *Les Noces de Pierrette*. In 2006, there followed works by Modigliani and once again Picasso. And thus it happily continued. The two men conducted the most transactions in 2008. In February of that year, Rybolovlev bought Modigliani's *Nu dolent*; in April, two pictures by Picasso and Degas; in June, the Tahiti painting *Te Fare* by Gauguin; in July, a *Venus* by Modigliani; the middle of August, Mark Rothko's *No. 1 (Royal Red and Blue)*; and finally on September 12, 2008, two of the most sought-after water-lily paintings by Monet. The last painting that Bouvier sold to Rybolovlev was in September 2013: Mark Rothko's large-scale *No. 6 (Violet, Green and Red)*. The inventory of all the purchases encompasses thirty-eight items worth about $2 billion.

Bouvier as his agent in these art deals was supposed to negotiate a good price for him, Rybolovlev said in reply; that's why he paid him the approximately 2 percent of the purchase price. As proof, Rybolovlev's lawyers introduced, among other things, emails and reports from April 10, 2013, in which Bouvier appeared to inform Rybolovlev and his colleagues about the apparent progress in the negotiations for the purchase of *Salvator Mundi*, which had been attributed to Leonardo. The unnamed seller was said to have rejected an offer of $100 million "without hesitation." "A really tough guy. I'm fighting and taking the time that is necessary," Bouvier wrote. On the same day, Bouvier told the Russian that he had offered the alleged seller first $120 million, and then $125 million. In the end Bouvier reported a purchase price of

$127.5 million—and represented that as a success: "Terribly difficult. But it's a good deal for Leonardo's singular masterpiece." And thereby he concealed that on that same day, the sellers of the panel attributed to Leonardo had in truth agreed to a sales price of $80 million. Bouvier defended his conduct as the usual business practices in a sale: his spokesperson wrote that it was completely normal and legal and that Bouvier had used sound commercial arguments to get a good price. Through the spokesperson, Bouvier said that the emails had played no role in the sale, as recognized by a court in Singapore.

Other purchases arranged by Bouvier that are related in the complaint written by Rybolovlev's team of lawyers turned out much the same way. For example, in September 2012, in another one of the most expensive private sales in the history of the art market, Sotheby's offered Gustav Klimt's *Water Snakes II*; Bouvier and one of his business partners went to look at it in Vienna. The bodies of naked women can be seen in the painting, floating in waters abounding in colorful fish and aquatic plants.

Bouvier signed a sales contract for the highly erotic painting for $126 million on September 11, 2012. That same day, he wrote an email to Rybolovlev saying that he was wholeheartedly dedicating himself to the negotiations: "They won't let it go for 180 and are at the breaking point. I think they'd go for 190. But I should try to make them take 185 with an initial deposit and the rest within 30 days. What should we do???" Later, Bouvier claimed to have come to an agreement with the seller at $183.8 million. Rybolovlev wired the purchase price as well as the additional fee for Bouvier's efforts in the amount of $3.67 million. In this transaction, Bouvier had thus earned about $60 million in a single day.

The two entities belonging to Rybolovlev meanwhile have also lodged a complaint against Sotheby's in New York, one of the most powerful art businesses in the world. The allegation: the auction house had in fourteen instances assisted Bouvier in obtaining the items that were then sold to Rybolovlev at high prices estimated by the auction house. Supposedly, the auction house concealed from Rybolovlev that

Bouvier had acquired the works at substantially lower prices.[283] The Swiss businessman was alleged to be one of the most important business partners of the house, especially when it came to discreet "private sales," transactions that take place apart from the public auctions. It was alleged that, for 2013, sales to Yves Bouvier accounted for more than a third of Sotheby's total private sales worldwide. Sotheby's did not respond to a request for comment on the complaint.

PICTURES LOST BY PICASSO'S STEPDAUGHTER

A few of the seven Picassos that had been sold to the Russian oligarch later led to criminal investigations in France. Catherine Hutin-Blay, the daughter of Picasso's last wife, Jacqueline, accused her art handlers of selling works that they had stolen from her out of a warehouse in the Parisian suburb of Gennevilliers. On March 13, 2015, she filed a complaint in Paris in connection with the two paintings and a total of fifty-eight drawings that were supposed to have come from a Picasso sketchbook of 1955.

The buyer for the Picassos, represented by Yves Bouvier, was likewise Dmitry Rybolovlev, who paid €27 million for the two portraits of Jacqueline Picasso and €9 million for the drawings. The attorney for the collector gave the French criminal investigators documentation for all the Picassos in the Rybolovlev collection and stated that they would be returned to their owner if the theft is proven. Through his spokesperson, Bouvier let it be known in 2015 that he had bought the pictures from a dealer whose name he could not specify for reasons of confidentiality. He said that he had obtained certificates of nonobjection for all the pictures from the London Art Loss Register, a commercial databank for stolen artworks that is active worldwide. A few years later, the French media reported that the works at issue hadn't been stolen from Hutin-Blay at all but rather were sold entirely legally to Bouvier's business partner—through a foundation belonging to the Picasso heiress that was registered in Liechtenstein. Hutin-Blay denied these claims and offered contrary representations: the alleged documentation was

shown to be related to earlier transactions that had nothing to do with
the theft from the warehouse.

The investigations into Bouvier and his business partner were in progress at the time this book went to press. Bouvier's spokesperson says that there is no complaint against Bouvier and that the amount of the bail has been reduced by 90 percent.

He has since sold his Swiss logistics company Natural Le Coultre in addition to his shares in the Geneva freeport. And the freeport in Singapore is supposed to be sold too, *Bloomberg* reported in 2019. Bouvier said in 2017 that his dispute with Rybolovlev had already cost him $1 billion in losses.[284]

He continued to be the majority owner of the freeports in Singapore and Luxembourg, which would operate with complete transparency—for example, with inventory lists that would show the beneficial owner of the goods stored—according to his spokesperson in 2019. He said that Bouvier spent most of his time with a team of lawyers who are fighting to prove his innocence.

THE FATE OF A COLLECTION WORTH BILLIONS

Yves Bouvier's empire is not the only one that has shrunk. The art collection that he helped put together for Dmitry Yevgenyevich Rybolovlev, for which a limited-edition, high-gloss catalogue had once been printed, is slowly dissolving. The entrepreneur has already had to sell many of the works, some at prices well below what he had paid Bouvier. He let go of Gustav Klimt's *Water Snakes II* in November 2015, according to reports in the media, for a loss of about $13 million and sold a sculpture by Rodin, *L'Éternal Printemps*, at a loss of about $28 million. The oligarch Rybolovlev, mired in legal proceedings, also decided to dispose of the painting that had been attributed to Leonardo, only four years after buying it.

Once again, *Salvator Mundi* became a powerful symbol of radical change in the art market. At the auction house Christie's, the Swiss art dealer Loïc Gouzer, who was the young star of the house, took charge

of the painting. He had already distinguished himself in the preceding years as an art curator who organized auctions thematically, rather than according to epoch, price, or the date of consignment. The ideas, whether intentionally or not, were loose and not conceived with intellectual rigor.

The auction of *Salvator Mundi* was to be Gouzer's biggest coup to date. He didn't group the painting in with the traditional auction for old-master works but rather into the contemporary sale. Not because the restoration work was in actuality so extensive that the piece could truthfully be called a work of twenty-first century art, but because the auctions for current art had for years generated higher prices, in the millions. In contrast to the person who said he had discovered the painting, Gouzer invited expert opinions and went so far as to organize a comprehensive public-relations campaign that allegedly cost several million dollars. A short pathos-laden advertising film was produced that, as if from the perspective of the painting itself, showed the amazed faces of visitors upon seeing the supposed "last Leonardo" at its exhibition in New York. These are the faces of anonymous people who had been waiting in long lines for this glimpse and, in front of the painting, which was protected by two security officers, broke into tears. In between, the face of the actor Leonardo DiCaprio pops up in the advertising teaser. He's one of Loïc Gouzer's friends and has emerged as an art collector himself (see Chapter 7).

On November 15, 2017, at the end of a nineteen-minute bidding war, lot 9B—in front of which many visitors had gawked and wept—was hammered out at $450 million (including Christie's fee for the auction) and sold to a Saudi prince, as the *New York Times* later found out and the Saudi consulate in Washington, DC, confirmed. Allegedly, the buyer was acting on behalf of Saudi Crown Prince Mohammed bin Salman, but soon thereafter the branch of the Louvre in Abu Dhabi announced that *Salvator Mundi* would be exhibited there in the future. The opening for the exhibition was set for fall 2018 but was canceled without any reasons being given. After that, the painting vanished. It was not shown

in fall 2019 in the grand retrospective at the Louvre in Paris to mark the five hundredth anniversary of Leonardo's death, though the director of the museum had requested the loan of the painting. Allegedly, the piece was not lent for the exhibition because it could not be labeled as being solely the work of Leonardo. The museum had readied for printing a catalogue that included the painting. And the plan for how the works in the show would be hung, which was leaked, held a prominent spot for *Salvator Mundi*.

Meanwhile, the picture is said to be stored in a warehouse in Switzerland, according to experts in the high-priced market who wish to remain anonymous. The art dealer Kenny Schachter came forward with the information in June 2019 that the painting was kept on the luxury yacht of Crown Prince Mohammed bin Salman. There isn't unambiguous proof of that. To whom the painting belongs, and whether there's a growing dispute about the attribution or about its condition after restoration—all that remains unclear. It is also unclear when the painting will be publicly exhibited again.

Art historians, such as the Leonardo expert Frank Zöllner in Leipzig, who is the author of the current catalogue raisonné, continue to point out that historical sources from Leonardo's time and the hundreds of years since do not provide any evidence of a painting called *Salvator Mundi*. Even still, this painted wood panel is the most important work of art with which to track the conditions of the global art market, the transactions between oligarchs and secretive advisers, the self-presentation of Arabian princes, and the longings of the masses who view art. The otherwise dark sides of the business of art become ever clearer the more that critical experts and artists engage with this work. As clear as the glass globe that Jesus holds in his left hand in the painting. The painting itself may remain missing for years. It will have an even bigger story to tell when it reemerges.

CONCLUSIONS

Ten questions about art and crime

Naturally, many stories remain untold at the end of this book, and many questions are left unanswered. Even as we prepared to go to press, spectacular news from the world of art and crime continued to arrive. At the end of November 2019, the treasure vaults of the city palace, the so-called Museum Grünes Gewölbe, or Green Vault Museum, in Dresden, Germany, were broken into, and three pieces of eighteenth-century jewelry—which were extremely valuable not just for the gold used and the thousands of diamonds, brilliants, and precious stones set in them but because of their historical significance—were stolen. In Gotha, Germany, five old-master paintings were returned that had been stolen in 1979.

The Italian Carabinieri arrested twenty-three people whom the criminal authorities accuse of forming an illegal organization that damaged the cultural heritage of the nation by trading in illegally excavated cultural artifacts throughout Europe. The items that had been dug up to be sold in Europe included vases and oil lamps, jewelry and coins, buckles and jugs. More than ten thousand objects were seized. Locations were also searched in England, France, Serbia, and Germany. As reflected in a conversation between two of the participants that was recorded during surveillance, it was said with respect to one excavation

site, in the Calabrian Paludi: "The valley has been completely dug up. Next is Paludi. Paludi too should disappear from the postcards."[285] They discussed their finds using code words such as "white truffle," "salami," or "asparagus." According to investigators, the conspiracy is presumably linked to a Mafia clan. There is no date yet for the trial.

At the same time, an appellate court in Lyon affirmed the judgment against Pablo Picasso's former electrician and the handyman's wife. In 2015 and 2016, respectively, they were given a two-year suspended sentence for misappropriating 271 works by the Spanish artist that they stored for years in their garage. Ironically, the electrician first came to the artist's house in the early 1970s to install an alarm system. When the couple sought to obtain certificates of authenticity from Picasso's son Claude in September 2010 for unsigned works, he became suspicious and lodged a complaint. Before the court, the electrician and his wife spoke of a "wondrous gift" that they had received from Picasso's second and last wife, Jacqueline. They testified that after the artist's death she asked the couple to take the drawings and other works that were packed in garbage bags—from the years 1900 to 1932, with an estimated value of €60 million. They said that she told them there were problems with Claude, the artist's son from his first marriage.[286]

A collector living in Bremen, Germany, complained that 342 pieces from her collection had disappeared in China. She had made the pictures and sculptures available to a company in Hamburg, Germany, which exhibited them with the assistance of German curators in Beijing, Shanghai, and Wuhan and, with the consent of the owner, offered them for sale. Anselm Kiefer—one of the artists affected, along with Markus Lüpertz—had already objected in 2017 to the project, which he said had taken place without his agreement. The exhibiting firm no longer exists; its former owner responded to the accusations of fraud by alleging that, to the contrary, the oral agreement for the loan was for ten years. It is said that €300 million is at stake, though there's no proof of the assertion, and also that the Chinese authorities have still not responded to the criminal charges which were brought in July 2019.[287]

The story remains to be told of a prominent Berlin gallerist who was arrested in the fall of 2019 because he was alleged to have engaged in fraud in art transactions. Supposedly, it's a matter of millions of euros. And, even apart from the investigations that led to the arrest, a collector who had been a customer of the gallery found that, instead of the original by Gerhard Richter that the gallerist had exhibited in 2014, he had in his possession an almost identical copy that the head of the artist's archives judged to be a fraud. It is still not clear who made the copy and who put it in circulation. The collector is said to have gotten a receipt that featured a photograph of the genuine work at the time the piece was transferred into his possession. Other collectors and business partners of the dealer meanwhile have made other accusations. The inquiries sent several times to the person under suspicion, who operated temporary branch offices in the Far East and once referred to artworks as shares of stock, received no response. The presumption of innocence applies to him.

Back in Florida, a German company that specializes in the financing of art acquisitions filed a complaint in fall 2019 against a different gallerist who was active in Miami and London. At issue is the alleged illegal conversion of contemporary art worth several million dollars.

Even the search for the art to grace the cover of this book led accidentally to evidence of a possible forgery. The dollar sign by Andy Warhol that was originally selected and was being offered for sale in an American internet auction caused consternation at the Warhol Foundation, which administers the rights of the artist: this motif was unknown, they said; most likely, it's a forgery. The dollar sign we finally chose for the cover was confirmed by the administrators of the artist's estate to be genuine.

There is an endless number of such stories that document the closely interconnected webs of art that is sold at ever-higher prices and crime that is increasingly sophisticated. To tell all these tales without any gaps is neither possible nor the purpose of this book. We are more concerned with spotlighting the structural dangers that arise in a market

in which art is no longer art but rather a vehicle for speculative investment. Independent of the question of guilt, all the cases we document are symptomatic of the thoroughgoing change in the global art market, in which new forms of fraud, misappropriation, and money laundering can thrive so well. "People with a lot of money want to have even more money by investing in art," the artist Daniel Richter once said in an interview, describing this social change. "The beauty of art, the search for truth, the interrogation of the pictures, liberating laughter, utopias—that's all not taking place. Instead of reversing the structures of ownership, they are radicalized."[288]

Many gallerists and art dealers try to keep pace with the booming art market, taking on debt for the purchase or lending of works. These participants are adapting to the changing system in the market, the practice known as "flipping," in which objects are resold within a short time frame. In this regard, the art market can compare with the securities exchanges and their commodities futures and put options. But what in an earlier era might have been a weekend trip to Luxembourg to slip into a discreet bank back room and clip the coupons on securities acquired with dirty money is today mirrored in visits to the almost completely unregulated freeports in Basel, Zürich, Liechtenstein, and Singapore.

Such deals are especially profitable when the transactions are "leveraged." A fictive example: for the purchase of an artwork at a price of $1 million, the buyer puts down only $100,000 himself, while agreeing to pay the remainder of the sales price to the seller at a later date. Then the buyer in turn resells the work, in the shortest possible time, for $1.2 million and straightaway pays the original owner the $900,000 still owed. For a quick return on an investment of $100,000, $200,000 remain: a fantastic return on an investment of 200 percent. Many of the investors and service providers that have flooded into the art market in the past few years have dreamed of business such as this. These leveraged transactions are even riskier in the art market than in the finance industry in general. If there's a conservation problem or a question about rightful ownership concerning the artwork that is the subject of the transaction,

or a sudden change in taste or a market crash that reduces demand, mountains of debt can accumulate in no time.

It is often forgotten that most of the participants in the art market continue to pursue their professional life or their interest in collecting honestly and legally. The forgery, fraud, money laundering, and corruption cases are so spectacular, the size of the material and monetary losses so staggering, that these stories spread like lightning around the world in the digital age.

The retrogressive lobbying work by the industry, on the pretense of tradition, customary rights, and maintaining the status quo, doesn't help. Only regulations that seek to be fair to all participants can address the new challenges.

Stock and commodity exchanges and government regulators oversee the international financial markets, and strict laws and rules are enforced in securities transactions. Service providers and participants are required to disclose conflicts of interests. Insider trading is forbidden. The art market is still by and large completely unregulated. Here precise and complex agreements are not required for million-dollar deals. Here—apart from generally applicable laws—there's no particular oversight of the market.

The new narrative of art is that of "gigantic profits," as the critic Georg Seeßlen diagnosed the problem in an interview in his publication *Money Eats Art. Art Eats Money*.[289] "The question 'what is art?' is increasingly only answered in dollars. Money has exerted a defining power over art. That is how art is lost to the very people who really need it, to experience a bit of happiness."[290]

TEN QUESTIONS FOR THE LIBERATION OF ART

How can art be regained as a joyful experience that extends consciousness and offers aesthetic pleasure? How can art be freed from the singular compulsion to make it the most profitable and tax-favorable financial investment? And the related question: How can the increasing infiltration of the art market by criminality be stopped?

Scholarship by rigorous, independent art historians must be supported. Experts and the art market must be regulated. Dealers and auction houses should be required to hold on to works that are suspect with respect to their authenticity or provenance and to notify the authorities about their suspicions. Forgeries should be permanently entered into a database as soon as they appear, and the databanks should be run by independent public institutions, not, as is the case today, by private companies in which the art trade is also a financial investor. Where such a database exists, UNESCO, in collaboration with Interpol, could serve as the institutional operator. This would forestall national organizations, such as lostart.de, funded by Germany at the federal and state levels, which not only is loosely and improperly run but failed in the past to do its job when suspicious works were supposed to be deleted, because of commercial interests. The only way that art can be saved in the long run from the forgers and fraudsters is to have such databases run by truly independent, honest, inviolable institutions.

Whenever new regulations are to be introduced, the economically and politically influential organizations of dealers and collectors regularly attempt to thwart change with noisy, exaggerated propaganda. For example, they fought against the law for the protection of cultural goods that went into effect in August 2016 in Germany, which, as with the EU strictures on money laundering, merely enacted the requirements as national laws. In particular, it was the new due-diligence duties that drove the dealers to the barricades, because now they would even have to document the names of the seller and the buyer and keep the information for thirty years. Numerous cases of forgery would have been solved sooner and with greater precision had this duty of documentation been required earlier. Successful dealers retain their business records for a long time anyway, since the knowledge of where artworks can be found in the market can be valuable for future business. Even still, dealers and collectors are fighting vehemently against such binding new rules, and not just with opinion pieces or letters to the editor. They

have founded the "Federation for the Protection of Culture," with the expressed goal "to coordinate objections to the planned law for the protection of cultural goods and thereby lend them the appropriate gravity," as summarized in a February 2016 solicitation letter that requested financial support for paying a lawyer. An industry group had already paid out tens of thousands of euros, the two-page letter explained, to establish its position with respect to the law.

This lawyer who was working on behalf of the lobbying group went public and appeared in the media as a quasi-independent expert on issues such as the law for the protection of cultural goods and the regulations on money laundering—arguing the industry's angle against oversight. It is precisely such regulations as formulated in the law for the protection of cultural goods and the new money-laundering strictures that could help protect the art market and its lucrative business against thieves, fraudsters, and forgers.

Much would be gained if everyone involved in the art market—dealers, collectors, and intermediaries—asked the following ten questions before each transaction:

- Can I verify with absolute certainty the provenance of the work of art or cultural asset that is being offered to me?
- Is the price of the work offered significantly below the usual market price?
- Can I verify the identity of the seller or the buyer?
- In transactions involving intermediaries or art advisers, who are the true owners of the art and who is the beneficiary of the transaction?
- Is the source of the money being paid transparent and can the transfers be traced (which is not true of transactions involving cash, cryptocurrencies, and online payment systems)?
- Have independent, recognized experts and scholars confirmed the authenticity of the works being offered?
- Does the cultural asset come from an area in crisis or at war?

- Does the cultural asset have the required and valid export license from its country of origin?
- Is the provenance of the artwork or cultural asset demonstrably unobjectionable for the time period of the Nazi terror?
- Is the provenance of the cultural asset demonstrably unobjectionable during the colonial period of the country of origin?

Anyone who asks these questions while buying, dealing in, or exhibiting art and antiquities and who, in doing so, has doubts should do more research. Inquiry into the provenance often elicits stories that make the work more interesting, more meaningful, and therefore more valuable.

Above all else, those artists, gallerists, curators, and auctioneers who operate cleanly and foster transparency and are still focused on art itself, its beauty, its critical power, and its humor should be much more robustly supported and celebrated.

They are, as always, the majority.

PHOTO INSERT CREDITS

Leonardo da Vinci, *Salvator Mundi* (p. 1): public domain; theft at the Bührle collection (p. 2, top): © Marko Djurica/picture alliance/REUTERS; pictures seized by the BKA (p. 2, bottom): © picture alliance/dpa; Imelda Marcos in front of her paintings (p. 3, top): © Romeo Cacad/AFP via Getty Images; illegal excavation site (p. 3, bottom): © Comando Carabinieri per la Tutela del Patrimonio Culturale; gold coins (p. 4, top): © picture alliance/REUTERS; *America* (2016) by Maurizio Cattelan (p. 4, bottom): © photograph by Tom Lindboe, courtesy of Blenheim Art Foundation, 2019; after the theft: © photograph by Pete Seaward, courtesy of Blenheim Art Foundation, 2019; alleged Hitler telephone (p. 6): © Patrick Semansky/picture alliance/AP Photo; alleged Hitler signatures (p. 7): © Christof Stache/AFP via Getty Images; title page of the forged *Sidereus Nuncius* with the forged signature of Galileo Galilei (p. 8): Photo © Barbara Herrenkind.

ACKNOWLEDGMENTS

Some of the stories we tell in *Art & Crime* are based on reporting that we did for various media where we have worked: Deutschlandfunk, *Die Zeit, Frankfurter Allgemeine Zeitung, Süddeutsche Zeitung, Die Tageszeitung, Die Welt, art,* and *Monopol.* For the book, we have revisited the original research and updated all the stories with new insight, interviews, and research.

We would like to thank:

Georgina Adam, Konstantin Akinsha, René Allonge, Andres Bautista, Marc-Oliver Boger, Elke Buhr, James Butterwick, Bart FM Droog, Matthies van Eendenburg, Sebastian Frenzel, Christian Fuchs, Olga Grimm-Weissert, Markus Hilgert, Charles Hill, Silke Hohmann, Wolfgang Hörner, Lisa Kaiser, Olivia Kuderewski, Stephan Lebert, Ben Lewis, Daniel Müller, Michael Müller-Karpe, Yassin Musharbash, Jörg Nabert, Vincent Noce, Hanno Rauterberg, Marc Restellini, Florian Ringwald, Elmer Schialer, Wolfgang Schönleber, J. Emil Sennewald, Adam Soboczynski, Tim Sommer, Holger Stark, Daniel Völzke, Oscar White Muscarella, Nick Wilding, Lisa Zeitz, Fritz Zimmermann, Frank Zöllner, as well as many important sources who asked to remain anonymous.

Stefan Koldehoff thanks: all those he loves.

Tobias Timm thanks: Jasmin, Dagmar, Uwe, Jacob, and Philipp Timm; Sabine Müller-Stoy.

NOTES

1 Helge Achenbach, "Mein Leben war eine Materialschlacht," interviewed by
 Sebastian Späth, *Spiegel Online*, October 30, 2019, https://www.spiegel.de
 /kultur/gesellschaft/helge-achenbach-ich-bin-in-der-lage-rueberzubringen
 -dass-ich-bereue-a-1293685.html.
2 Vincent Noce, *L'Affaire Ruffini: Enquête sur le plus grand mystère du monde de
 l'art* (Paris: Buchet Castel, 2021).
3 Vincent Noce, "Old Master fakes scandal: warrant issued for dealer Giuliano
 Ruffini as painter Lino Frongia arrested," *The Art Newspaper*, September 13,
 2019, https://www.theartnewspaper.com/news/giuliano-ruffini.
4 Sandy Nairne, *Die leere Wand. Museumsdiebstahl: Der Fall der zwei Turner-
 Bilder.* (Bern/Vienna: Piet Meyer Verlag, 2013).
5 Cf. Oliver Hollenstein, Yassin Musharbash, Holger Stark, Tobias Timm, and
 Fritz Zimmermann,"Familienbande," *Die Zeit*, no. 28/2018, July 5, 2018.
6 Tobias Timm, "Ziemlich leichte Beute," *Die Zeit*, no. 3/2019, January 10, 2019.
7 Mark Townsend and Caroline Davies, "Mystery of the stolen Moore solved," *The
 Guardian*, May 17, 2009, https://www.theguardian.com/artanddesign
 /2009/may/17/henry-moore-sculpture- theft-reclining-figure.
8 Kerstin Gehrke and Helena Davenport, "Von Kunst zu Schrott," *Der
 Tagesspiegel*, January 16, 2019.
9 André Zand-Vakili, "Zwei Skulpturen von Ohlsdorfer Friedhof gestohlen,"
 Hamburger Abendblatt, April 8, 2014.
10 Cf. Bernd Kluge, *Das Münzkabinett: Museum und Wissenschaftsinstitut*, 2nd ed.
 (Berlin: Staatliche Museen zu Berlin—Münzkabinett, 2005), 91.
11 Tobias Timm, "Sind die Diebe vielleicht Künstler," *Die Zeit*, no. 39/2019,
 September 18, 2019.
12 The judgment by the Landgerichts Wiesbaden in case 1 KLs—4423 Js 39160/12 of
 March 15, 2018.

13 Rita Kersting and Petra Mandt, eds., *Russian Avant-Garde at the Museum Ludwig: Original and Fake: Questions, Research, Explanations* (Cologne: Buchhandlung Walther König, 2020).

14 See the judgment by the Landgerichts Wiesbaden in case 1 KLs—4423 Js 39160/12 of March 15, 2018.

15 Tobias Timm, "Radikal erfindungsreich," *Die Zeit*, no. 26/2013, June 20, 2013.

16 Stefan Koldehoff and Tobias Timm, "Es roch nach frischer Farbe," *Die Zeit*, no. 43/2014, October 16, 2014.

17 Tobias Timm, "Radikal erfindungsreich," *Die Zeit*, no. 26/2013, June 20, 2013.

18 Maurizio Bellandi, "Amedeo Modigliani 1909," http://www.modigliani1909 .com/index2.html.

19 Naomi Rea, "Italian Police May Have Solved the Mystery of Who Was Behind an Exhibition of Fake Modigliani Paintings in Genoa," *Artnet*, March 14, 2019, https://news.artnet.com/art-world/ fake-modigliani-paintings -1488106.

20 Cf. Nicholas Green, "Dealing in temperaments: economic transformation of the artistic field in France during the second half of the nineteenth century," *Art History* 10, no. 1 (March 1987); Robert Jensen, "The avant-garde and the trade in art," *Art Journal* 47, no. 4 (Winter 1988).

21 Robert Jensen, *Marketing Modernism in Fin-de-Siècle Europe* (Princeton: Princeton University Press, 1994), 3.

22 Stefan Koldehoff, *Van Gogh—Mensch und Mythos* (Cologne: Dumont Verlag, 2003).

23 Citation translated from: "Un document sensationnel et inédit: l'enterrement de Vincent van Gogh, par le peintre Émile Bernard," *Art-Documents*, 29 (February 1953), 1 f.

24 Cf. Réunion des Musées Nationaux, ed., *Orangerie des Tuileries—Collection Jean Walter–Paul Guillaume* (Paris: Réunion des Musées Nationaux, 1966, new edition 1991).

25 Paris, Musée de l'Orangerie.

26 I am grateful to Susanne Kleine, Bonn, for the reference.

27 Dora Vallier, *Kunst und Zeugnis* (Zürich: Verlag der Arche, 1961), 50 f.

28 Cf. Fondation de l'Hermitage, ed., *Les Peintres de Zborowski—Modigliani, Utrillo, Soutine et leurs amis* (Lausanne: Fondation de l'Hermitage, 1994), exhibition catalogue.

29 *Moderne Kunst aus Deutschen Museen*, Galerie Fischer, Lucerne, June 30, 1939.

30 Gesa Jeuthe, "Die Moderne unter dem Hammer–Zur 'Verwertung' der 'Entarteten Kunst' durch die Luzerner Galerie Fischer 1939," in *Angriff auf die Avantgarde–Kunst und Kunstpolitik im Nationalsozialismus*, Uwe Fleckner (Berlin: De Gruyter, 2007), 278. (Schriften der Forschungsstelle "Entartete Kunst," Band 1.)

31 Clifford Irving, *FAKE!—The Story of Elmyr De Hory, the Greatest Art Forger of Our Time* (New York: McGraw-Hill, 1969).

32 *F for Fake*, directed by Orson Wells (France/Iran/Germany, 1973).

33 A comparison with the similar forgery scandal concerning Alexej von Jawlensky, which was substantially caused by the artist's heirs and which in 1988

inflicted long-term damage to the reputation of the Folkwang Museum, would be instructive but would go beyond the scope of this book.

34 Arthur Pfannstiel, *Modigliani—L'art et la vie* (Paris: Éditions Marcel Seheur, 1929).

35 Arthur Pfannstiel, *Dessins de Modigliani* (Lausanne: Mermod, 1958).

36 Koldehoff, *Van Gogh—Mensch und Mythos* (see note 3).

37 Ambrogio Ceroni, *Amedeo Modigliani: Peintre. Suivi des "Souvenirs" de Lunia Czechowska* (Milan: Edizioni del Millione, 1958).

38 In *The Art Newspaper*, May 2002.

39 Joseph Lanthemann, *Modigliani, 1884–1920: Catalogue raisonné—Sa vie, son œuvre complet, son art* (Barcelona: Graficas Condal, 1970).

40 Osvaldo Patani, *Modigliani. Catalogo generale—Dipinti* (Milan: Leonardo Editore, 1991).

41 Osvaldo Patani, *Modigliani. Catalogo generale—Sculture e disegni 1909–1914* (Milan: Leonardo Editore, 1992).

42 Osvaldo Patani, *Modigliani. Catalogo generale-Disegni 1906–1920, con i disegni provenienti dalla collezione Paul Alexandre (1906–1914)* (Milan: Leonardo Editore, 1994).

43 Quoted by Noël Alexandre, *Der unbekannte Modigliani. Unveröffentlichte Zeichnungen, Papiere und Dokumente aus der ehemaligen Sammlung Paul Alexandre* (Antwerpen: Oktagon/Mercatorfonds, 1993).

44 Quoted by Georgina Adam, "Fake Modiglianis Poison Art Market," *The Art Newspaper*, May 2002.

45 Marc Spiegler, "A Clouded Legacy," *ARTnews*, Summer 2007, 82–85.

46 Stephen Wallis, "The Modigliani Mess," *Art & Auction*, April 2001, 44.

47 *Modigliani e i suoi* (Borgaro Torinese: Fondazione Giorgio Cini, 2000).

48 Spiegler, "A Clouded Legacy" (see note 34).

49 Ksenija Prodanovic, "Unknown Modigliani painting surfaces in Serbia," *Reuters News Agency*, September 25, 2007, http://www.reuters.com/article /entertainmentNews/idUSL2576382620070925.

50 Christian Parisot, Modigliani—Témoignages. Catalogo ragionato, Tomo IV. (Turin: Canale Edizione, 1996), p. 40 ff.

51 Quoted by Marc Spiegler, "Modigliani: The Experts Battle," *ARTnews*, January 2004, 124–129.

52 Stephen Wallis, "Dealers Battle Over Modigliani—Or Is It?" *Art & Auction*, January 2000, 20–24.

53 Ibid.

54 Spiegler, "A Clouded Legacy" (see note 34).

55 Ibid.

56 "Wildenstein Institute," Wikipedia, https://en.wikipedia.org/wiki /Wildenstein_Institute.

57 Wallis, "The Modigliani Mess," 46 (see note 35).

58 Spiegler, "Modigliani: The Experts Battle" (see note 37).

59 *Le Figaro*, July 20, 2002.

60 Wallis, "The Modigliani Mess," 39 (see note 35).

61 Ibid.

62 All as quoted by Adam, "Fake Modiglianis Poison Art Market" (see note 31).

63 Quoted by Spiegler, "Modigliani: The Experts Battle" (see note 34).

64 "Hitler phone a fake: German phone expert," Deutsche Welle, February 25, 2017, https://www.dw.com/en/hitler-phone-a-fake-german-phone- expert /a-37713206.

65 "Interview Jo Rivett: 'Fakes an insult to history,'" *Droog Magazine*, 2019, http://www.droog-mag.nl/hitler/2019/rivett/index.html.

66 The name is stated in the original text and also elsewhere.

67 René Allonge, "Die Auffindung von Hitlers Bronzeskulpturen – Eine deutsch-deutsche Kriminalgeschichte," *Der Kriminalist*, no. 4/2017 (Berlin: 2017), 6–14.

68 Ibid.

69 Ibid.

70 Brigitte Zander, "Braune Nostalgie," *Die Zeit*, December 8, 1978, https://www.zeit.de/1978/50/braune-nostalgie.

71 *De Volkskrant*, August 19,1969, 9 (https://www.delpher.nl/nl/kranten /view?coll=ddd&identifier=ABCDDD:010847894:mpeg21:a0153).

72 Quoted by Hans Ulrich Gumbrecht, "Adolf Hitler verehrte Filme wie *Schneewittchen* oder *Bambi*," *Neue Zürcher Zeitung*, September 26, 2018, https://www.nzz.ch/feuilleton/adolf-hitler-verehrte-filme-wie -schneewittchen-oder-bambi-von-walt-disney-wer-den-grund-dieser -faszination-kennt-versteht-mehr-von-unserer-reaktionaeren-gegenwart -ld.1422529.

73 We are grateful to Bart FM Droog for the reference. See also: https://www .droog-mag.nl/hitler/2008/knacks-with-fake-hitlers.pdf.

74 "Frühe Hitlers," *Der Spiegel*, no. 23/1960, 60.

75 Ibid.

76 Sven Felix Kellerhoff, "Hitlers künstlerisches 'Werk' soll bis zu 3000 Bilder umfasst haben," *Die Welt*, January 30, 2019, https://www.welt.de /geschichte/article187933434/Kunstmarkt-Mythen-Hitler-soll-bis-zu-3000 -Bilder-gemalt-haben.html.

77 Österreichisches Staatsarchiv (Allgemeines Verwaltungsarchiv), E 1719 Lohmann Estate. Folder 116: Gedächtnisprotokolle, Korrespondenzen: Letter by Dr. Ernst Schulte-Strathaus (staff of the Führer's deputy) to Dr.Walter Lohmann, July 22, 1938; quoted by Franz Josef Gangelmayer, *Das Parteiarchivwesen der NSDAP. Rekonstruktionsversuch des Gauarchivs der NSDAP-Wien* (diss., University of Vienna, 2010), http://othes.univie.ac .at/12247/1/2010-10-09_0300622.pdf.

78 Ibid.

79 Horst Bredekamp, "Die Geschichte von Galileos O—Ein Forschungsbericht zum Sidereus Nuncius," *Sterne und Weltraum*, January 2012, 48, https://www.spektrum.de/magazin/die-geschichte-von-galileos-o/1133262.

80 Ibid., 45.

81 Nicholas Schmidle, "A Very Rare Book: The mystery surrounding Galileo's pivotal treatise," *New Yorker*, December 16, 2013, 63.

82 Bredekamp, "Die Geschichte von Galileos O," 42 (see note 1).

83 Horst Bredekamp, *Galilei, der Künstler: Die Zeichnung, der Mond, die Sonne* (Munich: Oldenbourg Wissenschaftsverlag, 2007).

84 Irene Brückle, Oliver Hahn, and Paul Needham, *Galileo's O, Vol. I & II* (Berlin: De Gruyter, 2011).

85 Schmidle, "A Very Rare Book," 65 (see note 3).

86 Horst Bredekamp, "Es traf uns wie ein Blitz," interviewed by Thomas de Padova, *Der Tagesspiegel*, February 12, 2014, https://www.tagesspiegel.de /wissen/gefaelschte-galilei-zeichnungen-es-traf-uns-wie-ein-blitz/9466754 -all.html.

87 Hanno Rauterberg, "Der gefälschte Mond," *Die Zeit*, December 27, 2013, https:// www.zeit.de/2014/01/faelschung-zeichnungen-galileo-galilei-horst -bredekamp/komplettansicht.

88 Schmidle, "A Very Rare Book," 67 (see note 3).

89 Ibid., 68.

90 Brita Sachs, "Ohne Beweisführung," *Frankfurter Allgemeine Zeitung*, June 20, 2014, https://www.faz.net/aktuell/fuenf-jahre-haft-fuer-herbert-schauer -ohne-beweisfuehrung-13000869.html.

91 Schmidle "A Very Rare Book," 71 (see note 3).

92 Ibid., 72.

93 Bayerische Staatsbibliothek, ed., *Globensegmente von Martin Waldseemüller— AMERICA Das frühe Bild der Neuen Welt* (Berlin: Kulturstiftung der Länder, 1992).

94 *Fine Books and Manuscripts, Including Americana* (New York: Sotheby's, November 30, 2005), lot 44 (ill.).

95 Schmidle "A Very Rare Book," 69 (see note 3).

96 Horst Bredekamp, Irene Brückle, and Paul Needham, *A Galileo Forgery: Unmasking the New York Sidereus Nuncius* (Berlin: De Gruyter 2014), 95.

97 Olga Kronsteiner, "Illegaler Antikenhandel: Die Mär von der Terrorismusfinanzierung," *Der Standard*, June 30, 2018, https:// www.derstandard.at/story/2000082486099/illegaler-antikenhandel-die -maer-von-der-terrorismusfinanzierung.

98 McGuire Gibson, "Art Loss in Iraq," International Foundation for Art Research, https://web.archive.org/web/20040206042450/http://www.ifar .org/tragedy.htm.

99 Günther Wessel, *Das schmutzige Geschäft mit der Antike* (Berlin: Ch. Links Verlag, 2015), 44.

100 Ibid. 45.

101 *Katholische Nachrichtenagentur*, KNA 45, October 8, 2019.

102 Wessel, *Das schmutzige Geschäft mit der Antike*, 45 (see note 3).

103 Michael Zick, "Das Milliardengeschäft der Raubgräber," *Der Tagesspiegel*, July 6, 2011, https://www.tagesspiegel.de/wissen/handel-mit -kunstschaetzen-das-milliardengeschaeft-der-raubgraeber/4365476.html.

104 Annette Hauschild, "Tor auf für Raubgrabungsgüter oder Schutz des Kulturerbes?" *Telepolis*, July 26, 2006, https://www.heise.de/tp/features /Tor-auf-fuer-Raubgrabungsgueter-oder-Schutz-des-Kulturerbes-3407179 .html.

105 "ILLICID—Illegaler Handel mit Kulturgut in Deutschland," GESIS Leibniz- Institut für Sozialwissenschaften, https://www.gesis.org/forschung/

drittmittelprojekte/archiv/illicid-illegaler-handel-mit-kulturgut
-in-deutschland.

106 "Pressemitteilung/Freispruch für den Kunsthandel,"
 Interessengemeinschaft Deutscher Kunsthandel, July 3, 2019, http://
 interessengemeinschaftdeutscherkunsthandel.de/2019/07/ 03
 /pressemitteilung-freispruch-fuer-den-kunsthandel/.

107 Rainer Schreg, "Der Abschlussbericht von ILLICID und die Umdeutungen des
 Kunsthandels," *Archaeologik*, August 13, 2019, https://archaeologik
 .blogspot.com/2019/08/der-abschlussbericht-von-illicid-und.html.

108 Ibid.

109 Ibid.

110 Ibid.

111 Ibid.

112 Christoph Schmälzle, "Die Sache mit den Ausfuhrpapieren," *Frankfurter
 Allgemeine Zeitung*, August 5, 2019, https://www.faz.net/aktuell/feuilleton
 /debatten/studie-ueber-illegalen-kunsthandel-alles-nicht-so-dramatisch
 -16317786.html.

113 Hauschild, "Tor auf für Raubgrabungsgüter oder Schutz des Kulturerbes?"

114 "Lost Treasures of Iraq," Oriental Institute of the University of Chicago, http://
 oi-archive.uchicago.edu/OI/IRAQ/iraq.html.

115 "Bewährungsstrafen wegen Hehlerei mit Himmelsscheibe von Nebra,"
 Frankfurter Allgemeine Zeitung, September 19, 2003, https://www.faz.net
 /aktuell/gesellschaft/urteil-bewaehrungsstrafen- wegen-hehlerei-mit
 -himmelsscheibe-von-nebra-174134.html.

116 Hans Kratzer, "Bayerns geplünderte Schatzkammer," *Süddeutsche Zeitung*,
 September 19, 2012, https://www.sueddeutsche.de/bayern/bullenheimer
 -berg-in-unterfranken-bayerns-gepluenderte-schatz kammer-1.1471545.

117 "Imeldarabilia: A Final Count," *Time*, February 23, 1987, http://content
 .time.com/time/magazine/article/0,9171,963620,00.html.

118 Caroline Kennedy, "The Marcoses and the Missing Filipino Millions," *Caroline
 Kennedy: My Travels*, June 24, 2011, https://anywhereiwander
 .com/2011/06/24/%E2%80%9Cthe-marcoses-the-missing-filipino
 -millions%E2%80%9D/.

119 "Noch nie dagewesene Plünderung einer Nation," *Der Spiegel*, April 7, 1986, 157
 ff.

120 Jeanie Kasindorf, "Stepping out—The Elusive Adnan Khashoggi, On the Town
 and in The Dock," *New York Magazine*, December 18, 1989, 37 ff.

121 Dominick Dunne, "Khashoggi's Fall," *Vanity Fair*, September 1989, https://www.
 vanityfair.com/magazine/1989/09/dunne198909.

122 Mark Hughes, "Imelda Marcos secretary 'tried to sell $32 million Monet
 painting,'" *The Telegraph*, November 21, 2012, http://www.telegraph.co.uk
 /news/worldnews/northamerica/usa/9694017/Imelda-Marcos-secretary
 -tried-to-sell-missing-32-million-Monet-painting.html.

123 "Billionaire Bought 'Hot' Imelda Marcos Monet," *The Smoking Gun*, October 29,
 2013, http://www.thesmokinggun.com/documents/billionaire-bought
 -hot-monet-painting-687432.

124 Jon Swaine, "British billionaire pays $10 million to avert legal claim on his Monet painting," *The Telegram*, October 31, 2013, http://www.telegraph .co.uk/news/worldnews/northamerica/usa/10418395/British-billionaire -pays-10-million-to-avert-legal-claim-on-his-Monet-painting.html.

125 Patricia Hurtado, "Imelda Marcos Owned Monets, and Now They're Trapped in Brooklyn," *Bloomberg*, January12, 2017, https://www.bloomberg .com/news/articles/2017-01-13/shoe-queen-imelda-owned-art-too-and -her-country-wants-it-back.

126 Roel Landingin, Karol Ilagan, and Mar Cabra, "Ferdinand Marcos' Daughter Tied to Offshore Trust in Caribbean," International Consortium of Investigative Journalists, April 2, 2013, https://www.icij.org/investigations /offshore/ferdinand-marcos-daughter-tied-offshore-trust-caribbean/.

127 Myles A. Garcia, *Thirty Years Later: Catching Up with the Marcos-Era Crimes* (San Francisco: MAG Publishing, 2016), 84.

128 Susanne Bobek, "Autos des Diktatorensohns in Genf beschlagnahmt," *Kurier*, November 3, 2016, https://kurier.at/chronik/weltchronik/schweiz -autos-des-diktatorensohns-in-genf-beschlagnahmt/228.771.822.

129 "Terrifying Taste: 21 Despots, Dictators, and Drug Lords, and the Art They Loved," *Huffington Post*, January 23, 2013, https://www.huffingtonpost.com /artinfo/terrifying-taste-21-despo_b_2535030.html.

130 "1MDB: Der Wegweiser zum Skandal," *Finenews.ch*, July 21, 2016, https://www. finews.ch/news/banken/23793-1mdb-usa-fbi-fin ma-mas-najib-razak -jho-low-khadem-al-qubaisi-bsi-ubs-falcon.

131 Eileen Kinsella, "Prosecutors Expose Jho Low's Secret Schemes to Illicitly Acquire $137 Million in Art," *Artnet*, July 20, 2016, https://news.artnet .com/art-world/documents-show-jho-low- tktkt-567875; "United States Seeks to Recover More Than $1 Billion Obtained from Corruption Involving Malaysian Sovereign Wealth Fund," The United States Department of Justice, July 20, 2016, https://www.justice.gov/opa/pr/united-states-seeks -recover-more-1-billion-obtained-corruption-involving-malaysian-sovereign.

132 Áine Cain, "Trump insisted on hanging bright gold drapes in the Oval Office— here are past presidents' offices for comparison," *Business Insider*, February 15, 2018, https://www.businessinsider.com/donald-trump-oval -office-white-house-design-2018-1?r=DE&IR=T.

133 Brian VanHooker, "An Oral History of Trump's Love of Van Damme's *Bloodsport*," *MEL Magazine*, https://melmagazine.com/en-us/story/an -oral-history-of-trumps-love-of-van-dammes-bloodsport.

134 Donald Trump, *Think Like a Billionaire* (New York: Ballantine Books, 2004), 108.

135 Dara Lind, "Why Donald Trump plays *Phantom of the Opera* at his rallies," *Vox*, January 23, 2016, https://www.vox.com/2016/1/23/10816588/donald -trump-phantom-opera.

136 Andrea Jefferson, "Uncovered Video Shows Trump Describing His Favorite Author and it Will Make You Miss Obama," *Political Flare*, June 14, 2019, https:// www.politicalflare.com/2019/06/uncovered-video-shows-trump -describing-his-favorite-author-and-it-will-make-you-miss-obama/.

137 Luke O'Neil, "What do we know about Trump's love for the Bible?" *The Guardian*, June 2, 2020, https://www.theguardian.com/us-news/2020/jun/02/what-do-we-know-about-trumps-love-for-the-bible.

138 https://www.youtube.com/watch?v=ERUngQUCsyE.

139 Jake Nevins, "Trump v. the art world: from a gold toilet to his latest culture war," *The Guardian*, July 30, 2018, https://www.theguardian.com/artanddesign/2018/jul/30/how-the-art-world-got-embroiled-in-trump-culture-war-venice-biennaletrump-v-the-art-world-from-a-gold-toilet-to-an-empty-venice-pavilion.

140 Gregory Krieg, "The 14 most shocking comments from Trump's Charlottesville news conference," CNN, August 16, 2017, https://edition.cnn.com/2017/08/15/politics/donald-trump-charlottesville-lines/index.html.

141 Nicole Pasulka, "Palm Beach Van Dyck," Oxford American, May 2, 2017, https://www.oxfordamerican.org/magazine/item/1186-palm-beach-van-dyck.

142 Ibid.

143 Mark Bowden, "The Art of the Donald," *Playboy*, May 1, 1997, https://www.playboy.com/read/the-art-of-the-donald.

144 Kevin Conley, "The Story Behind Donald Trump's Epic Mar-A-Lago Portrait," *Town & Country*, April 19, 2016, https://www.townandcountrymag.com/leisure/arts-and-culture/news/a5870/trump-portrait-mar-a-lago/.

145 "Trump makes legendary artist do portrait his way," *New York Daily News*, March 6, 2016.

146 David A. Fahrenthold, "This is the portrait of Donald Trump that his charity bought for $20,000," *Washington Post*, November 1, 2016, https://www.washingtonpost.com/gdpr-consent/?next_url=https%3a%2f%2fwww.washingtonpost.com%2fnews%2fpost-politics%2fwp%2f2016%2f11%2f01%2fthis-is-the-portrait-of-himself-that-donald-trump-bought-with-20000-from-his-charity%2f.

147 Sam Wolfson, "Trump used his charity's money to pay for portrait of himself, Cohen says," *The Guardian*, February 27, 2019, https://www.theguardian.com/us-news/2019/feb/27/michael-cohen-testimony-trump-painting-foundation-money.

148 Brendan J. O'Reilly, "East Hampton Artist's Trump Portrait Caught the Donald's Attention," *Dan's Papers*, November 3, 2015, https://www.danspapers.com/2015/11/east-hampton-artists-trump-portrait-caught-the-donalds-attention/.

149 http://quigleyart.com/commissionsportraits/.

150 O'Reilly, "East Hampton Artist's Trump Portrait."

151 "Testimony of Michael D. Cohen," Committee on Oversight and Reform, US House of Representatives, February 27, 2019, https://www.scribd.com/document/400649065/Testimony-of-Michael-D-Cohen.

152 O'Reilly, "East Hampton Artist's Trump Portrait."

153 Dinah Wisenberg Brin, "Cardinal Health to Buy Drug Distributor Kinray," *Wall Street Journal*, November 19, 2010, https://www.wsj.com/articles/SB10001424052748704104104575622363175617190.

154 O'Reilly, "East Hampton Artist's Trump Portrait."

155 Ibid.

156 "AG James Secures Court Order against Donald J. Trump, Trump Children, and Trump Foundation," New York State Office of the Attorney General, November 7, 2019, https://ag.ny.gov/press-release/2019/ag-james-secures -court-order-against-donald-j-trump-trump-children-and-trump.

157 Ibid.

158 "Trump muss Millionen für Missbrauch von Stiftungsgeldern zahlen," *Süddeutsche Zeitung*, November 7, 2019, https://www.sueddeutsche.de /politik/trump-stiftung-geld-missbrauch-1.4673267.

159 Donald J. Trump and Tony Schwartz, *The Art of the Deal* (New York: Ballantine Books 1987), 33 ff.

160 David F. W. Fenner, *Art in Context: Understanding Aesthetic Value* (Athens, Ohio: Ohio University Press, 2008), 157.

161 Tyler Foggatt, "Giuliani vs. the Virgin," *New Yorker*, May 21, 2018, https://www. newyorker.com/magazine/2018/05/28/giuliani-vs-the-virgin.

162 Carol Vogel, "Australian Museum Cancels Controversial Art Show," *New York Times*, December 1, 1999, https://www.nytimes.com/1999/12/01 /nyregion/australian-museum-cancels-controversial-art-show.html.

163 M. H. Miller, "'Absolutely Gross, Degenerate Stuff': Trump and the Arts," *ARTnews*, April 4, 2016, https://www.artnews.com/art-news/news/absolutely -gross-degenerate-stuff-trump-and-the-arts-6095/.

164 Ibid.

165 Brian Boucher, "No, Sylvester Stallone Won't Head Up the National Endowment for the Arts," *Artnet*, December 19, 2016, https://news.artnet .com/art-world/sylvester-stallone-national-endowment-arts-788579.

166 Sylvester Stallone, "Rocky ist eine Liebesgeschichte," interviewed by *Süddeutsche Zeitung*, May 17, 2010, https://www.sueddeutsche.de/kultur /interview-mit-sylvester-stallone-ich-war-ein-idiot-1.417300-2.

167 Miller, "'Absolutely Gross, Degenerate Stuff.'"

168 Nevins, "Trump v. the art world."

169 Eileen Kinsella, "President Trump Is Trying to Eliminate the National Endowment for the Arts—Again—in His Just-Released 2021 Budget Proposal," *Artnet*, February 10, 2020, https://news.artnet.com/art-world /trump-proposes-eliminating-nea-and-neh-again-1774236.

170 Menachem Wecker, "Beyond the Golden Toilet: How Does Art End Up in the White House, and What Does It Tell Us About Our Leaders?" *Artnet*, February 5, 2018, https://news.artnet.com/art-world/art-white-house -loans-cattelan-history-1215974.

171 Matt Stevens, "Museum Told White House: No Van Gogh, but Here's a Gold Toilet," *New York Times*, January 25, 2018, https://www.nytimes.com/2018 /01/25/arts/gold-toilet-trump.html.

172 Michael Slenske, "Gold Standard," Gagosian.com, Summer 2018, https:// gagosian.com/quarterly/2017/12/01/essay-michael-slenske-gold-standard/.

173 Wecker, "Beyond the Golden Toilet."

174 Steve Madeja, "The Bonwit Teller Building: How Donald Trump Destroyed an Art Deco Treasure," *Secrets of Manhattan*, August 16, 2017, https://

secretsofmanhattan.wordpress.com/2017/08/16/the-bonwit-teller-building
-how-donald-trump-destroyed-an-art-deco-treasure/.

175 "How a NYC Department Store Launched Warhol and Friends," *The Art Story*,
https://www.theartstory.org/blog/how-a-nyc-department-store
-launched-the-art-careers-of-warhol-and-friends/.

176 Max Weintraub, "On View Now: Andy Warhol and the Anxiety of Effluence,"
Art21 Magazine, October 4, 2012, http://magazine.art21.org/2012/10/04
/on-view-now-andy-warhol-and-the-anxiety-of-effluence/.

177 "How a NYC Department Store Launched Warhol and Friends," The Art Story.

178 Callum Borchers, "Donald Trump hasn't changed one bit since his first media
feud in 1980," *Washington Post*, March 18, 2016, https://www
.washingtonpost.com/news/the-fix/wp/2016/03/18/donald-trumps-first
-media-controversy-is-a-really-great-story-just-a-really-fabulous-story/.

179 Christopher Gray, "The Store That Slipped Through the Cracks," *New York
Times*, October 3, 2014, https://www.nytimes.com/2014/10/05/realestate
/fifth-avenue-bonwit-teller-opulence-lost.html.

180 Gwenda Blair, *The Trumps: Three Generations of Builders and a President* (New
York: Simon & Schuster, 2001), 315.

181 Borchers, "Donald Trump hasn't changed."

182 Blair, *The Trumps*, 315.

183 Ibid.

184 Sam Dangremond, "The Historic Building Donald Trump Demolished to Build
Trump Tower," *Town & Country*, August, 18, 2017, https://www
.townandcountrymag.com/leisure/arts-and-culture/a12030857/donald
-trump-bonwit-teller/.

185 Max J. Rosenthal, "The Trump Files: When Donald Destroyed Historic Art to
Build Trump Tower," *Mother Jones*, September 10, 2020, https://www
.motherjones.com/2020-elections/2020/09/trump-files-when-donald
-destroyed-priceless-art-build-trump-tower/.

186 Borchers, "Donald Trump hasn't changed."

187 Harry Hurt III, *Lost Tycoon: The Many Lives of Donald J. Trump* (London: Orion
Books, 1994), 126.

188 Quoted in Dangremond, "The Historic Building Donald Trump Demolished."

189 Rosenthal, "The Trump Files: When Donald Destroyed Historic Art to Build
Trump Tower."

190 Madeja, "The Bonwit Teller Building."

191 Blair, *The Trumps*, 315.

192 Dean Baquet, "Trump Says He Didn't Know He Employed Illegal Aliens," *New
York Times*, July 13, 1990, https://www.nytimes.com/1990/07/13
/nyregion/trump-says-he-didn-t-know-he-employed-illegal-aliens.html.

193 Ibid.

194 John Surico, "Remembering John Barron, Donald Trump's 'Spokesman' Alter
Ego," *Vice*, November 6, 2015, https://www.vice.com/en_us/article
/exqkbp/remembering-john-barron-donald-trumps-spokesman-alter
-ego-116.

195 Sue Carswell, "Trump Says Goodbye Marla, Hello Carla," *People*, July 8, 1991, https://people.com/archive/trump-says-goodbye-marla-hello-carla-vol-35-no-26/.

196 Dangremond, "The Historic Building Donald Trump Demolished."

197 Borchers, "Donald Trump hasn't changed."

198 Nicholas von Hoffman, *Citizen Cohn: The Life and Times of Roy Cohn* (New York: Doubleday, 1988).

199 Pat Hackett, ed., *The Andy Warhol Diaries* (New York: Warner Books, 1989), 375f.

200 Grace Marston, Andy Warhol Talks about Donald Trump throughout the Mid-1980s," The Andy Warhol Museum website, January 21, 2016, https://www.warhol.org/andy-warhol-talks-about-donald-trump-throughout-the-mid-1980s/.

201 Hackett, *The Andy Warhol Diaries*, 386.

202 Ibid., 398.

203 Ibid., 571.

204 Herbert Muschamp, "Trump, His Gilded Taste, and Me," *New York Times*, December 19, 1999, https://www.nytimes.com/1999/12/19/arts/art-architecture-trump-his-gilded-taste-and-me.html?pagewanted=all.

205 Donald Trump, *Think Like a Champion: An Informal Education in Business and Life* (New York: Vanguard Press, 2009), 86.

206 Ben Ashford, "Inside Donald Trump's $100 million penthouse," *Daily Mail*, November 10, 2015, https://www.dailymail.co.uk/news/article-3303819/Inside-Donald-Trump-s-100m-penthouse-lots-marble-gold-rimmed-cups-son-s-toy-personalized-Mercedes-15-000-book-risqu-statues.html.

207 Peter York, "Trump's Dictator Chic," *Politico Magazine*, March/April 2017, https://www.politico.com/magazine/story/2017/03/trump-style-dictator-autocrats-design-214877.

208 Ashford, "Inside Donald Trump's $100 million penthouse."

209 Mark Bowden, "Donald Trump Really Doesn't Want Me to Tell You This, But . . . " *Vanity Fair*, December 10, 2015, https://www.vanityfair.com/news/2015/12/donald-trump-mark-bowden-playboy-profile.

210 Nick Bilton, "Donald Trump's Fake Renoir: The Untold Story," *Vanity Fair*, October 13, 2017, https://www.vanityfair.com/news/2017/10/donald-trumps-fake-renoir.

211 "Two Sisters (On the Terrace)," Art Institute of Chicago website, https://www.artic.edu/artworks/14655/two-sisters-on-the-terrace.

212 Jennifer Jacobs, Nick Wadhams, and Katya Kazakina, "Trump Ended 2018 France Trip Having Art Loaded on Air Force One," Bloomberg, September 6, 2020, https://www.bloomberg.com/news/articles/2020-09-06/trump-ended-2018-france-trip-having-art-loaded-on-air-force-one?srnd=premium-europe.

213 Timothy L. O'Brien, "Once upon a time in Mar-a-Lago: a joyride in Trump's red Ferrari," *The Japan Time*, April 6, 2017, https://www.japantimes.co.jp/opinion/2017/04/06/commentary/world-commentary/upon-time-mar-lago-joyride-trumps-red-ferrari/.

214 Bonnie Malkin, "Time magazine asks Trump to remove fake covers from display at golf clubs," *The Guardian*, June 28, 2017, https://www

.theguardian.com/us-news/2017/jun/28/time-magazinetrump
-fake-covers-golf-clubs.

215 Jason Horowitz, "A King in His Castle: How Donald Trump Lives, From His
Longtime Butler," *New York Times*, March 15, 2016, https://www.nytimes
.com/2016/03/16/us/politics/donald-trump-butler-mar-a-lago.html.

216 Wolfgang Ullrich, *Mit dem Rücken zur Kunst: Die neuen Statussymbole der
Macht* (Berlin: Wagenbach, 2000), 19.

217 Helge Achenbach, *Vom Saulus zum Paulus: Kunst- und Architekturberatung*
(Regensburg: Lindinger + Schmid, 1995).

218 Helge Achenbach, *Der Kunstanstifter–Vom Sammeln und Jagen*, ed. Christiane
Hoffmans (Ostfildern: Hatje Cantz, 2013).

219 Helge Achenbach, *Selbstzerstörung: Bekenntnisse eines Kunsthändlers* (Munich:
Riva Verlag, 2019), 66.

220 Tobias Timm, "Und ein Picasso für den Aldi-Erben," *Die Zeit*, no. 51/2014,
December 11, 2014.

221 Achenbach, *Selbstzerstörung*, 163.

222 Martin Winterkorn and Klaus Biesenbach, "Utopie der Moderne," interviewed
by Cornelius Tittel, *Welt am Sonntag*, no. 22, May 29, 2011.

223 "VW rockt das MoMA", *Bunte*, no. 23, May 31, 2011.

224 Press release from Berenberg Art Advice, September 29, 2011.

225 Quoted by Tobias Timm, "Auf der Suche nach dem Interessenten," *Die Zeit*, no.
31/2013, July 25, 2013.

226 Achenbach, *Der Kunstanstifter*, 229.

227 Achenbach, *Selbstzerstörung*, 185.

228 Cf. Tobia Timm, "Trübe Collagen," *Die Zeit*, no. 8/2015, February 19, 2015.

229 Kai-D. Bussmann, *Geldwäscheprävention im Markt: Funktionen, Chancen und
Defizite* (Berlin: Springer-Verlag, 2018), 97.

230 Fausto Martin De Sanctis, *Money Laundering Through Art: A Criminal Justice
Perspective* (Cham/Heidelberg: Springer-Verlag, 2013), 3.

231 Patricia Cohen, "Valuable as Art, but Priceless as a Tool to Launder Money,"
New York Times, May 12, 2013.

232 Eileen Kinsella, "UK Art Dealer Matthew Green Charged in a $9 Million
Picasso Money-Laundering Scheme," *Artnet*, March 6, 2018, https://news
.artnet.com/art-world/matthew-green-charged-money-laundering
-us-1236929.

233 Alex Ralph, "Art dealer Matthew Green embroiled in Beaufort securities fraud
made bankrupt," *The Times*, May 13, 2019, https://www.thetimes
.co.uk/article/art-dealer-embroiled-in-beaufort-securities-fraud-made
-bankrupt-hqrmmdxlp.

234 Norbert Kuls, "Fast so dreist wie Bernie Madoff," *Frankfurter Allgemeine
Zeitung*, July 11, 2009, https://www.faz.net/aktuell/wirtschaft/marc-dreier
-fast-so-dreist-wie-bernie-madoff-1827893.html.

235 Jake Bernstein, "The Art of Secrecy," International Consortium of Investigative
Journalists, April 7, 2016, https://www.icij.org/investigations
/panama-papers/20160407-art-secrecy-offshore/.

236 "Leonardo DiCaprio muss seinen Picasso abgeben," *Bilanz,* June 16, 2017, https://www.handelszeitung.ch/panorama/leonardo-dicaprio-muss-seinen -picasso-abgeben.

237 "Tanore Finance: Inside Story of the 'Saudi Royal Donation': The FBI Files Continued," *Sarawak Report,* July 21, 2016, http://www.sarawakreport. org/2016/07/tanore-finance-inside-story-of-the-saudi-royal-donation-the -fbi-files-continued/.

238 Kinsella, "Prosecutors Expose Jho Low's Secret Schemes."

239 Kelly Crow and Bradley Hope, "1MDB Figure Who Made a Splash in Art Market Becomes a Seller," *Wall Street Journal,* May 19, 2016, https://www .wsj.com/articles/1mdb-figure-who-made-a-splash-in-art-market-becomes -a-seller-1463695018.

240 Cohen, "Valuable as Art" (see note 145).

241 Monika Roth, "Geldwäscherei im Kunsthandel, Referat bei der Tagung 'Kunst & Recht 2014,'" Universität Basel, June 20, 2014, 49 ff., online: Roth -Monika_Auszug_Tagung_Kunst_und_Recht_150312.pdf.

242 Ibid., 54.

243 Monika Roth, "Geldwäscherei im Kunsthandel: die richtigen Fragen stellen," *Kunst und Recht,* no. 2/2016 (Berlin: 2016), 35–40.

244 Ibid., 35.

245 Cohen, "Valuable as Art."

246 Ibid.

247 Bussmann, *Geldwäscheprävention im Markt,* 97 (see note 143).

248 Ibid.

249 Ibid., 124.

250 Ibid., 125.

251 David Kaplan and Alec Dubro, *Yakuza: Japan's Criminal Underworld* (Berkeley: University of California Press, 2012), 183.

252 Ibid., 184.

253 Hendrik Ankenbrand, "Chinas Kunstmarkt ist eine Spielwiese für Geldwäsche," *Frankfurter Allgemeine Zeitung,* March 29, 2019, https://www .faz.net/aktuell/finanzen/meine-finanzen/chinas-kunstmarkt-ist-eine -spielwiese-fuer-geldwaesche-16113447.html.

254 Toh Han Shih, "Jho Low and the Wolf of Wall Street: how Malaysian businessman 'hooked up DiCaprio,'" in: *South China Morning Post,* March 12, 2015, https://www.scmp.com/business/article/1735821/jho-low -and-wolf-wall-street-how-malaysian-businessman-hooked-dicaprio.

255 Crow, Hope, "1MDB Figure Who Made a Splash" (see note 152).

256 Jake Bernstein, "The Panama Papers—The Art of Secrecy," Icij.org, July 4, 2016, https://www.icij.org/investigations/panama-papers/2016 0407 -art-secrecy-offshore/.

257 Ibid.

258 Gary Baum, "Leonardo DiCaprio, the Malaysians and Marlon Brando's Missing Oscar," *Hollywood Reporter,* September 21, 2016, https://www. hollywoodreporter.com/features/leonardo-dicaprio-malaysians-marlon -brandos-931040.

259 Swantje Karich and Cornelius Tittel, "Der Kunsthandel sollte sich zentral organisieren," *Die Welt*, June 1, 2015, https://www.welt.de/kultur /article141743893/Der-Kunsthandel-sollte-sich-zentral-organisieren.html.

260 Mathias Döpfner, "Die Kunst gehört der ganzen Welt," *Blau-Magazin*, July 1, 2015.

261 *Non-Paper zum Regierungsentwurf zur Umsetzung der neuen EU-Geldwäschelinie* (Berlin: Bundesministerium der Finanzen, 2019).

262 Cf. Alessandra Dagirmanjian, "Laundering the Art Market: A Proposal for Regulating Money Laundering Through Art in the United States," *Fordham Intellectual Property, Media & Entertainment Law Journal*, vol. XXIX, no. 2 (New York: Fordham University, 2019), https://ir.lawnet.fordham.edu/iplj /vol29/iss2/7/.

263 Zachary Small, "Does the Art World Have a Money Laundering Problem?" *Hyperallergic*, October 18, 2018, https://hyperallergic.com/465736/does -the-art-world-have-a-money-laundering-problem/.

264 "Art and Finance Report," Deloitte, https://www2.deloitte.com/lu/en /pages/art-finance/articles/art-finance-report.html.

265 Gerd Seeliger, "Bedroht das neue Geldwäschegesetz den Kunsthandel?" *Monopol*, July 30, 2019, https://www.monopol-magazin.de/bedroht-das -neue-geldwaeschegesetz-den-kunsthandel.

266 Ibid.

267 Ibid.

268 Peter Raue, "Mit Kanonen auf Spatzen," *Kunstzeitung*, September 2019, 3.

269 Seeliger, "Bedroht das neue Geldwäschegesetz den Kunsthandel?" (see note 178).

270 Christiane Fricke, "'Ihren Ausweis, bitte!'—Kunsthändler müssen künftig die Identität der Kunden nachweisen," *Handelsblatt*, July 4, 2019, https://www. handelsblatt.com/arts_und_style/kunstmarkt/geldwaeschegesetz -ihren-ausweis-bitte-kunsthaendler-muessen-kuenftig-die-identitaet -der-kunden-nachweisen/24517294. html?ticket=ST-31668449-bIgvf1tOr3qjIUAsa9P3-ap3.

271 Raue, "Mit Kanonen auf Spatzen" (see note 181).

272 Fausto Martin De Sanctis, "Self-Regulation in the Art World and the Need to Prevent Money Laundering," *Business and Economics Journal*, vol. 5, no. 3 (2014), 7, https://www.omicsonline.org/open-access/business-and -economics-journal-2151-6219.1000108.php?aid=31714.

273 Ibid.

274 Bussmann, *Geldwäscheprävention im Markt*, 61 ff. (see note 143).

275 "Money laundering through art: What all stakeholders must know," *Private Art Investor*, April 30, 2018, https://www.privateartinvestor.com/art -business/money-laundering-through-art-what-all-stakeholders-must -know823/.

276 Simon Bradley, "Die diskreten Bunker der Superreichen," Swissinfo.ch, July 9, 2014, https://www.swissinfo.ch/ger/wirtschaft/die-diskreten-bunker -der-superreichen/40485786.

277 "Ports francs et entrepôts douaniers ouverts: Evaluation des autorisations et des activités de contrôle," Eidgenössische Finanzkontrolle, January 28, 2014, https://

www.efk.admin.ch/images/stories/efk
_dokumente/publikationen/_wirtschaft_und_verwaltung/oeffentliche
_finanzen_und_steuern/17458/17458BE_Version_finale_V04.pdf.

278 Philipp Meier, "Geburtsstunde einer Sammlung," *Neue Zürcher Zeitung*,
October 21, 2011.

279 Laura Gilbert, "Legal battle over Modigliani painting rumbles on," *The Art
Newspaper*, April 20, 2018, https://www.theartnewspaper.com/news/legal
-battle-over-modigliani-painting-rumbles-on.

280 J. Emil Sennewald and Tobias Timm, "Im Bunker der Schönheit," *Die Zeit*, no.
18/2013, April 25, 2013.

281 Ibid.

282 Ben Lewis, *The Last Leonardo. The Secret Lives of the World's Most Expensive
Painting* (London: Williams Collins, 2019).

283 United States District Court Southern District of New York, Accent Delight
International Ltd, et al., vs. Sotheby's, et al., Case 18-CV-9011 (JMF).

284 Chanyaporn Chanjaroen, Hugo Miller, and Ranjeetha Pakiam, "Asia's 'Fort
Knox' Said to Be Up For Sale As Owner Fights Tycoon," *Bloomberg*, July 17, 2019,
https://www.bloomberg.com/news/articles/2019-07-17/asia-s-fort
-knox-said-to-be-up-for-sale-as-owner-fights-tycoon.

285 Margherita Bettoni and Floriana Bulfon, "Italiens geraubte Schätze,"
Süddeutsche Zeitung, November 21, 2019, https://www.sueddeutsche.de
/kultur/operation-achei-italien-europol-schmuggel-archaeologie-1.4691210.

286 "Staggering Cache of Picassos Turns Up in France," NPR, November 29, 2010,
https://www.npr.org/2010/11/29/131664254/staggering-cache
-of-picassos-turns-up-in-france?t=1574523817055.

287 https://www.tagesschau.de/ausland/verschwundene-kunstwer-ke-in-china
-luepertz-101.html.

288 Daniel Richter, "Wenn es nach mir ginge, würden sich die Bilder selber malen,"
interviewed by Sven Michaelsen, *Süddeutsche Zeitung*, no. 37, September 16,
2015, https://sz-magazin.sueddeutsche.de/kunst/wenn-es
-nach-mir-ginge-wuerden-sich-die- bilder-selber-malen-81648.

289 Markus Metz and Georg Seeßlen, *Geld frisst Kunst. Kunst frisst Geld.* (Berlin:
Suhrkamp Verlag, 2014).

290 Georg Seeßlen, "Eine Revolte für die Kunst," interviewed by Tobias Timm, *Die
Zeit*, no. 35/2014, August 21, 2014, https://www.zeit.de/2014/35/georg
-seesslen-kunstmarkt.

STEFAN KOLDEHOFF is culture editor at *Deutschlandfunk* in Cologne, and writes for *Die Zeit* and *art-Das Kunstmagazin* among other publications. In 2008 he received the Puk journalist prize for his investigative research. TOBIAS TIMM studied urban ethnology, history, and cultural studies in Berlin and New York. He has written for *Die Zeit* on architecture, art, and crime. In 2012, Koldehoff and Timm published *False Pictures, Real Money*. The book was awarded the Prix Annette Giacometti and the Otto Brenner Prize. Koldehoff has also written *The Pictures Are Among Us: The Nazi-Looted Art Business and the Gurlitt Case* (2014) and *Me and Van Gogh: Pictures, Collectors and Their Adventurous Stories* (2015).

PAUL DAVID YOUNG's translations from German include *The Art of C.G. Jung* (2018) and, with Carl Weber, *Heiner Müller: After Shakespeare* (2014). Young's 2019 play, *All My Fathers*, at La MaMa E.T.C. was praised as "hilarious" by the *New Yorker*. www.pauldavidyoung.com.